2009

Frontispiece. SAMUEL BEMIS. BURIAL GROUND, KING'S CHAPEL, BOSTON, 1840-1841.

PHOTOGRAPHY AND ARCHITECTURE: 1839–1939

RICHARD PARE

INTRODUCTION BY PHYLLIS LAMBERT

Catalog by Catherine Evans Inbusch and Marjorie Munsterberg

CENTRE CANADIEN D'ARCHITECTURE · CANADIAN CENTRE FOR ARCHITECTURE

Callaway Editions

EXHIBITION SCHEDULE:

Galerie Lempertz Contempora, Cologne
arranged in collaboration with "photokina" bilder- und filmschauen
September 15–October 16, 1982

The Art Institute of Chicago
May 9 – June 26, 1983

Cooper-Hewitt Museum, The Smithsonian Institution's
National Museum of Design, New York
July 26 – October 16, 1983

Centre Georges Pompidou, Paris
February 24 – May 21, 1984

The National Gallery of Canada, Ottawa
September 13 – November 11, 1984

LIBRARY OF CONGRESS CATALOG CARD NUMBER 82–12892

ISBN 0–935112–06–5 (hard cover) ISBN 0–935112–07–3 (soft cover)

CONTENTS

THE PHOTOGRAPHIC COLLECTION of the Canadian Centre for Architecture started at an antiquarian bookshop in New York City one afternoon in September 1974. The first acquisition was a photograph of the Capitoline Hill by Robert Macpherson. In the eight years that have elapsed since, the collection has grown to include more than 25,000 images, encompassing the history of photography through architecture and the history of architecture through photography. The collections of the CCA are the result of the vision and commitment of the director and founder Phyllis Lambert, to whom I am grateful for the rare opportunity to gather together such a collection.

I would like to thank Berenice Abbott, Fritz Henle, Langdon Longwell, Werner Mantz, and Frank Navara. They answered our questions with great readiness and granted permission to reproduce their photographs.

For their indispensable contributions to the research for the catalog I would like to thank Barbara Coffey, London, and Maria Morris Hambourg, New York City.

For their assistance I would like to thank the staff of the Canadian Centre for Architecture and, particularly, Karen Coape-Arnold, Patricia Kirk, and Patricia Martin.

In the preparation of this book special services were provided by: Gilles Carter, Jim Dow and Jackie Strasburger, Raymonde Gauthier, Eun-Mo Griebsch, Laura McPhee, James Munsen, Larry Richie, and Nancy Wechsler.

I would like to thank the following institutions, whose staffs gave freely of their time in response to our questions: Avery Architectural Library, Columbia University, New York; the National Archives, Still-Picture Section, Washington, D.C.; the India Office Library and Records, London; the New York Public Library; and Joseph E. Seagram & Sons, New York City, in particular Barry Winiker and Carla Caccamise Ash.

Additional research material and advice were provided by: Pierre du Prey, Queens University; Mark Hayworth Booth and Alexandra Noble, Victoria and Albert Museum; Valerie Lloyd, London; Gertrude Mae Prescott, London; Marie de Thézy, Bibliothèque historique de la Ville de Paris; Françoise Heilbrun, Musée d'Orsay; André Jammes, Isabelle Jammes, and Marie-Thérèse Jammes, Paris; Bernard Marbot, Bibliothèque Nationale; Philippe Néagu and Alain Pougetoux, Service Photographique de la Caisse des Monuments historiques; Milo Beach, Williams College; Eve Blau, Wesleyan University; Rosemarie Bletter, Columbia University; Richard Brilliant, Columbia University; Peter Bunnell, Princeton University; John Coplans, New York City; Lois Craig, Massachusetts Institute of Technology; Bevan Davies, New York City; Mary Ellen Evans, New York City; Kenneth Finkel, the Library Company of Philadelphia; Peter Galassi, The Museum of Modern Art; Eugenia Parry Janis, Wellesley College; Renée Lüttgen, New York City; Hugo Munsterberg, Bard College; Peter Palmquist, Humboldt State University; Mary Panzer, Boston; Gerd Sander, Washington, D.C.; Marni Sandweiss, Amon Carter Museum; Joel Snyder, University of Chicago; David Travis, Art Institute of Chicago; Clark Worswick, Millbrook, New York.

Manfred Heiting, Amsterdam; Rudolf Kicken, Cologne; and Daniel Robbins, Troy, New York, were instrumental in the organization of the exhibition that accompanies this book.

For their help in reading and verifying the information in the book, special thanks are due to Julia Parker, Canadian Centre for Architecture, Montreal; and Adolph Placzek, Avery Librarian Emeritus, Columbia University, New York City.

For her enthusiasm and creative vision, I would like to thank Eleanor Caponigro, who designed the book. Eugenia Robbins, as editor, prepared the manuscript for publication with grace and unflagging energy.

Lastly, I would like to thank Hyun Höchsmann, especially, for her ideas and encouragement.

RICHARD PARE, *Curator of Photographs*
Centre Canadien d'Architecture/Canadian Centre for Architecture

INTRODUCTION

THE CANADIAN CENTRE FOR ARCHITECTURE was founded to study the significance of building in the unfolding of the history of our society, so that knowledge of the past may be a guide to the present and the future. The CCA's collections of drawings, books, prints, and photographs are concerned with architecture in its largest sense, a sense that includes the conceptualization as well as the shaping of the built and of the natural environment. The purposes of the Canadian Centre for Architecture are advanced through study programs, through publications, and through exhibitions. This book and the exhibition it accompanies show the range of architectural photography from the exhilarating discoveries in early daguerreotypes to images that record the impact of technology on architecture, both old and new, and on the way people live and shape their environment.

Drawings offer a private and singular source of information about architecture. They provide insight into the thinking of individual architects and the process of transmitting concepts through specialized notations. Through them we can look over the shoulder of the architect, sense the various possibilities of composition, scale, vocabulary, visual refinements, and we can even infer the influence of the client. Drawings by architects permit us to trace the development of a building. They may be quick exploratory sketches or magnificent renderings intended to convey the quality of materials and the articulation of the space of the building represented. They also may be detailed documents of construction, notes on buildings seen or problems to be solved.

While drawings provide evidence of architectural thought, printed books have been the vehicle for constant and continuous dissemination of architectural theory and criticism. Two printed treatises—the first on architecture—were published in quick succession. Leon Battista Alberti's *De re aedificatoria* was published in Florence in 1485. *De architectura* was published in Rome in 1486 from a manuscript of Vitruvius Pollio initially written in the 1st century B.C. Twenty-five years later, in 1511, the same text with accompanying woodcuts was published in Venice. This was the first illustrated printed book on architecture. Since its publication, the union of illustrations with printed text has been a key element in the exposition and discussion of the formal vocabulary of architecture. Illustrated books on architecture have been published continuously since the sixteenth century. These have ranged from theoretical works and copybooks to studies on perspective, engineering, construction techniques, landscape architecture, town planning, and interior design. Architects, scholars, and critics also have published monographs on individual buildings, on architects, and on clients, as well as critical works on all aspects of design and construction. This wide variety of printed text and illustration forms a coherent body of information about how buildings should look, how they do look, and how they did look.

Just as the various graphic media provide different levels of information about buildings, so photographs provide still other ways in which to know and study architecture. From the beginning photographers, critics, historians, and architects were aware of two special attributes of photography: rapidity of notation and accuracy of representation. William Henry Fox Talbot, who may be considered the

inventor of the negative process, commented in 1845 that "even accomplished artists now avail themselves of an invention which delineates in a few moments the almost endless details . . . which a whole day would hardly suffice to draw correctly in the ordinary manner."[1] Rapidity of notation and faithfulness of detail also meant that images of buildings could be taken far and wide. Within months of the announcement of the daguerreotype process in 1839, Nicolas-Marie Paymal Lerebours had sent photographers to record monuments from Paris to Egypt for his two-volume *Excursions daguerriennes* (Paris 1840–1842). This type of enterprising commercial venture was continued throughout the nineteenth and well into the twentieth century, with Francis Frith, among others, providing images of the most notable monuments for tourists and scholars.

Surveys by government agencies were also undertaken from the beginning. In 1851 the Commission des Monuments historiques sent five photographers to systematically inventory the major architectural monuments of France. Military surveys, which resulted in works such as those by Captain Linnaeus Tripe in India and Burma and Timothy O'Sullivan in America, were concerned with the discovery of a newly conquered world. The massive documentation of working and living conditions in the United States during the great depression, undertaken by the Farm Security Administration, continued the tradition of government photographic surveys.

Photographers also were commissioned by municipal and private agencies to document old buildings about to be destroyed by rapid urbanization and the city planning edicts that developed at the same time as photography itself. The systematic documentation of Paris by Charles Marville shows the two major effects of planning legislation: demolition of streets and neighborhoods and the development of entirely new areas of the city, for example, in and around the Bois de Boulogne. Photographs have been used for related purposes, such as the documentation of building techniques. For example, L. E. Walker

recorded the construction of the Treasury Building in Washington, D.C., and in the province of Limburg, the Netherlands, officials hired Werner Mantz to record the effects of seasonal change on newly built roads in order to assess the efficacy of their design. Photographs also could be used as evidence in litigation that arose from failure to meet schedules or other problems of construction.

Detailed records were made of the new railways and factories that had created the need for town planning. Early examples are publication of the railway routes from Paris to Boulogne and from Paris to Lyon and Toulon with photographs taken by Edouard Baldus in the 1850s. Some of these photographs were sent by the Ministère des Travaux publics to the International Exposition in Vienna of 1873. They inspired Léonce Reynaud, Inspecteur général des Ponts et Chaussées, to produce the five-volume work, *Les Travaux publics de la France*, published in 1883 with phototypie plates after photographs by Baldus, among others. In the United States, William H. Rau documented new railway lines in the industrialized East of the 1890s, showing the gradual encroachment of civilization on virgin lands, and Edouard Durandelle photographed the process of fabrication as well as mid-century construction in France.

Not all systematic documentation was generated by government or private industry. Henri Le Secq chose to photograph various French Gothic cathedrals extensively as well as the steady demolition of Paris around the Ile Saint-Louis, where he lived. Eugène Atget's later record of Paris and its environs was also individually conceived, a personal statement of his vision of French civilization and its history. Atget's contemporary, Frederick Evans, demonstrated a related attitude in his photography of French and British medieval churches. His platinotypes of details in the Chapter House at York Minster, however, are possibly more related to Le Secq's inference of the whole of a monument from the record of its parts. John Murray built an image of the revered complex of the Taj Mahal by moving in and around the site and its buildings, and Carleton E. Watkins in much the same way constructed a record of the settlements along the

1. Talbot, *The Pencil of Nature*, text to plate 17.

Columbia River Valley in 1867. Later he portrayed a complete environment; in sixty mammoth plates he showed all aspects of Thurlow Lodge, the newly constructed mansion and grounds of a California magnate.

All of these activities clearly indicate that the potential uses of the photographic survey and its capacity for compiling information from the juxtaposition of many separate images were understood almost immediately both by patrons and by individual photographers. Charles Nègre clearly expressed the services that photographers could render to architects and artists in his introduction to an unpublished portfolio of the early 1850s: *"I have attempted to join the picturesque aspect to the serious study of details so sought after by artists, architects, sculptors, and painters; each of these categories of artists will find . . . subjects that will enter his own special frame of reference without losing their condition of art."* For the architect, he wrote, *"I have produced a general view of each monument. . . . In placing the horizon line at the mid-point of the building's height and the point of view at the centre, I have tried to avoid perspective distortions and have attempted to give to the drawings the aspect and the precision of a geometric elevation."*[2]

Architects and critics also recognized early the support that the vast resources of photography would bring to the study of architecture and design. Not only were careful photographs like those of Nègre useful for the study of proportions of facades, but in addition photographs of the details of capitals, of friezes, and of other ornamental elements were compiled by architects as style manuals, replacing the earlier copybooks. Robert Henry Cheney, a Victorian amateur land-

scape architect and photographer, viewed photography as a design tool that would permit comparative studies *". . . so that you may see what it was and compare it with what it is – The not being able to do this, is the torment of landscape gardening – though in time when the facility of taking sun pictures is increased we may hope to remedy this defect."*[3] Viollet-le-Duc considered photographs to be irrefutable records of evidence, *"procès-verbaux irrécusables,"* which could be consulted constantly in the process of restoring ancient buildings.[4] In the 1840s he may have commissioned daguerreotypes of Notre-Dame Cathedral to help him develop plans for its restoration. The critic Henri Delaborde, like many others of the nineteenth century, was impressed by the veracity of the photographic image and its "objectivity," which for him rendered images superior to those drawn by Israël Silvestre, Gabriel Pérelle, and Giovanni Battista Piranesi. He was, however, wary of the dangers that this *"fidélité toute mécanique"* and its vast store of images held for the architect. He prayed that this new familiarity would induce not a taste for imitation but, to the contrary, would inspire the architect with the energy of invention.[5] Almost half a century later, a similar concern was recognized and reiterated by the American architectural critic Montgomery Schuyler: *"The promiscuous practitioner of architecture in America, or in any other modern country, is not of an analytical turn of mind. When things please him, he is not apt to inquire into the reasons why they please him; . . . He is . . . apt to reproduce them as he finds them, so far as this is mechanically possible. For this process our time affords facilities unprecedented in history. Photographs are available of everything striking or memorable that has been built in the world, and that survives*

2. ". . . j'ai tâché de joindre l'aspect pittoresque à l'étude sérieuse des détails si recherchés par les archéologues et par les artistes, architectes, sculpteurs, et peintres; chacune de ces catégories d'artistes trouvera . . . des motifs qui entreront dans leurs cadres spéciaux sans perdre leurs conditions d'art. Ainsi, j'ai fait pour l'architecte une vue générale de chaque monument. En plaçant la ligne d'horizon au milieu de la hauteur de l'édifice et le point de vue au centre j'ai cherché à éviter les déformations perspectives et à donner aux dessins l'aspect et la précision d'une élévation géométrale." Quoted in Borcoman, *Charles Nègre*, pp. 6–7.

3. Letter from Cheney to Thomas Cromek, London, May 8, 1846 (courtesy of The Pierpont Morgan Library, New York).

4. Viollet-le-Duc, *Dictionnaire*, vol. 8, 1866, p. 33.

5. "Quelles vastes ressources elles créent aux études techniques, comme à l'archéologie et à l'histoire. Puissent ce nouveau secours et ces exemples familiers tourner au profit de l'architecture contemporaine! puisse-t-elle, dans ce contact de tous les jours avec le passé, puiser, non pas le goût de l'imitation, mais au contraire une force d'invention nouvelle!" Henri Delaborde, "La Photographie et la gravure," *Revue des deux mondes*, 25th year, 2nd series, vol. 2 (March 1, 1856), p. 629.

even in ruins." Schuyler insists that although the photograph enables the architect "*merely to reproduce what he admires,*" it also "*increases the desirableness that he should admire rightly; that he should admire with discrimination; that he should analyze what he admires far enough to find out what it is that he admires it for, and what it is that may be useful to him in his own work.*"[6]

Photography became an indispensable tool for archeologists and art historians. Even in the early years, photographs were made for very specific scholarly purposes. In 1854 Auguste Salzmann photographed evidence in support of a disputed dating scheme–in this case the dating of successive civilizations in Jerusalem proposed by Louis-Félicien-Joseph Caignart de Saulcy, a member of the Institut de France. In 1859–1860, Emmanuel Guillaume Rey took Louis de Clercq on his expedition to the Near East. Such ventures multiplied as the process of making photographs became easier, and by the 1880s archeological expeditions routinely hired photographers.

The history of art is in part a descriptive science, which in turn depends on the comparative method. Groups of buildings are studied in order to trace their relationships and influences one on the other. Photographs are therefore a major resource, a visual record contributing to the making of history. Perhaps because of easy availability, art historians generally have been content to use images found in the vast collections established by photographic companies such as Fratelli Alinari, James Anderson, and Adolphe Braun. The extent of this reliance on photography today was described by John McAndrew. He reported a discussion between two distinguished art historians, who, while sitting in the Piazza San Marco, lamented that no one could work on the later architecture of Venice because there were no photographs of it in the Cini Library. This exchange disturbed McAndrew because it "*exposed a sinister belief that work with photographs is essential but work with the actual building is not.*"[7]

The dependence on photography by art historians not only raises the question of the effect of photography on our vision and understanding, but also points up our lack of critical understanding of photographs as images. Talbot's choice of titles for his publications of the 1840s, *Sun Pictures in Scotland* and *The Pencil of Nature*, indicates the popular contemporary claim to objectivity and faithful recording as well as its attendant quality: the anonymity of the image and of the photographer. The sun and the camera would draw everything. John Ruskin, among others, soon challenged this anonymity. In 1845 his initial reaction to photography, to the "*exquisitely bright, small daguerreotypes,*" was that the purchase of such an image of a building "*is very nearly the same thing as carrying off the palace itself; every chip or stone and stain is there and of course there is no mistake about proportions.*"[8] Like others, Ruskin initially accepted the photograph as transparent, as a stand-in for the real thing. He continued to use the medium for recording a monument "*stone by stone, sculpture by sculpture,*"[9] but his enthusiasm waned as he concluded that photographs could not express "*the personality, activity, and living perception of a good and great human soul.*"[10] Despite a few such changes in attitude, the earlier acceptance of an image as transparent was bequeathed to the art historian, who reproduces photographs in scholarly publications, for the most part without analysis of the image, without concern for the date on which the photograph was taken, and without concern for the name of the photographer.

Photographs, like all other graphic works, must be examined thoroughly as sources in themselves. It is assumed, for example, that an engraving by Piranesi must be analyzed for distortions of scale and proportion. To do this, the position of the artist relative to the subject must be ascertained. The image must be compared to other representations of the same subject in order to detect changes, to trace additions and subtractions to the building itself. In the same way,

6. "Last Words About the [1893] World's Fair," in Schuyler, *American Architecture*, vol. 2, pp. 556 – 557.
7. McAndrew, *Venetian Architecture*, p. x.

8. Ruskin, *Works*, vol. 3, note on p. 210.
9. *Ibid.*, vol. 8, p. 13 (preface to the 2nd ed. of *The Seven Lamps of Architecture*, 1855).
10. *Ibid.*, vol. 11, p. 201 (conclusion of *The Stones of Venice*, 1853).

photographs must be examined for veracity and for traces of the attitudes brought by the photographer to a subject. In a view of Piazza San Marco (plate 50), for example, an anonymous photographer made the irregular shape of the piazza seem rectangular by symmetrically framing his subject, creating an expectancy of regularity on the part of the viewer. The attitude of the photographer toward subject changes in much the same way as the architect's attitude to values in building or the painter's view of what is significant. For example, compare George Bridges' photograph of the temple of Athena Nike (plate 61) with Walter Hege's view of the Parthenon and the Odeion of Herodes Atticus (plate 67). In Bridges' image, a gentleman lounges on the porch of the temple; it is his private preserve, almost his own neoclassical villa. Later, for Hege, the Acropolis was no longer a private place but rather a sacred historical monument to be approached with reverence.

Photographs then, beyond their role as documents and like other works of art, are interpretive. Like the buildings they represent, photographs are both art and science, both spiritual and practical. They have influenced the way things are and how we have thought about them. Berenice Abbott has said that photographs are concerned with what buildings show, not what they don't show. The ready availability of images of buildings and the rapid transmission of these images since the invention of halftone printing a century ago are bound to have affected the interpretation of architecture. We have yet to assess the extent and nature of these influences.

To be able to evaluate photographs as historical documents and their effect on design a body of work must be studied; for this to happen, individual images and groups of images must be brought together. Therefore, as in the CCA collections, photographs as evidence in the history and concepts of architecture are to be studied alongside the evidence of texts, prints, and architectural drawings. It is hoped that the photographs and text in this publication will illuminate the developing study of architectural photographs.

PHYLLIS LAMBERT, *Director*
Centre Canadien d'Architecture/Canadian Centre for Architecture
Montréal, May 1982

PHOTOGRAPHY AND ARCHITECTURE:

1839–1939

PHOTOGRAPHERS FROM THE VERY BEGINNING have explored architecture as a main subject. This book is guided by the recognition of the close connection between photography and architecture in the development of photography and its processes. The intrinsic validity of the individual photographic image is the point of attention. The works are arranged according to an understanding of the growth and development of photography, commencing in England and France, then spreading throughout the world. This is an historical survey of the photography of architecture from the announcements of Daguerre and Talbot in 1839 and spans the first one hundred years of the history of photography.

There is in the best photographs of architecture an intention of space that can be portrayed through the intention of time. The photographer seeks to reveal aspects of space through his understanding of the effects of time. Time past, in the cumulative age of the building, time present in the photographer's moment, and time future in our present, all are interwoven, becoming an inseparable unit in the perception of each image. The success of a particular photograph depends largely on the photographer's interpretation of space through time. "*Epiphany*," Joyce's term for sudden illumination, can be brought to the subject by the photography of architecture. The transcendent moment is often captured in uncertainty, with a sense of impending failure. Photography is an art of failure in which success is measured against unattempted images and failures in an extremely disproportionate ratio. These moments, so dependent on temporal fluctuations, minute shadings of weather, all too often are gone before the photographer is ready to seize them. In this sense, the celebrated remark of Cartier-Bresson that "*photographers deal in things which are continually vanishing, and when they have vanished, there is no contrivance on earth which can make them come back again,*"[1] is as applicable to this area of photography as it is to any other. Success comes from a heightened awareness of the problems of photographing architecture, and this was sustained among the pioneers by what appears to be an almost mantic sense.

Photography of architecture has been central to the development of photography itself, yielding a wealth of extraordinary images in a period of little more than one hundred and fifty years. When the first experiments with photography began to bear fruit, they engendered great excitement. The enormous promise of the medium galvanized the pioneers into feats that even today remain awesome. The medium developed rapidly from a rudimentary and intransigent process into a highly refined and consistent technical procedure. What had begun as tentative qualities of expression quickly evolved into definable stylistic approaches, and the photographer emerged as an individual with a distinct point of view toward the subject before his camera. It took only a short time for photography to reach a high

1. Cartier-Bresson, *Decisive Moment*, n.p.

level of artistic endeavor and to arrive at levels of proficiency that caused radical change in both the availability and the quality of information about the visible world, a world about which the public was increasingly curious.

The history of photography is one of early triumph, followed by temporary decline in the latter part of the nineteenth century and a renaissance in the twentieth. Architectural photography is no exception to this pattern. After its initial success, unthinking commercial exploitation crowded out the early spirit of adventure with monotonous repetition of standard views. This led to a general debasement of the field, despite a few notable exceptions. What remains is an extraordinary legacy: visions of a different world. The architectural photographers of the nineteenth century who brought back these views stimulated the sedate and complacent populace at home.

The two great domains of early photography were architecture and portraiture, with architecture and the recording of the urban environment being the area of greatest creative endeavor. The first surviving photograph is of an architectural subject. Joseph-Nicéphore Niepce's view of 1827 can only be recognized as an image at all insofar as it shows the view across the rooftops of his property.[2] The volumes of the roofs seen from his attic window, faint and irregular in outline, are all that can be easily distinguished. One is left with only a rudimentary understanding of the architectural information contained in the image. It is recorded that his exposure was about eight hours, which surely required his chosen subject to remain in the same place. The only subject that readily provided the necessarily definitive forms and conditions of illumination for his experiment was an architectural composition.

After collaboration between Niepce and Louis-Jacques-Mandé Daguerre, the process was improved until the daguerreotype made its formal appearance in 1839. From the images that remain, it is clear that photographers preferred the relative simplicity of a portrait stu-

dio to the difficulties presented by working outside. Only a few chose the harder path, producing singular images of particular places that had limited usefulness and commercial appeal. Reproduced as conventional steel engravings in albums such as *Excursions daguerriennes*, the early silvered images were reduced to simple linear facsimiles in the engraving process. Still, these earliest albums of views began what was to become an engrossing preoccupation: the photography of the great monuments. As early as 1839 Nicolas-Marie Paymal Lerebours, the publisher of *Excursions daguerriennes*, sent daguerreotypists to Egypt, Nubia, Palestine, and Syria, also Greece, Spain, Italy, France, and other countries of Europe. So great a sense of veracity is imparted by a successful daguerreotype that it is understandable why a small number of men persevered in their efforts to bring back images of far-off places: Horace Vernet in 1839 in Egypt, J.-P. Girault de Prangey in Baalbek and Athens in 1842, and baron Gros, also in Athens.

The four daguerreotypes shown in this publication are of places closer to home; three have the appearance of having been exposed from a window convenient to the necessary equipment. They have an experimental quality, both technically and aesthetically. Four different attitudes toward subject matter emerge: the detail (plate 16); the parenthetical, in which the nominal subject is not of primary interest (Frontispiece); the documentary (plate 1); and the encompassing environmental view (plate 15). The very vocabulary of architectural photography is being established: an indistinct country is being mapped.

The announcement of the daguerreotype process in 1839 precipitated William Henry Fox Talbot's introduction of his own technique. The days of daguerreotypes were numbered by the announcement of Talbot's process. Like that of Niepce, the earliest surviving photograph by Talbot was an architectural subject. In August 1835, he produced a tiny image, not much larger than a 35-millimeter negative, of one of the windows of his ancestral home, Lacock Abbey. Later he wrote beside it that "*when first made, the squares of glass about*

2. Gernsheim, *History*, plate 21.

200 in number could be counted with the help of a lens."[3] This early interest in the ability of the photographic process to render detail anticipates the continuing fascination with clarity of rendition. With the paper negative process, images of greater size could be produced more simply with a far less complicated and dangerous chemistry than the heated mercury vapor required to make a daguerreotype, and eventually exposures were to be brought down to much more manageable times. The greatest advantage of Talbot's paper negative was its transparency. Utilizing paper negatives, multiple prints were possible from a single exposure, although it was not immediately clear to Talbot's contemporaries that this characteristic was a desirable benefit. In comparison to the clarity of a daguerreotype, the simplified blocking out of forms apparent in early examples of Talbot's work must have appeared crude and unappealing. In an attempt to overcome this resistance, Talbot set about the production of the first photographically illustrated book, *The Pencil of Nature*, which was issued to subscribers in fascicles between 1844 and 1846. The majority of the subjects included were architectural. It was not well received, mainly because the images were still only partially stable and varied considerably at the time of publication and immediately thereafter.

Talbot's premature announcement and restrictive control of his process through enforcement of his patents was to set Britain at a considerable disadvantage in the development of photography. Richard Beard, who had purchased rights to the daguerreotype process, exercised his rights in a similarly contentious manner, but this had little effect as later development was not to be dependent on the daguerreotype. By 1852, when Beard's patent ran out, use of the daguerreotype was declining. Although its resolution of detail remained unparalleled, it had been surpassed in convenience by paper and glass processes. In 1852 Talbot was pressured into easing the restrictions on his patents, which were to expire in 1853, and this left the way clear for the first British exhibition of photographs in December

3. Collection Science Museum, London.

14

of that year. Photography in England could develop once more.

The first paper prints of consistent technical quality were made by the partners David Octavius Hill and Robert Adamson in Edinburgh, who, being Scottish, were free from the constraints of Talbot's patent. Hill and Adamson gained much valuable technical information from Sir David Brewster in Edinburgh, who had experimented with Talbot's process and was in correspondence with him. By 1844 they had already produced a body of distinguished architectural photographs, particularly of Edinburgh, Newhaven, and St. Andrews. Even though their greatest recognition was for their portraits, Hill and Adamson were fascinated by the atmospheric, allusive rendering of architecture. The two examples given here are very different in character; one is boldly silhouetted and the other is a private and contemplative image. The photograph of Roslin Chapel (plate 5) is only nominally a picture of the chapel. Though the building takes up almost half of the area of the picture's space, the extremely oblique vantage point impacts the architectural information to such a degree that the picture is not so much an examination of the ruins of the building as it is a meditation on the nature of place, its past and its present. We see it enshrouded in creeping ivy and sheltered by an ancient stand of trees. This rhapsodic and romantic interpretation of architecture remained a particularly British characteristic and would not be displaced even by the stunning clarity of the collodion process.

The arrival of Talbot's paper negative process considerably expanded the horizon for photographers, although improvements would still be made. In Talbot's process the silver salts were most sensitive in a humid state, which made field use difficult. The problem was overcome in 1851 when Gustave Le Gray introduced a waxed-paper process in which the negative could be coated several days in advance of exposure and held for later development. This innovation greatly liberated photographers, removing the major impediment to geographical range. The process was to remain in use until at least 1862, especially in hot climates and on extended expeditions where the bulk and fragility of glass negatives presented difficulties. The works of

Murray (plate 84), Tripe (plates 85, 86), and de Clercq (plates 72–74) are all examples of waxed-paper processes used by photographic expeditions in unfavorable climates. Increasingly, photographers were able to seek out new subjects as they accompanied archeologists into undiscovered countries, marched with armies, and traveled with diplomatic expeditions sent to establish relations with foreign powers. As political boundaries dissolved, there were few nations whose monuments had not been recorded through the lens of a camera.

Advances in technique continued to be directed toward retention of maximum detail in the print. At first, this end was served by increasing negative size. By 1849, Baldus had made a print 33 by 43.2 centimeters (13 by 17 inches). Nègre produced negatives approximately 50.8 by 71.1 centimeters (20 by 28 inches), which are thought to be the largest paper negatives. These increases in size, as well as rapid progress in the science of photography, made much sharper images feasible. (No effective enlargements were possible until high-speed printing papers were introduced in the 1880s.) Eventually, the waxed-paper process gave an almost perfect transparency. Even these negatives were surpassed and made obsolete by the arrival in 1851 of the wet-plate collodion process, which used glass as the support for the sensitized material, but it was some time before collodion became reliable enough for use in the field. Within a short time technique had evolved to such a point that resolution of detail was no longer an obstacle. Although fine resolution had been achieved immediately with the daguerreotype process, a daguerreotype was generally not large enough for interpretation of the minute scale of its information. Large, evenly treated negatives, as they developed during the 1840s and early 1850s, were capable of rendering more information with greater verisimilitude than man had ever been able to achieve through the skill of his own hand. Introduction of the glass negative increased the transparency of the support to its ultimate point, allowing image size to diminish slightly and return to more practical limits.

The achievements of these mammoth wet-collodion plates are worthy of emphasis. Each image was a major undertaking and was often carried out under the most adverse circumstances. Until the era of the prepared dry plate during the 1870s, the elaborate procedures necessary made each photograph an extraordinary accomplishment. In order to produce their photograph of Paris from Notre-Dame, the Bissons had to carry everything along the roof of the cathedral (plate 14). A camera big enough to accommodate their large glass plates was just the beginning. All the chemistry, as well as the apparatus required for each negative, had to be transported to the camera position. A dark tent had to be provided for sensitizing and developing the plates, the tent had to be big enough to hold several tanks of different solutions, and the plates had to be coated, sensitized, slipped into the film holder, carried to the camera, exposed, carried back to the dark tent, and developed. All this had to be accomplished before the gum-like collodion became too dry and desensitized, which could be a very short time indeed. One reason why there are very few examples of interior views is that, even with the introduction of the dry-collodion process, the necessary exposure times were very long,[4] and with the wet-collodion process, they were almost completely impossible.

The increasing simplicity of craft, caused partly by the steady improvements in the prepared dry plate, brought about an explosion in the number of commercial photographers and a consequent decline in prices commanded by photographs. This may have been a major factor in the discouragement of many early practitioners, who suddenly abandoned photography; Fenton, Baldus, the Bissons, and Le Secq were only a few of the photographers whose careers were very short. The profession became filled with undistinguished workers who manufactured vast quantities of photographs. Only pockets of resistance to the general leveling of aesthetic standards remained in

4. "We noticed in many of the churches, a camera standing alone, exposed to some bit of carving. . . . These were the servants of Signor Naya. He uses dry plates . . . and where there is not much light at all he often exposes as much as five days." E. L. Wilson, *The Photographic News* (July 3, 1874), pp. 323–324.

Europe. In the United States the great western explorations after the Civil War allowed a continued vitality into the 1870s, but the same decline eventually set in. Through this fallow period there are some distinguished exceptions: William Rau in the United States in the 1890s (plates 107, 108), the anonymous photographer of the Forth Bridge (plate 109), and H. Dixon and Son in London in the 1880s (plates 114, 115), to name those represented here. Just before the turn of the century, photographic procedures had become essentially what they are today, and the technical gains since then have been mostly in the form of film speed and reliability of materials.

In the hands of a sensitive photographer, each technique called forth a mode of expression perfectly suited to it. The daguerreotype produced small jewel-like images of great precision. The precisely rendered view of the west front of Wells Cathedral (plate 1) is a typical example of an early exterior daguerreotype. The image of Saint-Sulpice, signed "L. et A. Breton," is far from typical in its extraordinary golden tone; otherwise it demonstrates well the peculiar and magical characteristics of the daguerreotype process (plate 16). The early salt print had great forcefulness that emphasized the component parts of the subject. This is most clearly demonstrated in the view of St. Andrews by Hill and Adamson (plate 4). More advanced paper techniques produced images of great sensuality, with the slightly grainy quality caused by the paper fibers in the negative imparting an almost mystical sense that was never again captured in later processes. This graininess can be seen clearly in the desert views of J. B. Greene (plates 79, 80) and in the ethereal portrayal of a Crusader castle by Louis de Clercq (plate 74). The highest technical achievement of the paper negative in Britain was reached by B. B. Turner in the last part of the 1850s (plate 8), whose pictures display a complete range of tone in conjunction with sharpness of image. At the same time Roger Fenton was producing his great series on British architecture and landscape using the glass-plate collodion process (plates 9–11).

Other short-lived processes were the albumen-on-glass negative and the collodio-albumen negative processes, which are here repre-sented in the works of Pietro Dovizielli and Robert Macpherson. Though it is difficult to be certain exactly which technique each photographer used, each technical vocabulary had certain distinctive traits that can be recognized in the different works of different practitioners. Dovizielli's image of the Spanish Steps (plate 40) has brilliant and acutely delineated surface values characteristic of the albumen-on-glass process. Robert Macpherson used a technique that was inherently of high contrast; the print divided sharply into upper and lower values, as in the photograph of Orvieto (plate 45). Each photographer had to come to terms with the technical shortcomings of the tools at his disposal. The way different surfaces and textures are rendered in terms of photography needs to be fully understood in advance if an image is to succeed. Therefore, the technique chosen by a photographer has to be closely wedded to the subject in order to make a valid and convincing interpretation.

The great photographers of architecture have always striven to utilize the medium in its most convincing way, reaching out toward the limits of technical precision and working toward a balance between technique and subject. The balance can be defined as a weighing of the means at the disposal of the photographer and possibilities of interpretation. It is best explained in the different approaches engendered by the developing technology. For example, it would have been unthinkable that an image such as the Bissons' view taken from Notre-Dame (plate 14) should have been attempted in the paper negative processes available a few years before; the poor degree of resolution would have made the photograph meaningless. Only much later were photographers able to respond to subject matter with a variety of techniques, to choose whether to break up an image in a soft-focus, pictorial manner or to turn to a brilliant sharp-edged rendering. These differences can be seen in two photographs by Alfred Stieglitz, made in 1910 and 1935 (plates 123, 125).

For the pioneers of photography, the obsession with clarity of rendition drove them to great lengths and extraordinary feats of endurance, best represented here in Frith's mammoth plate of the desert

civilizations (plate 82). Their overriding concerns were clarity, directness, and rationality. In a great photograph, artistry of the photographer is never out of balance with subject, and what is sought is the maximum of information conveyed in an objective way. There is hardly the sense of the egotist obsessed with his own feelings. Edouard Baldus exemplifies these values. Even in his earliest surviving photograph it can be seen that he seeks to portray his subjects in the most direct manner. The photograph of the Chapel of Sainte-Croix (plate 18) provides scale by his acceptance of the ladder and cart, which could have easily been removed. From this single image, we learn that the chapel is of a certain height and, because Baldus indicates another semicircular apse to the left of the one we see completely described, that it is most probably cruciform in plan. By his choice of time of day, Baldus describes the mass of the building in the most effective way. The chosen moment describes precisely the structural relationship of each part of the chapel to the other, with particular attention to the corner detail of the tower and the manner in which the stone roof is constructed. He allows light to perfectly delineate the volumes of the building and leaves nothing open to question. From the way in which a building is portrayed, it should be possible to imply as much as possible about the volumes of which it is composed. This applies equally to the photography of interior spaces as it does to exteriors.

The description of volume is an essential attribute of a successful architectural photograph. Volume, in this context, is an understanding of the interior space of the building and the solidity of the materials of which it is composed. A sense must be given of the mass of the subject portrayed and a sense of what it is like to move in and around a building. With careful analysis of the image, it should be possible to gain an understanding of what it is like to stand in that particular space. The experience should be analogous to being in the presence of the building itself. By his choice of vantage point, hour, and season, the photographer can, in a transitory moment, permanently record and reveal unnoted characteristics of a subject. Such revelations may be derived from modifications of illumination in the scene caused by a passing cloud or can be analytical, as in a highly detailed view.

The description of architectural detail was evolved to the highest point by Henri Le Secq, whose approach is unique. The portfolio of twenty-five plates of Chartres, with only one image of the entire edifice, succeeds in giving a rich and vibrant idea of the nature of the whole building. Each is a part of the group and reinforces the others, often interconnecting in subtle ways. For example, within the series is an image of the three portals of the south porch seen from the side. Another picture is of one of the major pillars of the porch and its sculptural program, which gives enough information to understand exactly where the picture fits into the organic framework of the building. Other images include a detail of the base of the dividing post of the great portals, the sculptural group to the left of the left-hand door, and the sculptures on the righthand side. It is possible to see in the photographs a highly analytical way of approaching architecture. These images give a clear understanding of the architectural organization. In the lucid qualities of Le Secq's exposition, they appear to follow the rhythms of the building. His approach is not so rigid as to limit the creative flow of his images; he made carefully selected, independent photographs–a window, a corner detail–that stand for whole classes of information. Through careful selection of relevant details, he was able to suggest the essence of the whole structure and gradually to unfold the splendors of the building and its sculptures.

In the preface to the volume *Egypt, Sinai, and Jerusalem*, published about 1860 by Francis Frith, an anonymous writer states, "*the views of Jerusalem and Cairo are examples of that delicate detail in a confused subject which a human hand cannot attain. The series representing the pyramids, especially interesting for its completeness, is notable as showing the same mastery of detail which is one of the chief merits of the photograph.*"[5] This

5. Preface to Francis Frith, *Egypt, Sinai, and Jerusalem: A Series of Twenty Photographic Views*, London, William Mackenzie, n.d.

interpretation of detail, distinct from that of Le Secq, was the outcome of technical advances. Frith's perseverance in overcoming the difficulties of the wet-collodion process had made the process viable for use in the field. His pictures capture incredibly precise renderings of large edifices and are diametrically opposite to those of Le Secq in the description of subject matter. The plates were of glass; the chemistry had astonishing powers of resolution; and the combination of the two for the first time made it possible to delineate every pebble on the desert floor and every modification of surface. Frith portrayed the appearance of the cities, the deserts, the great works of ancient Egyptian architecture, and most important of all, the pyramids, in large scale and with greater clarity than any previous photographer.

The impact of these photographs, when they were first published, must have been very dramatic. The viewer could look beyond the print and, with the conviction of truth that only a photograph can give, could carry away a very real sense of what the pyramids were like. To increase this sense of immediacy, Frith subtly suggested the scale of his subjects. Keenly aware of the importance of scale, he disposed members of his party and his pack animals so that they appear to recede in the long vistas, leading the observer's eye deeper into the picture plane and effectively creating a gauge of the distance between camera and subject (plate 82). *Egypt, Sinai, and Jerusalem* was one of the most elaborately produced albums of the period. Each image was accompanied by a description "By Mrs. Poole and Reginald Stuart Poole," which provides the basic historical information and certain anecdotal embellishments in the style of the period.

The extremely arid and hot climate in which Frith produced these images, using the wet-plate collodion process, required superhuman efforts to produce even a technically inferior negative. Frith rightly takes the credit for this first completely successful application of the technique in the field, and such was the success of the project that it remains his most significant achievement. As a result, Frith was able to establish himself with a happy coincidence of artistic achievement and material success.

Attitudes toward architecture varied; so did the photographic interpretation of the urban environment. Both were influenced by technical processes and informed by the photographer's interpretation of the urban environment. The four views of Paris and London (plates 11–14) are a progression of increasingly complex subject matter. In Fenton's photograph of the new and uncompleted Houses of Parliament (plate 11), the simple tripartite composition is extremely disproportionate. His carefully balanced disposition of the main subject is confined in a narrow but highly articulated strip bounded by the footings of the suspension bridge and the unfinished Victoria Tower. The modification that the irregular silhouette of the Houses of Parliament had made to the skyline of London is his subject. He draws attention to the way in which the new building has come to overshadow the previously singular and serene outline of Westminster Abbey, now reduced in importance by the highly accented roofline of the new seat of government.

Le Gray's two views, which can be seen as a diptych, both use the Pont du Carrousel as the central unifying element (plates 12, 13). Less rigorously organized than Fenton's photograph, Le Gray's relies almost completely on illumination for the drama of these two images. This is especially so in the view to the east, where the light shimmers and catches different parts of the scene with varying intensity. The light and subtle rendering of tones in the sky add to a masterly composition. All the disparate elements are held in place. Le Gray's ability to recognize and capture the transcendent moment is clearly demonstrated.

The most encompassing of these environmental views is the photograph taken by the two Bissons from a scaffolding erected to build the spire over the crossing of Notre-Dame (plate 14). As a record of Viollet-le-Duc's restoration of the cathedral, the image shows that the finial had been recently installed and that the cresting at the ridge of the roof was still in process of installation. The renewal of the roof lead is in progress and the scaffolding is still in place. This is all useful factual information, but is hardly the subject of the photograph. Be-

cause of the elevated point of view, a great section of the city is spread out before us. The undulating form of the river, which draws the eye into the picture, unites the image. The whole composition is brought to a focal point by the elaborately wrought cruciform finial at the eastern end of the cathedral, which appears to be in a state of graceful suspension over the river, drawing the city toward its dominant position. At the same time, this suggests the pre-eminent place filled by the cathedral in the life of the city. These pictures all display the early fascination with the photographic rendering of water. There is a limpidity and brightness in the four environmental images, each of which is an outstanding technical and creative achievement, and each of which demonstrates a fine understanding of the vital role that illumination plays in the making of a photograph.

When photography was first announced, it caused a great deal of excitement and attracted a broad social spectrum. Aristocratic men, such as comte Flachéron and duc de Luynes, well-educated men like Fenton and J. B. Greene, army officers like Tripe and Murray, and ambitious tradesmen like Richard Beard were all attracted to photography for reasons that varied from personal gain, through discovery of an unequaled tool for documentation, to an enthralling way of making images. As the techniques of photography developed, so did its usefulness as a source of architectural documentation. The daguerreotype and Talbot's process were used immediately to record architectural subjects, and the daguerreotypist produced images of far-off countries in the very year of its announcement. The British photographer was also immediately involved in the photography of architecture, but got off to a slower start than the French in the realm of expeditions to foreign lands.

The desire to consolidate the world was typical of the nineteenth century, as was the great curiosity about the world's wonders. Exhibitions and publications aroused the interest of the public, which encouraged the photographer to go ever further afield. It was almost incidental to several of the pioneer photographers of England that some of their works were published, and many did not even bother to publish at all. The Reverend George Bridges was one of these. An early photographic traveler, Bridges is represented here in one of the images from an album of fifty-nine plates of the Acropolis executed about 1850 (plate 61). Talbot and Fenton are early exceptions in that they sought to gain recognition for photography. They worked hard to assure its success and sought financial reward through their efforts: Talbot through the sale of patents and patented materials, Fenton from commissions, exhibitions, and in the marketplace.

Nicolaas Henneman, who had begun as Talbot's assistant, opened a photographic printing establishment at Reading. This was not a success, however, since the British photographers in the early days worked independently and tended not to use commercial printers. A more successful enterprise was set up by Louis-Désiré Blanquart-Evrard at Lille. He was a highly ingenious entrepreneur who originally devised a greatly improved paper negative process, which he continued to develop. This in turn led to very proficient printing techniques that he felt encouraged enough to explore on a large scale. He set up his printing works with a large staff, mass-producing prints for amateur photographers, and published highly professional and expensively produced books, albums, and portfolios of photographs, which reached a level infinitely superior to those made at Henneman's establishment in England. Blanquart-Evrard's publications include the first major photographically illustrated book in France: the record of Flaubert and Du Camp's expedition, *Egypte, Nubie, Palestine et Syrie*, illustrated with 125 plates. This remarkable volume was followed by others: many folios and albums containing prints by Henri Le Secq (plate 26), Charles Marville (plate 29), and Jean Walther (plate 62); and Salzmann's record of the monuments of Jerusalem (plates 69–71), which contains 174 plates. Further expeditions led to other publications in France. *Exploration archéologique de la Galatie et de la Bythinie* by Georges Perrot, with photolithographs from photographs by Jules Delbet, and *Voyage d'exploration à la Mer Morte* by duc de Luynes, illustrated with gravures by Charles Nègre from photographs by L. Vignes, were published in 1872 and 1874 respec-

tively. Both are distinguished examples of photographs in the service of archeology.

This immediate grasp of the usefulness of photography to document was initially almost exclusively a French preoccupation, and it was not until much later that the British set about the documentation of their own land. The French, under government and private sponsorship, produced many different types of photographic documents. The Commission des Monuments historiques had a large field program in 1851, with Le Gray, Mestral, Baldus, Le Secq, and Bayard working on assignment. Two of the greatest documentations were two separate projects that were commissioned from Baldus by the great financiers to record the sites along the railroad routes: *Ligne de Paris à Boulogne* of 1855 and *Chemins de Fer de Paris à Lyon et à la Méditerannée* [sic] of 1859. Edouard Durandelle photographed the construction of the Paris Opéra for the architect Charles Garnier. The earliest and singular British example of building construction is probably the album on the re-erection of the Crystal Palace at Sydenham by Philip Delamotte, published in 1855, which can be considered the most detailed album of its kind from Britain.[6] Later on, from the 1860s to the 1880s, there are sporadic flowerings of documentation in Britain. In London, Dixon and Bool were activated by an awareness that the fabric and texture of the city were quickly disappearing. Thomas Annan was working from similar motivation, though prompted by the opposite point of view: that the closes in Glasgow were slums that should be swept away in rehabilitating the area.[7]

The rest of Europe was also to fall under the scrutiny of the photographer. The field of German photography is still largely unknown, and major works by German photographers are very scarce. It is improbable that works of the first years in Germany have gone completely unnoticed, or that the destruction of World War II could have been fully responsible for the scanty information on the subject. The small number of known works may reflect a lesser degree of interest in photography for purposes other than portraiture. Or perhaps it is due to a longer survival of the daguerreotype in Germany and consequent reluctance to adopt paper and glass negative techniques. Nineteenth-century German photography is represented here by a small number of photographs. The earliest is G. Thomas Hase's photograph of Freiburg (plate 31), probably from the mid-1850s. The latest is that of the Church of St. Nicolai in Hamburg by an anonymous photographer from about 1875 (plate 33). Of others, we know little more than their names. From France, Marville traveled along the Rhine Valley for Blanquart-Evrard, and this expedition produced an album of twenty-eight images in 1853 (plate 29).

The greatest nineteenth-century German photographer known to us in the field of architecture is Jakob August Lorent. He appears to have worked mainly in northern Italy, with images of Venice comprising the majority of his works. Italy became a highly competitive arena for photographers, and many foreign photographers established themselves there even before the Italians turned to the field. Photographers stepped into the tradition of *vedute* of the great classical monuments, mainly in Rome, which by the great wealth of its architecture and antiquities continued to have great fascination for travelers. By 1852 Flachéron was established at the center of a small group of amateurs in Rome, and he was known for the high quality of his work. Eugène Constant, a member of Flachéron's circle, also shows an extraordinarily high level of technical refinement in his photographs (plates 35, 36). Images by both men are typical of the classical subjects so appealing to nineteenth-century taste. Photographers in Rome quickly set themselves up to provide prints to the tourist market, and of these Robert Macpherson was pre-eminent. Through his energy and brilliance, he became one of the most celebrated architectural photographers in Rome, and his prints have come down to us in large quantities—though regrettably inconsistent in quality. At their best, his prints have an emphatic and vibrant responsiveness to subject, and they range from lyrical evocation of place, such as the

6. Gernsheim Collection, University of Texas, Austin.

7. For further discussion of photography and documentation, see Introduction, pp. 8–10.

distant view of St. Peter's from the Pincio (plate 43), to sensitively chosen details like the detail of the relief at Orvieto (plate 45). By about 1855 Italian photographers began to emerge: Pietro Dovizielli in Rome, the Fratelli Alinari in Florence, and a host of others in Venice, most notably Carlo Ponti.

In the second half of the nineteenth century, the British Empire was at the height of its power, firmly under control and rapidly expanding. In these circumstances, the photographer played a role rather like that of the chronicler of the great sixteenth-century circumnavigations of the world, the task being to bring back a vivid record of the territories and documentation of annexation. Many of these men, like Pigou, Murray, and Tripe, probably received their photographic training in the military and operated primarily in India and the subcontinent. They worked with paper negatives in arduous circumstances as late as 1860. These expeditions also served political and military functions insofar as they located places precisely and produced the maps so important in the control of the regions documented. The purpose of these projects was twofold: to demonstrate the wealth of the newly subject states and to provide information that could assist in their control and exploitation.

The photographer who best exemplifies the spirit of adventure and inquiry was the Italian-born Felice Beato, who still amazes us with his prolific and brilliant output. He apparently became a British citizen, but spent very little time in Britain. His work in Europe, the Middle East, and the Far East took him to many of the outposts of empire. After he formed a partnership with James Robertson, they worked first in Malta in the early 1850s, then in Constantinople in 1853. Here, they produced the five-part panorama of the city (plate 75). This is a remarkable technical achievement since it is composed of carefully matched prints from negatives based on a particularly intractable chemistry. They were in Athens in 1854, before they moved on to the Crimea to continue Fenton's documentation of the war, and they made a detailed record of the fall and destruction of Sebastopol. Next came India during the Mutiny of 1857 and, after that, Beato

went on alone to make a visual record of what was essentially medieval warfare, the Opium War in China in 1860. Beato lived in Japan in the 1860s, one of the first photographers in that country. There, he made another panorama, of a Daimyo compound (plate 97), which is one of the few surviving records of Tokyo in the mid-nineteenth century. He traveled around the East and finally worked in Rangoon, Burma, where he produced perhaps his last photographs, which were of Burmese furniture. During all these years, following one campaign after another in the far corners of the world, Beato's creative energy never flagged. Throughout his career, he continued to produce superlative albums. Always in the vanguard in some of the most appalling conflicts of the nineteenth century, he succeeded in producing an unparalleled documentation of unfamiliar peoples and cultures.

The only other photographer who approaches this level of virtuosity in his photographs of the East is John Thomson, a native of Britain, who spent several years on the China coast. By the early 1870s China had opened trade with the West, and he was not obliged to keep company with an invasion force. His pictures have a lyric quality in which the English obsession with the atmospheric reappears. Able to travel more independently than Beato, Thomson produced work of greater tranquility. A careful observer, he dealt exhaustively not just with the built environment but also with the inhabitants. He visited many of the same sites that Beato had photographed and recorded the decay that set in after the Opium Wars, which culminated in the sack of the Summer Palace (plates 92–94).

Once the documentary idea had been established among British photographers, the type proliferated, with documentations of everything from the Sinai Desert to Stonehenge, conducted by the Ordnance Survey, a military department attached to the Royal Engineers. This tradition continued in the 1870s with the great American geological surveys led by Clarence King, commencing in 1867, and Lieutenant George Montague Wheeler, whose expeditions began in 1871. The exception to the general decline of late nineteenth-century

photography is the United States, where the impetus forward evolved into a new approach toward photographic representation of landscape. The American photographer of architecture had a difficult time of it if he sought the monumental. The general sense of American architectural photography during the 1860s and 1870s is a record of the progress made in the development of the cities as well as of the destruction wrought on older cities of the East by the Civil War.

Photography in the United States grew out of destruction. The Civil War was the first war to be followed extensively in photography and trained a whole generation of photographers. It was documented in great detail by keen observers who later became involved in the great expeditionary surveys of the 1870s. Mathew Brady, a portrait photographer in Washington, saw the war as an opportunity to create a record of the events. He expanded his operations and set up several field vans, which were operated by his employees, the most outstanding of whom was undoubtedly Timothy O'Sullivan. Two other colleagues in the Brady studio were George Barnard and Alexander Gardner, who soon left his service to work independently. Gardner took O'Sullivan with him and Barnard also went his own way. He produced the most coherent album of the Civil War as the result of his appointment to the Military Division of the Mississippi under General Sherman. Barnard published his album as a permanent record of the devastation wrought by Sherman's campaign. The photographs of the war were seen as a terrible indictment. Barnard's photographs were rarely explicit, but they have great power. There is a sense of arrested growth, of terrible destruction, and a suspension of the normal course of daily life that is clearly seen in the photograph of Atlanta (plate 103). The bank in the foreground has been completely destroyed. There is a subcurrent of violence that runs far deeper than the simple destruction of a single building, for the bank represents the economic basis of the community, and its removal symbolizes the elimination of its foundations, thus opening the way for carpetbaggers from the North. The very stasis of Barnard's composition enhances the sense of desolation and stillness.

Pre-eminent among nineteenth-century American landscape photographers was Carleton Watkins, who developed his vision on the West Coast, largely free of outside influence. His photographs of Yosemite may be compared with Le Secq's images of Chartres, which became an architectural pilgrimage for French photographers. Watkins worked in a similar way, measuring his power to express perception against the monumental valley of Yosemite. His images take on hieratic qualities; they have become icons of the last vision of an uncorrupted world. Watkins was a keen observer of the transitions between wilderness and encroaching humanity, and many of his photographs reflect this. The two shown here (plates 98, 99) state the theme around which the nineteenth-century American photographs are selected. It is not so much a wistful record of the vanishing wilderness as an affirmation of the land of promise and the assumption of the American birthright. It is a vision *"of past hopes and future longings."*[8]

More typical of the American attitude to photographing architecture are images such as Watkins' view of the rudimentary settlements in Washerwoman's Bay (plate 99), Moeller's panorama of Grand Island, Nebraska (plate 106), and – at last a monumental subject – the raising of the U.S. Treasury Building in Washington by Lewis Walker (plate 105). These are all images that deal with the American expansion of the latter part of the nineteenth century. Watkins' view shows the very beginning of the settlement at Washerwoman's Bay. Fences, blanched white in the salt air of the peninsula, uncertainly define property lines in the landscape. Moeller's panorama of Grand Island, Nebraska, is a touching document that describes the clustering of a population seeking a spirit of community. The country spreads away from us in vast and empty isolation. Undisturbed by any undulation, the Great Plains continue to the horizon. Yet, in the immediate foreground, unaffected by the solitude, life continues; a family exercises its dog, and horses and buggies can be seen passing down the streets. The verso is more specific still, with many of the major edi-

8. I am indebted to John Coplans for this remark.

fices of the town represented. The owners and patrons of the businesses stand on the doorsteps, and the commercial basis of the community can be easily interpreted from the types of business portrayed. The Treasury Building is a monumental subject but, in a typically pragmatic American sense, it is depicted in the process of construction. It is very different from the subtleties with which Baldus portrayed the new Louvre.

American photography has always had a close affinity to the landscape, which the burgeoning cities of the nineteenth century did not diminish. William Rau's vision of Towanda (plate 107) is typical of this attitude to the relationship between construction and environment. This is most forcefully addressed in the greatest of the nineteenth-century American images shown here: Watkins' photograph of a buckeye tree (plate 98). Part of a series on specimen trees, each choice example was selected so that he might portray it clearly, generally in isolation from its immediate surroundings. Concerned with clarification more than isolation, Watkins uses the simple dwelling to set off the tree in such a manner that the whole becomes a symbol of growth and renewal, shelter and industriousness. The wooden harrow left beneath the flowering tree conveys his conviction that man is the rightful heir to the promised land of the West, an heir who would, by industrious dedication, better himself. Unromanticized optimism, so characteristic of Watkins, suffuses this deceptively simple photograph. Its incisive economy of observation makes it an unforgettable image. It is a momentous work in which continuity of life and fertility is suggested by the tree.

From a generally undistinguished field at the turn of the century, two remarkable photographers emerged: Eugène Atget and Frederick Evans. Eugène Atget came to photography late in his career, but was an accomplished and indefatigable worker. He continued to use materials that were essentially those of the nineteenth century—when it was no longer common to do so. With these materials, he captured a unique vision of Paris and its environs, a vision that has never been equaled. The systematic development of his themes into

an evocative and poetic unity is remarkable for its modesty and lucid integrity. The three examples here are typical and are drawn from three different categories of his work. His study of Fontainebleau (plate 116) comes from an extended series on the major architectural sites of the region. The view of the gardens of Versailles is a part of a long and extraordinary series on the great formal parks, gardens, and statuary (plate 118). (The series includes Saint-Cloud, the Jardin du Luxembourg, and the Tuileries, among others.) The view of Balzac's house, or rather the street beside the house, is part of another extensive group on the streets of Paris and its neighborhoods (plate 117). Atget delights in leading the eye along the alley or street until it curves out of sight. Although he died in 1927, his pictures belong more to the nineteenth century than they do to the twentieth because he scarcely modified his working method at all during his career.

Evans was entranced with the Gothic cathedrals of Europe, and he is deservedly celebrated for his magnificent interior views. The purity of his vision, his knowledge of his subject, and his patience all combined to give him an acute perception of the qualities of light as it filters through the structure. His photograph of the interior of Bourges Cathedral (plate 119) is very small, but it gives a vivid impression of the soaring interior space of the building. The effect is not achieved by giving a great deal of information about the structure, for the subject is the way light is affected as it passes through the structure. In this respect, Evans' photograph is more akin to the impressionist approach, dissolving form in light, than it is to the great photographers of the mid-nineteenth century, who wished to delineate the building in all its detail. This photograph was among those by Evans reproduced in *Camera Work* in 1903. He was the first English photographer to have his work printed in Alfred Stieglitz' magazine.

The return of Alfred Stieglitz to New York from Germany in 1890, after his technical training, brought about a renaissance in photography. As editor of *Camera Notes*, the journal of the New York Camera Club, he was unable to accept the compromises required of him and resigned in order to set up his own journal, *Camera Work*,

which began publication in 1902. *Camera Work* became the standard around which the photographers who constituted the Photo-Secession gathered. Stieglitz used it to state his theories about photography and, later, to discuss other arts, introducing the work of Matisse and Rodin, among many others, to the United States. The quality of the photographic reproductions in this journal was never surpassed; it is indicative of the exacting standards characteristic of the entire career of Alfred Stieglitz. The benchmark set by Stieglitz propelled photographers in America forward, re-establishing photography as an art worthy of serious endeavor.

His own work was diverse, beginning with relatively conventional images similar to the contemporary work of the period. He eschewed the highly manipulative techniques then espoused by the salon photographers. Stieglitz' work was informed by a lively curiosity about the medium; he overcame the limitations of craft, capturing directly on film effects that had previously been impossible. The nuances of light that a photographer could choose became more fleeting, thus broadening the spectrum of available situations. Photographing in rain, snow, and at night, Stieglitz succeeded in bringing back images full of energy and the sense of the conditions in which they were made. Such photographs as "The Terminal" and "Icy Night" were considerable achievements at the time, and they remain high in his canon. By the 1920s his thinking had changed from the pictorial secessionist ideas, and he became one of the leading exponents of precisionism.

Of the three works by Stieglitz in this publication, each falls into a different category, reflecting broad ideas about the nature of the modern city. The earliest, "The Street–Design for a Poster," is a later print of about 1932 from a negative of about 1899, and reflects his changing ideas on the nature of photography (plate 121). In an earlier gravure printing of this image, he achieved a much softer effect in which the whole image appears irradiated with reflected light. The present example is much more straightforward, with less modification of the subject. The one is an interpretation of the image as

print, using gravure to make an impression in ink; the other is an interpretation in the materials of pure photography. The qualities that Stieglitz admired in gravure can be seen in another photograph, "Old and New New York" (plate 123). Here he uses the diffused character of the gravure plate to heighten the totemic qualities of the image. It becomes more a universal statement about change and growth of cities rather than an identifiable fact about a particular place at a particular time. With the development of reliable materials and the rapidity of execution gained from increased film speed, the photographer had gained a far greater degree of control over his materials and a new freedom of interpretation. Further investigation of the characteristics of the vertical city, which had been proposed in the earlier images of Ruzicka and Stieglitz, was still possible. Stieglitz' series taken from the Shelton Hotel remains one of the monuments of modern photography. In his precisionist image from this series (plate 125), the sense of awe in the promise of the skyscraper had not yet evaporated. This attitude is also present in the work of Charles Sheeler (plate 124).

In the 1920s and 1930s architectural photography became a commercial enterprise. The photographer began to function entirely as the instrument of the architect, his photograph a gloss on the architect's vision of his structure rather than an interpretive vision. The characteristics of this field are shown in the photograph of the Irving Trust Company by Fay Sturtevant Lincoln (plate 130) and in Samuel Gottscho's Rainbow Room (plate 129). There is an element of fantasy in these photographs that is reminiscent of the elaborate musicals of the era.

The photographs of Berenice Abbott for the Works Progress Administration are in sharp contrast to this idealized view. There is nothing naive in these works. She portrays the skyscraper in her image of Exchange Place in all its domineering verticality (plate 132). To achieve this, Abbott stretched the format of the image, using two negatives, and accepted the necessary distortion that was required to include the tops of the buildings. Edward Steichen was similarly in-

terpretive in his rendering of the Empire State Building (plate 131). In this montage, the surging verticality of the architecture is suggested, and in the shifted point of view, two renderings of the building's facade are given. The whimsical title "The Maypole" was no doubt suggested by the small cast figure atop the traffic light at the extreme left. The tiny figure appears to be suspended from the ribbons of fenestration and swings out of the image, propelled by the force of the building itself.

Manipulation such as Steichen's was of no interest to Walker Evans or Berenice Abbott, who viewed the role of the photographer in a different way. That the photographer should so obviously show his hand would not have occurred to either of them. Their intention was to present the subject in such a discreet way that it could be accepted without question by the viewer. The viewer would not be able to conceive the photograph in any other way. Evans considered this as a coat of invisibility. However, the steps he took to achieve this discreet presence were elaborate, and his photographs apply rigorous formal considerations of balance and tension. In the two classic examples here, the devices are completely different. In the view of Bethlehem the irony is heavy; he draws parallels between the tombstones and the windows, then windows and chimneys, in a subtle accusation (plate 136). The whole is presented with uncompromising clarity, the rapidly telescoping perspective finally dissolving in infinity. The drawing room in the photograph of Belle Grove is presented with an immutability that has outlasted the structure itself (plate 135). All change is suspended and crystalized in this one instant, and Evans makes an image of disciplined formal arrangement. The interpretation of the photograph is left to the observer, who can ponder the decaying splendor of the South or the frailty of human ambition, but such conclusions are not directly implied. Evans reserves judgment and presents the evidence in a measured disquisition. Both of these photographs were made while Evans was working for the Farm Security Administration, which was set up in part to document the effects of the depression. Evans found it uncongenial to

work on assignment and could not adjust his vision to the type of broad coverage that the project sought from the photographers. He was the first photographer to leave the project.

During the same period, Germany was reshaping the vocabulary of architecture, most notably in the work of Mies van der Rohe and Walter Gropius. This was reflected in the way photographers approached the portrayal of the new architecture. The work of Walter Gropius is represented in Lux Feininger's photograph of the Bauhaus. The new vision was applied not only to new architecture, but the theoretical reappraisal that had been introduced by new architectural principles was applied by photographers to all architecture. The ways in which photographs analyzed structure were influenced by movements in painting: expressionism, constructivism, and the modernist aesthetic are all clearly identifiable in works by Werner Mantz, Renger-Patzsch, and Lux Feininger. The photographers apply an intellectual approach that is completely in sympathy with the contemporary work before them. There is an empathy with the architect's intention, but the photographer does not simply reinforce the architect's renderings. The solution is purely photographic and utilizes the particular characteristics of photography to further the spirit of the buildings. Through this close collaboration, a sense of the period is instilled in photographs; they can be looked upon as reflections on architecture, rather than as mere pictures of architecture. This harmonious interaction with the age in which the photographer stands is not new. It can be seen in Marville's photographs of the Bois de Boulogne or Baldus' view of the station of Toulon. What is distinctive in the German photographers is the understanding of the radical changes in the architectural vocabulary that led to a similarly radical change in the photographer's view of architecture.

The purity of the new architecture found a felicitous collaboration in the work of Werner Mantz and other German photographers. Mantz was particularly aware of the revolutionary quality of contemporary architecture and seized upon it to make a series of meticulous photographs that reflected the spirit of new architecture. He

casts an appraising and detached eye on an apartment interior (plate 145) and, in the same way, he analyzes the architectural purity of the facade (plate 147). His penetrating insight relishes the precise manner in which the shadows of the unseen balconies fall so perfectly across the windows; only the number of the apartment house interrupts the orderliness and simple rhythm. A similar attitude is expressed in the interior, which is a consciously planned space into which the tenant has introduced strangely incompatible elements: a Venetian glass chandelier and a rubber plant in an elaborate jardiniere. The seemingly incongruous elements are presented without comment and are made to appear strangely compatible.

The great portrait photographer August Sander was also seriously engaged in the photography of architecture throughout his career. He is represented here by three very different images, all built upon highly geometricized frameworks. This is most clearly seen in the view across the roofs toward the cathedral in Cologne (plate 140). He maximizes the shifting angular volumes of the towers and roofs of the church in the foreground to contrast with the fragile appearance of the cathedral's spires in the distance. A similar tightly organized composition is hidden in the view of Andernach, in which a series of triangulated spaces is laid out, each melding into the others (plate 141).

Albert Renger-Patzsch is represented by three images, all of which address the architecture of the past. He brought the same attitudes to the delineation of these structures as he did to the works of his own age. The nature of his inquiry is of a modernist order. His awareness of the problems of vaulting, for example, enabled him to show structure with great clarity. There are echoes of the painter Lyonel Feininger in the photograph of the pierced buttresses of the Church of St. Katharine (plate 137), and perhaps of Paul Klee in the curiously springing vaults of the Sandkirche (plate 138).

The Bauhaus provided the environment where Lux Feininger learned a new creative approach to photography. The work of his father and his friends, Klee and Kandinsky, had a powerful influence upon the young Feininger's work. Surrounded by an innovative environment, he could abandon the normal conventions of image making. The photograph shown here uses converging verticals and a tilted axis purely as compositional devices (plate 146). He could have presented a corrected view, as Mantz did of the apartment building. There was no great height involved here, as in the images of skyscrapers by Steichen and Abbott, which compelled the photographer to tilt the camera sharply upward. But in all the previous examples of distortion there is an acceptance of the base line as a convention for the ground. Feininger eliminated this and constructed an image in which only one ribbon of the framing members of the glass wall is approximately vertical. There is no acknowledgment of the convention of ground at all. The composition is therefore weightless, a direct response to the freedom derived from abstraction. The Bauhaus, the nominal subject of this photograph, was vital to the revolution that was taking place in art, architecture, and photography. A particular development in architecture imparted a corresponding momentum to photography; this empathy between architecture and photography led to a high point in the history of photography.

The importance of photographs of architecture in the development of photography has not been adequately acknowledged by scholars or the general public. Photographs are a valuable source of knowledge about all architecture, both as documentation and representation. The photographs shown here are more than an historical study. Valid and challenging as a springboard for the present, they embody the spirit of adventure in photography. To the photographer they are not relics of the past or immutable ideas. Instead, they present a hypothesis to be tested in the investigation of the possibilities in architectural photography and provide a framework for further discoveries and invention. Achievements in architecture deserve to be represented by nothing less than equally outstanding achievements in photography.

THE PLATES

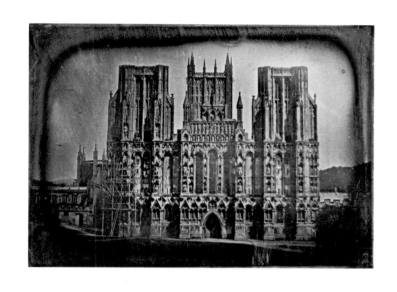

[1] RICHARD BEARD OR PATENT LICENSEE. WEST FRONT, WELLS CATHEDRAL, 1840S.

[2] WILLIAM HENRY FOX TALBOT. SCOTT MEMORIAL UNDER CONSTRUCTION, EDINBURGH, 1844.

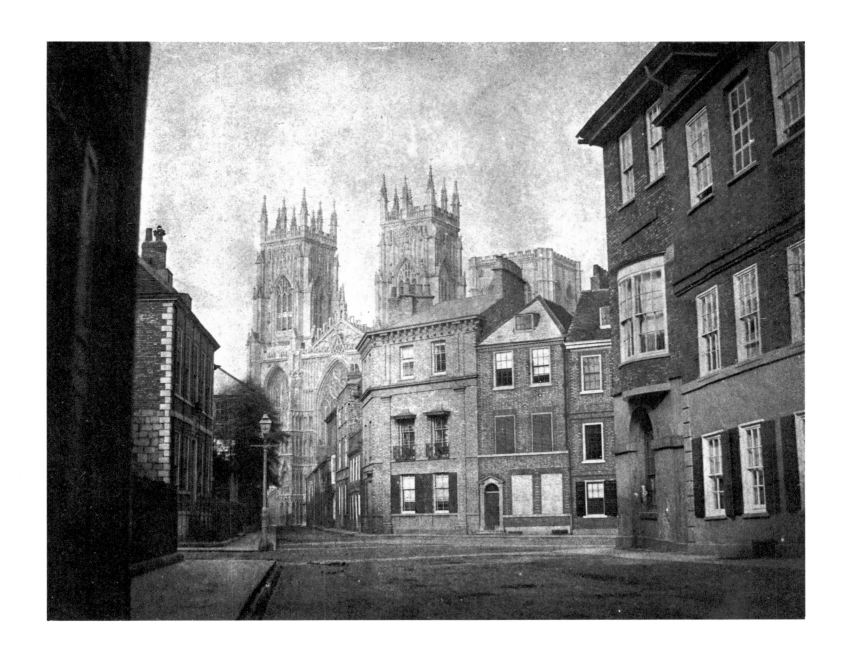

[3] WILLIAM HENRY FOX TALBOT. WEST FRONT, YORK MINSTER, FROM LENDAL STREET, 1845 (?).

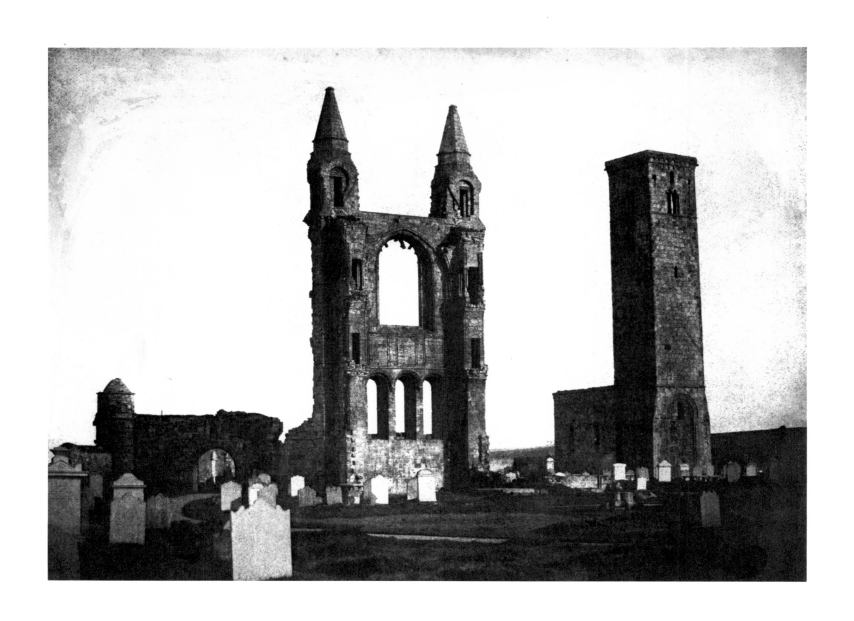

[4] DAVID OCTAVIUS HILL AND ROBERT ADAMSON. EAST GABLE OF THE CATHEDRAL AND ST. RULE'S TOWER, ST. ANDREWS, CA. 1844.

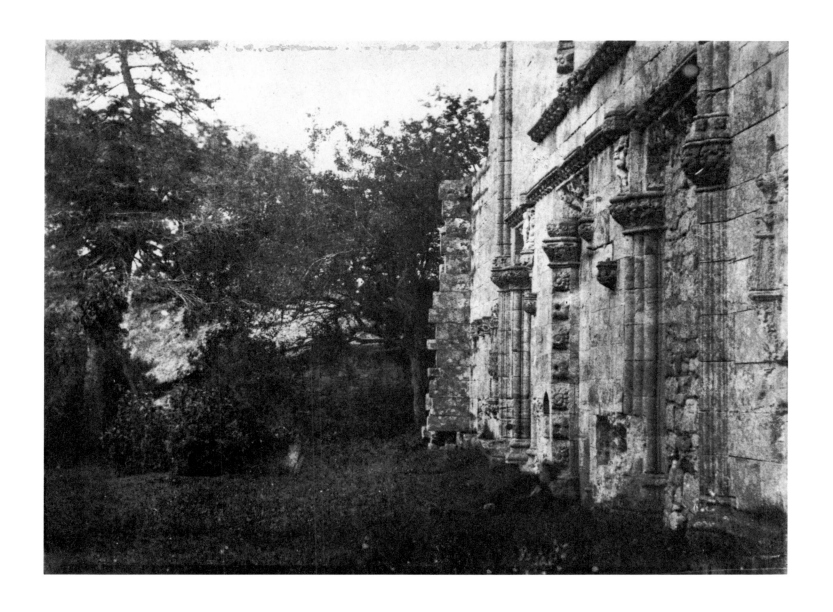

[5] DAVID OCTAVIUS HILL AND ROBERT ADAMSON. WEST WALL, ROSLIN CHAPEL, MIDLOTHIAN, 1844 (?).

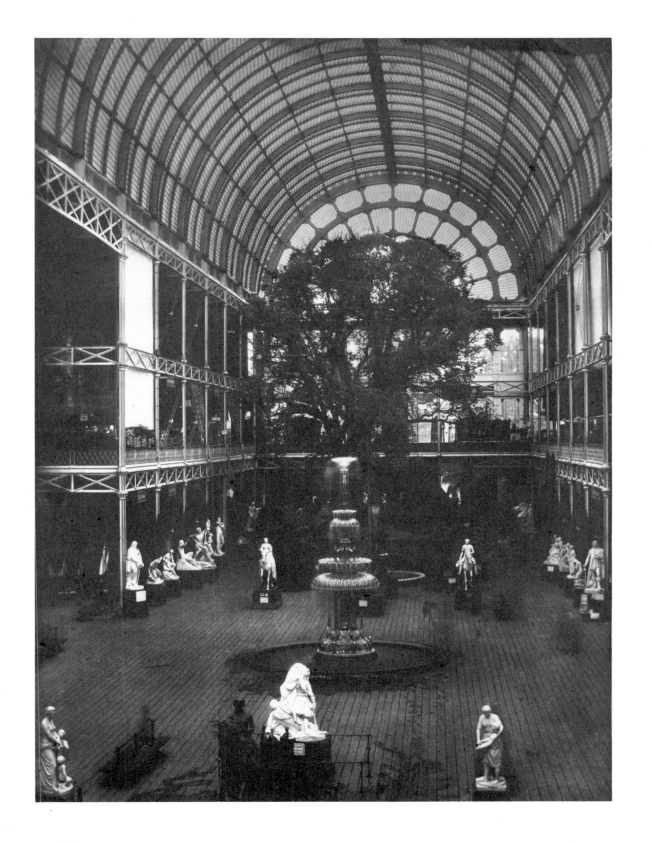

[6] CLAUDE-MARIE FERRIER. NAVE AND NORTH TRANSEPT, CRYSTAL PALACE, LONDON, 1851.

[7] ROBERT HENRY CHENEY. GUY'S CLIFFE, WARWICKSHIRE, 1850S.

[8] BENJAMIN BRECKNELL TURNER. BELL HARRY TOWER, CANTERBURY CATHEDRAL, AND ST. AUGUSTINE'S ABBEY, 1850S.

[9] ROGER FENTON. ELY CATHEDRAL FROM THE SOUTH, LATE 1850S.

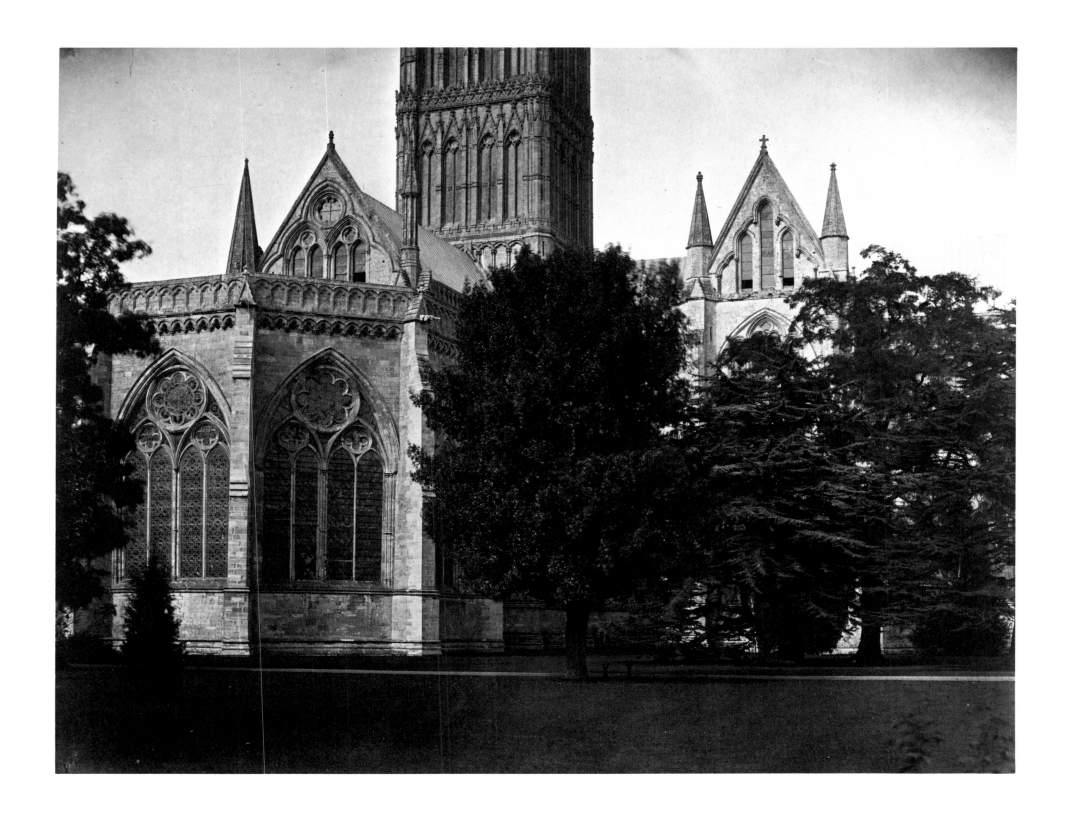

[10] ROGER FENTON. CHAPTER HOUSE AND CATHEDRAL, SALISBURY, FROM THE BISHOP'S GARDEN, LATE 1850S.

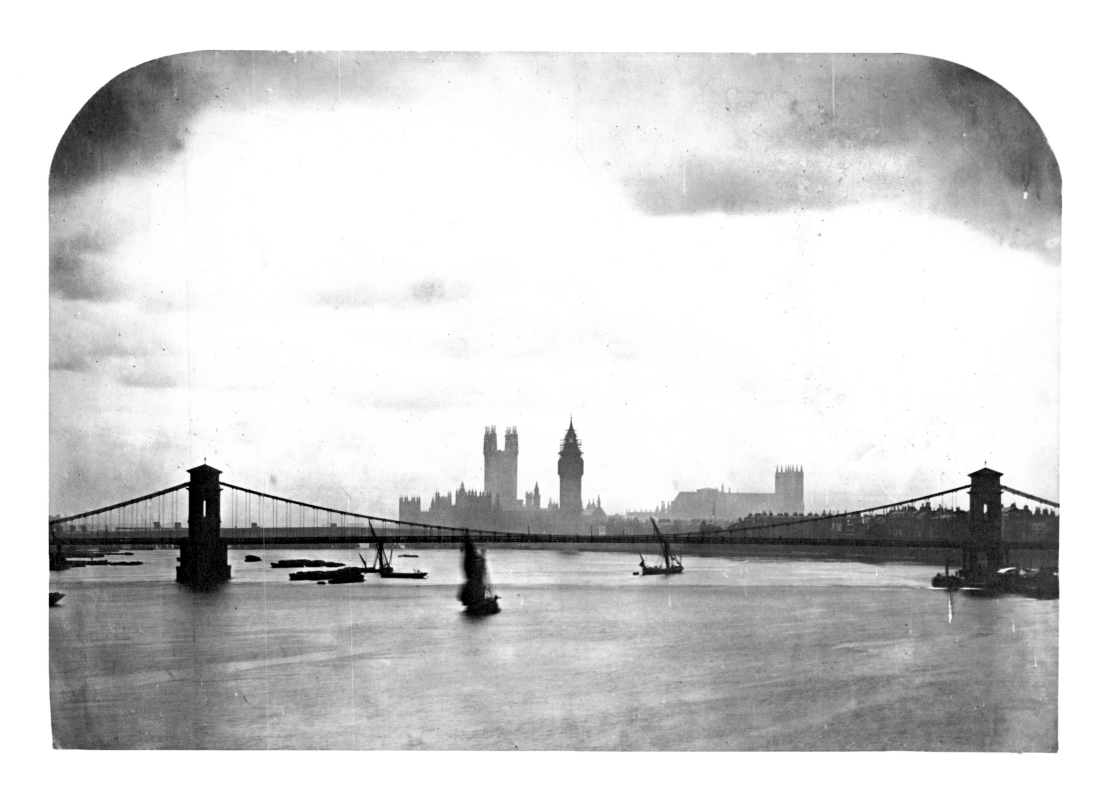

[11] ROGER FENTON. HOUSES OF PARLIAMENT UNDER CONSTRUCTION, LONDON, 1858 (?).

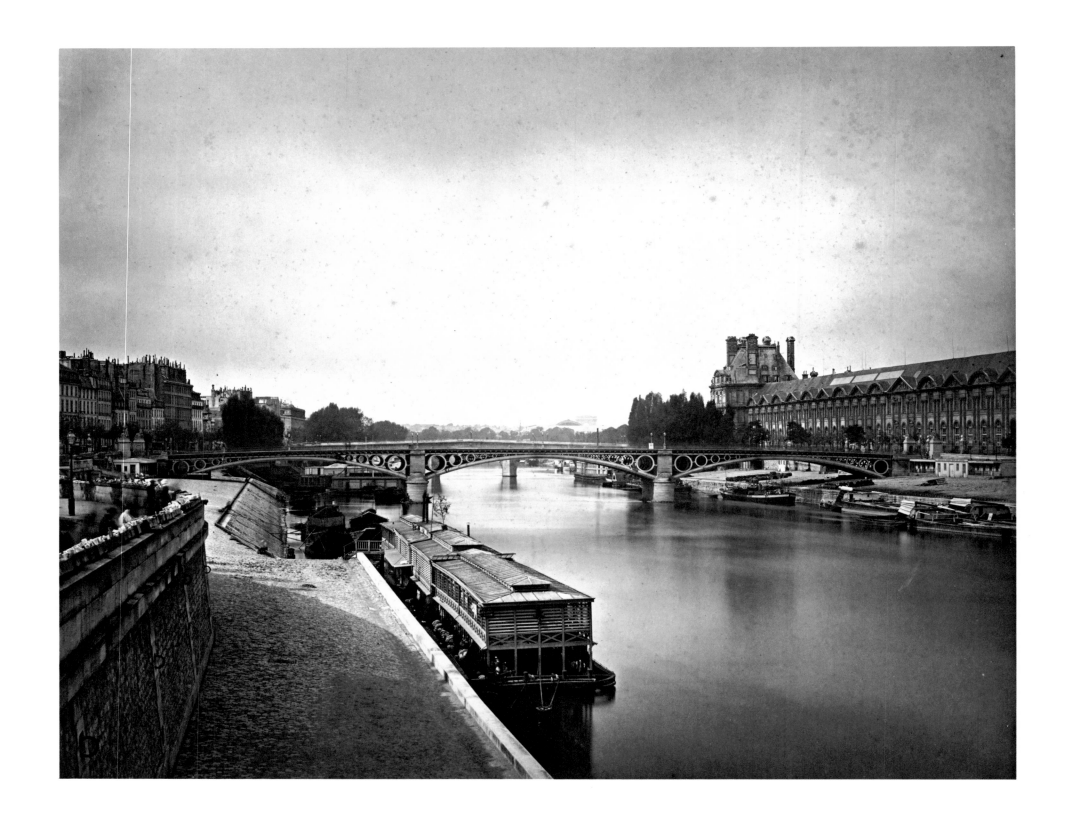

[12] GUSTAVE LE GRAY. VIEW TO THE WEST FROM THE PONT DES ARTS, PARIS, 1855–1856.

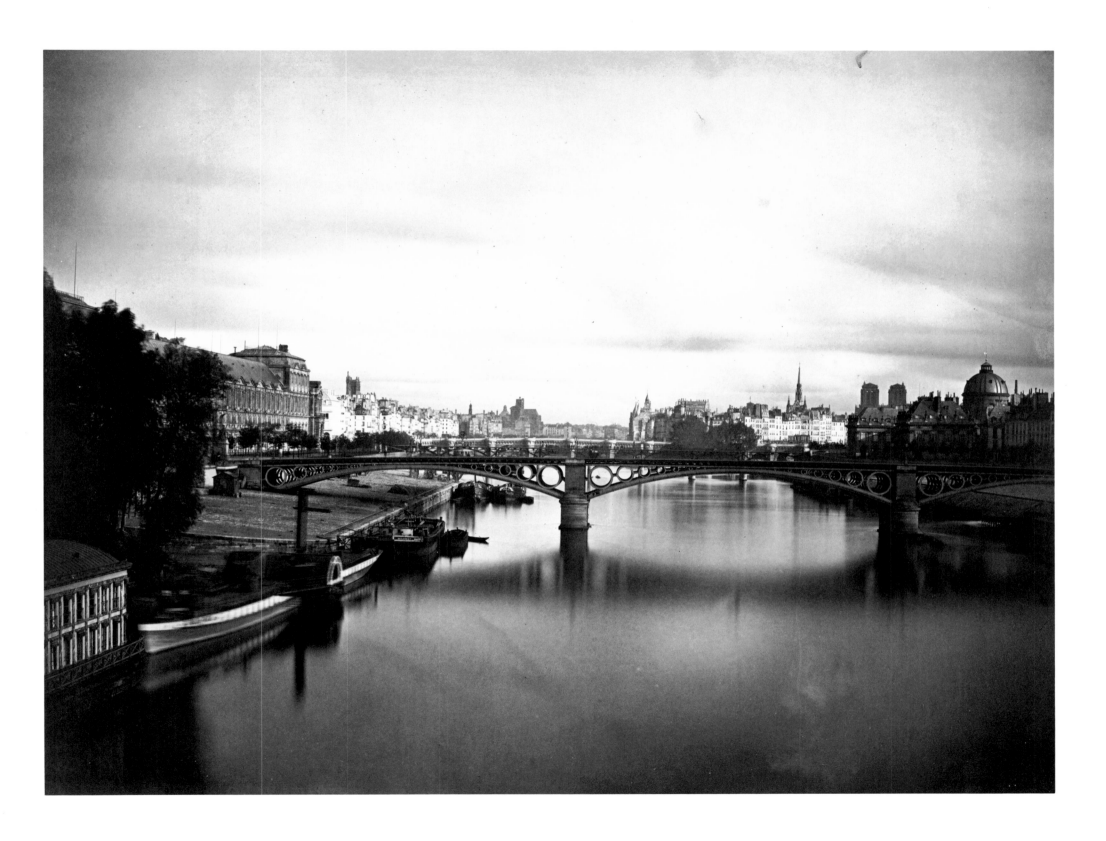

[I3] GUSTAVE LE GRAY. VIEW TO THE EAST FROM THE PONT ROYAL, PARIS, 1855–1856.

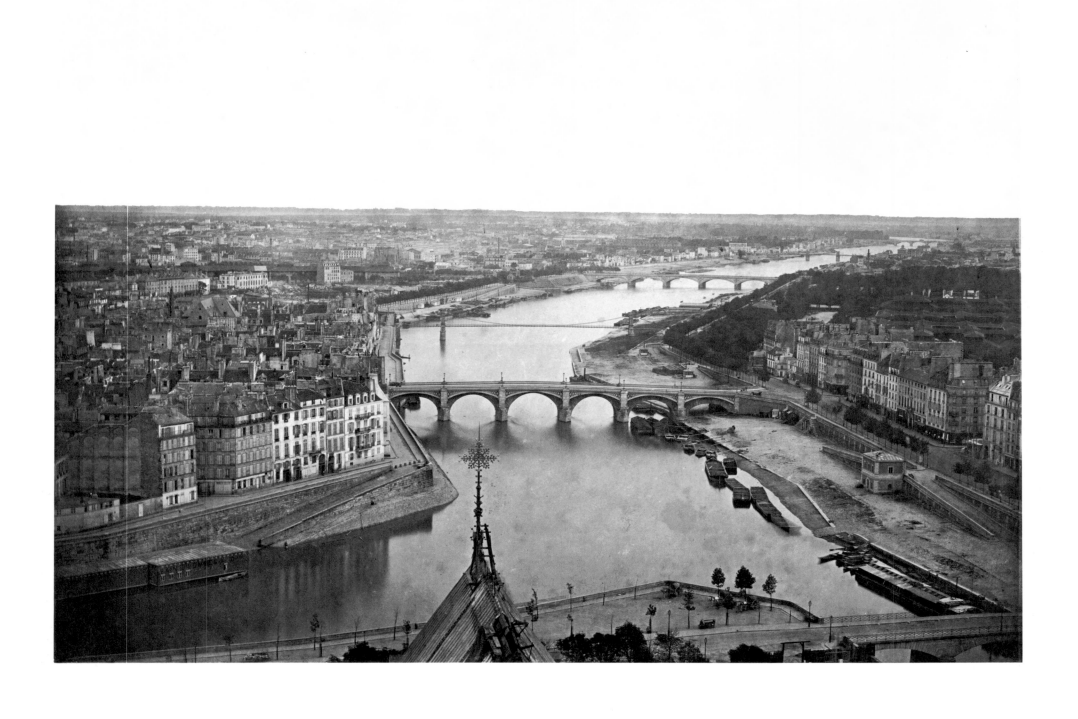

[14] BISSON FRÈRES. VIEW TO THE EAST FROM THE CATHEDRAL OF NOTRE-DAME, PARIS, BEFORE 1858.

[15] ANONYMOUS. PONT-NEUF, PARIS, AFTER 1841.

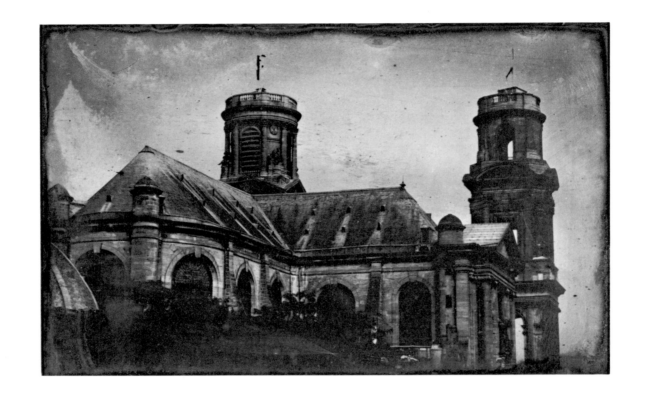

[16] BRETON FRÈRES. CHURCH OF SAINT-SULPICE, PARIS, FROM THE EAST, CA. 1839.

[17] HIPPOLYTE FIZEAU. WEST FACADE, CHURCH OF SAINT-SULPICE, PARIS, 1841–1842 (?).

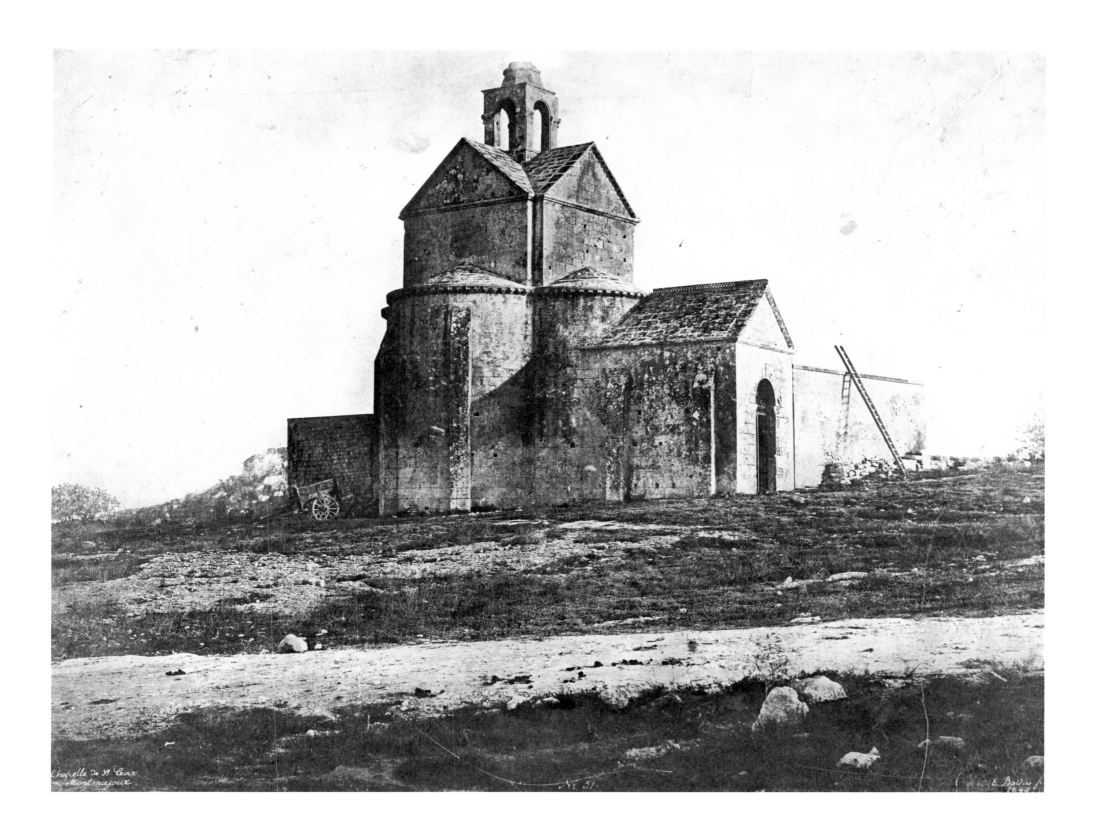

[18] EDOUARD BALDUS. CHAPEL OF SAINTE-CROIX, MONTMAJOUR, 1849.

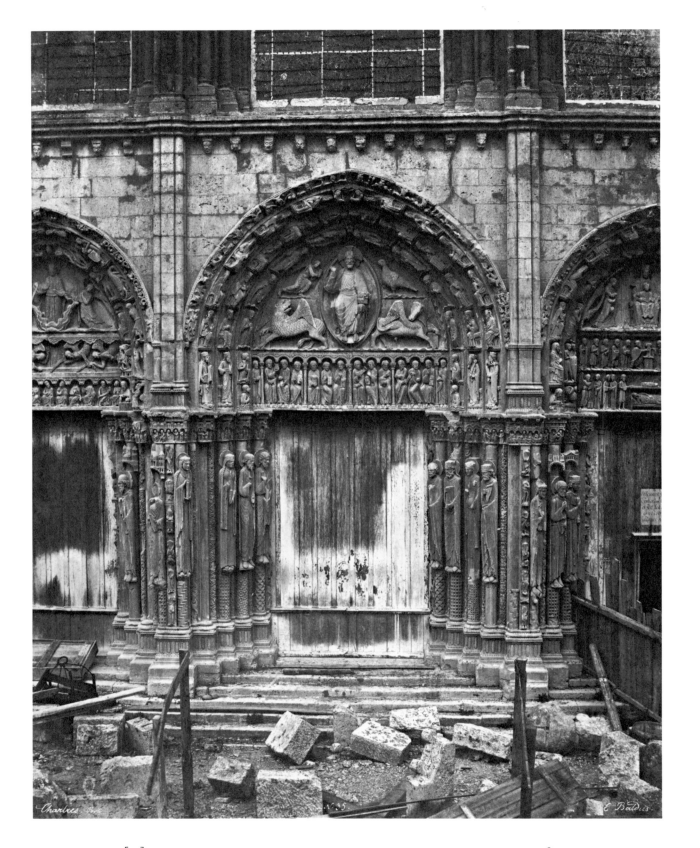

[19] EDOUARD BALDUS. ROYAL PORTAL, CHARTRES CATHEDRAL, EARLY 1850S.

[20] HENRI LE SECQ. COLUMNAR FIGURES, NORTH PORCH, CHARTRES CATHEDRAL, NEGATIVE 1852; PHOTOLITHOGRAPH LATE 1870S.

[21] HENRI LE SECQ. PORTAL OF SAINTE-ANNE, CATHEDRAL OF NOTRE-DAME, PARIS, EARLY 1850S.

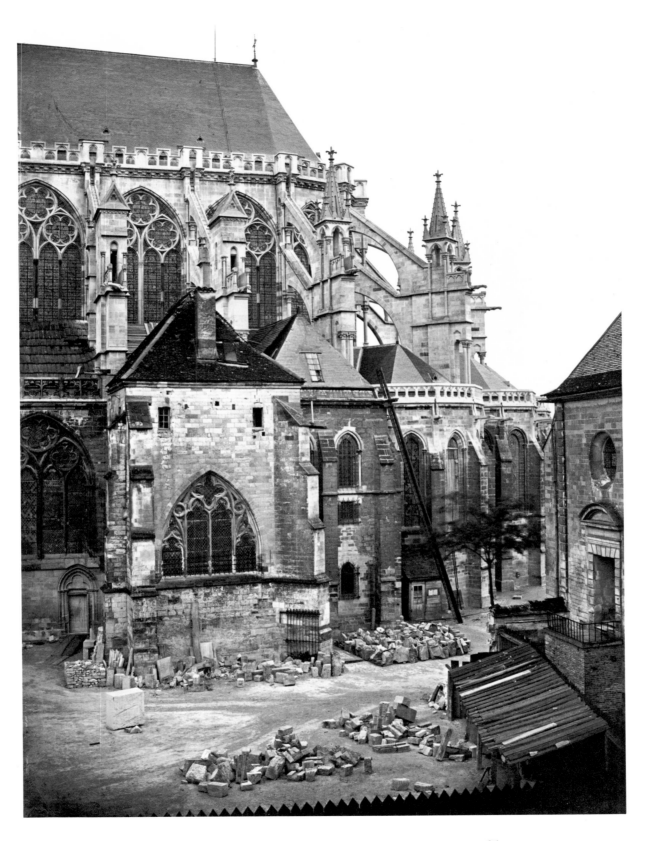

[22] CHARLES MARVILLE. EAST END, TROYES CATHEDRAL, 1863.

[23] BISSON FRÈRES. PORTALS, WEST FACADE, CHURCH OF SAINT-VULFRAN, ABBEVILLE, BEFORE 1859.

[26] HENRI LE SECQ. SOUTH FACADE, CHURCH OF THE MADELEINE, PARIS, PUBLISHED 1851–1853.

[27] EDOUARD BALDUS. TRAIN STATION, TOULON, LATE 1850S.

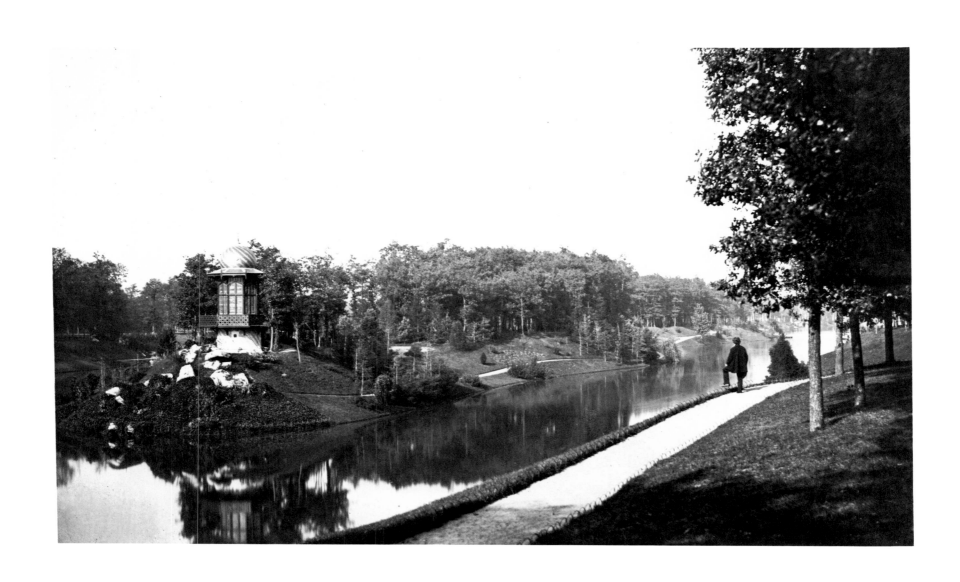

[28] CHARLES MARVILLE. SOUTHERN END OF THE GREAT LAKE, BOIS DE BOULOGNE, PARIS, 1858.

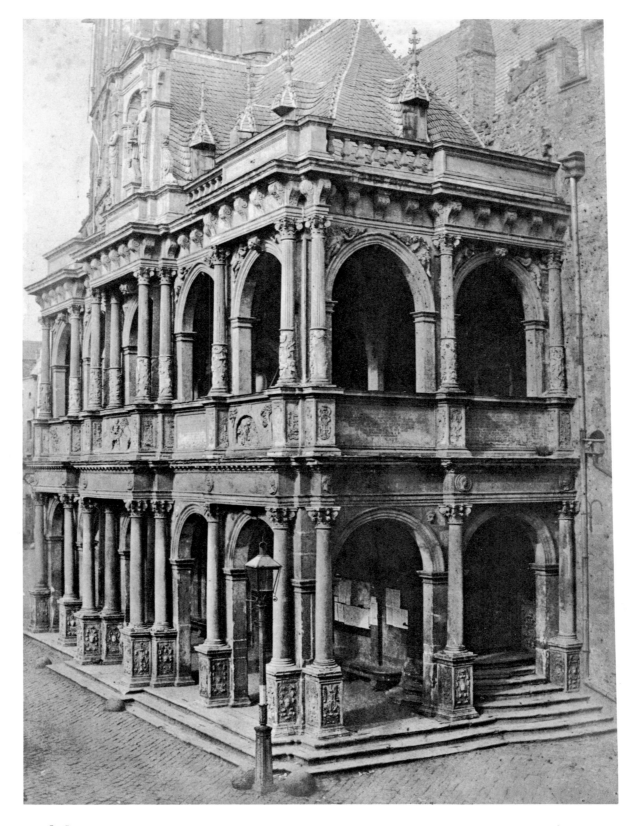

[29] CHARLES MARVILLE. RENAISSANCE PORTICO, TOWN HALL, COLOGNE, PUBLISHED 1853.

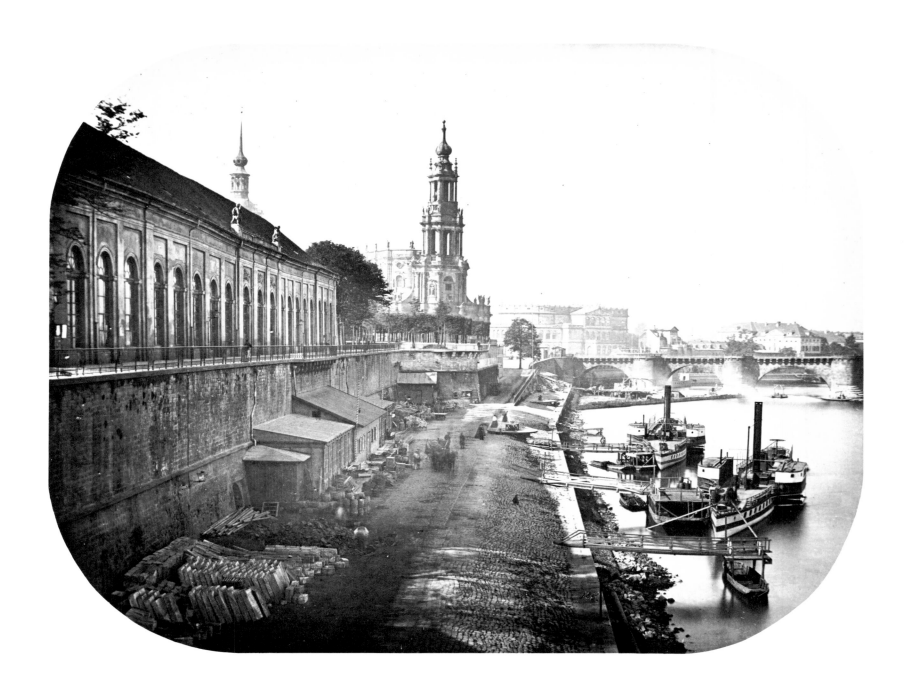

[30] HERMANN KRONE. HOFKIRCHE AND OPERA HOUSE, DRESDEN, BEFORE 1869.

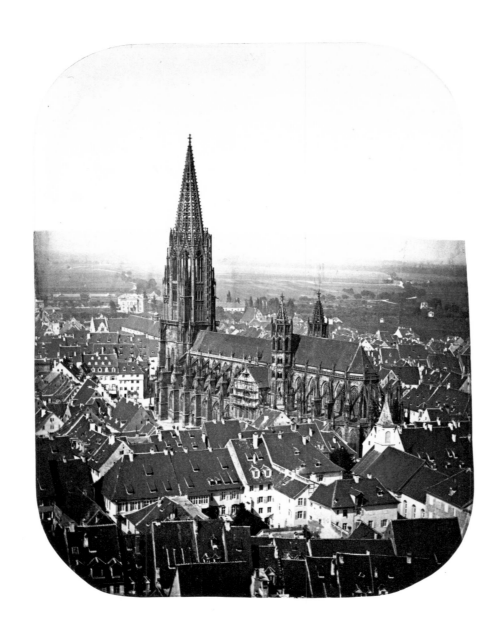

[31] G. THOMAS HASE. FREIBURG MÜNSTER FROM THE SCHLOSSBERG, 1850S (?).

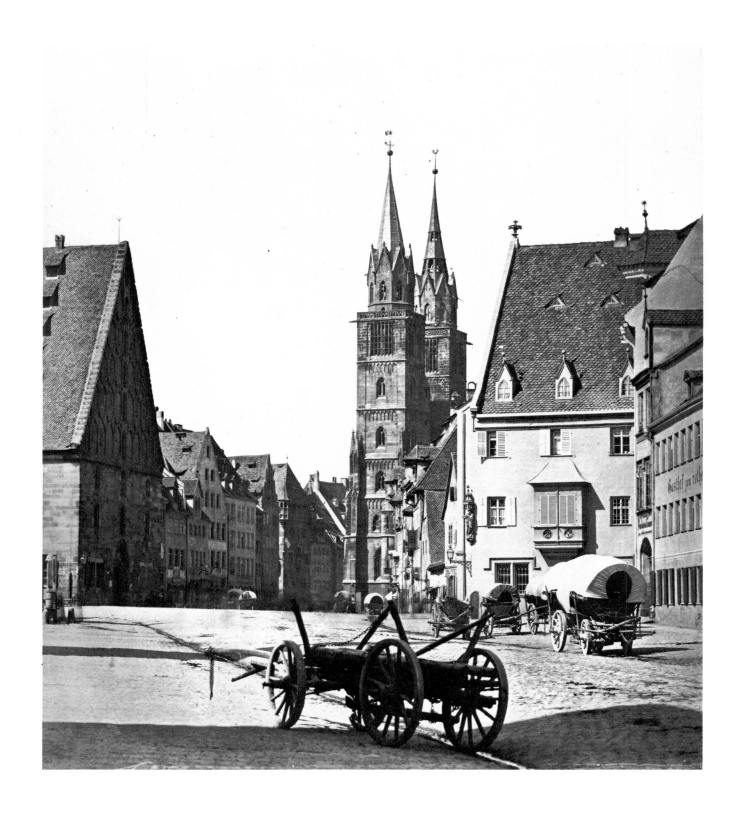

[32] ANONYMOUS. TOWERS, WEST END, CHURCH OF ST. LORENZ, NUREMBERG, 1860.

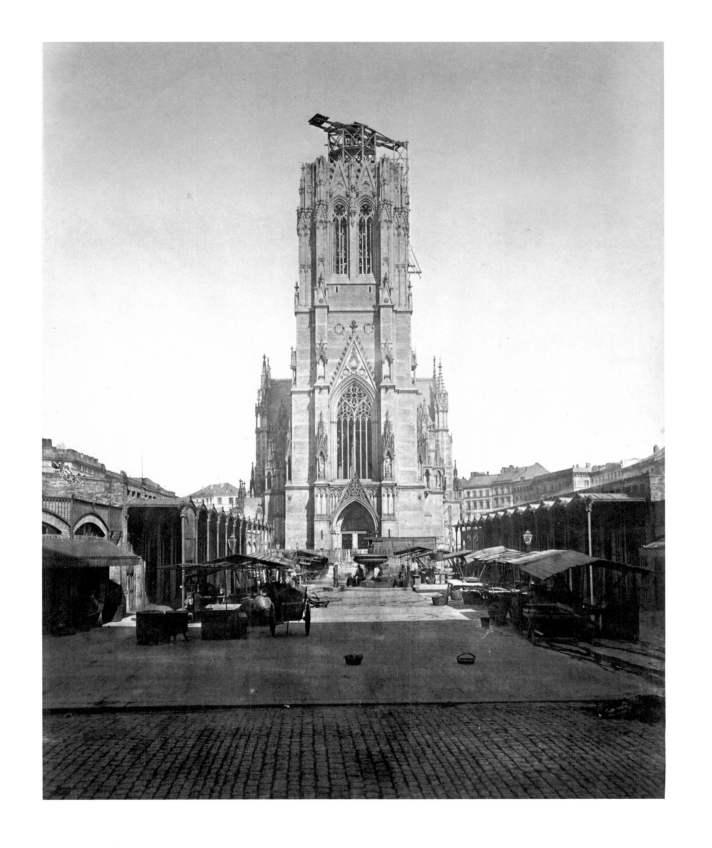

[33] ANONYMOUS. WEST FACADE, CHURCH OF ST. NICOLAI, HAMBURG, BEFORE 1875.

[34] ATTRIBUTED TO BISSON FRÈRES. MINED TOWER, HEIDELBERG CASTLE, BEFORE 1858 (?).

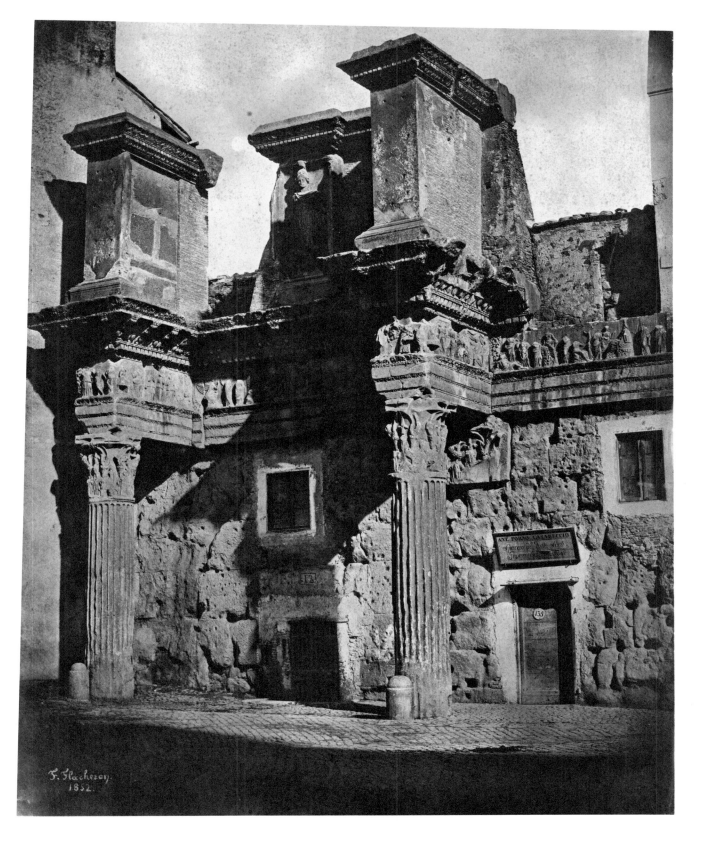

[35] FRÉDÉRIC FLACHÉRON. THE "COLONNACCE," FORUM OF NERVA, ROME, 1852.

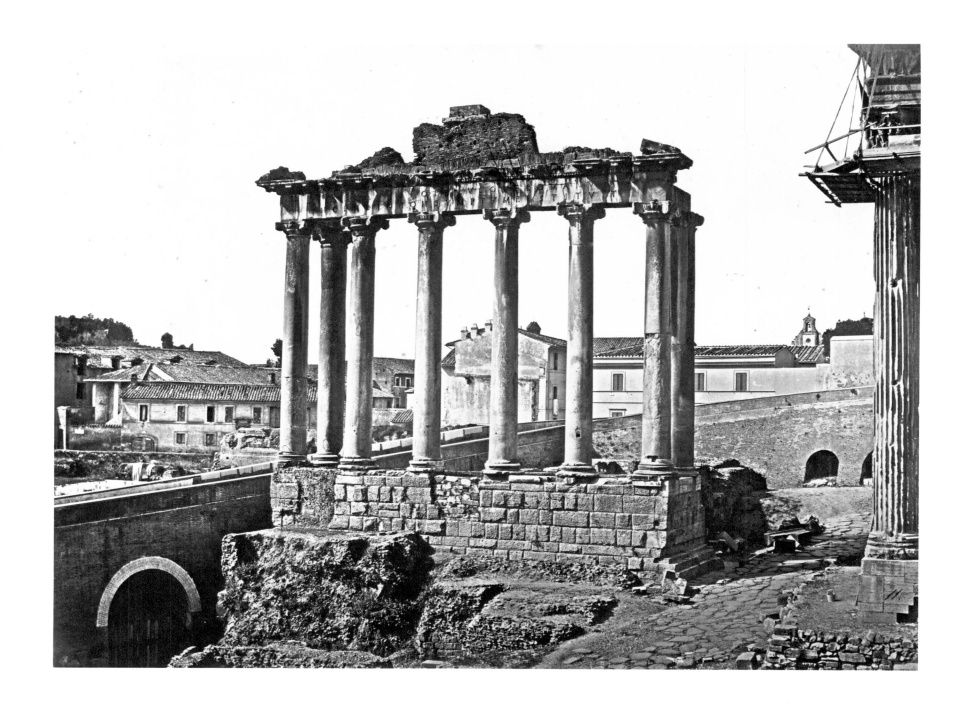

[36] EUGÈNE CONSTANT. TEMPLE OF SATURN, ROMAN FORUM, ROME, EARLY 1850S.

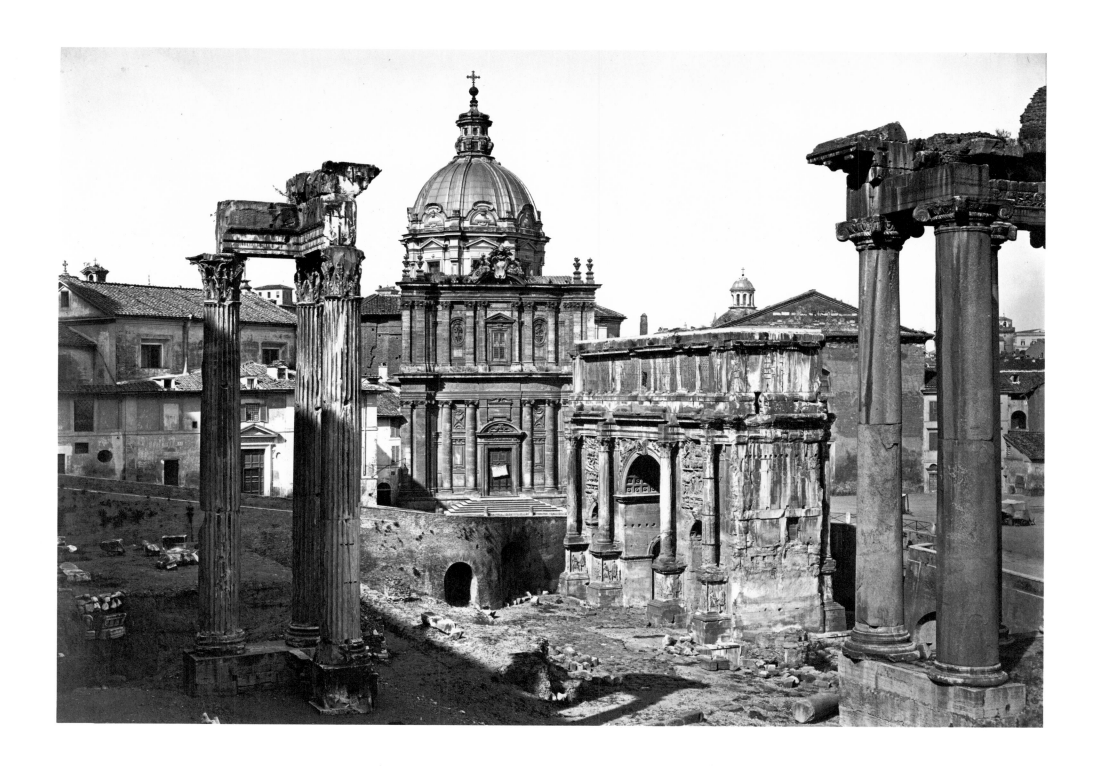

[37] AUGUSTE-ROSALIE BISSON. ROMAN FORUM AND CHURCH OF SS. LUCA E MARTINA, ROME, BEFORE 1864.

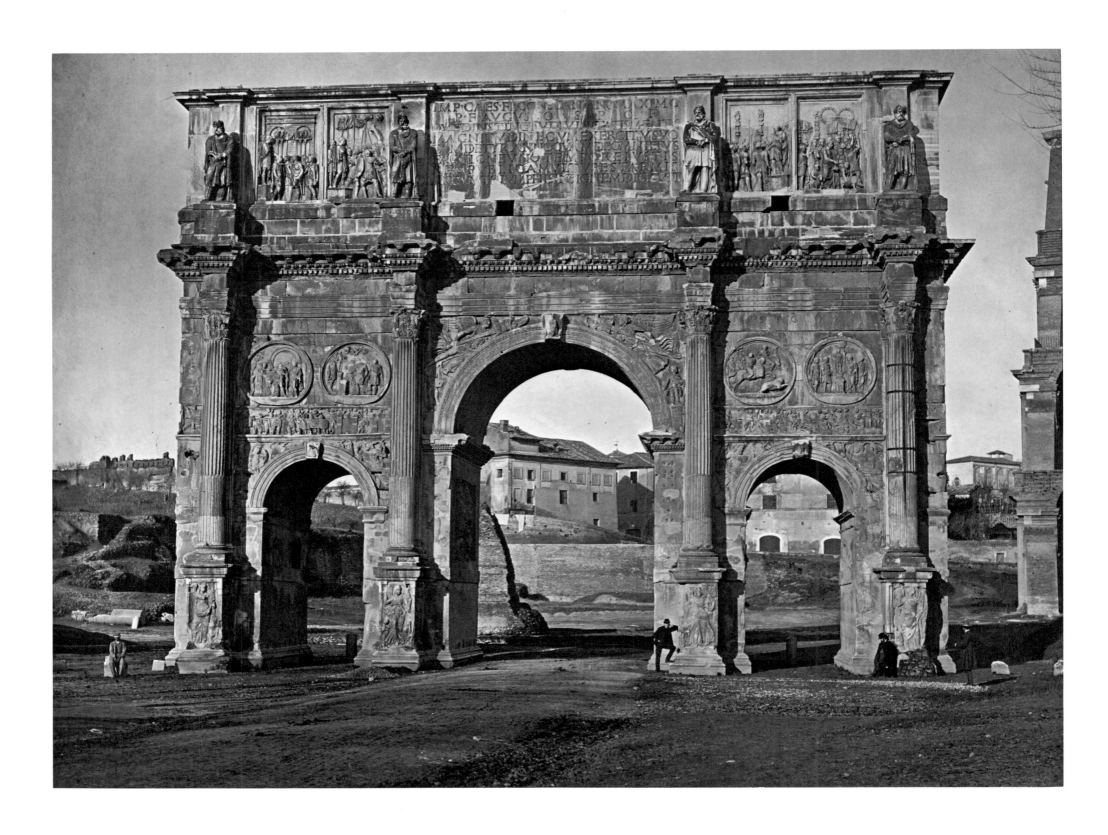

[38] ADOLPHE BRAUN. ARCH OF CONSTANTINE, ROME, BEFORE 1876.

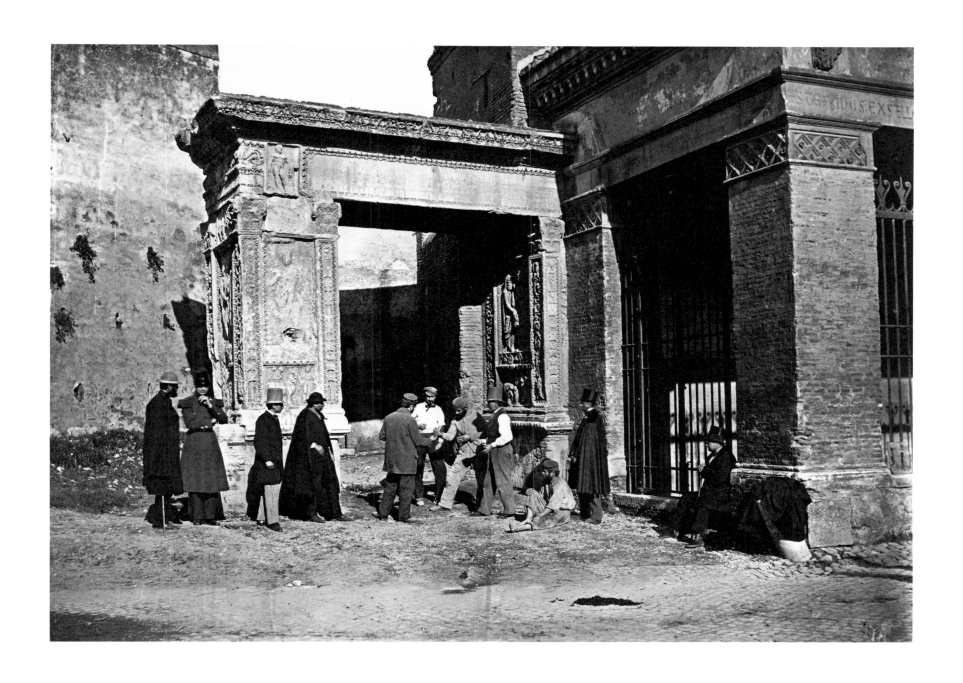

[39] GIOACCHINO ALTOBELLI AND POMPEO MOLINS. ARCH OF THE SILVERSMITHS, ROME, EARLY 1860S.

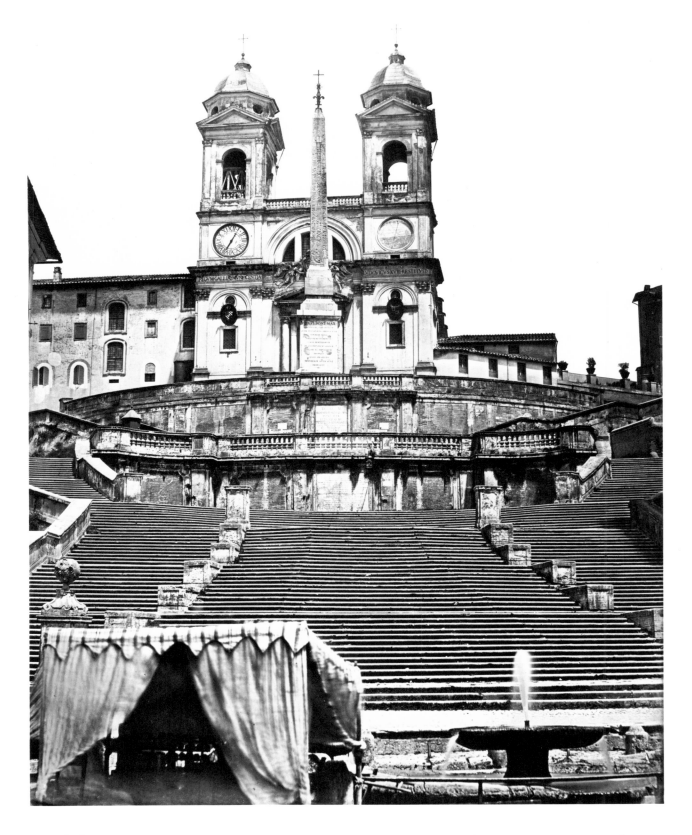

[40] PIETRO DOVIZIELLI. SPANISH STEPS AND THE CHURCH OF TRINITÀ DEI MONTI, ROME, CA. 1854.

[41] PIETRO DOVIZIELLI. CHURCH OF S. GIOVANNI IN LATERANO AND PORTA S. GIOVANNI, ROME, CA. 1854.

[42] JAMES ANDERSON. BRACCIO NUOVO, VATICAN GALLERIES, ROME, CA. 1854.

[43] ROBERT MACPHERSON. VIEW OF ROME FROM THE FRENCH ACADEMY, MONTE PINCIO, PROBABLY BEFORE 1863.

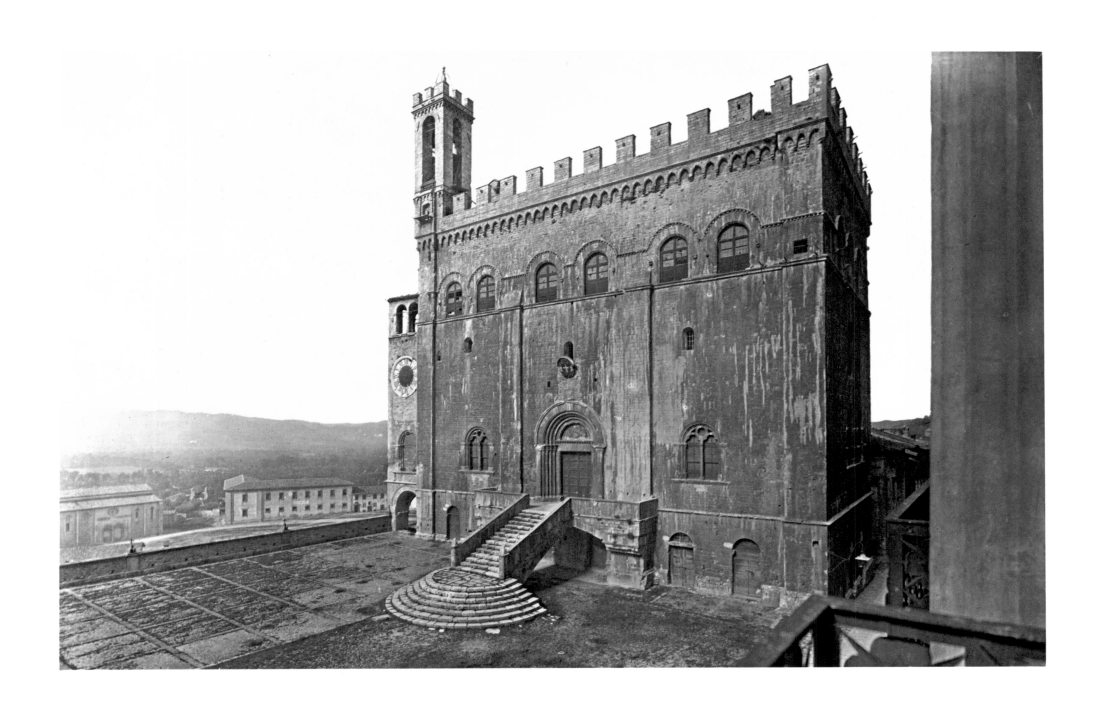

[44] ROBERT MACPHERSON. PALAZZO DEI CONSOLI, GUBBIO, CA. 1864.

[45] ROBERT MACPHERSON. BAS RELIEF, WEST FACADE, ORVIETO CATHEDRAL, PROBABLY BEFORE 1859.

[46] LÉON GÉRARD. TERRA COTTA DECORATION, SOUTHERN APSE, CHURCH OF S. MARIA DELLE GRAZIE, MILAN, CA. 1857.

[47] ATTRIBUTED TO POMPEO POZZI. SEPULCHRAL MONUMENTS OF THE ANDREANI, CORENNO PLINIO, CA. 1860.

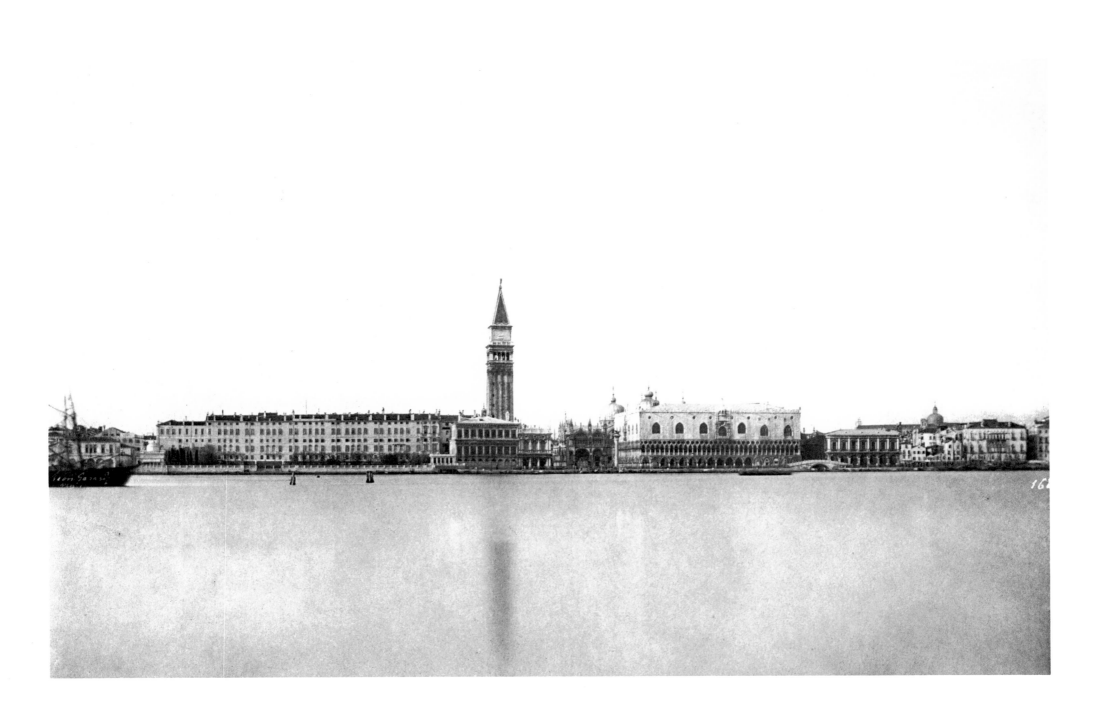

[48] LÉON GÉRARD. VIEW OF THE MOLE FROM GIUDECCA, VENICE, CA. 1857.

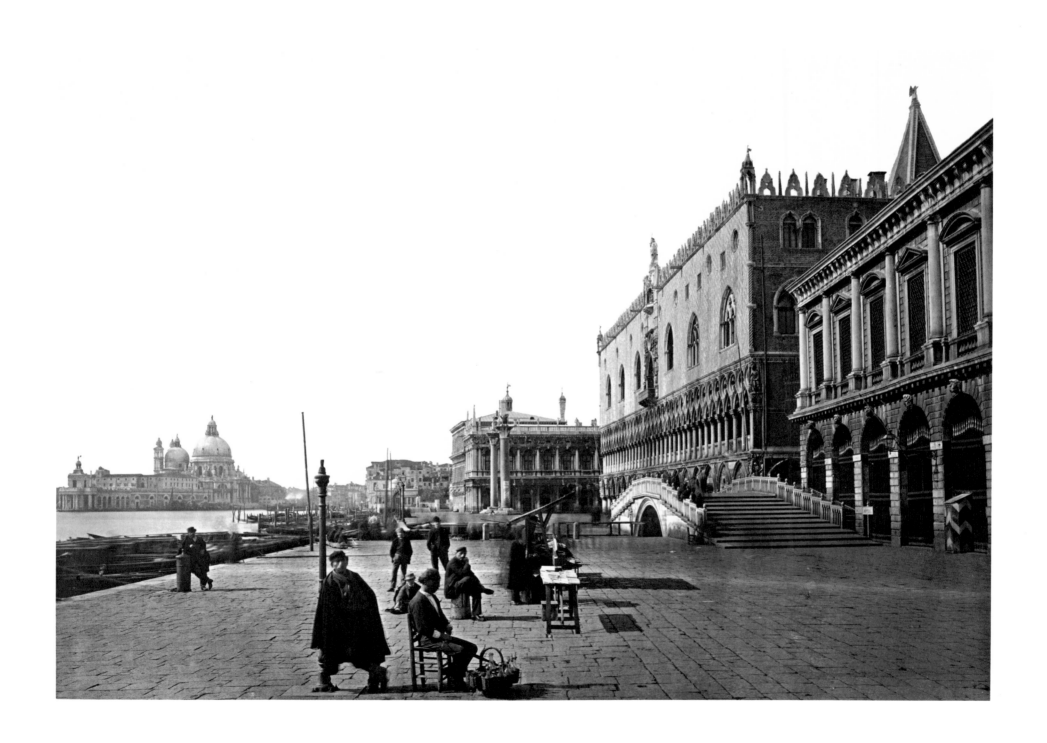

[49] CARLO PONTI. DOGE'S PALACE AND CHURCH OF S. MARIA DELLA SALUTE, VENICE, 1860s (?).

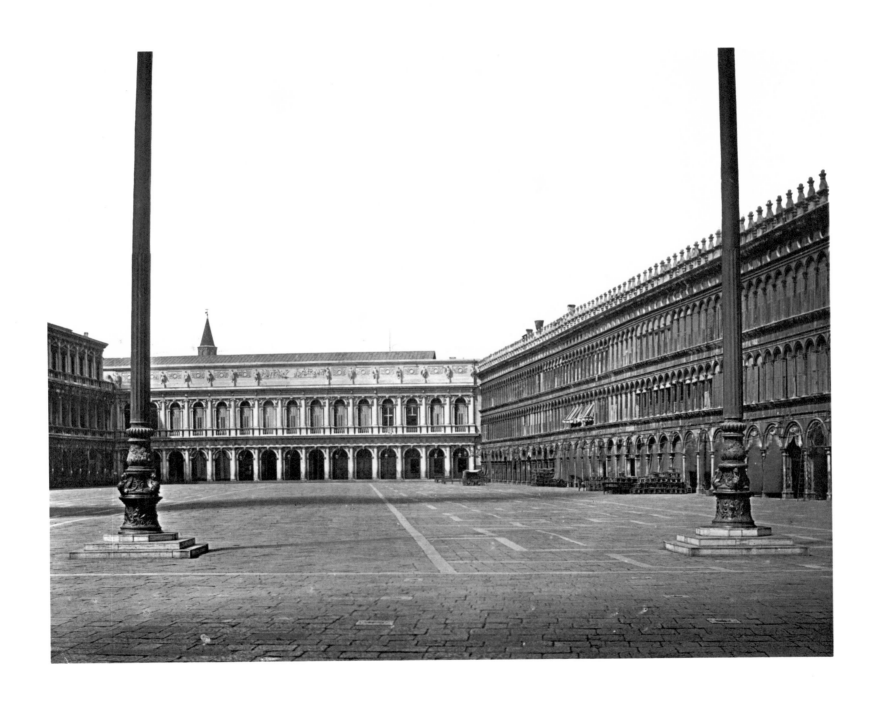

[50] ANONYMOUS. PIAZZA SAN MARCO, VENICE, 1860s (?).

[51] CARLO PONTI. BAPTISMAL FONT, BAPTISTERY, BASILICA OF SAN MARCO, VENICE, 1860s (?).

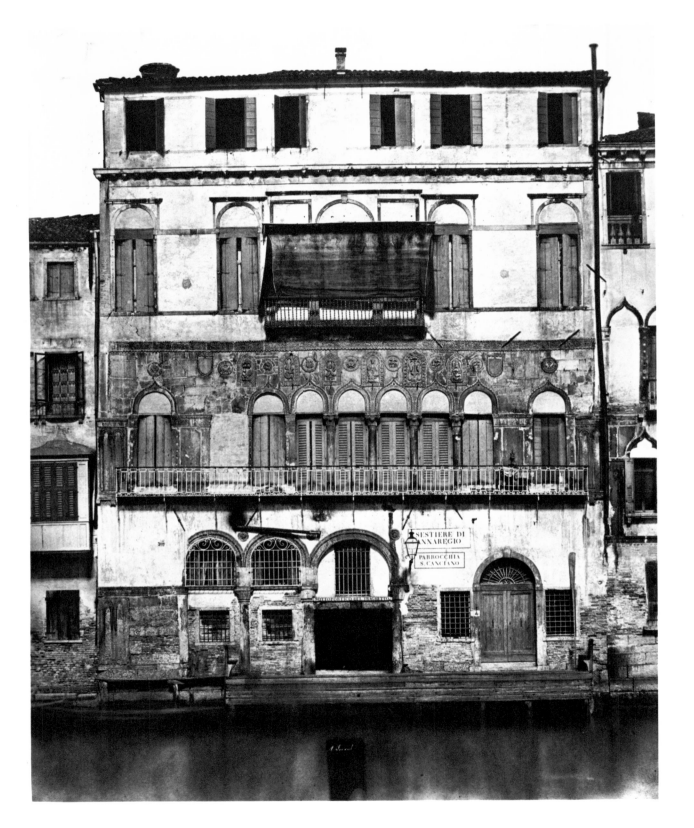

[52] JAKOB AUGUST LORENT. CA' DA MOSTO, VENICE, 1853 (?).

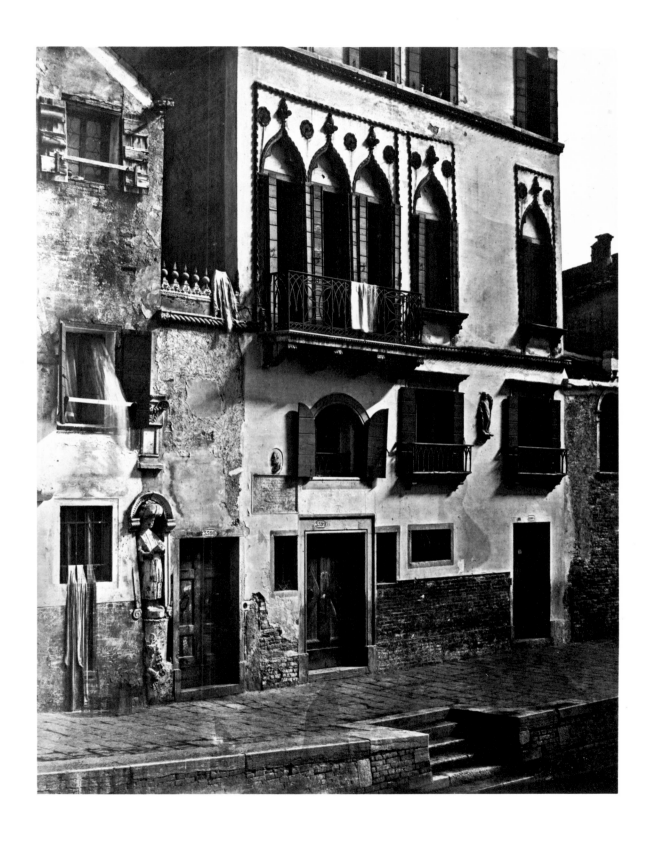

[53] CARLO PONTI. CASA DEL TINTORETTO, VENICE, 1860s (?).

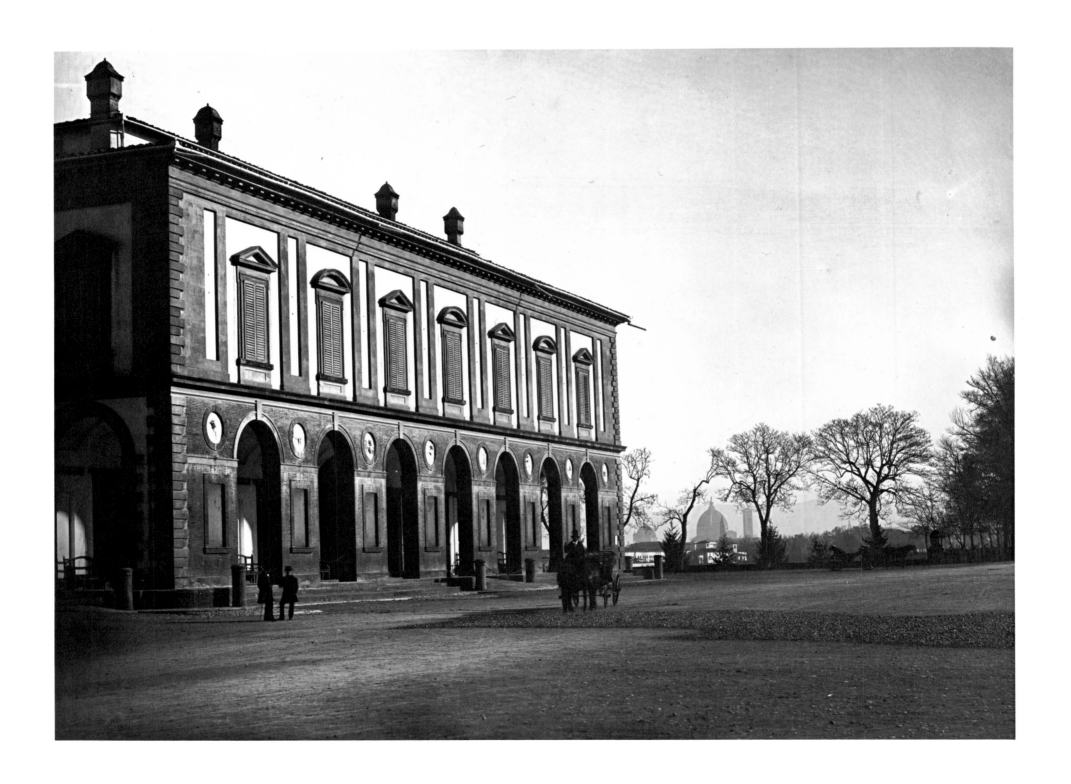

[54] FRATELLI ALINARI. PALAZZO DELLE CASCINE, FLORENCE, CA. 1855.

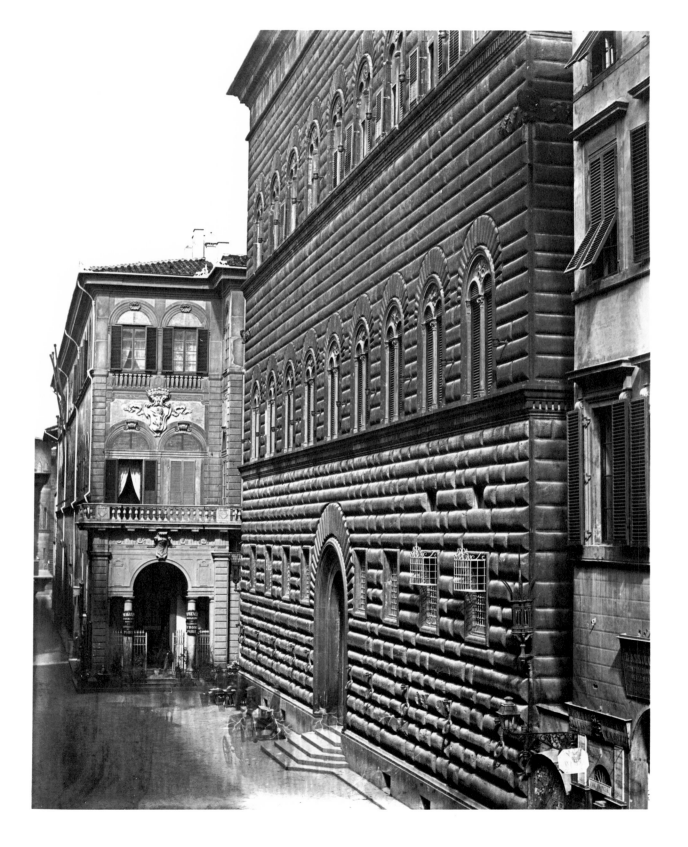

[55] FRATELLI ALINARI. PALAZZO STROZZI AND PALAZZO CORSI, FLORENCE, CA. 1855.

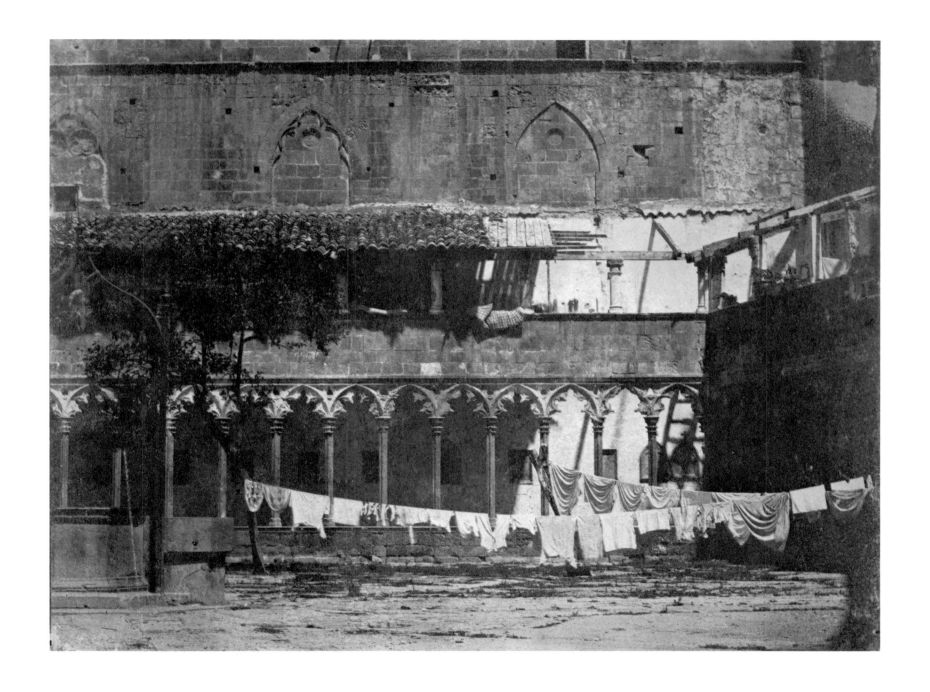

[56] ALPHONSE DAVANNE. COURTYARD, CONVENT OF SAN FRANCISCO, PALMA, MAJORCA, EARLY 1850S.

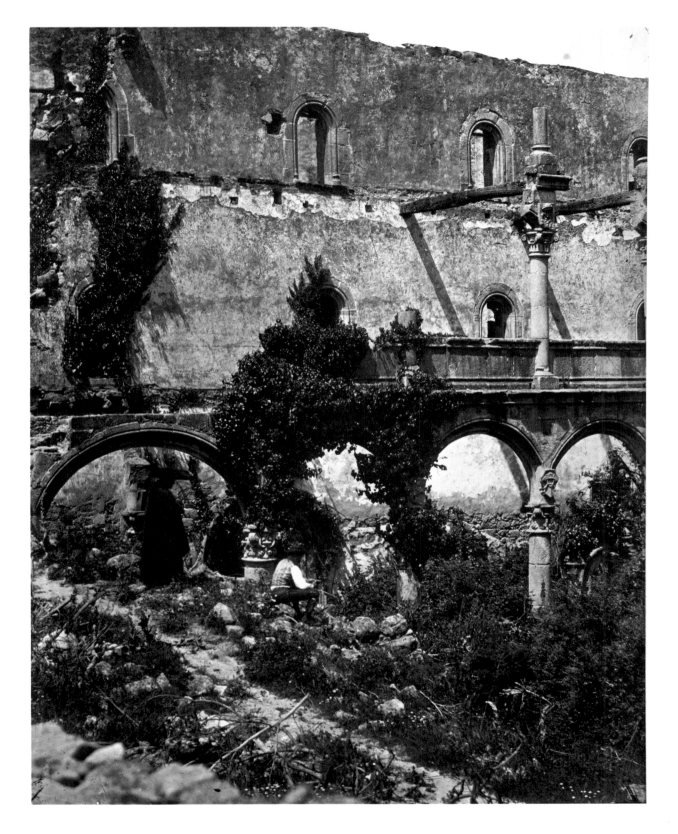

[57] CHARLES CLIFFORD. RUINS OF THE MONASTERY OF SAN JERÓNIMO, YUSTE, LATE 1850S.

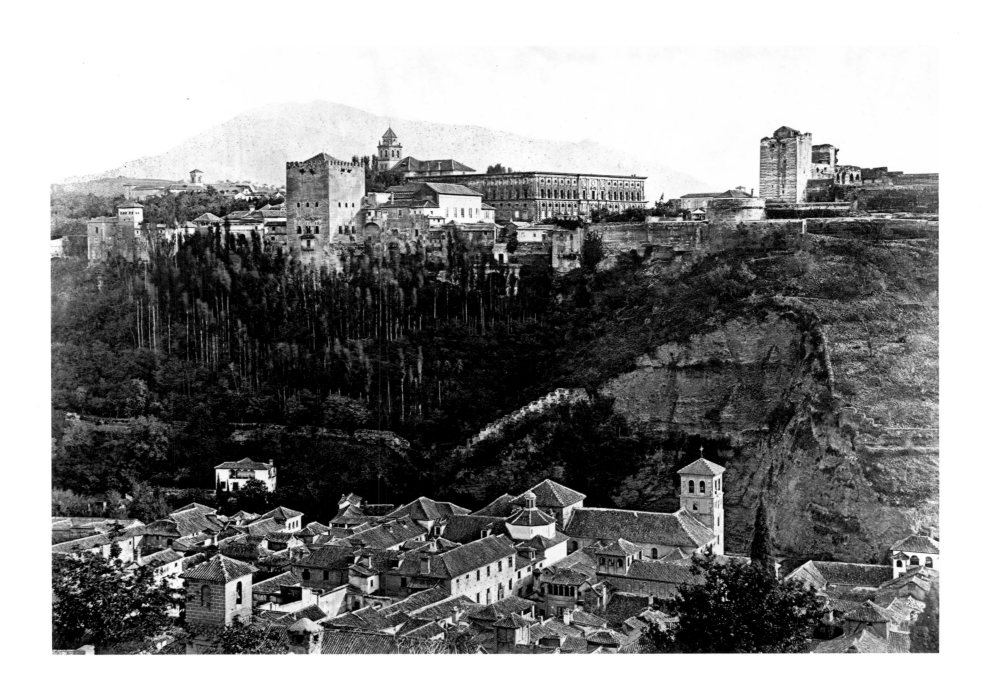

[58] CHARLES CLIFFORD. THE ALHAMBRA, GRANADA, LATE 1850S.

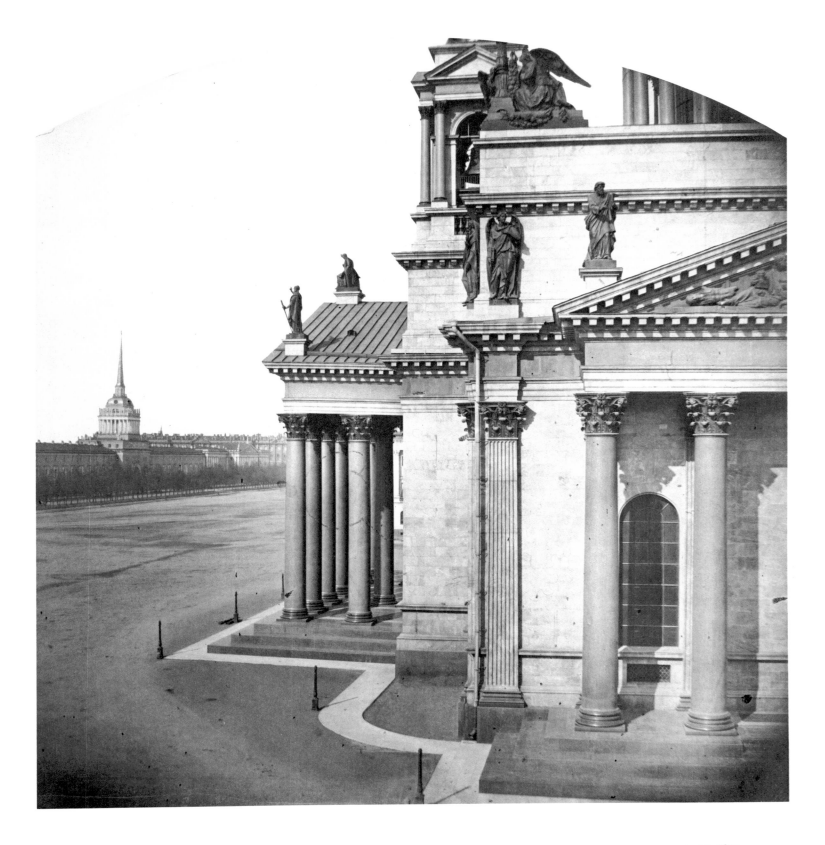

[59] A. RICHEBOURG. PORTICO OF THE CHURCH OF ST. ISAAC AND THE ADMIRALTY, LENINGRAD, PUBLISHED 1859.

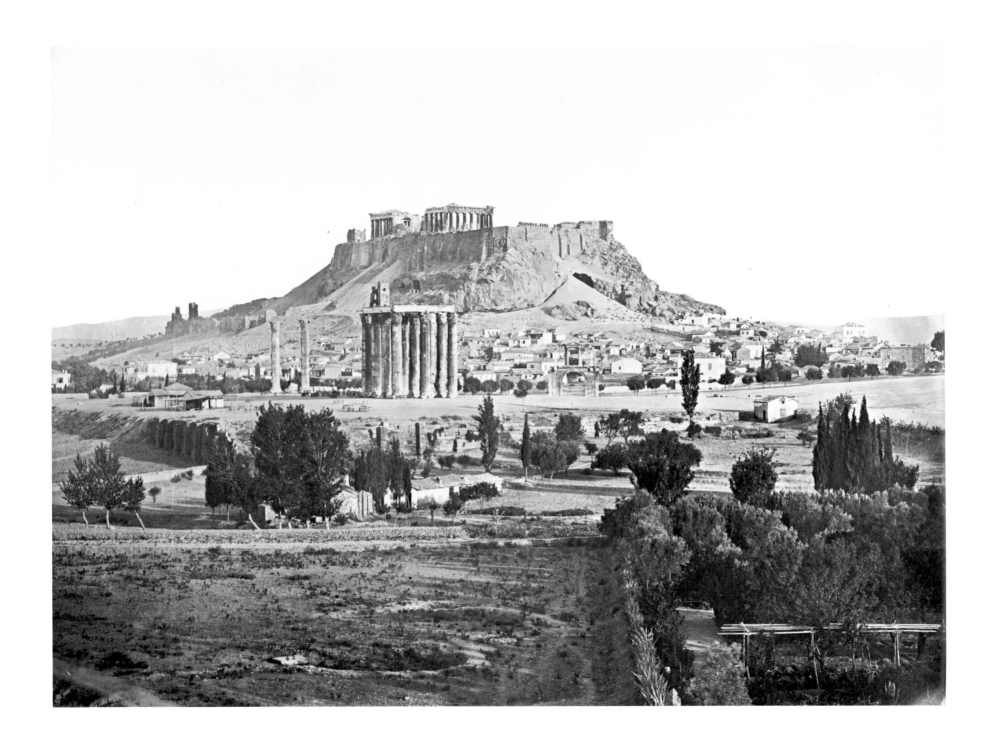

[60] P. MORAITES. VIEW OF THE ACROPOLIS WITH THE TEMPLE OF ZEUS AND ARCH OF HADRIAN, ATHENS, 1860S.

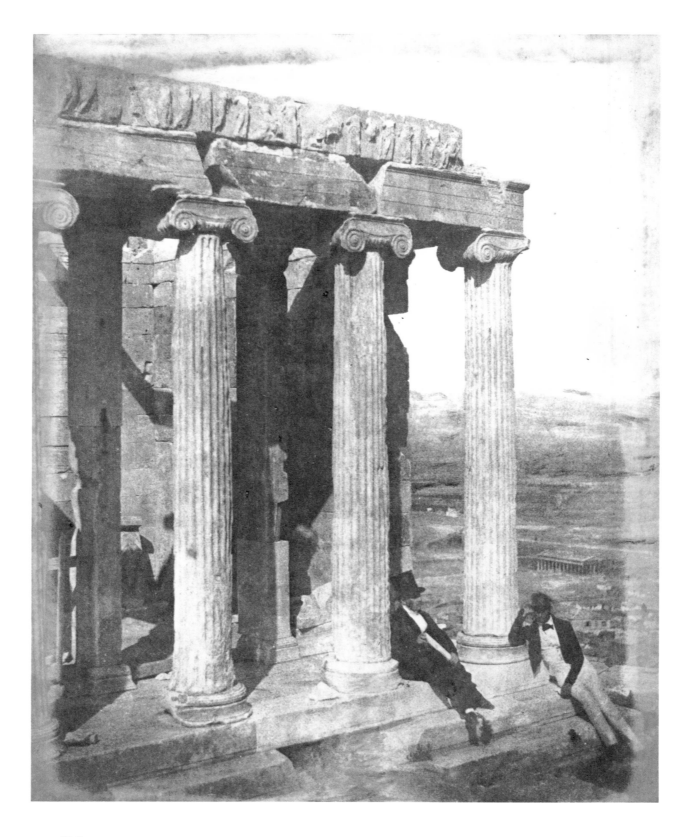

[61] GEORGE M. BRIDGES. EAST FACADE, TEMPLE OF ATHENA NIKE, ACROPOLIS, ATHENS, CA. 1850.

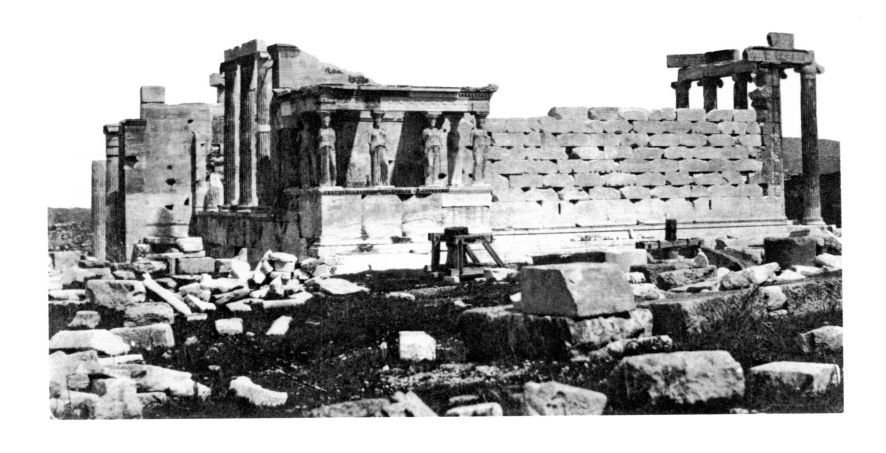

[62] JEAN WALTHER. VIEW OF THE ERECHTHEION FROM THE SOUTHWEST, ACROPOLIS, ATHENS, PUBLISHED 1851–1853.

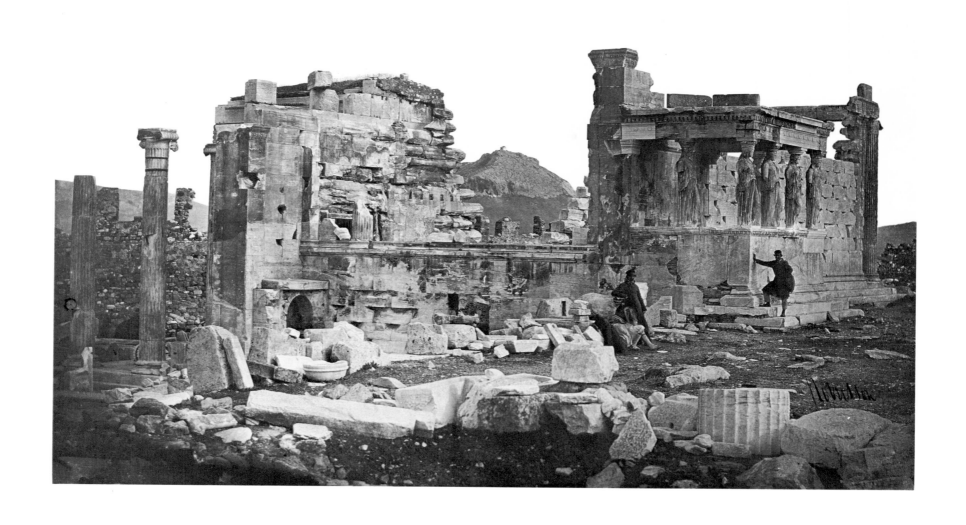

[63] JAMES ROBERTSON. VIEW OF THE ERECHTHEION FROM THE SOUTHWEST, ACROPOLIS, ATHENS, 1854.

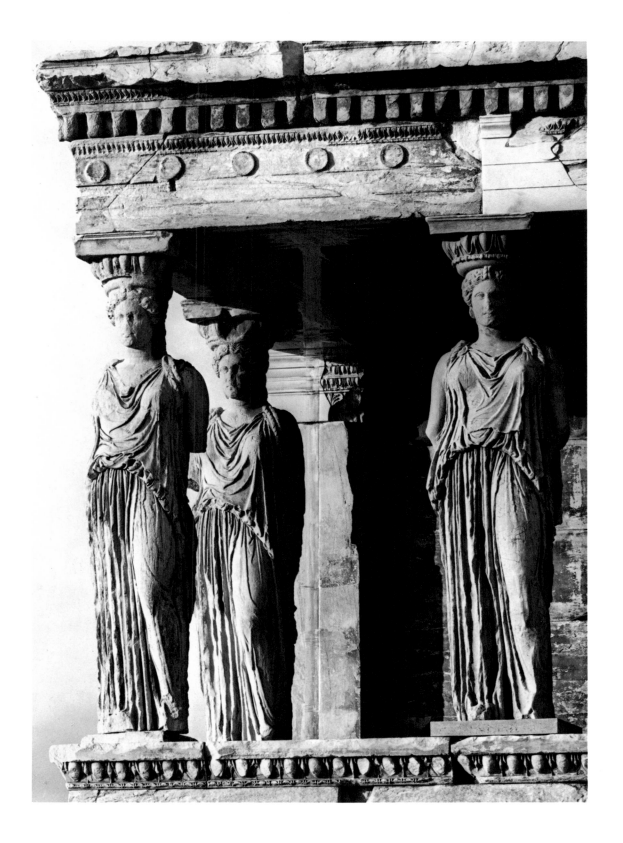

WALTER HEGE. CARYATIDS, PORCH OF THE MAIDENS, ERECHTHEION, ACROPOLIS, ATHENS, 1928.

[65] WILLIAM JAMES STILLMAN. NORTH PORCH, ERECHTHEION, ACROPOLIS, ATHENS, 1868–1869.

[66] WILLIAM JAMES STILLMAN. EAST PORCH, PARTHENON, ACROPOLIS, ATHENS, 1869.

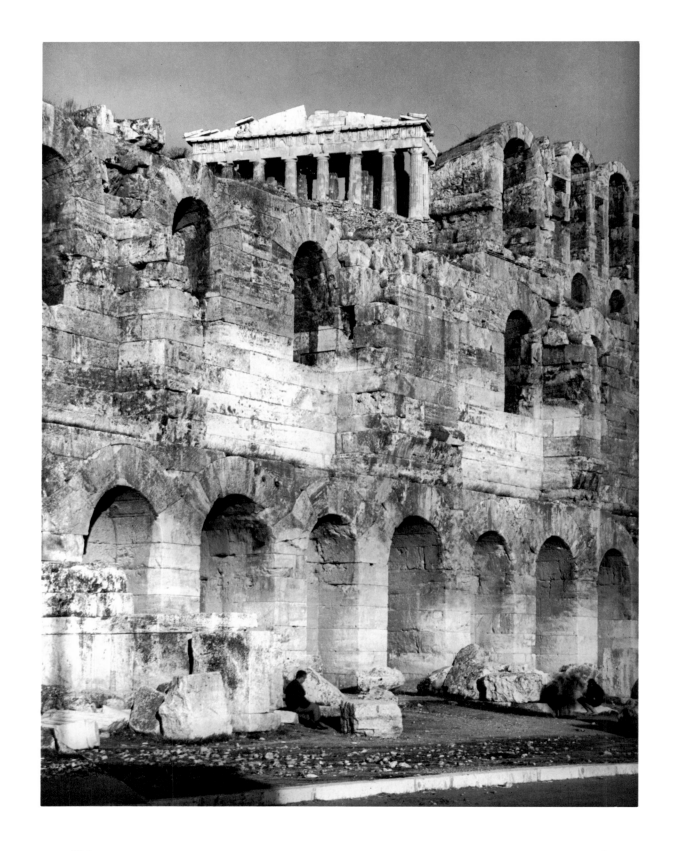

[67] WALTER HEGE. THE PARTHENON AND THE ODEION OF HERODES ATTICUS, ATHENS, 1928.

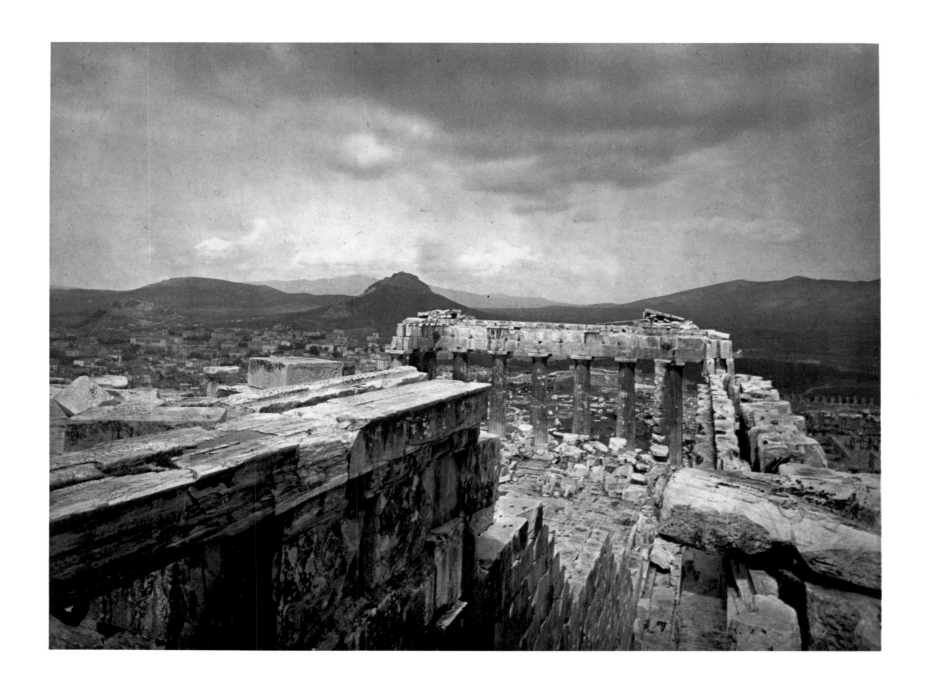

[68] WILLIAM JAMES STILLMAN. VIEW FROM THE SOUTHWEST CORNER OF THE PARTHENON, ACROPOLIS, ATHENS, 1868–1869.

[69] AUGUSTE SALZMANN. ABSALOM'S TOMB, VALLEY OF KIDRON, JERUSALEM, 1854.

[70] AUGUSTE SALZMANN. DOORWAY, CHURCH OF THE HOLY SEPULCHRE, JERUSALEM, 1854.

[71] AUGUSTE SALZMANN. DETAIL OF LINTEL, TOMBS OF THE KINGS, JERUSALEM, 1854.

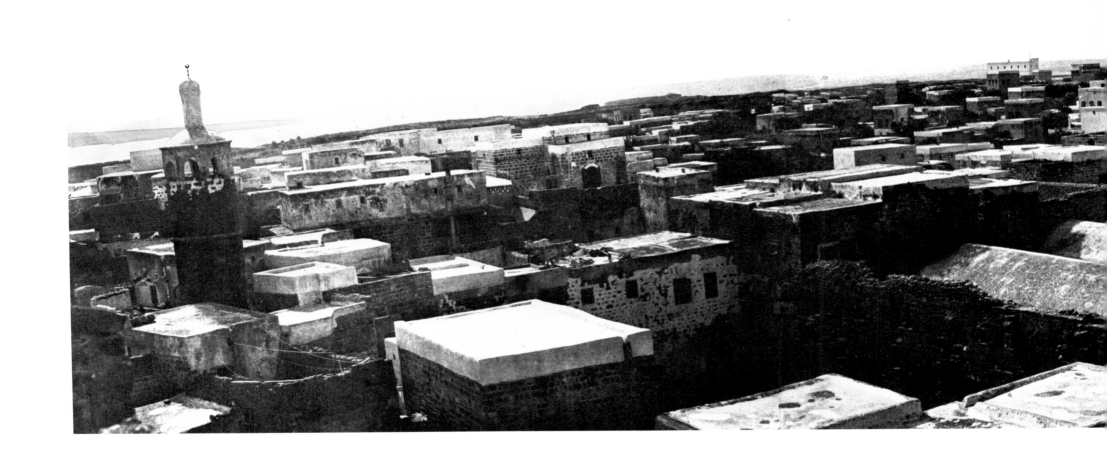

[72] LOUIS DE CLERCQ. TRIPOLI, LEBANON, 1859.

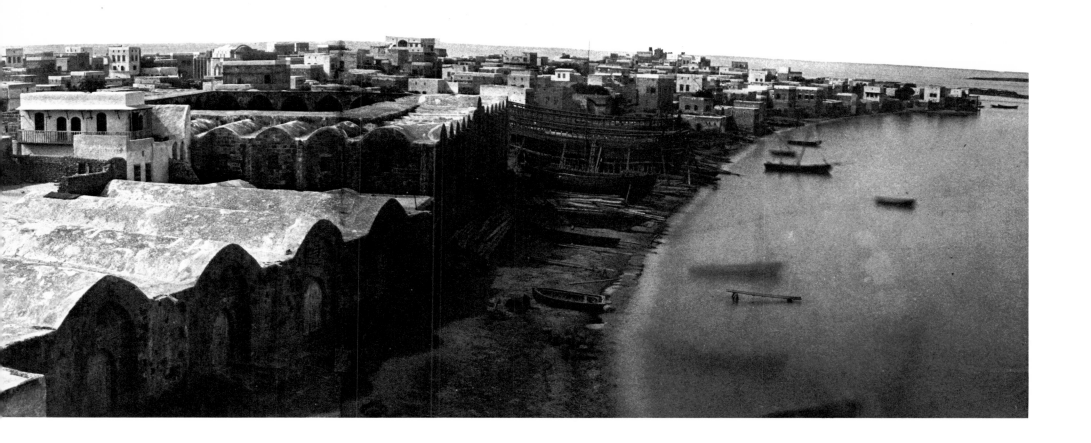

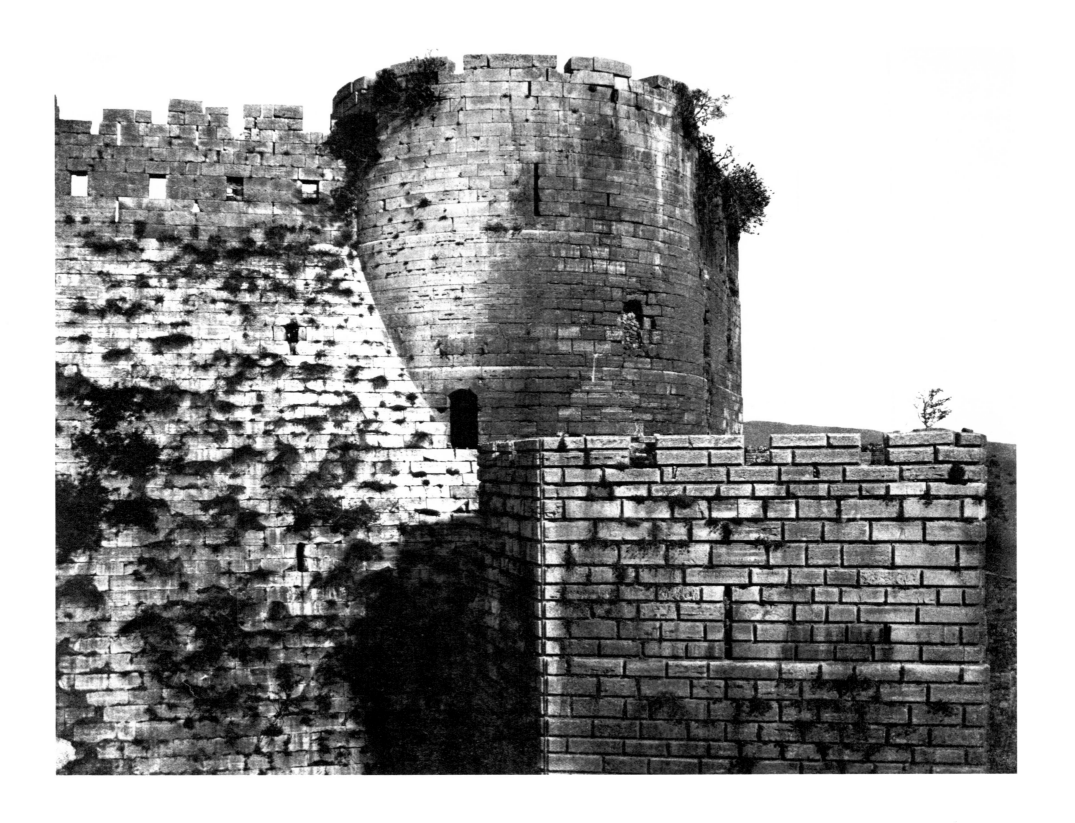

[73] LOUIS DE CLERCQ. KRAK OF THE KNIGHTS (KALAAT - EL - HOSN), SYRIA, 1859.

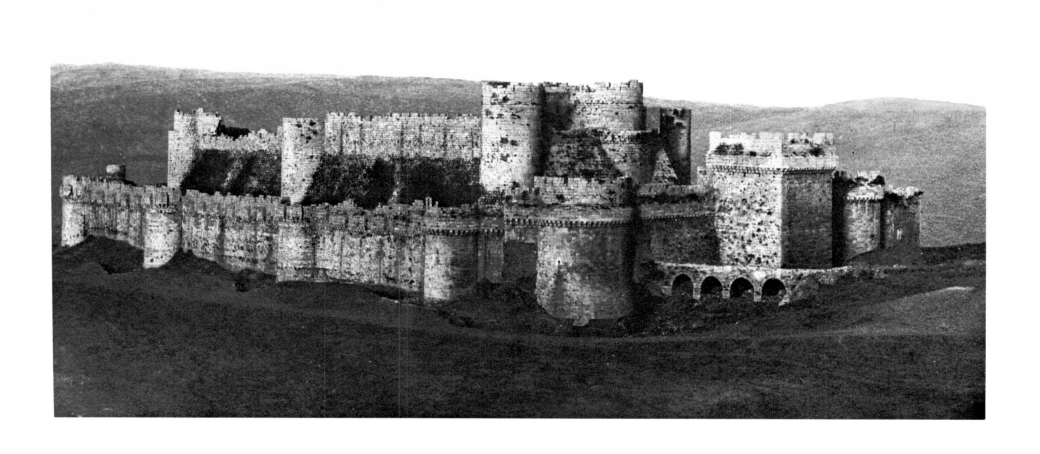

[74] LOUIS DE CLERCQ. SOUTHERN SIDE, KRAK OF THE KNIGHTS (KALAAT - EL - HOSN), SYRIA, 1859.

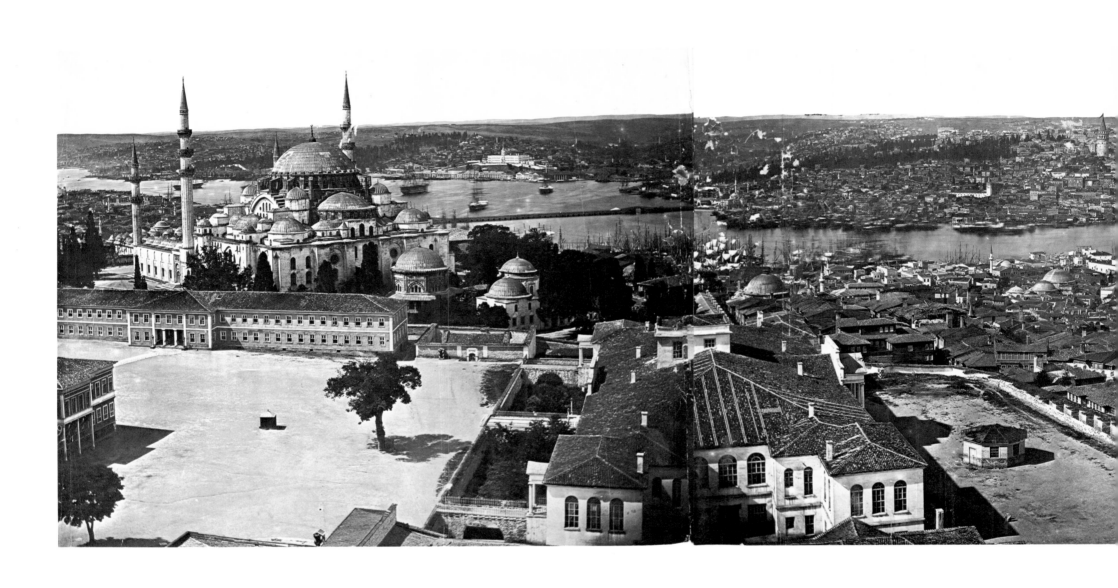

[75] JAMES ROBERTSON AND FELICE BEATO. ISTANBUL AND THE BOSPORUS FROM THE SERASKIER TOWER, 1853.

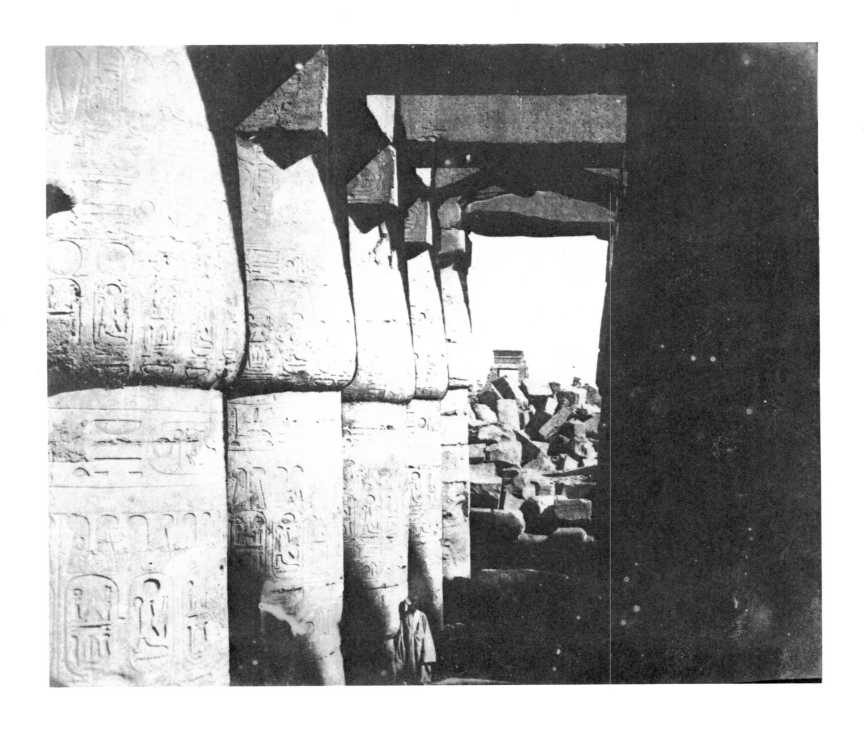

[78] CLAUDIUS GALEN WHEELHOUSE. THE GREAT HYPOSTYLE HALL, TEMPLE OF AMUN, KARNAK, CA. 1850.

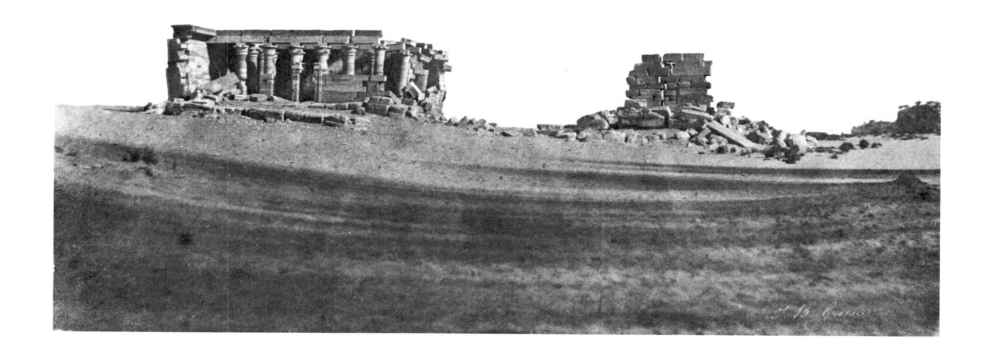

[79] JOHN BULKLEY GREENE. TEMPLE OF MAHARAKKA, NUBIA, 1854.

[80] JOHN BULKLEY GREENE. DROMOS, TEMPLE OF SEBUA, NUBIA, 1854.

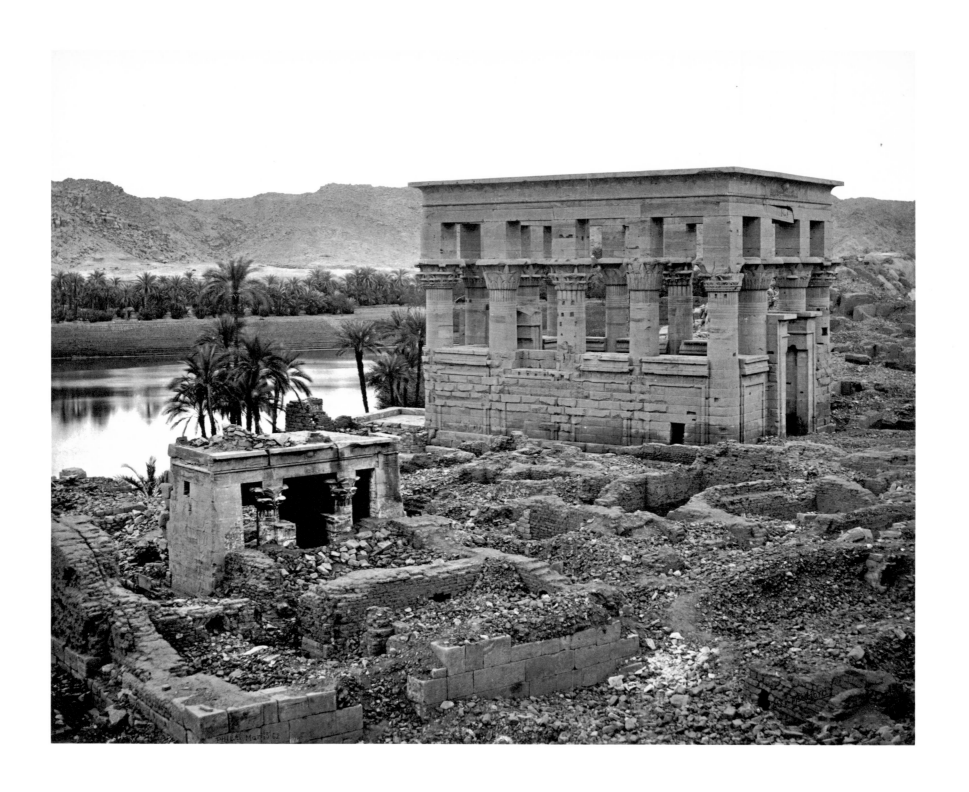

[81] FRANCIS BEDFORD. KIOSK OF TRAJAN AND TEMPLE OF HATHOR, PHILAE, 1862.

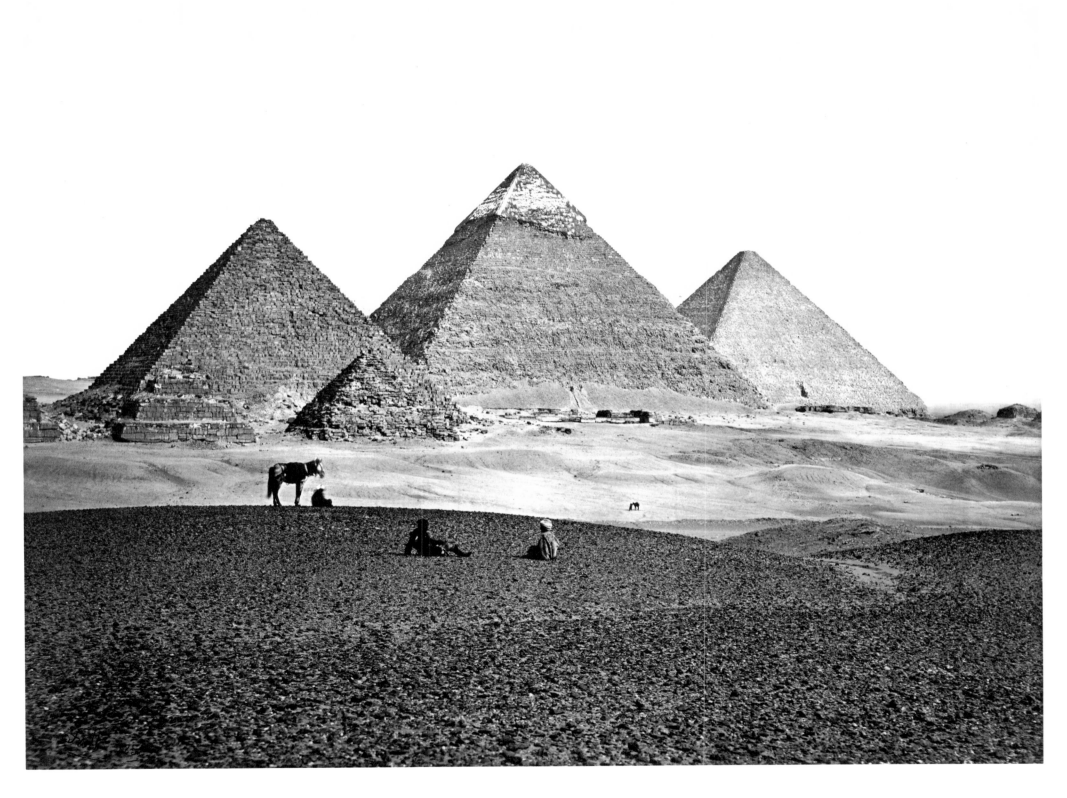

[82] FRANCIS FRITH. THE PYRAMIDS OF MYCERINUS, CHEPHREN AND CHEOPS, GIZA, 1858.

[83] DÉSIRÉ CHARNAY. THE RED HOUSE, CHICHÉN-ITZÁ, MEXICO, 1860.

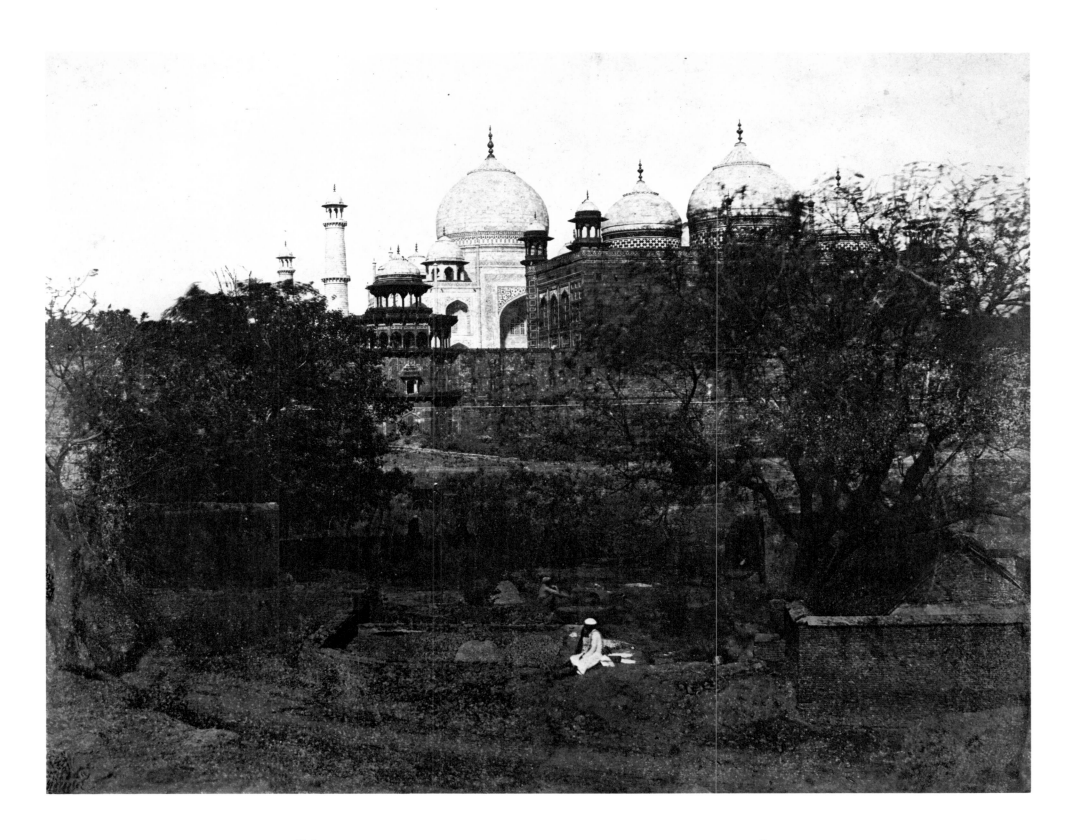

[84] JOHN MURRAY. THE TAJ MAHAL FROM THE SOUTHEAST, AGRA, PUBLISHED 1857.

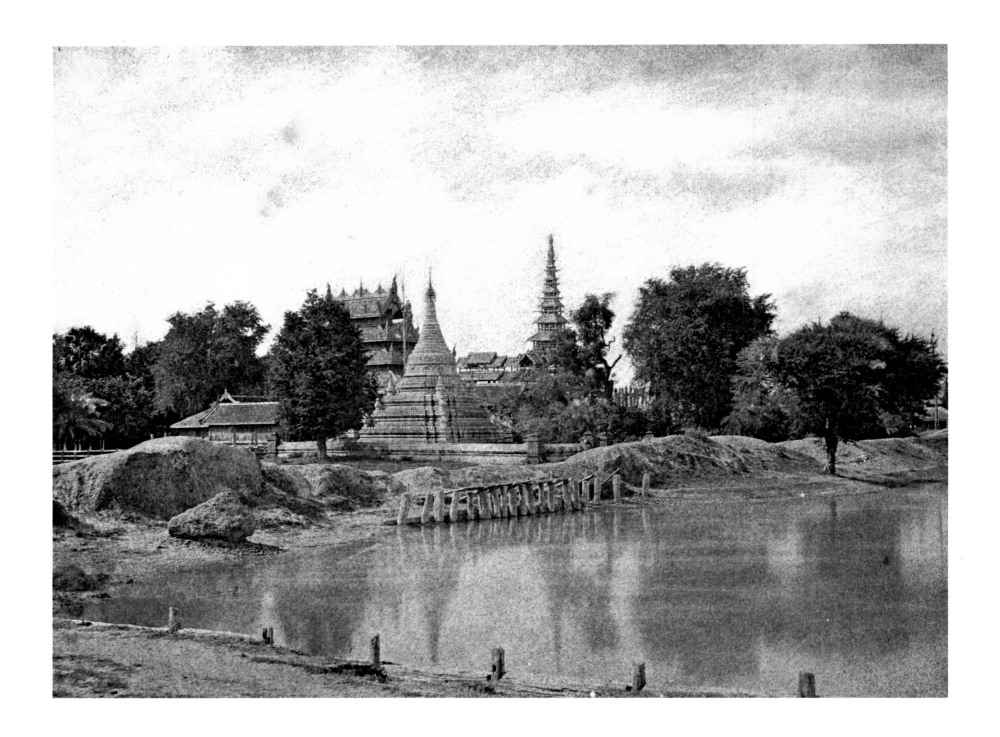

[85] LINNAEUS TRIPE. AMARAPOORA, BURMA, 1855.

[86] LINNAEUS TRIPE. SOUTH FACADE, RAJRAJESVARA TEMPLE, TANJORE, PUBLISHED 1858.

[87] W.H. PIGOU. TEMPLE, CHITRADURGA, INDIA, NEGATIVE 1857–1859; PUBLISHED 1866.

[88] FELICE BEATO. TOMB OF ILTUTMISH, DELHI, 1858.

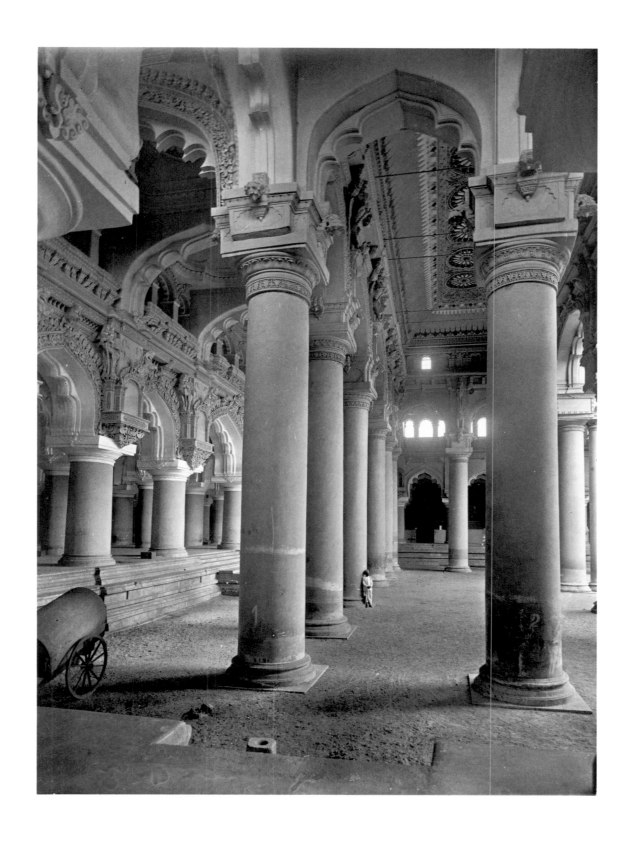

[89] P.A. JOHNSTON. TIRUMALA NAYAK'S PALACE, MADURA, 1880S.

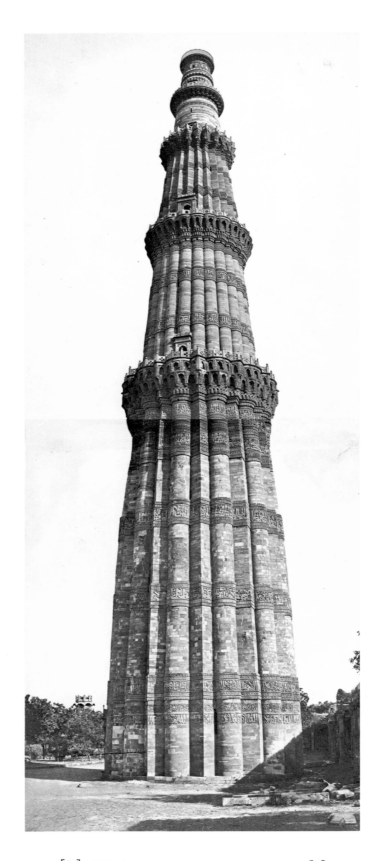

[90] FELICE BEATO. QUTB MINAR, DELHI, 1858.

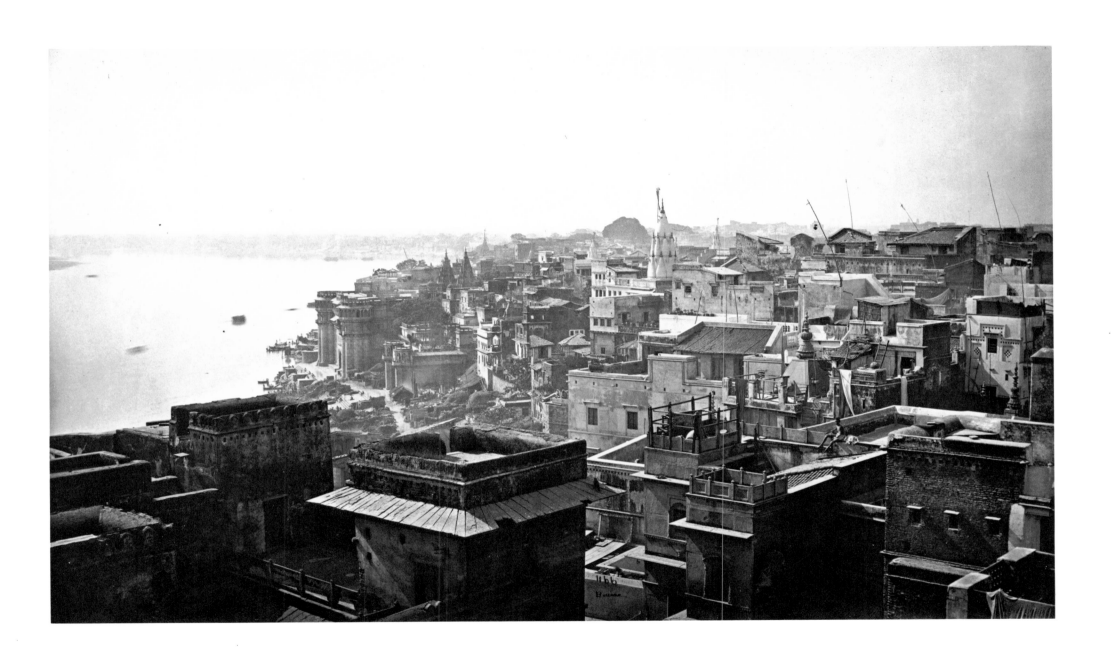

[91] SAMUEL BOURNE. VIEW OVER THE GANGES RIVER, VARANASI, 1867–1868.

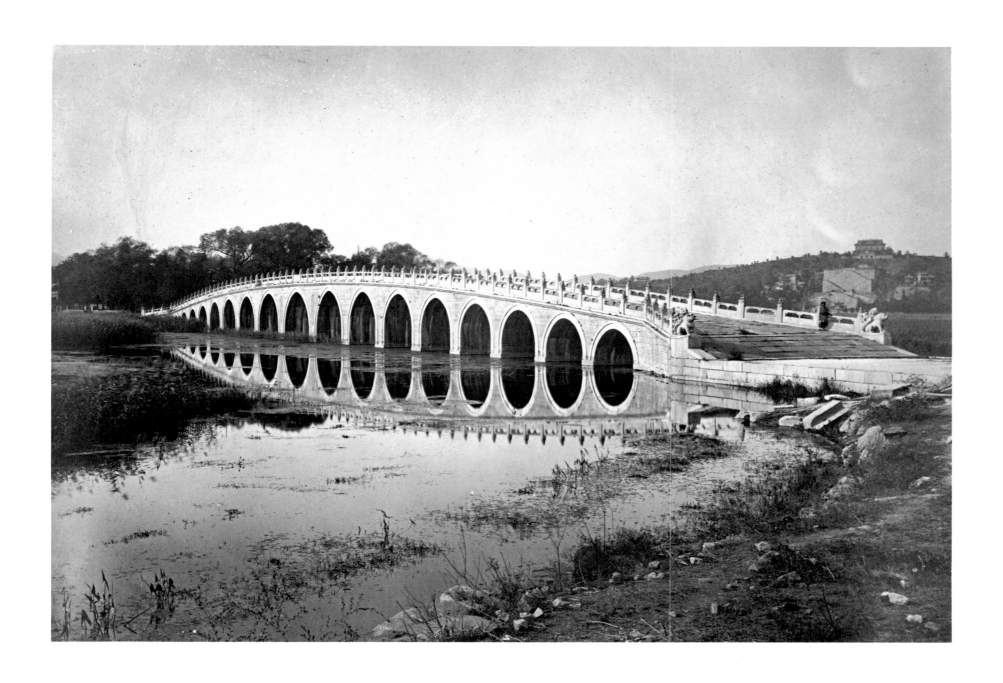

[92] JOHN THOMSON. THE SEVENTEEN-ARCH BRIDGE, YUAN MING YUAN, PEKING, 1870–1872.

[93] JOHN THOMSON. HUNTING GROUND, YUAN MING YUAN, PEKING, 1870–1872.

[94] JOHN THOMSON. THE BRONZE TEMPLE, WAN SHOW SHAN, YUAN MING YUAN, PEKING, 1870–1872.

[95] CHARLES LEANDER WEED. RIVER VIEW, NAGASAKI, 1867.

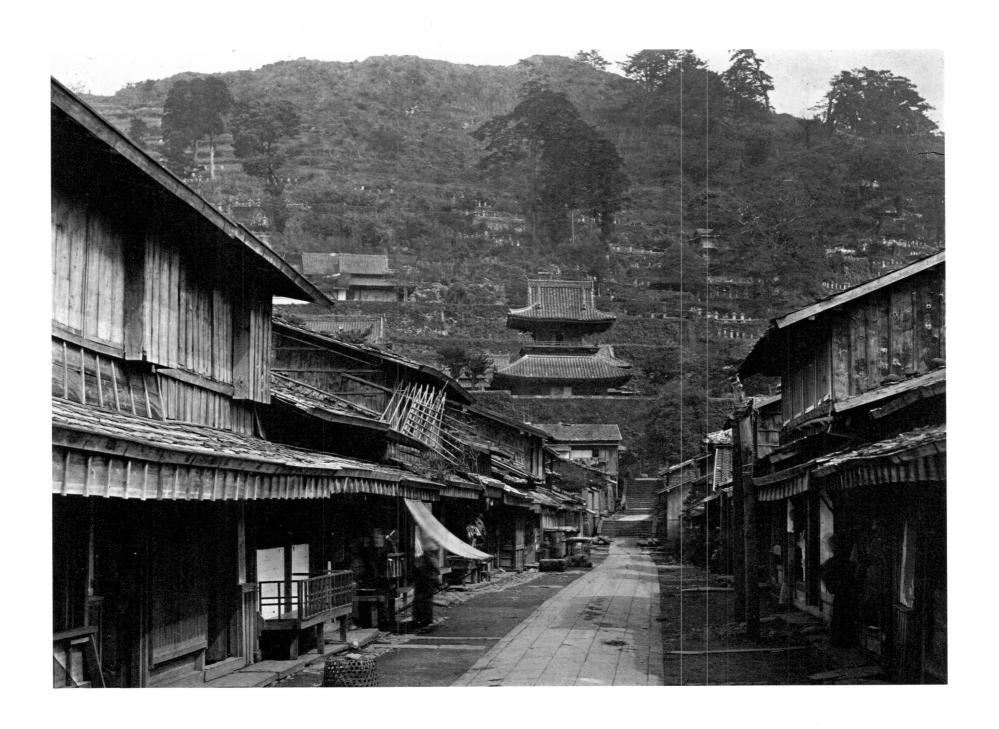

[96] FELICE BEATO. BUDDHIST TEMPLE AND CEMETERY, NAGASAKI, 1864–1865.

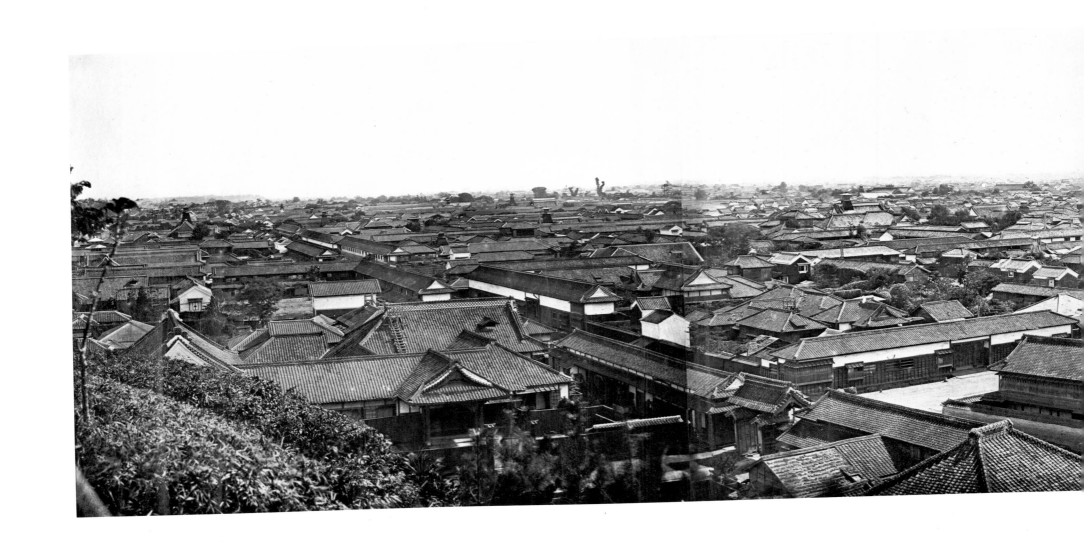

[97] FELICE BEATO. DAIMYO COMPOUND, TOKYO, 1865–1866.

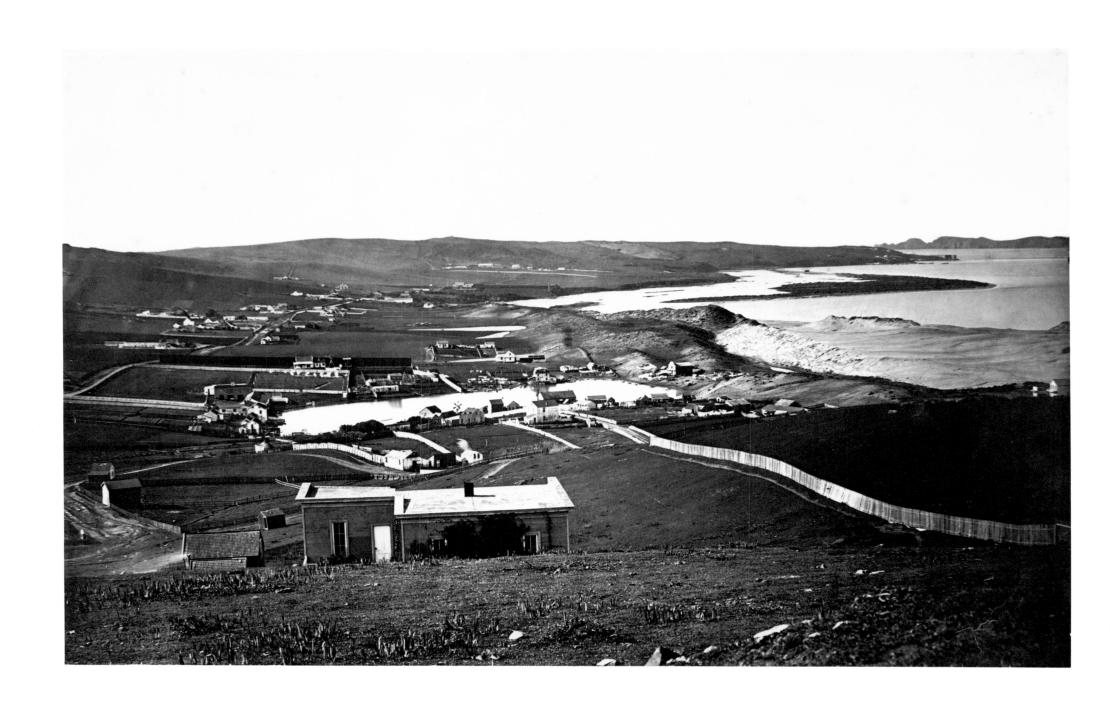

[99] CARLETON E. WATKINS. WASHERWOMAN'S BAY, SAN FRANCISCO, 1858 (?).

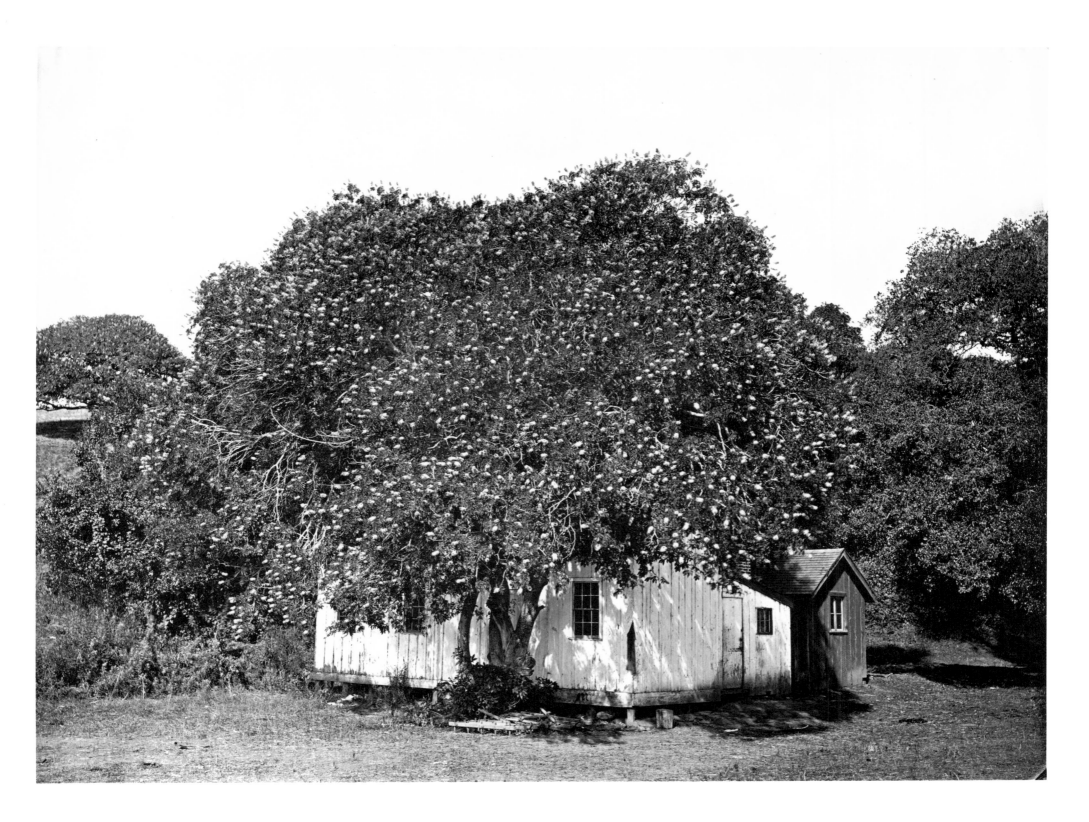

[98] CARLETON E. WATKINS. BUCKEYE TREE, CALIFORNIA, CA. 1870.

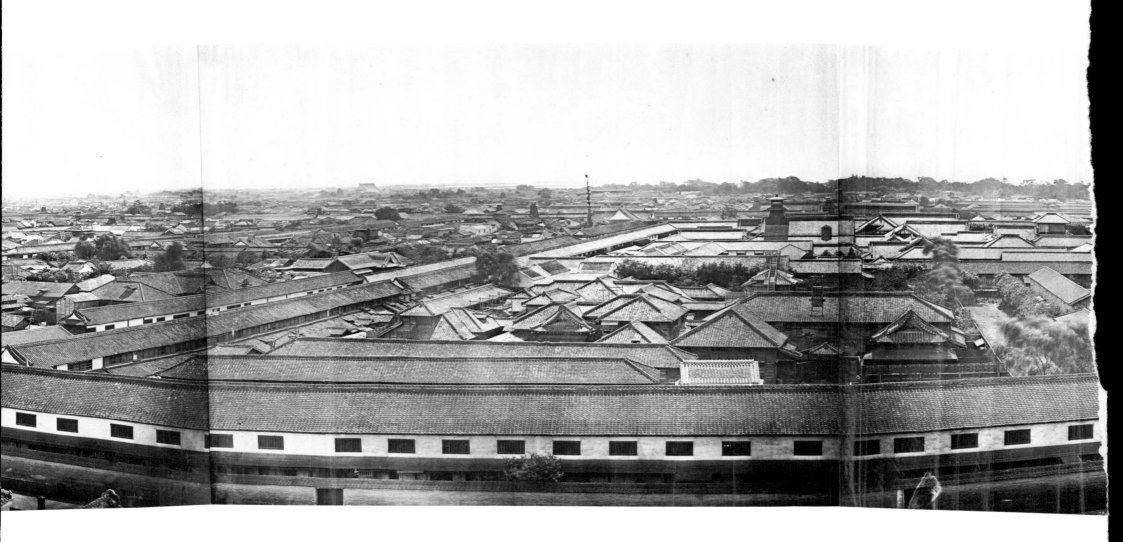

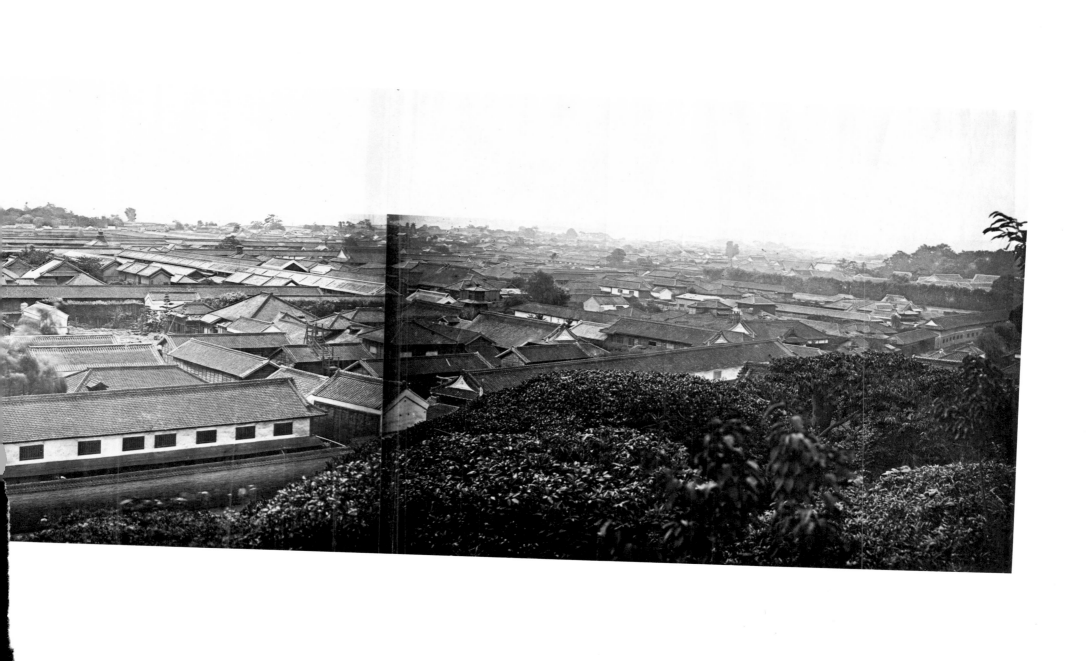

[100] ANONYMOUS. MARKET STREET, BETWEEN 15TH AND 16TH STREETS, DENVER, 1865.

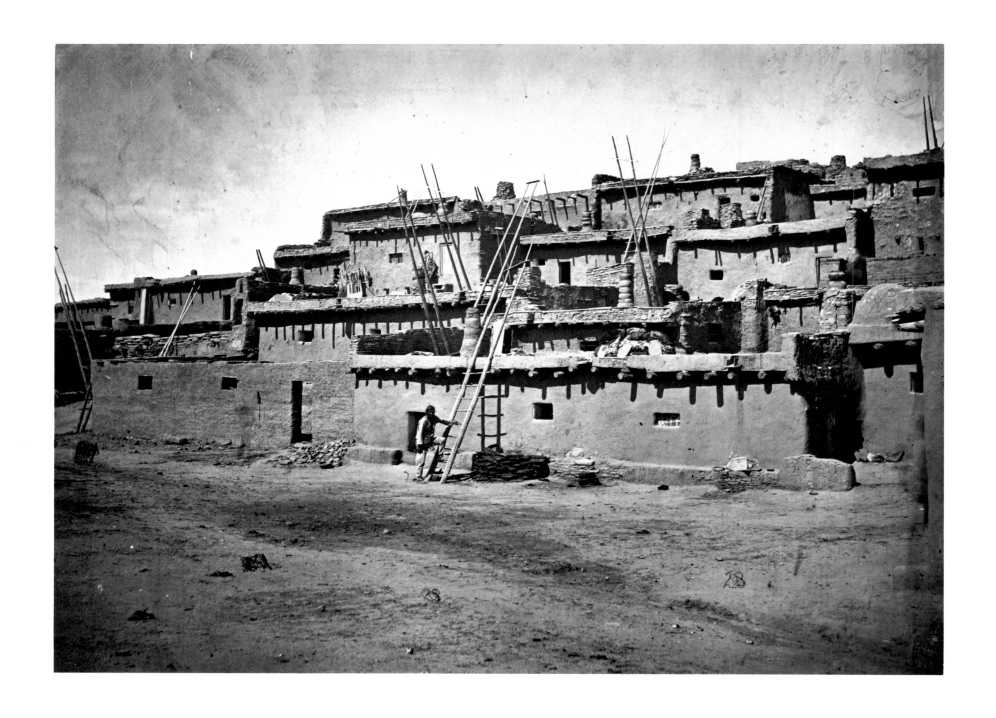

[101] TIMOTHY H. O'SULLIVAN. ZUNI PUEBLO, MCKINLEY COUNTY, NEW MEXICO, 1873.

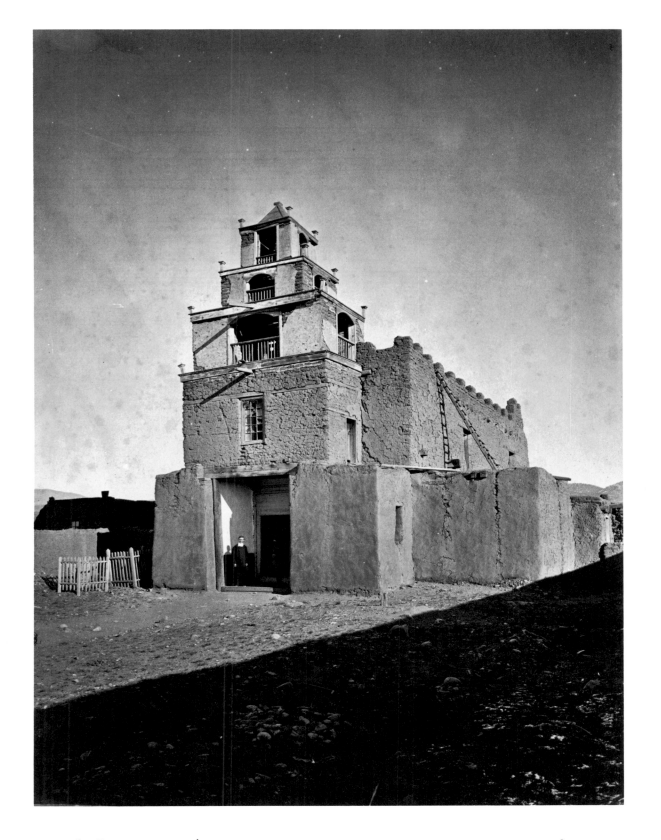

[102] TIMOTHY H. O'SULLIVAN. CHURCH OF SAN MIGUEL, SANTA FE, NEW MEXICO, 1873.

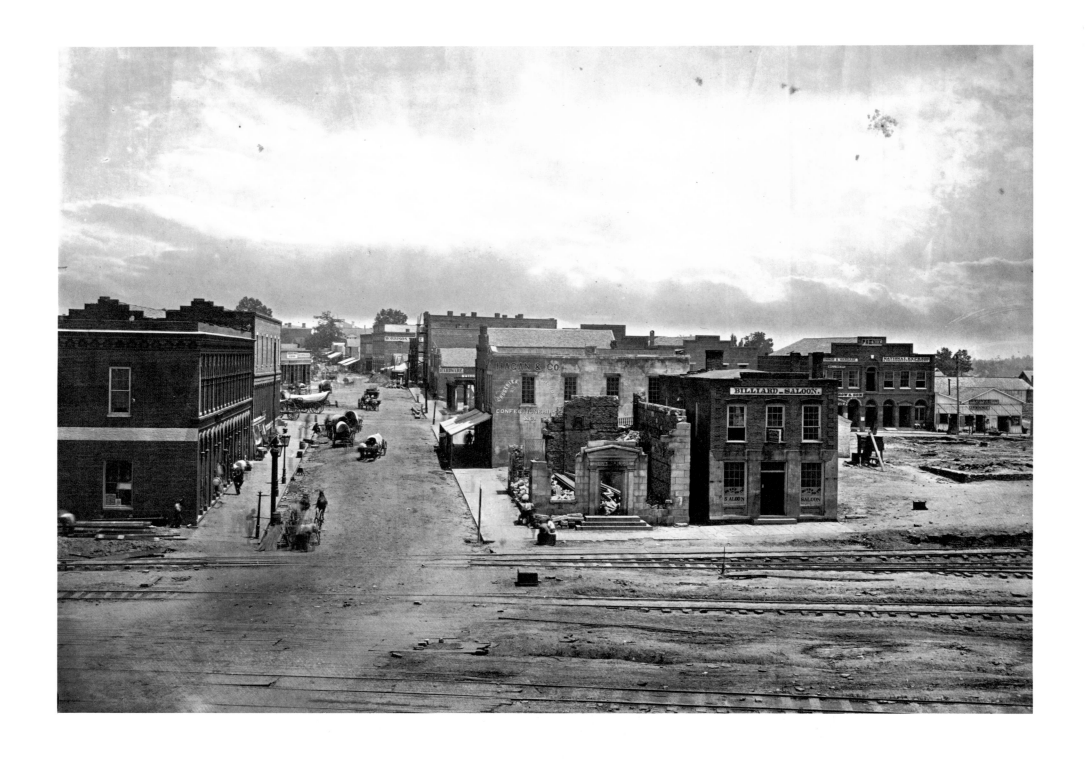

[103] GEORGE N. BARNARD. ATLANTA, GEORGIA, AFTER SHERMAN'S MARCH, 1864.

[104] GEORGE N. BARNARD. VIEW FROM THE CAPITOL, NASHVILLE, TENNESSEE, 1863.

[105] LEWIS EMORY WALKER. CONSTRUCTION OF THE SOUTH WING, DEPARTMENT OF THE TREASURY, WASHINGTON, D.C., 1861.

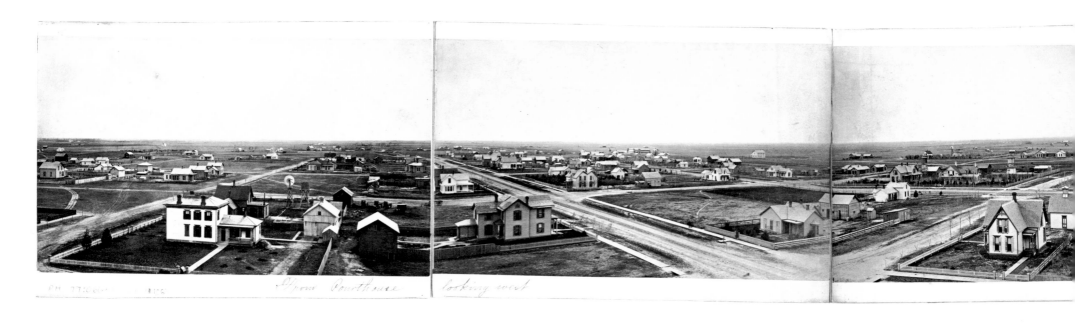

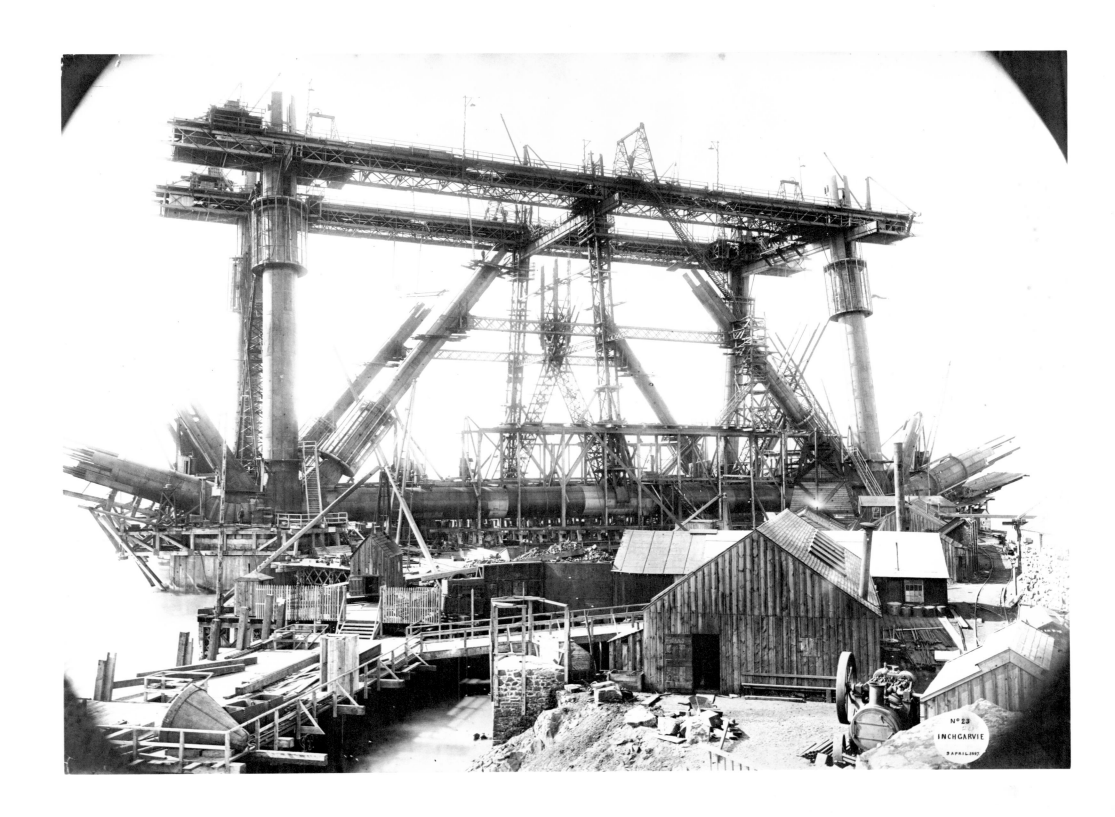

[109] ANONYMOUS. PIER UNDER CONSTRUCTION, INCHGARVIE, FORTH BRIDGE, 1887.

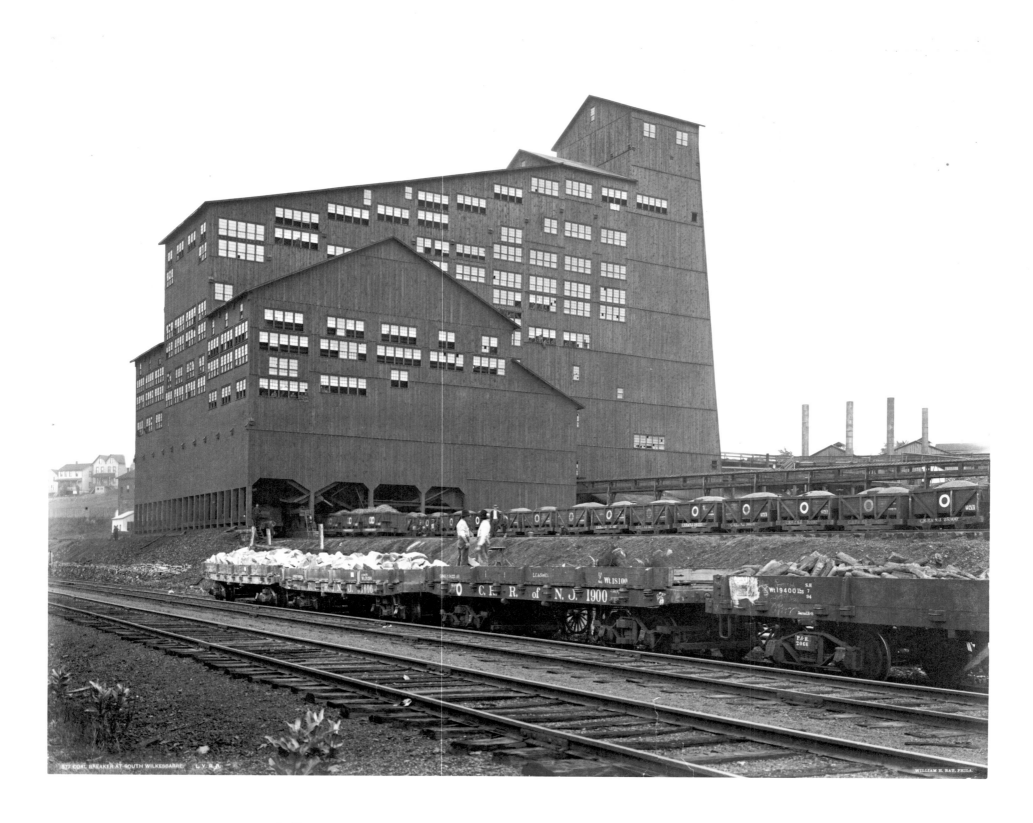

[108] WILLIAM H. RAU. COAL BREAKER, WILKES-BARRE, PENNSYLVANIA, LATE 1890S.

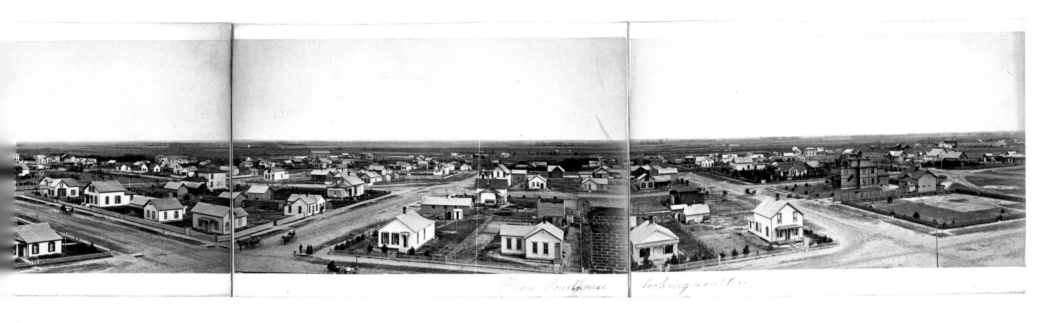

From Courthouse looking south

Opera House Himmel & Platt S. D. Banking Co. Hilbert & Noble Public School (north side)

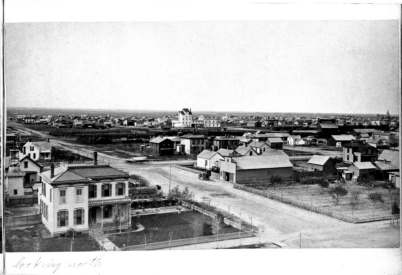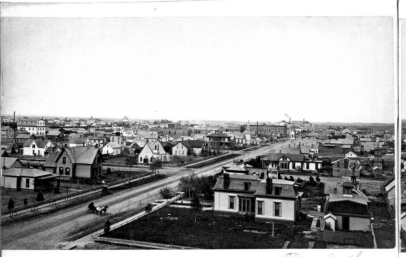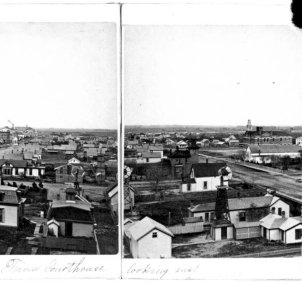

From Courthouse *looking north* *From Courthouse* *looking east* *Courthouse*

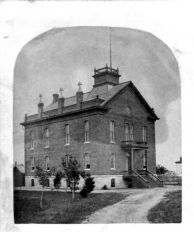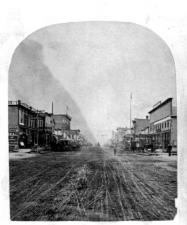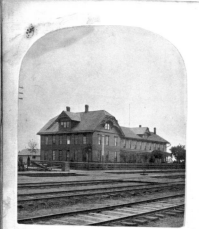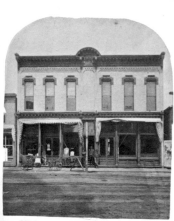

National Bank *Courthouse* *3rd St. looking east* *U. P. R. R. Hotel* *U. P. Shops* *1st National Bank*

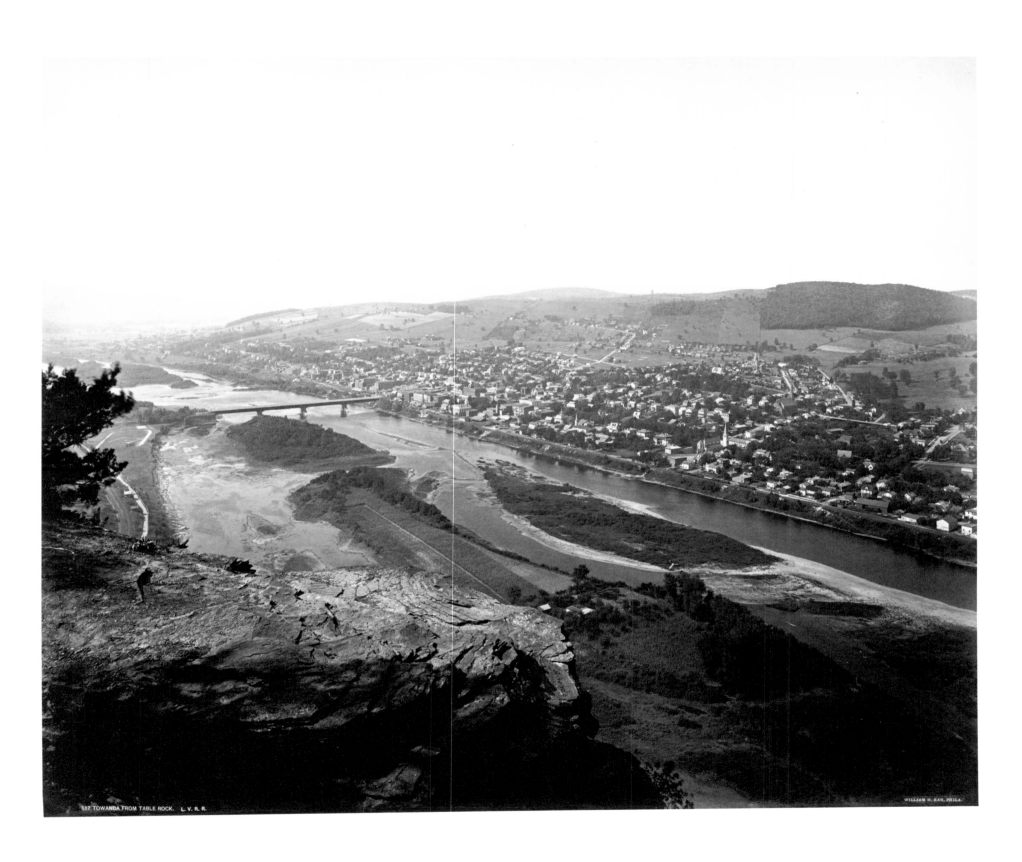

[107] WILLIAM H. RAU. TOWANDA, PENNSYLVANIA, FROM TABLE ROCK, LATE 1890S.

[110] EDOUARD DURANDELLE. HYDRAULIC APPARATUS, FOUNDRY, BIACHE SAINT-VAAST, PAS-DE-CALAIS, 1870S (?).

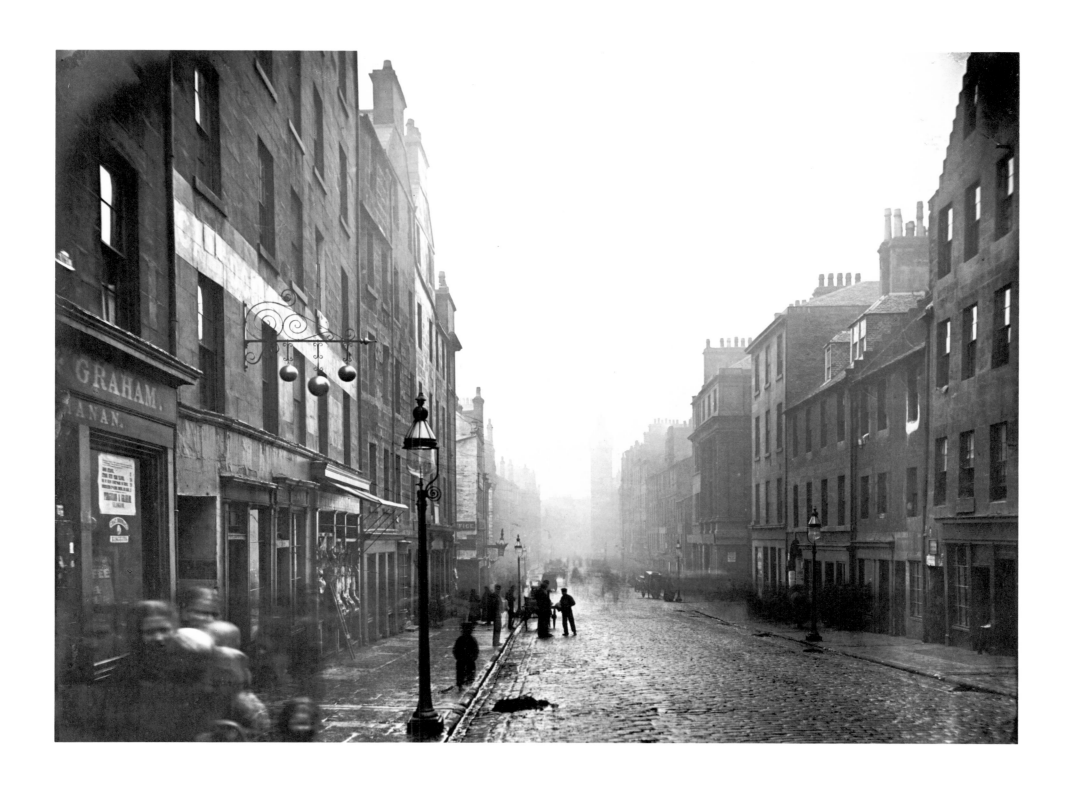

[111] THOMAS ANNAN. HIGH STREET, GLASGOW, PUBLISHED 1878 or 1879.

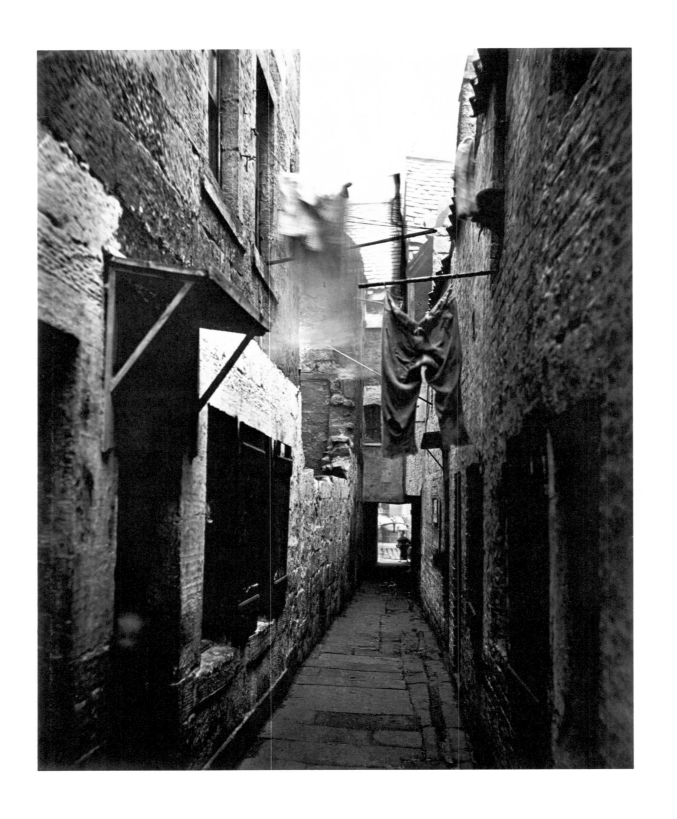

[112] THOMAS ANNAN. CLOSE, 101 HIGH STREET, GLASGOW, PUBLISHED 1878 OR 1879.

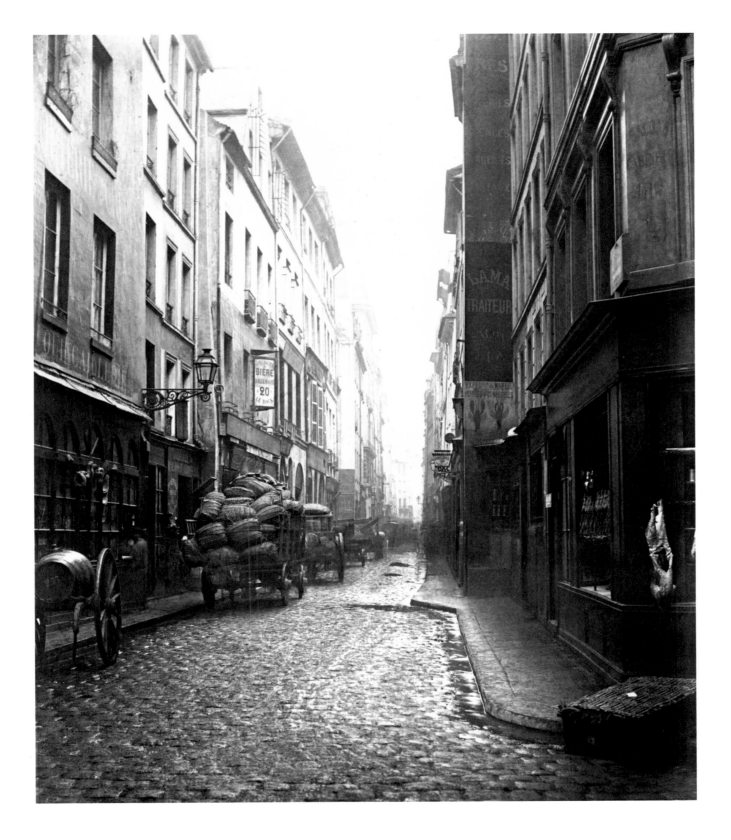

[113] CHARLES MARVILLE. RUE DE LA GRANDE TRUANDERIE FROM RUE MONTORGUEIL, PARIS, 1862–1865.

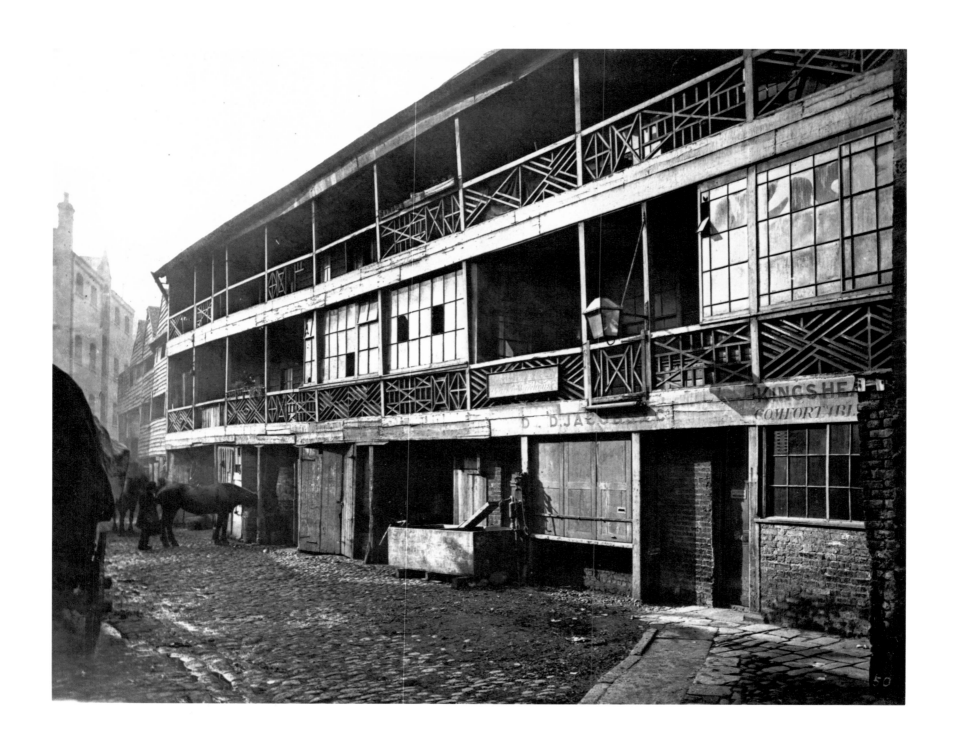

[114] HENRY AND T.J. DIXON. KING'S HEAD INN YARD, SOUTHWARK, LONDON, PUBLISHED 1881.

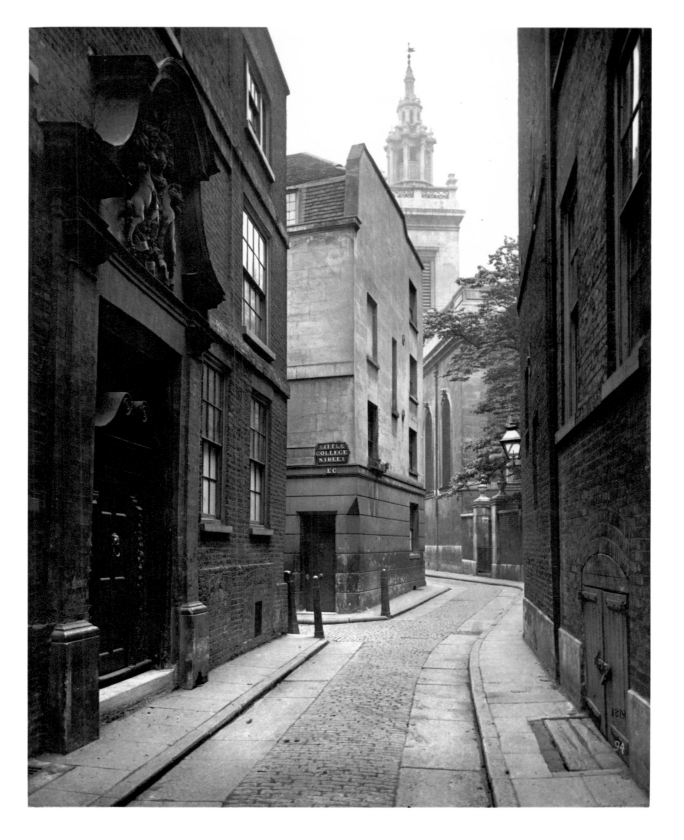

[115] HENRY AND T.J. DIXON. COLLEGE STREET WITH CHURCH OF ST. MICHAEL PATERNOSTER ROYAL, LONDON, NEGATIVE 1879; PUBLISHED 1884.

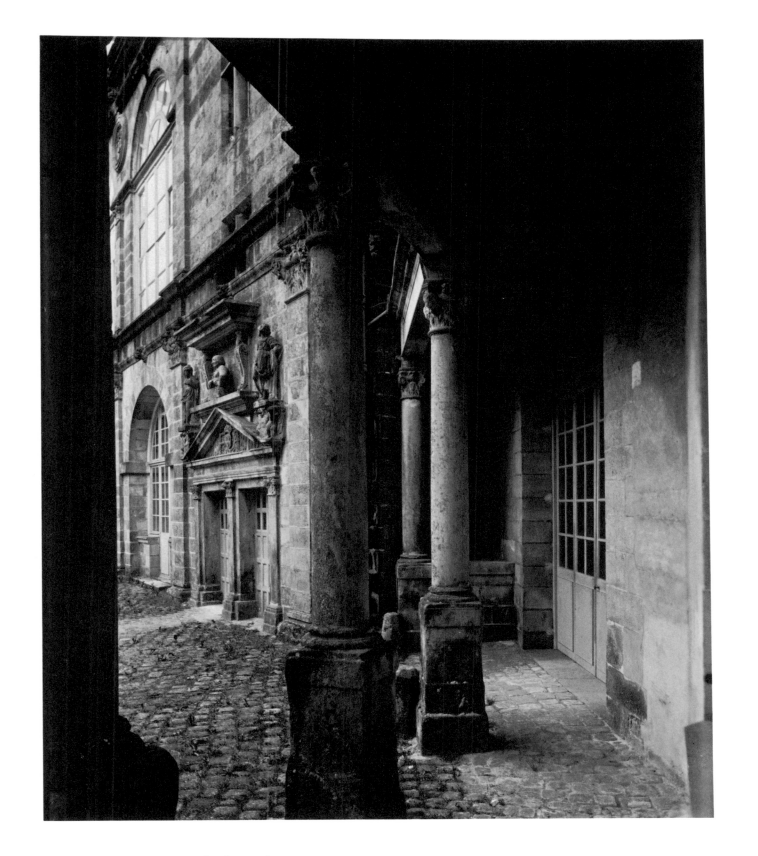

[116] EUGÈNE ATGET. OVAL COURT, FONTAINEBLEAU, 1903.

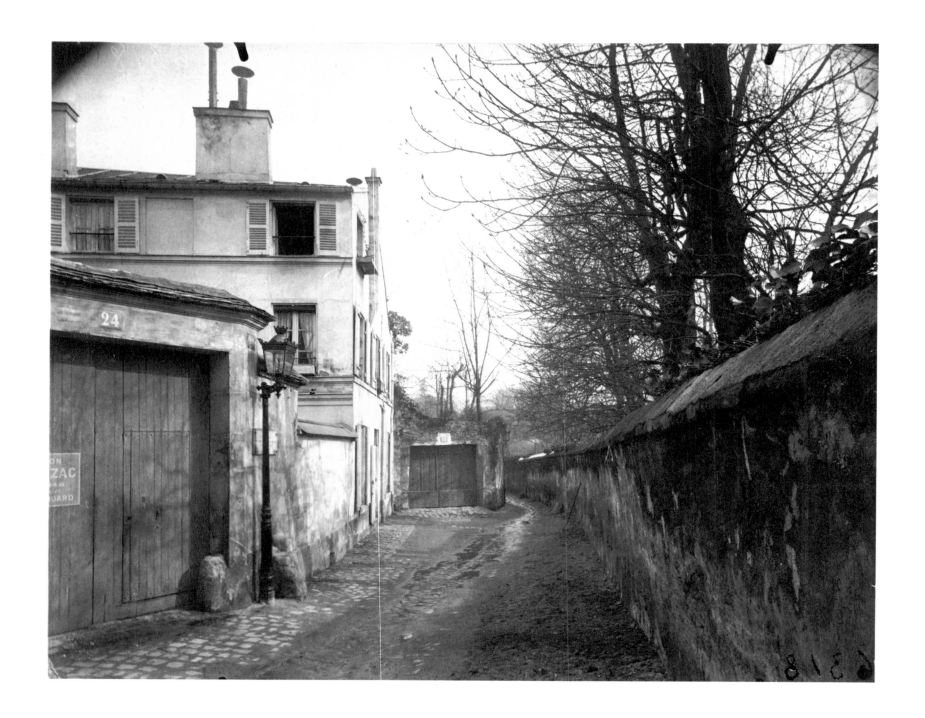

[117] EUGÈNE ATGET. MAISON DE BALZAC, RUE BERTON, PARIS, 1922.

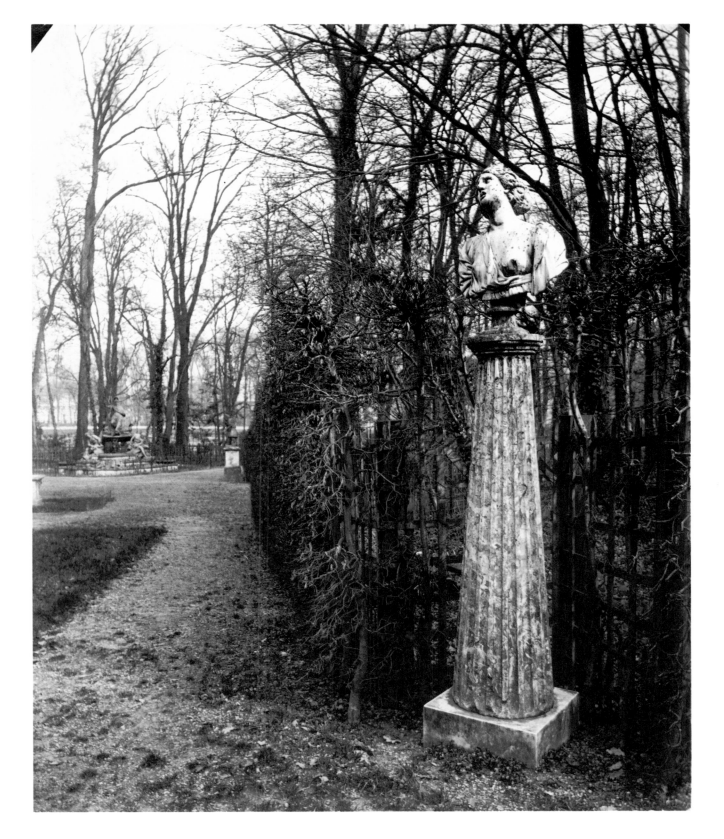

[118] EUGÈNE ATGET. ARBOR OF THE TRIUMPHAL ARCH, VERSAILLES, 1906.

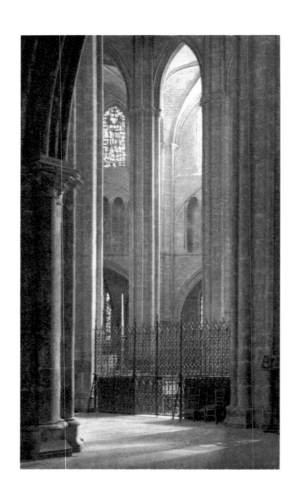

[119] FREDERICK H. EVANS. INTERIOR VIEW, BOURGES CATHEDRAL, 1900.

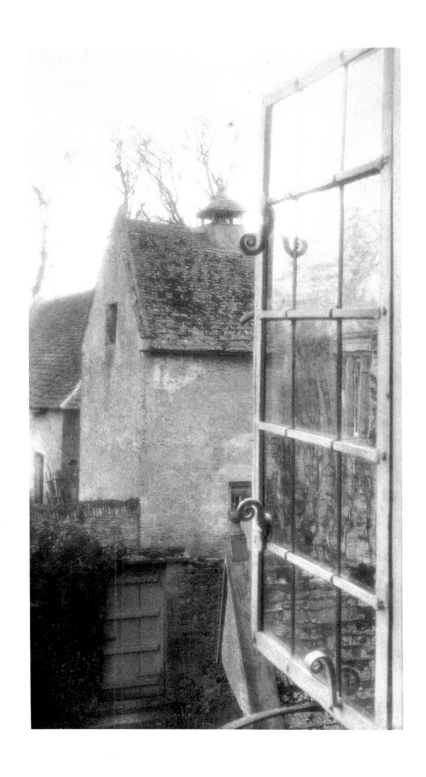

[120] FREDERICK H. EVANS. VIEW FROM THE TAPESTRY ROOM, KELMSCOTT MANOR, OXFORDSHIRE, 1896.

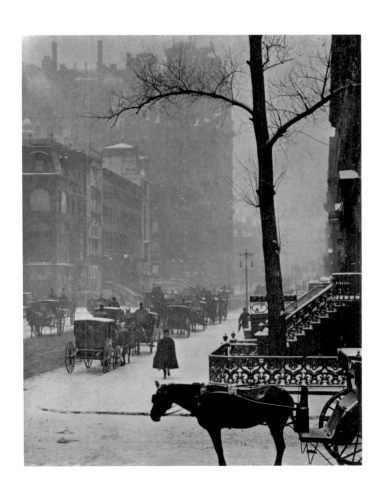

[121] ALFRED STIEGLITZ. THIRTIETH STREET AND FIFTH AVENUE (?), NEW YORK CITY, NEGATIVE 1899; PRINTED 1932 (?).

[122] DRAHOMIR JOSEPH RUZICKA. SINGER AND WOOLWORTH BUILDINGS, BROADWAY, NEW YORK CITY, AFTER 1913.

[123] ALFRED STIEGLITZ. NEW YORK CITY, 1910.

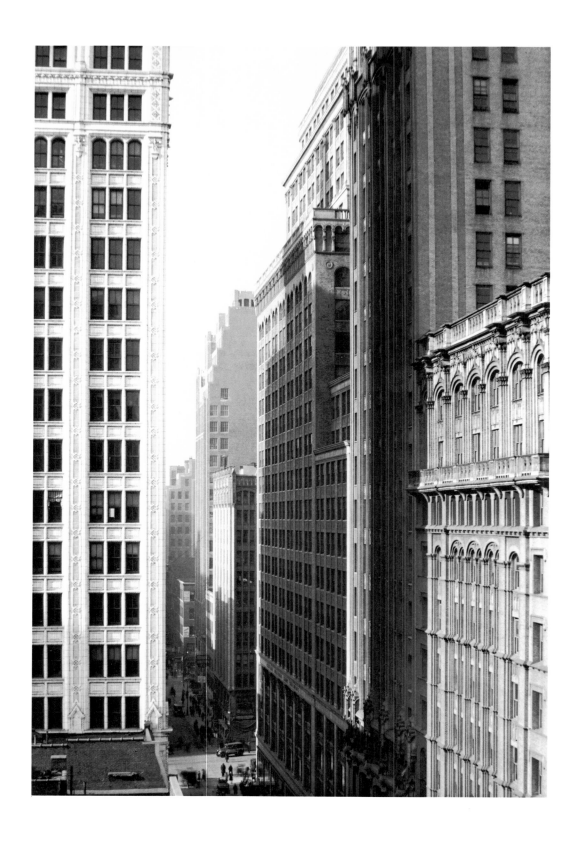

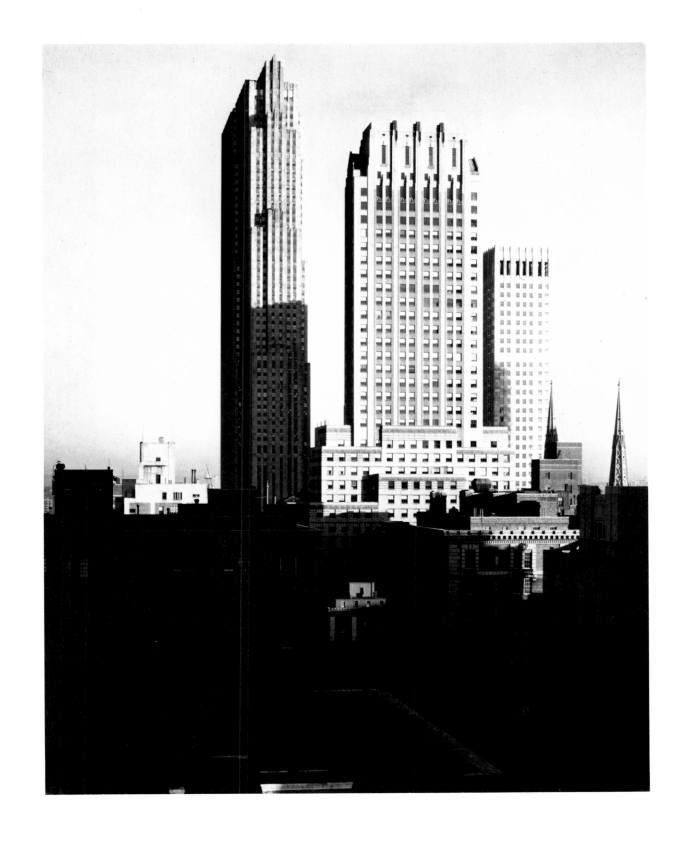

[125] ALFRED STIEGLITZ. ROCKEFELLER CENTER FROM THE SHELTON HOTEL, NEW YORK CITY, 1935.

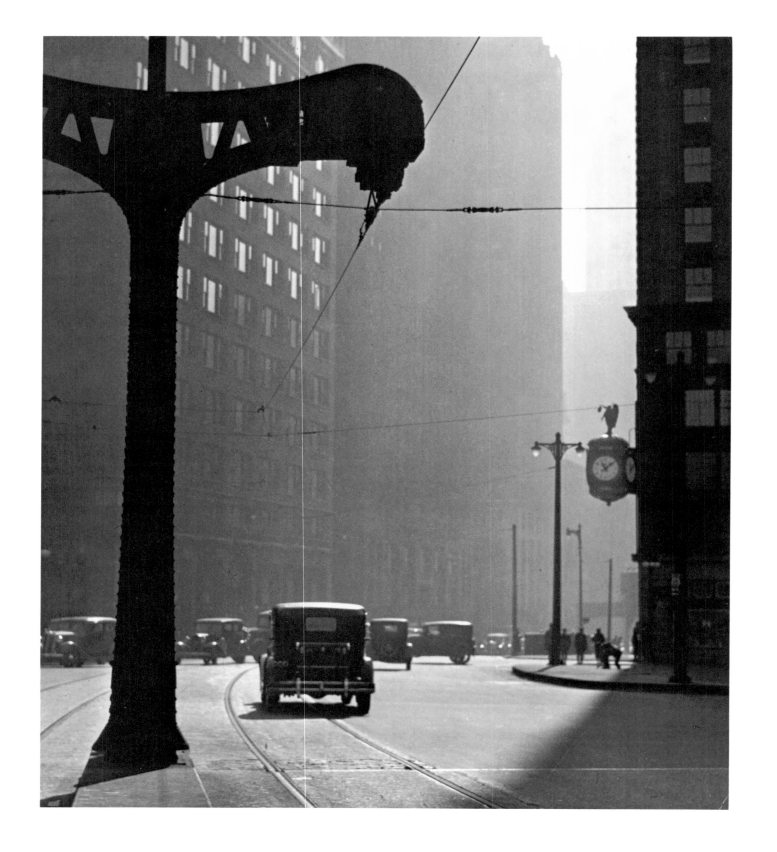

[126] LANGDON H. LONGWELL. WABASH AVENUE AND WACKER DRIVE, CHICAGO, 1920s (?).

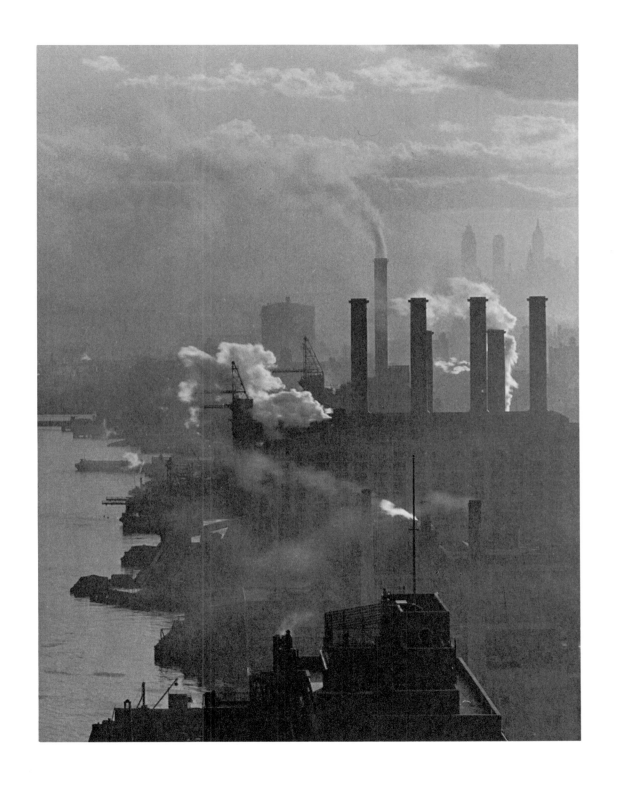

[127] SAMUEL H. GOTTSCHO. MANHATTAN AND THE EAST RIVER, 1931.

[128] MARGARET BOURKE-WHITE. VIEW FROM THE TERMINAL TOWER, CLEVELAND, OHIO, 1928.

[129] SAMUEL H. GOTTSCHO. VIEW FROM THE RAINBOW ROOM, RCA BUILDING, NEW YORK CITY, 1934.

[130] FAY STURTEVANT LINCOLN. MAIN BANKING ROOM, IRVING TRUST COMPANY, NEW YORK CITY, 1932 (?).

[131] EDWARD STEICHEN. EMPIRE STATE BUILDING, NEW YORK CITY, 1932.

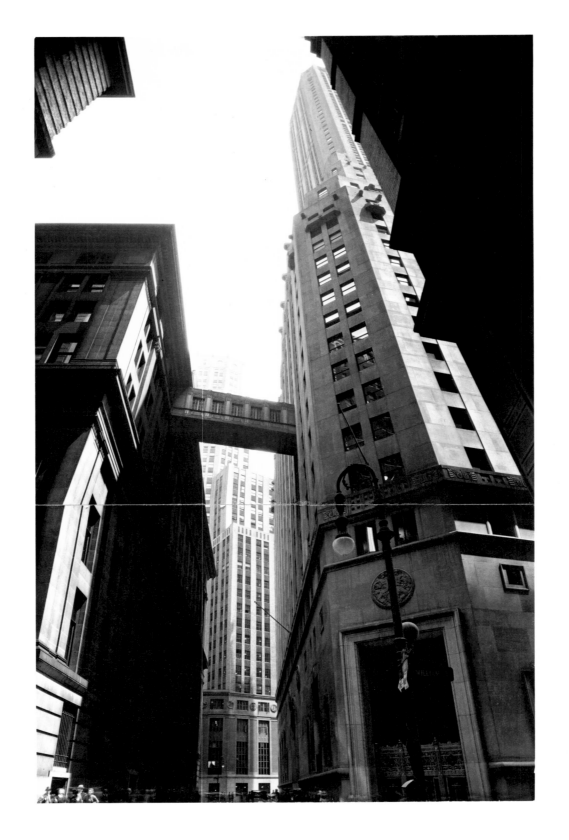

[132] BERENICE ABBOTT. EXCHANGE PLACE, NEW YORK CITY, 1936.

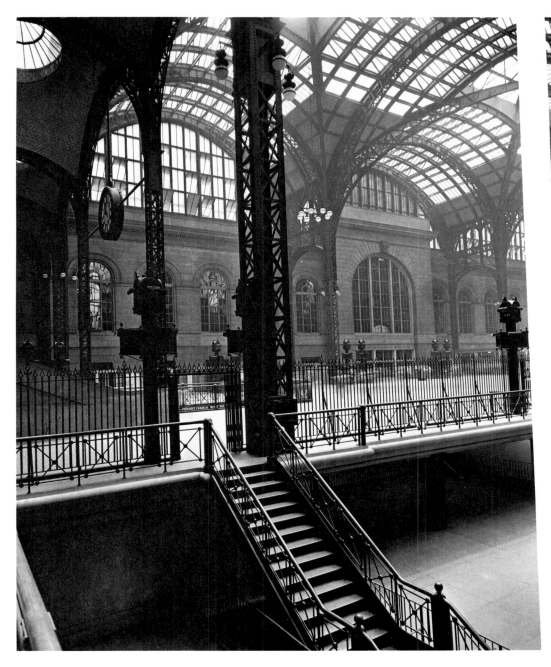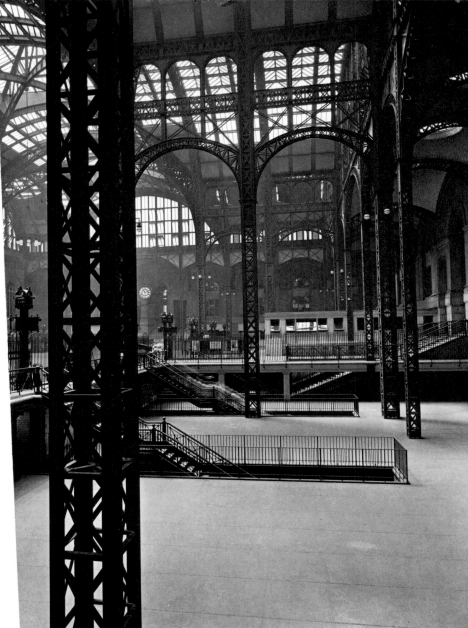

[133] BERENICE ABBOTT. INTERIOR, PENNSYLVANIA STATION, NEW YORK CITY, CA. 1937.

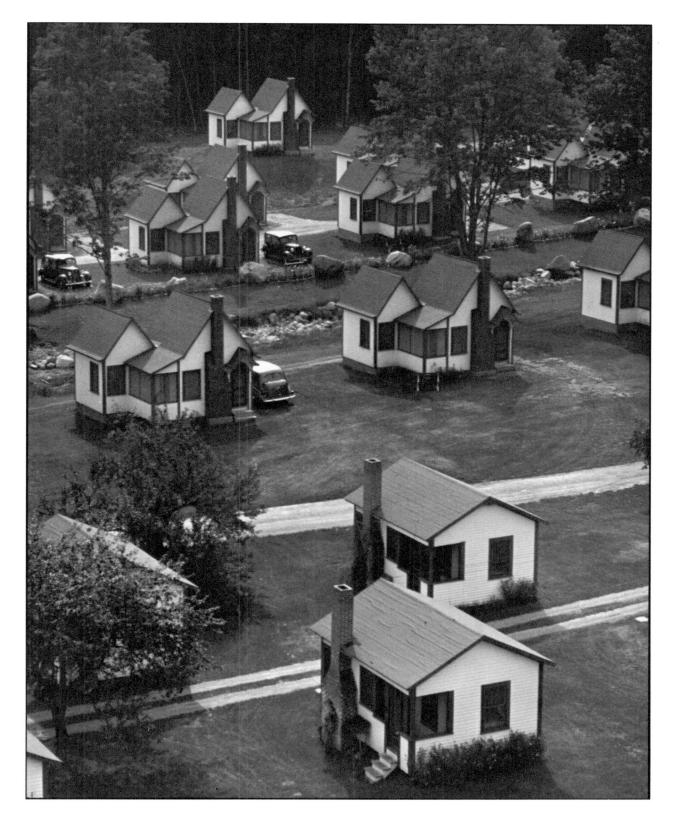

[134] FRANK NAVARA. RENTAL CABINS NEAR WOODSTOCK, NEW HAMPSHIRE, 1935.

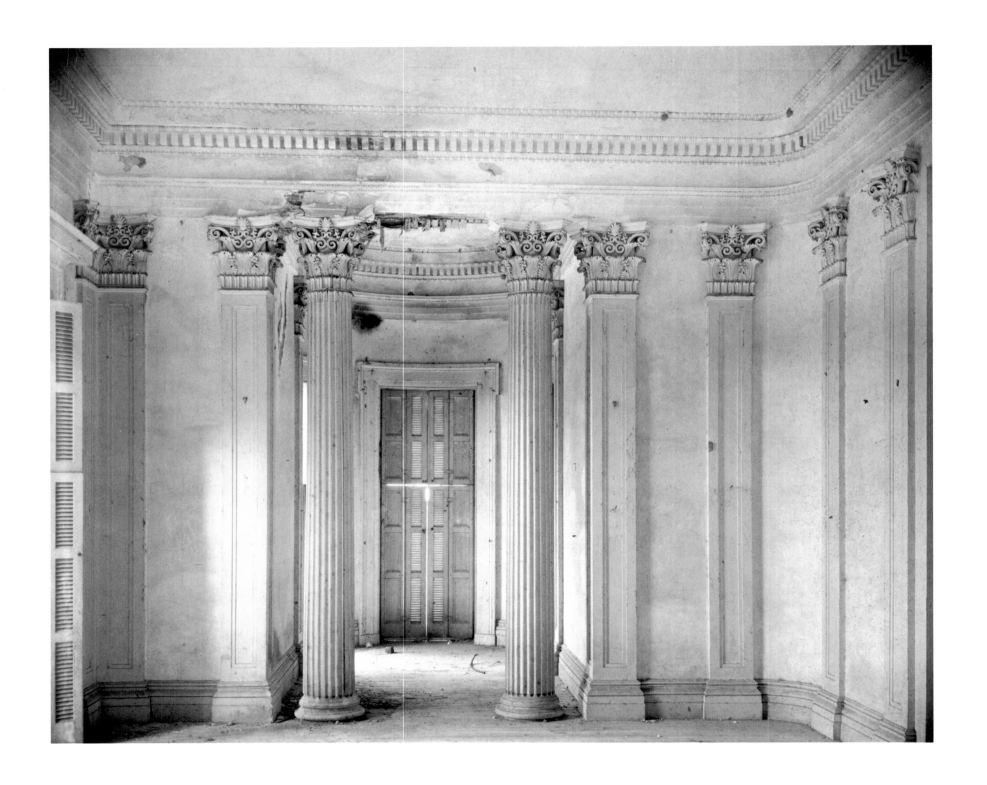

[135] WALKER EVANS. DRAWING ROOM, BELLE GROVE PLANTATION, IBERVILLE PARISH, LOUISIANA, 1935.

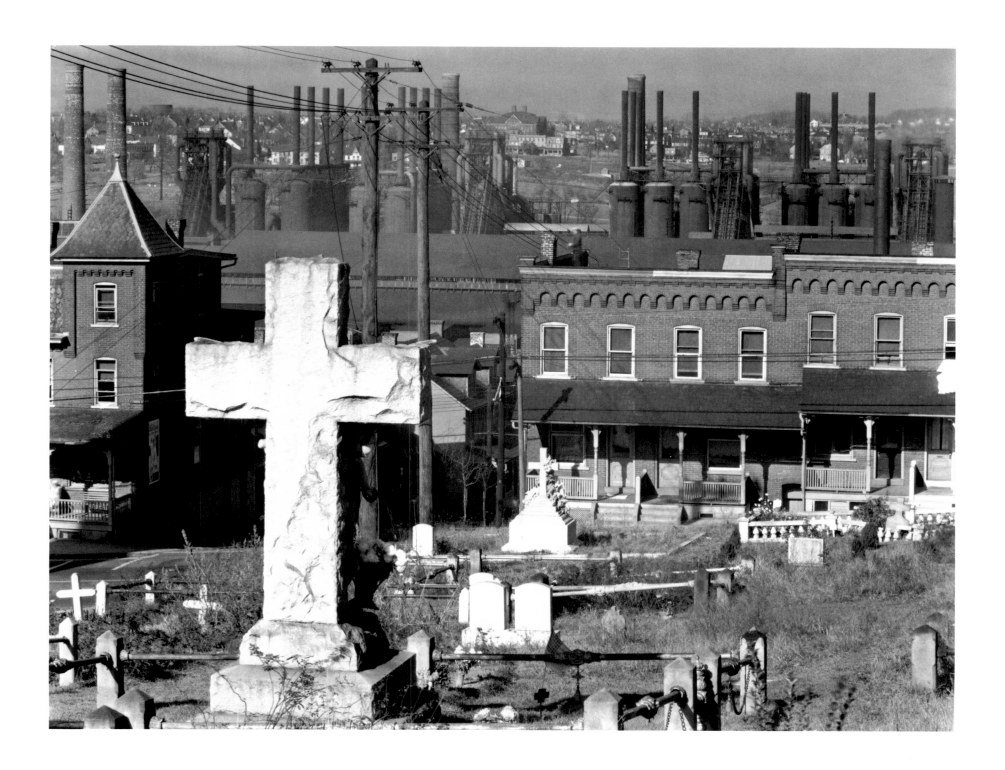

[136] WALKER EVANS. BETHLEHEM, PENNSYLVANIA, 1935.

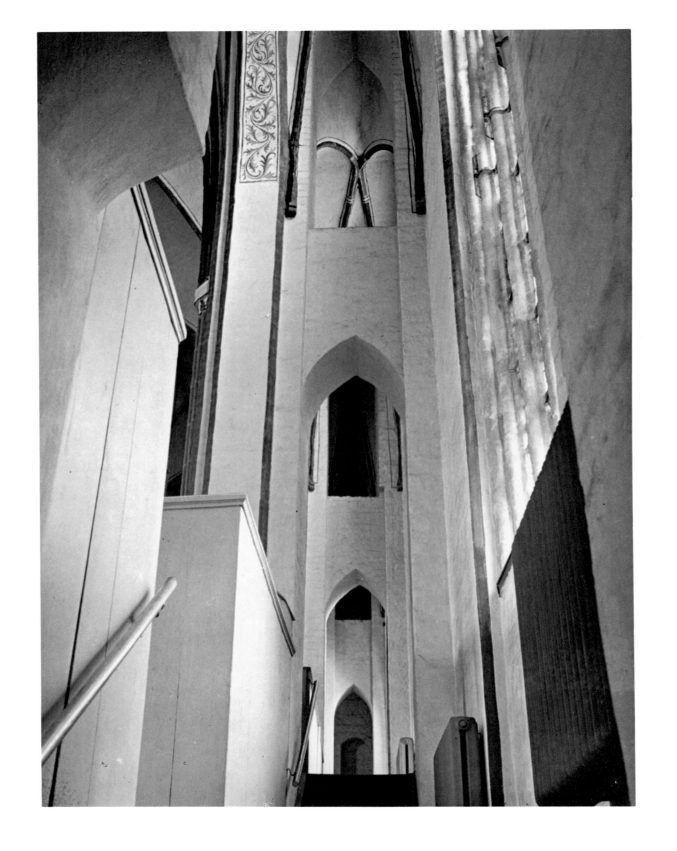

[137] ALBERT RENGER-PATZSCH. SOUTH AISLE, CHURCH OF ST. KATHARINE, BRANDENBURG, PUBLISHED 1930.

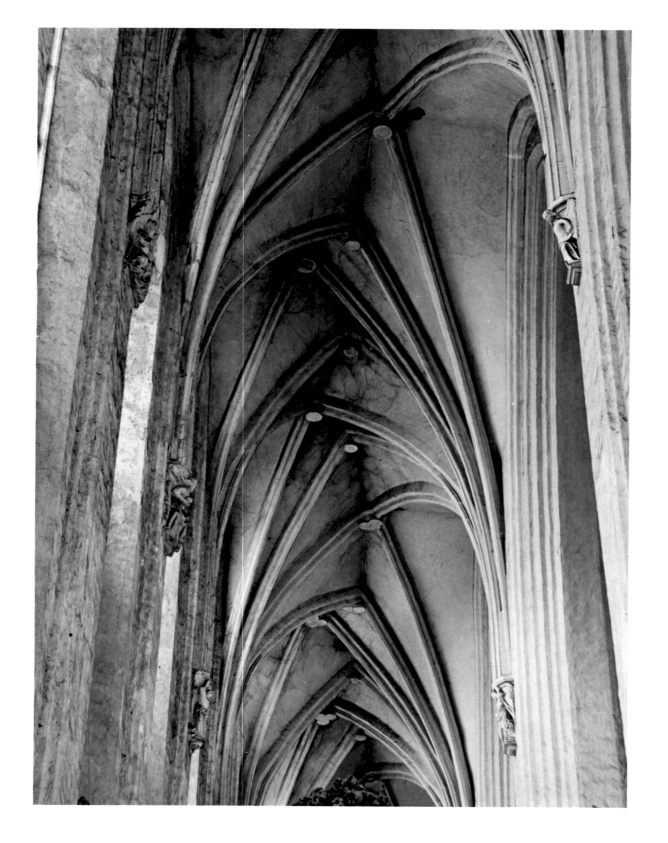

[138] ALBERT RENGER-PATZSCH. SOUTH AISLE, CHURCH OF ST. MARIA AUF DEM SANDE, WROCLAW, POLAND, PUBLISHED 1930.

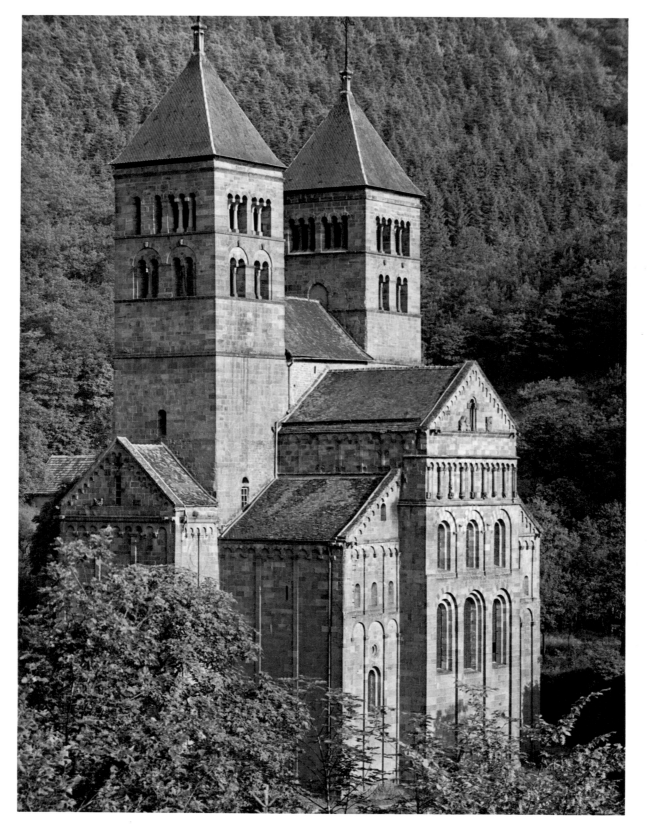

[139] ALBERT RENGER-PATZSCH. TOWERS AND EAST FRONT, ABBEY, MURBACH, ALSACE, LATE 1930S.

[140] AUGUST SANDER. ROOFTOPS WITH COLOGNE CATHEDRAL, 1930S.

[141] AUGUST SANDER. ANDERNACH AND THE RHINE RIVER FROM THE KRANENBERG, 1930S.

[142] FRITZ HENLE. COOLING TOWERS, DORTMUND, 1929.

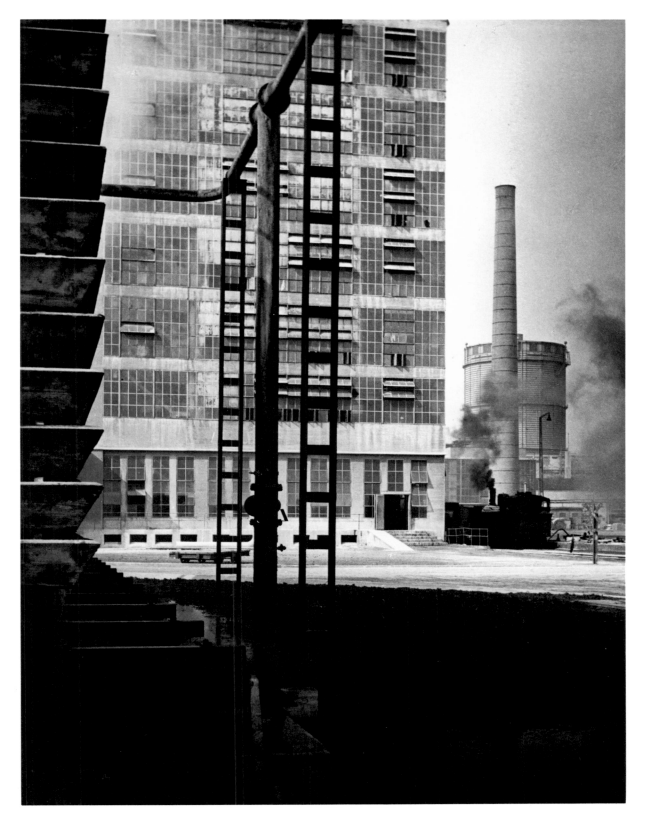

[143] WERNER MANTZ. S.B.B. GELEEN INDUSTRIAL SITE, THE NETHERLANDS, 1937–1938.

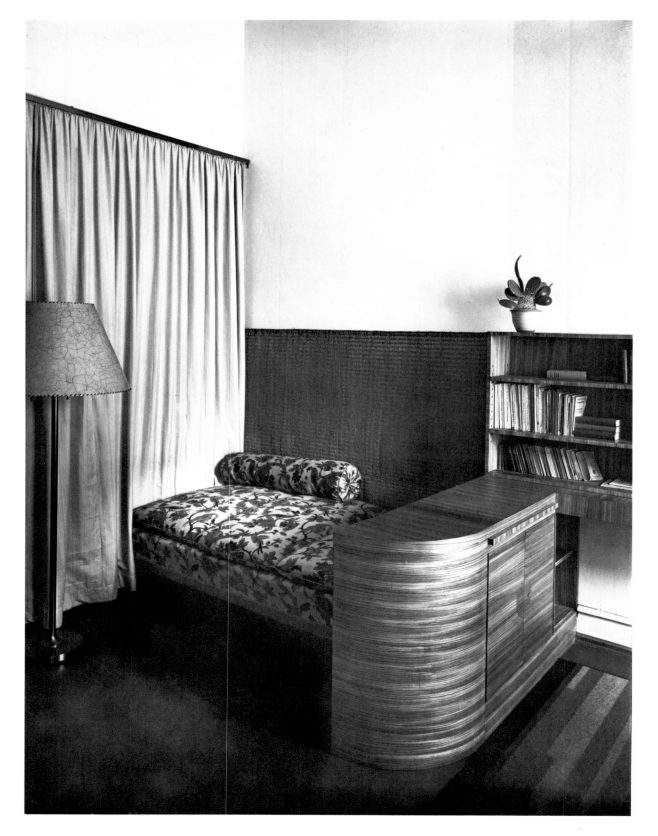

[144] AUGUST SANDER. APARTMENT OF DR. LEHMANN, DRESDEN. 1929 OR 1930.

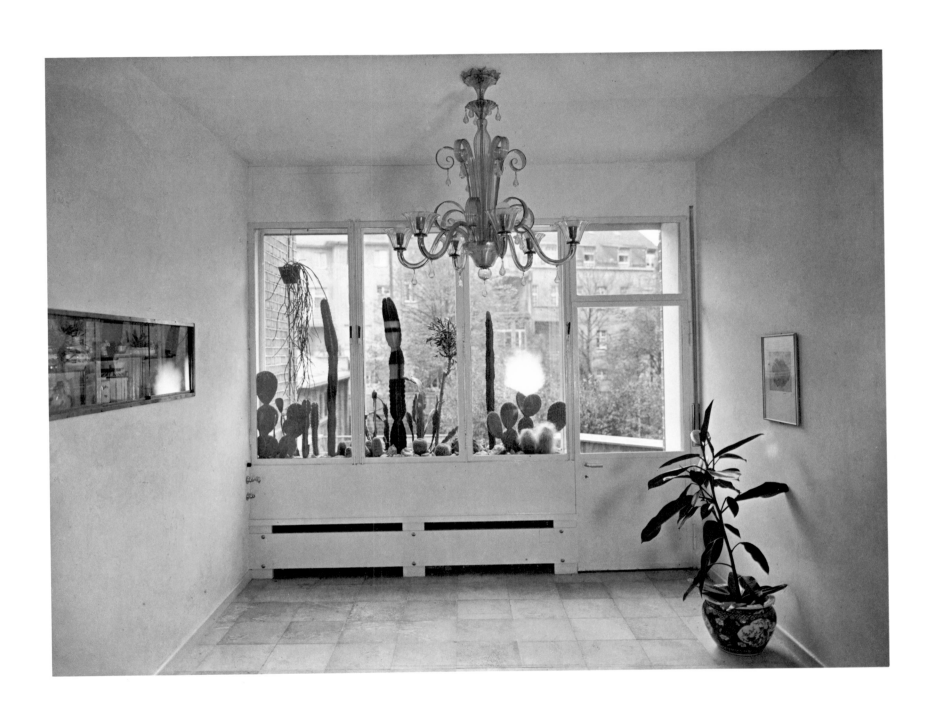

[145] WERNER MANTZ. VILLA, MARIENBURG, COLOGNE, 1928.

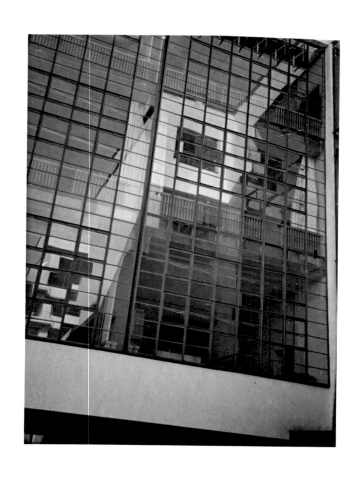

[146] T. LUX FEININGER. CURTAIN WALL, WORKSHOP BUILDING, BAUHAUS, DESSAU, LATE 1920S.

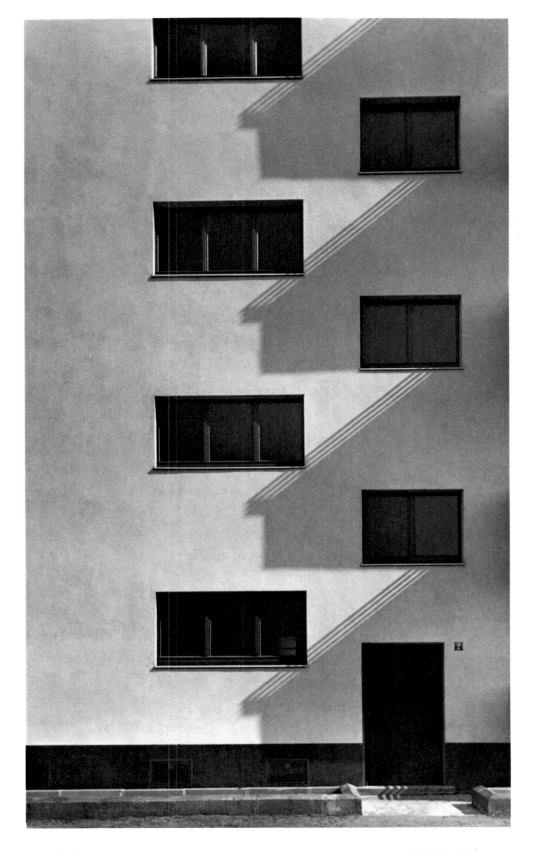

[147] WERNER MANTZ. APARTMENT HOUSE, KALKERFELD, COLOGNE, 1928.

CATALOG

THESE NOTES follow the order of the plates. A biography precedes the first example of work by that photographer. When a photographer's pictures do not follow immediately, other plates are listed following the biography. Technical information about each picture precedes each entry. When the same negative has been used to provide an image for an album, portfolio, or publication, its use is recorded with the technical information at the beginning of an entry. Due to the often individual nature of nineteenth-century books, however, it is not always possible to know whether a particular image has actually been removed from a volume or was, in fact, never included in one. In measurements, height precedes width. In both biographies and entries, citations are provided for all direct sources except Helmut and Alison Gernsheim's *History of Photography*, Piero Becchetti's *Fotografi e fotografia in Italia, 1839–1880*, and the countless guidebooks that provide basic information about sites. Short citations are fully identified in the bibliography.

In our text, distinctions have been made among *publications*, in which illustrations are bound with letterpress text, *portfolios* of unbound sheets, and *albums*, which are bound without letterpress text or captions.

CATHERINE EVANS INBUSCH, *Assistant Curator of Photographs*
MARJORIE MUNSTERBERG, *Associate Curator of Photographs*
Centre Canadien d'Architecture/Canadian Centre for Architecture

SAMUEL BEMIS
1789–1881

§ Samuel Bemis, a dentist and jeweler, bought a daguerreotype camera in Boston on April 15, 1840 for fifty-one dollars. The sale was made by François Gouraud, who represented Alphonse Giroux & Cie, the Paris-based distributors of Daguerre's apparatus and manual. Gouraud gave demonstrations of the new camera to the public and was quickly approached by interested pupils, among whom was the inventor Samuel Morse. Four days after the purchase, Bemis made his first daguerreotype of the King's Chapel Burial Ground in Boston (collection of the International Museum of Photography at George Eastman House, Rochester, N.Y.). On the back, Bemis carefully recorded the forty-minute camera exposure, the exact weather conditions, and time of day. He photographed it systematically through the winter of 1840–1841, much as he methodically documented a farming area in Crawford Notch, New Hampshire, probably during the summer of 1840 (collection of the International Museum of Photography at George Eastman House, Rochester, N.Y.). Nothing is known of his other photographic

activities. Bemis, like many other early practitioners of the medium, probably stopped making photographs after a few experimental efforts.

Reference: Rudisill, *Mirror Image*, pp. 69–70.

FRONTISPIECE. Samuel Bemis. *Burial Ground, King's Chapel, Boston*. Whole-plate daguerreotype, 1840–1841, 15.2×20.3 cm (6×8 in).

Samuel Bemis' view into the cemetery shows King's Chapel at right. Designed in 1754 by the British-American architect Peter Harrison (1716–1765), King's Chapel was the first stone church in the United States. As in many early daguerreotypes, the image is laterally reversed. Fitted into a homemade, simple wood frame, this is one of a group of whole-plate daguerreotypes that Bemis made of the subject. Others that preceded this image show the small building in the foreground in different phases of construction. Although a record of seasonal and environmental change, this series seems intended to display the photographic process. It is a demonstration of photography's ability to depict precisely an everyday view–perhaps the one from Bemis' window.

RICHARD BEARD
1801–1885

§ Richard Beard, who was born in East Stonehouse, in the county of Devon, England, worked in the family grocery business for a short time. He married in 1825 and moved to London in 1833. There he became a partner in a coal firm, which he took over the following year. He established a similar business under the name R. Beard & Company, selling the company at substantial gain about ten years later. In 1839 he filed the first of many patents, this one for the color printing of fabrics. Through the licensing agent Miles Berry, Beard became aware of the daguerreotype patent of Louis-Jacques-Mandé Daguerre (1787–1851) and Joseph-Nicéphore Niepce (1765–1833) that was obtained the same year. In 1840, as a result of being introduced to the Wolcott mirror camera, he filed to patent this improved apparatus in Britain, also securing the British monopoly on the daguerreotype process through negotiations with Berry as well as with Daguerre and Niepce. By the next year he had opened the first public photographic studio in London at the Royal Polytechnic Institution on Regent Street. Beard began to sell licenses outside London, and by 1841 photographic studios were set up by regional operators in Bristol and Bath, among some seven other cities. The daguerreotype of Wells Cathedral, near Bath, therefore may have been executed by a licensee rather than by Beard himself. Keeping a watchful eye over his patent, he filed suit against the rival London daguerreotypist Antoine-François-Jean Claudet (1797–1867), claiming operation of a studio

without the necessary permission. Although the court decision was in Beard's favor, Claudet appealed and the injunction against him was removed, leaving Beard the official patentee while both could continue to operate studios. In the meantime, in 1842, Beard secured a patent for hand-colored daguerreotypes and opened two more studios in London: 34 Parliament Street, Westminster, and 85 King William Street. Beard continued to file suit against other studio owners. His major lawsuit against Jeremiah and John Warry Egerton and Charles Bates dominated the years 1845 to 1849. It so absorbed him that he began to extricate himself from personal involvement with his London studios. He offered licenses to independent operations within the city much as he had in the provinces. By 1849 he had declared bankruptcy, which may have been a shrewd business decision, since there is evidence of his continuing prosperity. His son Richard carried on the family's involvement, repurchasing the license in 1840, and opening a studio in Liverpool. He also reopened a former establishment of his father's in Cheltenham. The elder Beard had not abandoned photography; he applied his newly-developed protective coating of enamel to daguerreotypes, some of which were exhibited at the Crystal Palace in 1851. Although an American claimed credit for the invention of this process, Beard rigorously, and predictably, challenged the claim. By the mid-1850s, his London studios had been vacated or had changed hands and, although his photographic activities continued to decrease, Beard nevertheless formed a partnership with James Thomas Foard, with whom he produced portraits and daguerreotypes. Foard took over the business in 1857, and in 1858 or 1859 Beard embarked on another short-lived venture: Sharp & Beard, Photographic Artists. In the 1860s he billed himself as a medical galvanist, but during the next decade all of the family's facilities closed down. Beard retired to Hampstead, where he died and was buried.

Reference: Heathcote, "Richard Beard."

PLATE 1. Richard Beard or patent licensee. *West front, Wells Cathedral.* Quarter-plate daguerreotype, 1840s, 6.7×9.2 cm (2⅝×3⅝ in). Blue label pasted on verso: "BEARD'S/PATENT PHOTOGRAPHIC PORTRAITS/TAKEN AT/85, King William Street, City/34 Parliament Street, Westminster/AND/Royal Polytechnic Institution./309, REGENT STREET."

The west front of Wells Cathedral, completed between 1215 and 1240, supports a varied and complex sculptural program. The towers were built two hundred years later. This daguerreotype presents a conventional architectural view, showing the full west front without noticeable distortion of perspective. The point of view, slightly off-center and favoring the left, suggests that the photographer was interested in recording the process of restoration. The subtle angle adds a sense of depth to the single-plane depiction of the facade. Because the blue label on the verso lists all three of Beard's studios, the first two estab-

lished only in 1842, and because Beard declared bankruptcy in 1849, the image was probably made sometime between 1842 and 1849.

WILLIAM HENRY FOX TALBOT
1800–1877

§ A nineteenth-century gentleman and prominent man of letters and science, William Henry Fox Talbot pursued diverse scholarly interests throughout his life. Born in Dorset, Talbot was educated at Trinity College, Cambridge. In 1832 he married Constance Mundy, with whom he had three daughters and one son. As early as 1822, he published papers in mathematical journals, and by the 1830s he was recognized as a linguist, especially for his publication *Hermes–Or Classical and Antiquarian Researches* (London: Longman, Orme, Brown, Green & Longmans, no. 1, 1838; no. 2, 1839). Optics and botany were other subjects of great interest to Talbot. The Royal Society, the most celebrated organization devoted to scientific study in Great Britain, elected him to membership in 1831. With this background, it is not surprising that Talbot became one of the inventors of photography. By 1835, he had managed to stabilize, or fix, images that he had made on light-sensitive paper, a process he called photogenic drawing. He then took the significant step of creating a paper negative, thus inventing the process on which present photography depends. In France, on January 7, 1839, the Académie des Sciences announced Daguerre's invention: using the camera obscura, he could make faithful and permanent, although unique, images. On February 21, 1839, well before the August publication of Daguerre's discovery, Talbot presented a paper to the Royal Society describing his own photographic system. He continued to refine and modify his process and, in 1841, secured a patent to establish his rights as inventor. Like Beard, Talbot aggressively pursued any who infringed his patent, although his primary concern was probably not financial. The vigilance with which he guarded his invention had the unfortunate side effect of impeding the development of the paper negative in England during the 1840s. Scotland and France, where the restrictions did not apply, had lively and fruitful years of experimentation. In 1853, however, Talbot's patent expired. The following year, Talbot's suit against Martin Laroche (1809–1886), a professional portraitist, established Talbot as the inventor of the paper negative but not of the wet-collodion process. Talbot was responsible for two photographic projects. *The Pencil of Nature* (London: Longman, Brown, Green & Longmans, 1844–1846) comprises a total of twenty-four plates, most of which are of architectural subjects, with Talbot's descriptive commentary and introduction. The photographs were printed by Nicolaas Henneman (1813–1875?) and issued over two years in six paper-covered fascicles. As an introduction to the new medium, the book was intended to demonstrate photography's various capacities through

examples and explanations. Next he issued *Sun Pictures in Scotland* (London 1845) by subscription, with twenty-three photographs of landmarks in picturesque Scotland, but without text. Talbot, an inveterate traveler, made photographic tours of Scotland in 1844, of York, Bristol, and Devon in 1845, and of the Rhine Valley and Switzerland in 1846. Also in 1846, Talbot opened a studio on Regent Street, London, which he sold two years later to Henneman and Thomas A. Malone. After the 1840s, Talbot remained involved in photography, particularly with the reproduction process. In 1858 he secured a patent called "Improvements for the art of engraving," which he described in an article for *Photographic News* (London: Petter and Galpin, Oct. 22, 1858). One of seven different photoglyphic engravings of architectural subjects was distributed with the November 12, 1858 issue. Like many other early photographers, however, his photographic activity diminished. Talbot was elected to the Royal Photographic Society in 1873, one of the countless honors bestowed upon him throughout his lifetime. He died at Lacock Abbey, Wiltshire, in 1877, leaving the house and an extensive estate that have recently been opened to the public as the Talbot Museum.

Reference: Buckland, *Fox Talbot.*

PLATE 2. William Henry Fox Talbot. *Scott Memorial under construction, Edinburgh.* Salt print from paper negative, 1844, 19.7×15.8 cm (7¾×6¼ in). Numbered in ink on verso: "LA 26". Plate 2, titled "Sir Walter Scott's Monument, Edinburgh; as it appeared when nearly finished, in October 1844," in *Sun Pictures in Scotland* (London: by subscription, 1845).

Designed by George Kemp (1795–1844) in 1840, the monument to Sir Walter Scott on Princes Street was completed in 1846. The 200-foot spire houses a statue of Sir Walter executed by Sir John Steel, but not yet installed when the picture was taken. The image, together with twenty-two other salt prints by Talbot, was included in *Sun Pictures in Scotland* in 1845, although this particular example is not taken from it. Primarily a collection of picturesque Scottish landscapes and monuments, Talbot's book also demonstrates by example the nature of the new photographic medium. In this image, the transitory condition of the still uncompleted memorial emphasizes the ease and the inevitability with which the camera describes the particulars of the physical world.

PLATE 3. William Henry Fox Talbot. *West front, York Minster, from Lendal Street.* Salt print from paper negative, 1845(?), 16×20.2 cm (6⁵⁄₁₆×7¹⁵⁄₁₆ in).

York Minster, the largest of the English Gothic cathedrals, stands in the center of the city with houses pushing up against it. Talbot's photograph shows the massive west front, completed in 1345, and the towers, finished later. The photograph was taken from the intersection of Lendal and Dancombe Streets, about one-half mile from the cathedral. Many other photographers, including Roger Fenton, made nearly identical photographs, perhaps because they, too, were overwhelmed by the almost celestial rise of York Minster over the crowded city streets.

DAVID OCTAVIUS HILL
1802–1870
ROBERT ADAMSON
1821–1848

§ David Octavius Hill was one of nine children born to a bookseller and publisher in Perth. Both parents gave their family a solid sense of the value of work and education, and three of the children became prominent in the law and arts. Like his brothers, Hill attended the excellent Perth Academy. Either there, or later in Edinburgh, he received advanced instruction in drawing, painting, and lithography. Hill published his first lithographs at age nineteen and exhibited his first landscapes at the Royal Institution, Edinburgh, at age twenty-one. In 1829 Hill and other artists established the Royal Scottish Academy. For the next forty years, he served as its secretary and exhibited landscape paintings there almost every year of his life. In 1836 the Academy was able to pay Hill a salary, and this financial security enabled him to marry Ann Macdonald in 1837. In May, 1843, a dramatic split in the Church of Scotland caused four hundred ministers to walk out of the General Assembly to form the Free Church of Scotland. Hill was so deeply affected by this event that he decided to commemorate it in a life-size painting. Sir David Brewster (1781–1868), the eminent physicist and a friend of William Henry Fox Talbot, suggested that Hill use photography to help him with the considerable task of obtaining the necessary likenesses. Brewster had experimented with Talbot's process in St. Andrews in 1841, and while there he had trained a colleague, John Adamson. Adamson, in turn, taught his brother Robert, whose health had become too precarious to pursue his profession as an engineer. Both brothers were born in the family home at Burnside, but lived in nearby St. Andrews. In 1843 Brewster introduced Hill to Robert Adamson, and together they opened a studio at Rock House, Calton Hill, Edinburgh, where they began posing and photographing all of the 450 clergymen who signed the Deed of Demission. Hill and Adamson soon extended their activities beyond the studio, working in Durham and York in 1844 and extensively around Edinburgh and St. Andrews. Together they produced about 2,500 paper negatives between 1843 and 1848, a staggering achievement given the cloudy weather of Britain and the other commitments of both men. In the autumn of 1847, Adamson became seriously ill, and he died in January of the following year. After Adamson's death, Hill put photography aside for a decade. During the 1850s he devoted himself almost entirely to family and artistic matters. In 1862 he married Amelia Robertson Paton (1820–1904), a sculptor and the sister of the painter

Noel Paton. From 1860 to 1862, Hill photographed again, this time in collaboration with the Glasgow photographer A. McGlashan. They issued a portfolio of fifteen photographs in 1862, called *Some Contributions toward the Use of Photography as an Art*, but it lacked the quality of the earlier work. In 1866 Hill finally completed his huge painting of the First General Assembly of the Free Church, which he exhibited in Glasgow and Edinburgh. A reduced photographic facsimile of the picture was put on sale through the Free Church, and a group of subscribers raised £1,200 to purchase the painting, which now hangs in the Edinburgh offices of the Free Church. In 1869 Hill suffered an attack of rheumatic fever that caused him to give up his post at the Royal Scottish Academy. He died in 1870 and was buried in Dean Cemetery, Edinburgh, where a portrait bust by his wife marks the grave.

References: Michaelson, *A Centenary Exhibition*; and Stevenson, *David Octavius Hill and Robert Adamson*.

PLATE 4. David Octavius Hill and Robert Adamson. *East gable of the Cathedral and St. Rule's Tower, St. Andrews*. Salt print from paper negative, ca. 1844, 14.8×20 cm (5 13/16×7 7/8 in). Written in pencil on verso: "F & S 303/B".

The Romanesque tower of St. Rule, forty yards to the southeast of the cathedral, is widely believed to have been built in 1144 by Bishop Robert, although legend decrees that St. Rule (or St. Regulus) brought the relics of St. Andrew to Scotland in the eighth or ninth century. The small church is possibly a later addition. The ruined cathedral to the left of the tower was started by Bishop Arnold in 1161 and completed in 1311 by Bishop Lamberton. Ravaged by storm in the 1270s, by fire about 1350, and again by storm in 1409, the cathedral finally fell into disrepair after the Reformation. In 1826 the Barons of Exchequer decided to preserve the remains. This view to the west, a popular subject, simultaneously offers the appeal of an ancient Scottish monument and that of a Gothic ruin. It also had personal significance for Adamson because his family grave was in the cemetery.

PLATE 5. David Octavius Hill and Robert Adamson. *West wall, Roslin Chapel, Midlothian*. Salt print from paper negative, 1844(?), 14.8×19.7 cm (5 13/16×7 3/4 in). Written in pencil on mount: "D. O. Hill. R. S. A. & R. Adamson. Edinburgh 1844./No. 13. Roslin Chapel." Written in pencil on verso: "13/Part of West Gable of Roslin Chapel".

Roslin Chapel, designed by William St. Clare, Earl of Orkney, and built in 1446 as a collegiate chapel, was famous for its combination of Norman massiveness and intricate Tudor ornament. In 1668 rioters pillaged the building, which was not completely restored until 1862. This photograph shows the west wall and part of the north transept, which, because the chapel was never completed,

marks the end of the building. Hill and Adamson's view contrasts the highly finished carving with the ruined condition of the building as a whole, here suggested by the jagged end of the wall and an unruly landscape beyond. The reclining man in a top hat in the foreground may be one of the photographers, who are known to have sometimes posed in their photographs.

CLAUDE-MARIE FERRIER
1811–1889

§ Claude-Marie Ferrier together with Hugh Owen (1804–1881) illustrated the jury reports for the *Exhibition of the Works of Industry of All Nations* in 1851. Ferrier used glass negatives while Hugh Owen produced paper negatives, but all the prints were made by Talbot's printer, Nicolaas Henneman, in his Regent Street studio between September and November 1851. Henneman's task consisted of printing over 20,000 photographs on salted paper for 130 presentation copies of the four-volume report. In an unusual gesture of goodwill, Talbot waived his rights to the photographic process to make these books possible without great additional expense. In return he received fifteen complimentary copies. Subsequent to his work in England, Ferrier became a successful landscape photographer in France, producing popular views of the Alps and other subjects. He is also mentioned by contemporary critics as having recorded the Loire flood of 1856 as well as Napoléon III's Austrian campaign of 1859.

Reference: Goldschmidt and Naef, *The Truthful Lens*, p. 198.

PLATE 6. Claude-Marie Ferrier. *Nave and north transept, Crystal Palace, London*. Salt print by Nicolaas Henneman from wet-collodion glass-plate negative by Ferrier, 1851, 21.7×15.9 cm (8 9/16×6 1/4 in). Unnumbered plate in *Exhibition of the Works of Industry of All Nations. 1851. Reports by the Juries*. (London: Spicer Brothers, Wholesale Stationers; W. Clowes and Sons, Printers, 1852). Printed on mount: "VIEW OF TRANSEPT, LOOKING NORTH".

The London Crystal Palace, a 1,848-foot-long glass and iron structure, was designed by Joseph Paxton (1803–1868). As the first major expression of architecture in the industrial age, it is a landmark in architectural history. Opened by Queen Victoria on May 1, 1851, the Crystal Palace displayed the more than 100,000 products of the early industrial age that formed the first major international exhibition. Both transepts were lined with statues, and a crystal fountain marked the center of the crossing. In this photograph, the ghost of a camera and tripod stands to the right of the fountain. Because of public demand that Hyde Park's magnificent elms not be sacrificed for the Palace's construction, the interior was built to accommodate them. However, the accompanying sparrows

presented such grave problems that the Queen's advice on the matter was solicited. She deferred to the Duke of Wellington, who replied, "Try sparrow hawks, Ma'am." (Longford, *Queen Victoria*, p. 223.)

ROBERT HENRY CHENEY
ca. 1800–1866

§ Robert Henry Cheney and his brother Edward played important roles in the history of Victorian art as collectors and connoisseurs. Robert Henry, the eldest of Lieutenant-General Robert Cheney's four children, grew up at the family seat of Badger Hall, Shropshire. The death of his father in 1820 caused him to leave Oriel College, Oxford, and accompany his mother on an extended stay in Italy. His brother Edward joined them after graduation from Sandhurst and some years of quiet military duty in India. About this time, both brothers tried their hand at Gothic fiction. Edward's novel, *Malvagna, or the Evil Eye*, was published in London in 1838, but attracted little attention; Robert Henry's *Rossano, a Neapolitan Story* was only printed privately in 1871. Robert Henry also drew and perhaps even studied art with the British watercolorist Peter Dewint. The family was welcomed in Roman society, and they almost immediately became regular guests at the great houses. Robert Henry seems to have returned to Badger Hall during the 1830s, probably to manage the family affairs. Edward lived in Venice, where he built up a fine art collection that ranged from fifteenth-century Italian paintings and oil sketches by Tiepolo to etchings by Rembrandt. Both brothers wrote scholarly articles about Italian history and art, many of which appeared in the *Quarterly Review*. Judging from the collection of letters now in The Pierpont Morgan Library and quoted here with their kind permission, Robert Henry spent much of his time during the 1840s designing the gardens of Badger Hall. On January 21, 1846, for example, he wrote to the watercolorist Thomas Cromek: "*I am doing very little-drawing hardly at all-but amusing myself with landscape gardening which is in its way a sort of painting-.*" Later that year he wrote to Cromek: "*Everybody walks about the world with an iron collar round their necks-but when one is young one does not perceive it-My life is spent in doing things I am indifferent to or dislike-My only real pleasure is wandering and sketching in Italy-& from that I am debarred-by what? you will ask-why many of the thousand considerations similar if not the same, that prevent your coming to England-.*" Perhaps some of these burdens came from Cheney's civic duties: in 1851 Sheriff of Shropshire and a Justice of the Peace. About this time Cheney took up photography-a process that had interested him as early as the 1840s as a means of recording his work in landscape gardening (see Introduction, p. 9). He photographed extensively through the 1850s, depicting Badger Hall as well as gardens, country houses, towns, and monuments of Britain. Cheney used waxed-paper negatives from which he apparently made salt prints, although the prints made from 1859 to 1860 by his

nephew, Colonel Alfred Capel-Cure, are on albumen paper. It seems that he neither exhibited nor published his pictures, which probably represented the same kind of gentlemanly amusement as his watercolors and his landscape gardening.

References: Haskell, *Rediscoveries in Art*, p. 80; and Houghton, "Edward Cheney."

PLATE 7. Robert Henry Cheney. *Guy's Cliffe, Warwickshire*. Albumen print by Alfred Capel-Cure from waxed-paper negative by Cheney, 1850s, 17.5 × 22.2 cm (6⅞ × 8¾ in). Written in ink on mount: "Guyscliffe".

Guy de Beauchamp, Earl of Warwick (d. 1315) was named after a legendary romantic hero, Guy of Warwick, who slew a Danish giant in an attempt to prove his valor to his beloved. The victorious Guy then retired to Warwick, where he lived as a hermit. In honor of the medieval Earl, a descendant, Thomas, built Guy's Tower at the end of the fourteenth century. Richard de Beauchamp, also Earl of Warwick and Thomas' son, in 1422–1423 rebuilt a nearby chapel overlooking the Avon on the same site where the legendary Guy was reported to have died. Cheney's view shows how the eighteenth-century house to the left abuts the chapel. The strangely constructed composition and dramatic illumination reflect not only the history of the place but also the attitude of the gentleman-amateur photographer in search of the picturesque.

BENJAMIN BRECKNELL TURNER
1815–1894

§ Benjamin Brecknell Turner entered the family tallow-chandling concern in London at the age of sixteen and managed it from 1841, when his father died, until his own death in 1894. The company also produced saddle soap, which continues to be marketed under the family name by another firm. He married Agnes Chamberlain of the Worcester China family. According to their son, Dr. Philip D. Turner, Turner began to make photographs in 1849. Some of his photographs of Hyde Park were shown at the Great Exhibition in the Crystal Palace in 1851. A more important exhibition of his work was held in 1853 at the Society of Arts, where Prince Albert greatly admired his prints. During these years, he operated a portrait studio above the family business in the Haymarket. In 1857 Turner traveled to Holland on a photographic tour with his brother-in-law, Humphrey Chamberlain. He attracted such crowds that at one point his equipment accidentally fell into a canal and all but about six of his negatives were destroyed. Turner appears to have ceased photography in 1862, one of the last photographers to abandon the paper process in Great Britain.

Reference: Unpublished letter of July 28, 1977 from Professor Giles Robertson, B. B. Turner's great-grandson, in the Archives of the Department of Prints,

Drawings and Photographs, Victoria and Albert Museum, London, used here with their kind permission.

PLATE 8. Benjamin Brecknell Turner. *Bell Harry Tower, Canterbury Cathedral, and St. Augustine's Abbey.* Albumen print from waxed-paper negative, 1850s, 28×38.6 cm (11×15$\frac{3}{16}$ in). Written in pencil on mount: "1/359".

The ruined wall of St. Augustine's Abbey, formerly known as the Abbey of St. Peter and St. Paul, stands in the center of Turner's view. Behind it rises Bell Harry Tower, built in the 1490s and the tallest of the five towers of Canterbury Cathedral. What distinguishes Turner's photograph from the conventional view of Bell Harry Tower is his interest in context, expressed in the abundance of incidental details, such as the draped cloth and cart at the left and the poster on the door. The cart may be the two-wheeled vehicle that Turner's son described as having transported his bulky photographic paraphernalia.

ROGER FENTON
1819–1869

§ Roger Fenton, born in Crimble Hall, Lancashire, was one of seventeen children. In 1838 he began a Master of Arts course at University College, London, under the painter Charles Lucy. On completing the program in 1841, he moved to Paris, where he continued his studies of painting in the popular studio of Paul Delaroche. He may have met Gustave Le Gray, Charles Nègre, and Henri Le Secq, all of whom studied in Delaroche's studio, and he first learned photography at this time. Between 1844 and 1847, Fenton trained as a solicitor in London. After finishing his legal degree, he married Grace Maynard. In 1847 he joined the newly-founded Calotype Club, indicating that he had maintained his interest in photography although he continued to paint. He showed one painting af each exhibition of the Royal Academy, London, between 1849 and 1851. In 1851 Fenton joined a firm of London solicitors, but he also went to Paris to study the organization of the Société héliographique, the first photographic society in the world. Fenton's proposal for the formation of a photographic society in Britain appeared in *The Chemist* (March 1852). On January 20, 1853, the Photographic Society was announced. Charles Eastlake, a painter, architect, and the future director of the National Gallery, became its first chairman. Fenton was appointed Honorary Secretary, a post he held until 1856. The first exhibition of the Society, which opened in December 1852, included thirty-nine photographs by Fenton. Just prior to the opening, Fenton had traveled to Russia to photograph the construction of a bridge over the Dnieper River, Kiev, being built by Charles Vignoles, an engineer and a close friend of Fenton. The collection of

waxed-paper negatives with which he returned to London also included views of Moscow. In early 1854 Fenton photographed the Royal Family at Buckingham Palace and Windsor Castle. Later that spring he began to photograph objects in the collection of the British Museum, for which he continued to work until 1860. In 1854 Thomas Agnew, the Manchester publisher, asked Fenton to photograph the Crimean War for the British Army, and Fenton agreed, leaving for Balaklava in February 1855. Before the fall of Sebastopol, he returned to England with about 360 photographs. Many people saw the Crimean photographs during various exhibitions in Britain and France. They included Queen Victoria, Prince Albert, and Napoléon III. Enthusiasm did not translate into sales, however, and Agnew auctioned all the remaining stock – including negatives – in 1856. Fenton's next major project was to manage and produce photographs for Paul Pretsch's patent Photo-Galvanographic Company. The company's first publication, *Photographic Art Treasures* (London 1856), contained reproductions of four photographs by Fenton. Despite this publication and ambitious plans for the future, the firm closed in 1858. Fenton spent the last years of the 1850s photographing landscape and architectural sites in Britain. He exhibited these views in both Britain and France to great acclaim. In 1858, for example, *Photographic Notes* remarked: "*There is so much character about* [his work], *that we know it to be a 'Fenton', without consulting the catalogue.*" (Vol. 3, 1858, p. 60.) He also took many stereoscopic photographs in 1858 and 1859, some of which were published in the monthly *Stereoscopic Cabinet*. In the early 1860s, Fenton's interests turned to still life. These compositions also were popular, and Fenton won a medal for a selection of these works shown at the International Exhibition, London, in 1862. In the same year, Fenton stopped photographing. He sold his equipment, negatives, and prints at auction in London in November and returned to the law, which he practiced until his retirement in 1865. In 1866 the Photographic Society presented him with the first "Prince Consort Medal" in recognition of his work as a founding member. He died in London after a short illness in 1869. Either shortly before or sometime after his death, Francis Frith began to print from Fenton's negatives, which he had acquired at the auction of 1862. Frith's publications ranged from a portfolio, *The Works of Roger Fenton*, to postcards that continued to be sold into the 1960s. Even the finest of these lacks the quality of the earlier prints.

Reference: Hannavy, *Roger Fenton*.

PLATE 9. Roger Fenton. *Ely Cathedral from the south.* Albumen print from wet-collodion glass-plate negative, late 1850s, 35.7×44 cm (14$\frac{1}{16}$×17$\frac{5}{16}$ in). Written in pencil on mount: "11". Printed on mount: "Photographed by R. Fenton." Printed on label, pasted on mount: "30 Ely Cathedral, from the Park".

The west front and tower of Ely Cathedral were completed about 1200, while the 100-foot octagon, unique in Gothic architecture, replaced the central tower, which collapsed in 1322. The Great Park exemplifies the English tradition of separating cathedrals from residential areas by precincts–expansive, landscaped lawns. Fenton's photograph shows a favored nineteenth-century view. It emphasizes the two distinctive features of the building and places the cathedral in its pastoral context. The photograph was made in the early morning and is filled with the tranquillity of a summer day.

PLATE 10. Roger Fenton. *Chapter House and Cathedral, Salisbury, from the Bishop's garden.* Albumen print from wet-collodion glass-plate negative, late 1850s, 34.3 × 44 cm (13½×17⁵⁄₁₆ in). Titled and numbered in pencil on mount: "Salisbury Cathl, view in the Bishop's garden. z. NO. 61/21". Printed on mount: "Photographed by R. Fenton".

Fenton's photograph shows the chapter house and the gable of the southwest transept of the cathedral, one of two transepts on the south side. This close view, like Fenton's long view of Ely, is similar to the standard photograph of the cathedral. The large size and the fine quality of Fenton's prints, as well as his skillful placement of compositional elements, distinguish his work from that of his contemporaries.

PLATE 11. Roger Fenton. *Houses of Parliament under construction, London.* Salt print from wet-collodion glass-plate negative, 1858(?), 30.3×42.2 cm (11¹⁵⁄₁₆× 16⁵⁄₈ in), arched top.

The Houses of Parliament, properly called the New Palace of Westminster, and the Gothic Westminster Hall form a single complex of buildings. Charles Barry (1795–1860) won the commission to design the new structure as the result of a competition held in 1835. He was assisted by A. W. N. Pugin (1812–1852), who was responsible for the elaborate Gothic detail. Construction began in 1840 on the site of the previous building, which had been destroyed by fire in 1834. Fenton's view, taken from the north embankment of the Waterloo Bridge and overlooking the Hungerford Suspension Bridge, a foot bridge, presents the new towers rising triumphantly over the Thames. They offer a striking addition to the familiar vista. The clock tower at the north end, popularly called Big Ben after the largest of the bells, stands 318 feet high, while the Victoria Tower at the southwest end rises to 340 feet. Although the towers were erected without exterior scaffolding, the spire of the clock tower as well as the pinnacles of the Victoria Tower required scaffolding and thus date the image to about 1858. The large building to the right of Big Ben is Westminster Abbey.

GUSTAVE LE GRAY
1820–1882

§ Like Roger Fenton, Henri Le Secq, and Charles Nègre, Gustave Le Gray studied painting in Paris with Paul Delaroche, one of the best-known teachers of the time. Although Le Gray exhibited paintings at the Paris Salons of 1848 and 1853, he had turned his attention to photography by the late 1840s. In 1851 he announced the discovery of the waxed-paper process that combined the tonalities and flexibilities of the paper negative with a clear, sharp surface that approached the transparency of glass. Many photographers, including Louis de Clercq and Jakob August Lorent, adopted Le Gray's technique. Le Gray himself taught photography to Maxime Du Camp and Le Secq, among others. In 1851 the Commission des Monuments historiques appointed Le Gray as one of five photographers of the Mission héliographique. The following year he received a commission to record the galleries of the Paris Salon, and in 1857 he documented military maneuvers at the camp at Chalons. Le Gray probably photographed Chalons–as Baldus photographed the new Louvre–at the command of Napoléon III. During these years, Le Gray achieved a position of influence and prominence in the French photographic community. He was a founding member of the Société héliographique and of the Société française de Photographie. He participated in almost all the international photography exhibitions of the 1850s. In 1855 he won a first-class medal for his photographs at the Exposition Universelle, Paris. The jury report described the excellence of Le Gray's photographs: "*Par la variété des sujets de son exposition, M. Le Gray, à Paris, prouve qu'il réussit dans toutes les branches de la photographie. Au milieu de beaux portraits, savamment éclairés, on voit de charmants paysages, des monuments très-bien rendus, des reproductions de dessins et de bas-reliefs bien réussies. C'est à M. Legray qu' est due l'invention et la vulgarisation du procédé papier du négatif ciré. . . . Peintre distingué, M. Legray s'est voué à la photographie dès son origine et l'a toujours cultivée avec goût.*" [By the variety of subjects in his exhibition, M. Le Gray in Paris proves that he is successful in all branches of photography. Along with fine, well-lit portraits, one sees charming landscapes, well-rendered monuments, successful reproductions of drawings and bas reliefs. It is to M. Le Gray that is owed the invention and popularization of the waxed-paper negative process. . . . A distinguished painter, M. Le Gray has been committed to photography from its origins and always has cultivated it with taste.] (*La Lumière*, April 25, 1857, p. 67.) About 1859 professional failure and an unhappy marriage caused him to leave Paris. By the mid-1860s Le Gray had become professor of design at the Ecole Polytechnique in Cairo, where he continued to practice photography. He died in Cairo in 1882 from injuries suffered during a fall from a horse.

Reference: Néagu, *La Mission héliographique*, pp. 69–91.

PLATE 12. Gustave Le Gray. *View to the west from the Pont des Arts, Paris.* Albumen print from wet-collodion glass-plate negative, 1855–1856, 37.8×47.6 cm (14⅞×18¾ in).

In Le Gray's view from the Pont des Arts, the Pont du Carrousel (1831–1834) serves as the base for the skyline of western Paris. Most distinctive among the monuments depicted are the long wing of the Tuileries at the right and the Arc de Triomphe on the horizon. This and the next photograph belong to a group of five cityscapes by Le Gray, a complete set of which is now in the Bibliothèque historique de la Ville de Paris. They constitute an important part of Le Gray's contribution to the rich topographical tradition of representation of Paris and the Seine.

PLATE 13. Gustave Le Gray. *View to the east from the Pont Royal, Paris.* Albumen print from wet-collodion glass-plate negative, 1855–1856, 38.4×50.5 cm (15⅛×19⅞ in).

In this photograph, a companion to the preceding plate, Le Gray again placed the Pont du Carrousel at the base of the Parisian skyline. The view looking east from the Pont Royal includes many of the most characteristic monuments of the city. Prominent on the Right Bank are the Tuileries, the tour Saint-Jacques, and the facade of Saint-Gervais, while the towers of Notre-Dame Cathedral and the spire of Sainte-Chapelle rise from the Ile de la Cité. At the right, across the Seine, is the dome of the Institut de France. The collodion negative for this print is now in the Bibliothèque historique de la Ville de Paris.

LOUIS-AUGUSTE BISSON
1814–1876
AUGUSTE-ROSALIE BISSON
1826–1900

§ Louis-Auguste and Auguste-Rosalie Bisson were active in the arts before their venture into photography. The elder brother was an architect, employed by their native city of Paris, while the younger worked with their father, a heraldic painter. Soon after Daguerre's announcement of his invention in 1839, the family established the photographic firm Bisson Père et Fils. Their earliest works resulted from commissions for daguerreotypes of specimens of natural history, works of art, and portraits. Between 1848 and 1849, for example, they photographed all nine hundred members of the National Assembly, portraits which were later published as lithographs. They also showed their daguerreotypes at the major international photography exhibitions during the 1840s and early 1850s. In the early 1850s, the Bissons changed to glass negatives and albumen prints, a more commercially advantageous process since it permitted the replication of any

given image. About the same time, they moved their large, extensively stocked studio to the prestigious address of 35 boulevard des Capucines. They continued to exhibit their prints regularly through the 1850s and early 1860s, winning awards for the excellence of their work. In 1855 the brothers won a first-class medal at the Exposition Universelle, Paris, and the jury report cited them among the photographers of monuments as equaled only by Le Gray and Baldus: "*MM. Bisson frères, à Paris, et M. Baldus, à Paris, rivalisent entre eux pour la dimension et pour la perfection de leurs oeuvres.*" [MM. Bisson frères, in Paris, and M. Baldus, in Paris, rival one another for the size and the perfection of their works.] (*La Lumière*, April 25, 1857, p. 67.) Their photographs were admired beyond the boundaries of France. The *Journal of the Photographic Society of London* reviewed the Bissons' pictures in the Photographic Society's exhibition of 1857: "[Their photographs] *astonish from the purity and superiority of their atmosphere.... This is rank sorcery, and staggers the imagination; the shadows are cut so dark and knife-like; the middle tint is so diffuse and calm.*" (Vol. 3, 1856/7, p. 214.) Their most ambitious project appeared in installments between 1853 and 1862: *Reproductions photographiques des plus beaux types d'architecture et de sculpture d'après les monuments les plus remarquables de l'Antiquité, du Moyen-Age, et de la Renaissance*, a complete copy of which is in the Bibliothèque Nationale, Paris. A compilation of large albumen prints of works from all over Europe, the portfolio reflects the period's passion for the recording and study of great monuments of the past. Nègre's uncompleted portfolio, *Midi de la France*, arose from similar ambition. In 1860, the younger Bisson photographed the Alps at Chamonix and issued an album of Alpine scenery. In 1861 he climbed the Mont-Blanc Massif to photograph the summit. These monumental pictures of the Alps express the nineteenth century's craving to depict, and in the process somehow conquer, the monuments of the physical and man-made world. In 1864 the Bissons sold their studio to Emile Placet, who continued to print their negatives with the initials "EP" rather than "BF." Louis-Auguste Bisson retired, while Auguste-Rosalie worked for various other photographers, including Léon et Lévy and Adolphe Braun. Both brothers died in Paris.

Plates 14, 23, 34, 37.

PLATE 14. Bisson Frères. *View to the east from the Cathedral of Notre-Dame, Paris.* Salt print from wet-collodion glass-plate negative, before 1858, 35.4×49.5 cm (13¹⁵⁄₁₆×19½ in). Photographers' signature stamped on mount: "Bisson frères".

This photograph of the view to the east of Notre-Dame probably was taken from the scaffolding erected during the building of Viollet-le-Duc's spire in 1856 to 1859. Various signs of construction and repair are visible along the peak of the roof, and far below is the walled plaza complete with newly-planted trees that Viollet added at the back of the cathedral. The Bissons deposited this picture at the Bibliothèque Nationale under the title *Panorama de Bercy* in 1857, along

with a similar view to the west called *Panorama de Paris*. They also included both photographs as plates 50 and 51 in *Reproductions photographiques des plus beaux types d'architecture et de sculpture*. The area of Bercy received its name from the large complex of wine warehouses, called the Entrepôt de Bercy, which is visible at the upper left.

PLATE 15. Anonymous. *Pont-Neuf, Paris*. Whole-plate daguerreotype, after 1841, 14.1×19.1 cm (5⁹⁄₁₆×7½ in).

The Pont-Neuf, built between 1578 and 1606 during the reign of Henri III, is shown here not as an isolated monument but as an integral part of the commercial life of the city. Two of the stores in the Place du Pont-Neuf are photographic establishments: the studio of Charles Chevalier, which opened there in 1842 or 1843, and the shop with the sign "Portraits Instantanés," which perhaps belonged to Nicolas-Marie Paymal Lerebours, the publisher of *Excursions daguerriennes* (Paris 1840–1842). Quite possibly one of the two photographers made this early daguerreotype, since the image could serve both as a business advertisement and as a record of a famous Parisian location.

LOUIS-ANDRÉ BRETON
ANDRÉ BRETON

§ As opticians and makers of scientific instruments, Louis-André and André Breton were led naturally to experiment with daguerreotypes soon after the invention of the process. In 1842 they won a medal for their success with a plate more than a meter high from the Société d'Encouragement pour l'Industrie nationale. Very few of their daguerreotypes are known today. These include a view of the Chapel of the Invalides, framed and labeled exactly like the example shown here, and a view of Notre-Dame Cathedral, now in the Franklin Institute, Philadelphia.

PLATE 16. Breton Frères. *Church of Saint-Sulpice, Paris, from the east*. Half-plate daguerreotype, *ca.* 1839, 9.5×14.9 cm (3¾×5⅞ in). Written in ink on mount: "Paris./Eglise St. Sulpice L. et A. Breton." Label pasted on verso: "MAGASIN ... RUE BOURBON, 9./BRETON FRÈRES/Opticiens, Constructeurs d'Instruments/ de Physique, de Chimie et Mathématiques/ ATELIERS, RUE SERVANDONI, 4./Près St Sulpice./PARIS".

In this daguerreotype Saint-Sulpice appears less as a formally presented monument than as an almost incidentally seen subject. The location of the studio of Breton Frères–at 9 rue du Petit-Bourbon, directly behind the church–suggests that the practice of photography was more to their purpose than the documentation of the building. Similarly, the splendor of this golden-toned, framed object probably celebrates the success of the new medium.

ARMAND-HIPPOLYTE-LOUIS FIZEAU
1819–1896

§ Hippolyte Fizeau, a physicist in Paris and a member of the Académie des Sciences, was one of a number of prominent scientists who attempted to perfect the daguerreotype process during the 1840s. In 1840 Fizeau demonstrated that toning with gold chloride gave the mirror surface of the image greater tonal contrast and greater protection against abrasion. It also slowed the oxidation of the silver that formed the picture. In 1841 he announced a method of etching the daguerreotype directly and using it as the printing plate, a process he used for the three illustrations by him included in the second volume of Nicolas-Marie Paymal Lerebours' *Excursions daguerriennes*, published in Paris in 1842. This technique, which proved to be the most successful at that time, was patented in England by Antoine-François-Jean Claudet (1797–1867) in November 1843. Fizeau continued research in optics and light during the late 1840s and 1850s. In 1856 his work in physics won the Grand Prix from the Institut de France, and in 1860 he was elected to the Académie des Sciences, becoming its president in 1878. In 1875 he was awarded the Legion of Honor. Fizeau died at the Château de Venteuil, Seine-et-Marne, in 1896.

Reference: *Dictionnaire de biographie française*, vol. 13, p. 1426.

PLATE 17. Hippolyte Fizeau. *West facade, Church of Saint-Sulpice, Paris*. Etching from quarter-plate daguerreotype, 1841–1842(?), 7.3×9.8 cm (2⅞×3⅞ in). Written in pencil on border: "H FIZEAU."

This photo-etching of the Church of Saint-Sulpice demonstrates the results of Fizeau's method of electrotyping directly on the daguerreotypes, thus making them into printing plates. He made another version of the same view with a different lens and at a different season–the trees are bare of leaves. As with the daguerreotype by Breton Frères, the informality of the composition suggests that the motivation of the work was the demonstration of the process. Saint-Sulpice appears within the confusion of a dense urban setting rather than as an isolated monument. The vantage point seems to be explained by the nearby location of the studio of Fizeau's engraver, Martin Hurlimann (d. 1842), from which the photograph probably was taken.

EDOUARD-DENIS BALDUS
1813–1882

§ Like many of the outstanding photographers of the nineteenth century, Edouard-Denis Baldus began his artistic career as a painter in Paris. After a brief mili-

tary career, he turned to painting, exhibiting religious and genre subjects at the Paris Salons of the 1840s. He also may have worked as a portraitist during the late 1830s in New York. By 1849, however, Baldus was definitely in France, where he had begun photographing. Presumably on the strength of his early work, the Commission des Monuments historiques selected him as one of the five photographers who formed the Mission héliographique in 1851. Created to document the architectural heritage of France region by region, the Mission assigned Baldus the provinces of Burgundy, the Dauphiné, and Provence. Further commissions shaped his career during the rest of the decade. In 1852 he recorded Parisian monuments for the Ministry of the Interior, and in 1855 baron James de Rothschild commissioned Baldus to photograph the railroad line between Paris and Boulogne. Twenty-five copies were compiled, one of which Rothschild presented to Queen Victoria. The copy in the collection of the Canadian Centre for Architecture, numbered 7, is inscribed to "Baron N. de Rothschild." Baldus compiled a second album in 1859, this one commemorating the extension of the Marseilles-Lyon line to Toulon (plate 27). In 1856, 1857, and 1858, again for the Ministry of the Interior, he documented the flooding of the Rhône and the construction of the new Louvre (plate 25). Baldus also exhibited widely during the 1850s, achieving such fame as a photographer that a critic used Baldus' achievement as the standard by which to praise Jakob August Lorent (see p. 236). About 1860 he rephotographed Paris with a smaller camera, and, judging from the abundance of these albumen prints, he must have sold many of the pictures. Apparently Baldus did not take any new photographs after the mid-1860s, although in Paris in 1875 he published *Les monuments principaux de la France reproduits en héliogravure par E. Baldus*, using negatives from the 1850s. Also at this time, Morel et Cie published four folio volumes of heliogravures by Baldus of the sculptural decorative motifs at Versailles, the Louvre, and the Tuileries that in approach and scale resemble Edouard Durandelle's documentation of the Paris Opéra. Baldus received the Cross of the Legion of Honor in 1860. He died in 1882.

Plates 18, 19, 25, 27.

Reference: Néagu, *La Mission héliographique*, pp. 32–49.

PLATE 18. Edouard Baldus. *Chapel of Sainte-Croix, Montmajour*. Salt print from paper negative, 1849, 33.3 × 43 cm (13⅛ × 16¹⁵⁄₁₆ in). Titled, numbered, signed, and dated in negative: lower left, "Chapelle de St Croix/à Montmajour"; lower center, "No 51"; and lower right, "E. Baldus fc/1849".

This image, the earliest known work by Edouard Baldus, is signed, titled, and dated 1849 by the photographer. Only one other print of this picture has been found, a cropped version in the collection of the Bibliothèque de la Direction du Patrimoine, Paris. The late twelfth- to early thirteenth-century chapel, located

a few miles from Arles in Montmajour, lies just over the hill from the ruined Benedictine abbey and not far from the Chapel of Saint-Pierre. This collection of architectural sites made the area a popular stop for travelers in search of the picturesque. Charles Nègre also photographed this building, but unlike Baldus, who judiciously centered the structure in the middle of his large negative, Nègre filled his picture with the sculptural mass of the apse.

PLATE 19. Edouard Baldus. *Royal Portal, Chartres Cathedral*. Salt print from waxed-paper negative, early 1850s, 44.5 × 34 cm (17½ × 13⅜ in). Titled, numbered, and signed in negative: lower left, "Chartres. Porte."; lower center, "No 35."; and lower right, "E. Baldus." Photographer's signature stamped on mount: "E. Baldus".

Edouard Baldus' photograph depicts the main portal of the west facade of Chartres Cathedral, known as the Royal Portal from the identification of the jamb figures as kings and queens. The photograph is one of a series of large architectural views, all titled, signed, and numbered in the same way, that Baldus appears to have made during the 1850s. Perhaps he planned to publish a collection of such pictures, similar in intent to Nègre's unrealized *Midi de la France* and the Bisson Frères' *Reproductions photographiques des plus beaux types d'architecture et de sculpture*. No such portfolio from the 1850s is known, although some of the prints were included in the album commissioned by baron James de Rothschild in 1855 to document the railway from Boulogne to Paris.

JEAN-LOUIS-HENRI LE SECQ DES TOURNELLES
1818–1882

§ Henri Le Secq, born in Paris, studied painting in several Parisian studios, including that of Paul Delaroche. He exhibited paintings regularly at the Paris Salon between 1842 and 1880 and achieved a modest success, winning a third-class medal in 1845 for *Sieste des modèles à Rome*, which was bought by Queen Marie-Amélie. Le Secq began to photograph in the late 1840s, taught by Gustave Le Gray. In 1850 he made an extensive series of pictures of Amiens Cathedral and, probably on the strength of this experience, won an assignment from the Commission des Monuments historiques to depict buildings in Champagne, Lorraine, and Alsace for the Mission héliographique in 1851. During the first half of the 1850s, Le Secq photographed extensively: the cathedrals of Rheims, Strasbourg, Amiens, and Chartres, as well as the demolition of old Paris, the forest landscape at Montmirail, and the harbor of Dieppe. He exhibited these works widely during the early 1850s and, at least in France, achieved a considerable public reputation. In 1855 Paul Périer reviewed Le Secq's contribution to the photographic exhibition in Paris: "*Le contingent architectural de M. Lesecq lui donne un rang, dans cette catégorie, non moins élevé que dans le paysage; il participe à toutes les*

qualités du genre, et même il nous a semblé s'y distinguer par un certain caractère de fermeté, par un aspect grave et comme ascétique. . . . Il y a dans toutes ces épreuves une intention de sérieux et d'étude, un point de vue d'artiste, auxquels répond une exécution supérieure et d'un relief surtout très remarquable." [The architectural photographs of M. Le Secq distinguish him no less than his landscapes; he participates in all the qualities of the genre, and he seems to us characterized by a certain authority, by a serious and almost ascetic quality. . . . There is in all his photographs an attitude of commitment and study, an artistic point of view, which is expressed by the finest execution and a most remarkable plasticity.] (*Bulletin de la Société française de Photographie*, vol. 1, 1855, p. 225.) After completing a series of strangely evocative still lifes, Le Secq gave up photography in about 1856. In the late 1870s, however, he published at least two portfolios of photolithographs depicting Rheims and Chartres made after his paper negatives from the 1850s. He continued to draw and paint for the rest of his life. Upon his death in Paris in 1882, Le Secq left a large collection of medieval ironwork to his son Henry, who established the Musée Le Secq des Tournelles in Rouen in 1920. The Musée des Arts décoratifs and the Bibliothèque historique de la Ville de Paris hold large collections of his photographs.

Plates 20, 21, 26.

Reference: Néagu, *La Mission héliographique*, pp. 50–68.

PLATE 20. Henri Le Secq. *Columnar figures, north porch, Chartres Cathedral.* Photolithograph, late 1870s, from waxed-paper negative, 1852, 32.7×22.5 cm (12⅞×8⅞ in). Unnumbered plate in *Fragments d'Architecture et Sculpture de la Cathédrale de Chartres d'après les Clichés de M Le Secq, artiste peintre et imprimés à l'encre grasse par Mrs Thiel âiné et Cie Editeurs à Bruxelles, Aug. Vandeemolen et Cie, 2 rue Cantersteen 2. Dépôt à Paris, Chez Mrs Thiel âiné et Cie. 75 rue la Condamine 77."* Signed, titled, and dated in negative, lower right: "H. Le Secq./Chartres./1852".

This photolithograph resulted from Le Secq's efforts during the late 1870s to reprint in more permanent form a selection of his paper negatives from the 1850s. The original salt print, part of an extensive documentation of Chartres that Le Secq made in 1852, appears as plate 20 in an album of his views of Amiens and Chartres cathedrals now in the collection of the Bibliothèque Nationale, Paris. The lithograph is one of twenty-five published in *Fragments d'Architecture et Sculpture de la Cathédrale de Chartres* (Paris, n.d.), a work probably contemporary with his *Monographie de la Cathédrale de Reims* (Paris 1879), another series of photolithographs made after paper negatives from the 1850s. As in many other pictures of Chartres from the same portfolio, the viewpoint represented is that of a visitor to the cathedral, requiring no special access.

PLATE 21. Henri Le Secq. *Portal of Sainte-Anne, Cathedral of Notre-Dame, Paris.* Albumen print from waxed-paper negative, early 1850s, 27.3×18.9 cm (10¾× 7 7/16 in).

The Portal of Sainte-Anne, the southern door on the west facade of Notre-Dame Cathedral, was valued in the nineteenth century for its elaborately decorated doors and its twelfth-century sculpture. Le Secq described these aspects of the portal in this photograph, working from a position somewhat above that of the normal visitor. He may well have used scaffolding erected by Viollet-le-Duc, who extensively restored the entire facade between 1848 and 1855 (Reiff, p. 18). The rich shadows and softly modeled forms characteristic of Le Secq's work create a sense of mystery and spirituality. His frequently experimental approach to process here produced a print of an extraordinary apricot color, which further enhances the expressive quality of the image.

CHARLES MARVILLE
1816–1879(?)

§ Charles Marville was born in Paris. A painter, lithographer, and illustrator, he began to photograph in 1851. He worked extensively during the next five years, making paper negatives of cathedrals, castles, and cities, especially the city of Paris. Over one hundred of these pictures were published by the photographer, printer, and editor Blanquart-Evrard, with whom Marville collaborated from 1851 until 1855, when Blanquart-Evrard's printing establishment in Lille closed. In 1856 Marville joined many of his contemporaries in the change from paper to glass negatives, which required shorter exposures and could capture more detail. In the late 1850s he started to work for the city of Paris, a relationship that became official in 1862, when he was named "Photographe de la ville de Paris." Two extensive projects were the documentation of the new parks around the capital (plate 28) and the systematic recording of the old streets and buildings in Paris that Georges-Eugène, baron Haussmann (1809–1891) had slated for demolition (plate 113). Marville continued to photograph until his death, although the quality of his work declined sharply during the 1870s.

Plates 22, 28, 29, 113.

Reference: Hambourg and de Thézy, *Charles Marville.*

PLATE 22. Charles Marville. *East end, Troyes Cathedral.* Albumen print from glass-plate negative, 1863, 36.4×26.8 cm (14 5/16×10 9/16 in). Photographer's blindstamp on mount: "CH. MARVILLE/PHOTOGRAPHE/DU MUSÉE IMPERIAL/ DU LOUVRE". Written in pencil on mount: "TROYES, Juin 1863".

Restoration of the choir of Troyes Cathedral, initiated by Viollet-le-Duc in 1849, continued until the year after Marville took this picture. This photograph shows the final stages of Viollet's work on the upper parts of the south chapels. It seems probable that this image, like many similar pictures by Marville and other photographers, was taken at the request of Viollet to record the progress of the work.

PLATE 23. Bisson Frères. *Portals, west facade, Church of Saint-Vulfran, Abbeville.* Albumen prints from three wet-collodion glass-plate negatives, before 1859, 45.1×35.2 cm, left; 44.6×35.1 cm, center; 45.6×35.2 cm, right (17¾×13⅞ in, left; 17⁹⁄₁₆×13¹³⁄₁₆ in, center; 17¹⁵⁄₁₆×13⅞ in, right). Photographers' circular blind-stamp on each print, lower left, partially cut off: "BF". Photographers' signature stamped on each mount: "Bisson frères". Written in pencil on each mount, partially cut off on right: "Abbeville-St Wulfran".

The Bisson Frères deposited the photographs of the left and central portal of Saint-Vulfran at the Bibliothèque Nationale in 1858, and that of the right portal slightly later. All three views were numbered as plates 176, 177, and 195 in their massive compilation, *Reproductions photographiques des plus beaux types d'architecture et de sculpture*, issued in installments between about 1855 and 1863 or possibly later. Since neither the deposit nor the publication of the three pictures was simultaneous, perhaps the Bissons did not initially conceive of the three pictures as a triptych. It is more likely, however, that this view of the right portal replaced an earlier one that had become unusable. The attention the brothers paid to the portals reflected a general admiration for the west facade of Saint-Vulfran, which was regarded as one of the finest examples of late Gothic French architecture.

CHARLES NÈGRE
1820–1880

§ Charles Nègre, born in Grasse, studied painting in Paris with Paul Delaroche and Michel Drolling, both of whom were admired for their highly finished, detailed pictures. Nègre had the most successful painting career of all the early French photographers. In 1843, his first painting, *Portrait of M. Lions*, was accepted for the Paris Salon, and in 1849 Théophile Gautier praised his large oil painting, *Universal Suffrage*. Napoléon III bought pictures by Nègre from the Salon of 1851. Nègre won gold medals at the Salons of 1851 and 1852, which entitled him to acceptance without jury review in all future Salons. His photographic career was equally successful. He began to make daguerreotypes in 1844, and by the end of the decade was working with paper negatives. In 1851 he showed work at the exhibition of the Société héliographique, which included

his *Little Ragpicker* in a portfolio intended to illustrate the best French photography. In 1852 Nègre left for the south of France to begin an extensive project documenting the monuments of the Midi. Goupil and Vibert published the first two installments of *Midi de la France* in Paris in 1854, but subsequent issues based on Nègre's two hundred negatives did not appear. In 1855 Nègre won gold medals at the exhibitions of the International Society of Industry in Amsterdam and the Exposition Universelle in Paris. He also showed at the first exhibition of the Société française de Photographie in 1854. In September of that year, he received the first of a number of government commissions, this one to photograph Chartres Cathedral. Others were to follow. These included the reproduction of certain works in the Louvre (1858) and the documentation of the new Imperial Asylum for disabled workmen in Vincennes (1859). Nègre became interested in the reproduction of photographs by photogravure, which would make it possible to print photographs on the same page as text. In 1854 he started experimenting with etching the photographic image into the printing plate with acid, and he exhibited the results at the Photographic Society, London, in 1856. In that year he also submitted gravures and the metal plates from which they were pulled to the competition established by duc de Luynes for the discovery of the most commercially viable process of printing. Although Luynes hired Nègre in 1865 to make the plates for *Voyage d'exploration à la Mer Morte, à Petra et sur la rive gauche du Jourdain* (Paris: Arthur Bertrand, 1871–1875), he did not award the photographer the prize in his competition on the grounds that Nègre's process was too difficult. Throughout the late 1850s and 1860s Nègre regularly exhibited photogravures at the international photography exhibitions –where they won medal after medal–and he continued to send paintings to the Paris Salons. In 1861, however, ill-health caused him to move to Nice, where he opened a photographic studio and taught drawing at the Lycée Impérial. Nègre exhibited for the last time at the Exposition Universelle, Paris, in 1878, and in the same year he received the Palmes académiques from the French government. He died in Grasse in 1880.

References: Borcoman, *Charles Nègre*; and Heilbrun, *Charles Nègre, Photographe.*

PLATE 24. Charles Nègre. "*The Seine and the Marne*," *Tuileries gardens, Paris.* Salt print from wet-collodion glass-plate negative, 1859, 37.8×41.3 cm (14⅞× 16¼ in).

Like other photographs that Nègre made in the Tuileries in 1859, this view of *The Seine and the Marne* (1712) by Nicolas Couston isolates the sculptural group from its landscaped surroundings. The lateral reversal of the subject suggests that Nègre intended this print for publication. Other photographs in the same series have small scratches that resemble registration marks at the lower right of the negative. Such an undertaking would be very much in the spirit of

the mid-nineteenth century, which produced ambitious projects of documentation like Baldus' portfolios of the sculpture of the Louvre, Tuileries, and Versailles and Edouard Durandelle's photographs of the new Paris Opéra.

PLATE 25. Edouard Baldus. *Pavillon Richelieu, Nouveau Louvre, Paris*. Salt print from wet-collodion glass-plate negative, *ca.* 1855, 34.3 × 44.1 cm (13½ × 17⅜ in). Photographer's signature stamped on mount: "E. Baldus". Titled and numbered in pencil on mount: "66/Louvre, Paris".

Baldus extensively photographed Napoléon III's grandest architectural project, the restoration and completion of the Louvre (1847–1857), perhaps at the request of the Emperor himself. This picture depicts the nearly completed facade of the Pavillon Richelieu from a scaffolding erected in the central court, with only a few scattered remains of the construction process and one workman, precariously perched on a ladder, still in evidence. The superb quality and size of the print suggest that Baldus made it for exhibition. Perhaps this is the work the critic Ernst Lacan saw at the photographic exposition held in Brussels in 1856: "*Si l'on étudie, par exemple, le fragment du pavillon de Richelieu, qu'il a intitulé* Grand détail du nouveau Louvre, *on y trouvera à la fois toutes les qualités, tous les luxes de la photographie: exquise finesse de détails, transparence aérienne dans les ombres, modelé parfait dans les figures, richesse, ampleur, puissance dans les effets de lumière et de relief.*" [If one studies, for example, the fragment of the Pavillon Richelieu that he entitled *Detail of the New Louvre*, one finds in it all the qualities, all the splendor of photography: exquisite fineness of details, aerial transparency in the shadows, perfect modeling in the figures, richness, amplitude, strength in the effects of light and relief.] (*La Lumière*, November 22, 1856, p. 1.)

PLATE 26. Henri Le Secq. *South facade, Church of the Madeleine, Paris*. Salt print by Blanquart-Evrard from waxed-paper negative by Le Secq, 22.4 × 32.2 cm (8¹³⁄₁₆ × 12¹¹⁄₁₆ in). Plate 14 in *Paris Photographique* (Lille: Imprimerie Photographique de Blanquart-Evrard, 1851–1853). Printed on mount: "PARIS PHOTOGRAPHIQUE. / BLANQUART-ÉVRARD, ÉDITEUR. / ÉGLISE DE LA MADELEINE. / P. VIGNON ARCHTE 1807. MR HUVÉ ARCHTE 1830. / Imprimerie Photographique de Blanquart-Evrard, à Lille. / Pl. ". Other versions signed in negative, lower right.

Plans for the site of the Madeleine offer a history of classical building in France, ranging from the original plan for Louis XV of a domed church in the form of a Latin cross to Napoléon's projected Temple of Glory. The church that was erected, primarily designed by Pierre Vignon (1763–1828) and J. J. M. Huvé, was begun under the Bourbon Restoration in 1816 but not completed until 1842. This photograph appeared in Blanquart-Evrard's *Paris photographique*, a collection of at least thirty-six images of Parisian monuments made by various photographers. Characteristically, Le Secq included enough of the setting of the

church to locate us precisely as viewers, thus transforming a straightforward view of the main facade into an evocation of the experience of place. The variety of the surrounding buildings also emphasizes the rigorous classicism of the church's design. The buildings to the left were removed during baron Haussmann's rebuilding of Paris.

PLATE 27. Edouard Baldus. *Train Station, Toulon*. Albumen print from wet-collodion glass-plate negative, late 1850s, 27.6 × 43.2 cm (10⅞ × 17 in). Photographer's signature stamped on mount: "E. Baldus". Printed on mount: "TOULON".

This photograph appeared as the last plate in Baldus' album, *Chemins de fer de Paris à Lyon et à la Méditerannée* [sic], which commemorates the extension of the Lyon railway to Toulon. The picture describes the iron and glass shed of the new train station at Toulon, surrounded by traditional masonry construction. Despite the modernity of the subject, Baldus employed a traditionally symmetrical composition.

PLATE 28. Charles Marville. *Southern end of the Great Lake, Bois de Boulogne, Paris*. Albumen print from wet-collodion glass-plate negative, 1858, 21.1 × 35.2 cm (8⁵⁄₁₆ × 13⅞ in).

The city of Paris commissioned Marville to photograph the Bois de Boulogne, Napoléon III's first park and one of the primary projects in the rebuilding of Paris. A leather-bound album of fifty-nine views resulted—now in the Bibliothèque Nationale, Paris—which the city of Paris probably exhibited at London's International Exhibition of 1862. This image, which also appears as the ninth plate in that album, is part of a series of views around the two lakes designed by Napoléon III in imitation of Hyde Park's Serpentine. The man standing on the shore is probably Marville himself, here acting the part of the quintessentially nineteenth-century dandy or *flâneur*.

PLATE 29. Charles Marville. *Renaissance portico, Town Hall, Cologne*. Salt print by Blanquart-Evrard from waxed-paper negative by Marville, 35.2 × 25.7 cm (13⅞ × 10⅛ in). Plate 4 in *Les Bords du Rhin* (Lille: Imprimerie Photographique de Blanquart-Evrard, 1853). Printed on mount: "CH. MARVILLE, PHOT BLANQUART-ÉVRARD, ÉDIT. / HÔTEL DE VILLE DE COLOGNE / XVIe SIÈCLE." Written in ink on mount: "Town-house of Cologne."

Marville's photograph shows the oldest part of the Cologne Town Hall, which was built on the foundations of a Roman stronghold in the fourteenth century. In 1569–1571 an arcaded portico that faces the courthouse square, built from the plans of Wilhelm Vernickel (d. 1607), was added to the facade. Published by Blanquart-Evrard as the fourth of twenty-eight plates for *Les Bords du Rhin*, Marville's picture belongs to a tradition of recording the Rhine Valley as romantic river landscape and settlement. August Sander's photograph of Ander-

nach (plate 141) demonstrates the continuation of this pictorial tradition into the twentieth century.

HERMANN KRONE
1827–1916

§ Hermann Krone is known primarily as a portraitist in Dresden. The commercial nature of his photography and publishing studio is indicated by the information printed on the mounts of his photographs, where he refers to his studio as a *"photographic artistic establishment for portraiture and landscape."* In 1853 he published *Album der Sächsischen Schweiz*, comprising thirty-six topographical views. In that same year he suggested that the government of Saxony establish a post for the instruction of scientific photography and hire him. Due to lack of funds, and perhaps because photography as an academic subject was relatively unheard of at that time, the request was denied. Much later, in 1870, he became instructor of photography at the Dresden Polytechnikum. In 1898 he was appointed assistant professor and, subsequently, full professor of photography at the Dresden Technical College, from which he retired in 1907. Krone was responsible for many technical advances in the medium and he was awarded many honors.

Reference: Eder, *History*, pp. 686–687, 771.

PLATE 30. Hermann Krone. *Hofkirche and Opera House, Dresden*. Albumen print from wet-collodion glass-plate negative, before 1869, 16.5×21.4 cm (6½×8⅞ in), with rounded corners. Numbered in negative, lower right: "185." Printed on mount: "Dresden./Photogr. u. Verlag v. Hermann Krone, Dresden, Waisenhausstr. 15. Photogr. artist. Anstalt für Portrait und Landschaft./Appareille."

Krone's harbor view along the Elbe River in Dresden includes popular tourist sites: the Brühl Terrace, the Hofkirche, and, in the distance, Semper's opera house. Gottfried Semper (1803–1879), who in 1834–1841 built the round neoclassical structure seen here, also designed a second opera house, which replaced the original after its destruction by fire in 1869. Dresden was devastated during World War II, and the Hofkirche, built between 1739 and 1755 by Gaetano Chiaveri (1689–1770), has been much restored.

G. THOMAS HASE

§ No specific details are known about the life of G. Thomas Hase. His views of popular sites in Freiburg, such as the town hall and the cathedral, as well as the oval presentation format, suggest that he made them for the tourist trade.

PLATE 31. G. Thomas Hase. *Freiburg Münster from the Schlossberg*. Albumen print from wet-collodion glass-plate negative, 1850s(?), 13.5×11.4 cm (5¹⁵⁄₁₆× 4½ in), with rounded corners. Written in ink on mount: "Friburg en Brisgoux/ Cathédrale Notre Dame". Printed on mount: "G. Th. Hase Maler & Hofphotograph, Freiburg i.B."

The dark red sandstone cathedral stands in the center of Freiburg, a medieval city founded in the eleventh century in Breisgau. The transept and side towers date from the twelfth century, the nave was begun about 1250, and the tower was built between 1270 and 1301. Hase's photograph was taken from the Kanonen-Platz on the Schlossberg, a favorite tourist spot that overlooks the city from the south.

PLATE 32. Anonymous. *Towers, west end, Church of St. Lorenz, Nuremberg*. Salt print from paper negative, 1860, 27.3×23.8 cm (10¾×9⅜ in). Titled in ink on mount: "Lorenzkirche/König-Strasse./1860/Nürnberg."

The west facade of the church of St. Lorenz (begun *ca.* 1278) faces the Lorenzer-Platz in the center of Nuremberg. The towers of the west end face the Königstrasse, one of the most active commercial streets in the city. The covered farmers' carts in the foreground suggest the bustling life of the thoroughfare. Most of Nuremberg was severely bombed during World War II and has been heavily reconstructed since 1945, with restoration of the Church of St. Lorenz begun in 1952. The houses that line the street on the right of the photograph were rebuilt with sandstone, while those on the left are completely modern structures.

PLATE 33. Anonymous. *West facade, Church of St. Nicolai, Hamburg*. Albumen print from glass-plate negative, before 1875, 33.2×26.4 cm (13¹⁄₁₆×10⅜ in). Titled in pencil on mount: "Nicolaikirche-Hamburg".

The Church of St. Nicolai, located in the old city near the harbor of the North Elbe River, was designed by the celebrated British church architect, Sir George Gilbert Scott (1811–1878). Based on fourteenth-century German Gothic vocabulary, it was begun in 1842, but the west tower (485 feet tall) was not completed until 1874, just after the time of this photograph. This view, like others of the same subject, emphasizes the dominant position of the church in the stall-lined market area.

PLATE 34. Attributed to Bisson Frères. *Mined tower, Heidelberg Castle*. Albumen print from wet-collodion glass-plate negative, before 1858(?), 34.3×41.8 cm (13½×16⅞ in). Numbered in ink on print, right edge: "57".

Heidelberg Castle was probably begun by Count Palatine Ludwig I between 1214 and 1231, and a later building was erected by Rupert III at the end of the fourteenth century. It was expanded during the sixteenth and seventeenth cen-

turies, but was largely destroyed in the Thirty Years' War (1618–1648). This tower, located on the hill just southeast of the castle complex, was mined by the French in 1693. Its construction was so sound, however, that half of the tower fell as an unbroken mass into the moat. The upper section of the remaining walls (nineteen feet thick) and the tangle of vegetation that covers the ruin fill this photograph with great presence and detail. Less picturesque and more architecturally informative views of Heidelberg Castle by the Bisson Frères were deposited at the Bibliothèque Nationale in 1858 as part of *Reproductions photographiques des plus beaux types d'architecture et de sculpture*. The size and the quality of this print as well as the compositional approach suggest an attribution to the Bisson Frères.

JEAN-FRANÇOIS-CHARLES-ANDRÉ
(called Frédéric) FLACHÉRON
1813–1883

§ Frédéric Flachéron, the son of one of the official architects of the city of Lyon, became a pupil of the sculptor David d'Angers in about 1836. In 1839 he won the second Prix de Rome, which entitled him to study at the French Academy there. In 1842 he married Caroline Hayard, whose father owned an artists' supply store on the Piazza di Spagna. Flachéron apparently took up photography in 1848 or 1849, becoming the center of a small circle of amateur photographers that included Eugène Constant. Works in the collection of the Bibliothèque Nationale, all salt prints of Roman monuments, are dated 1849, 1850, and 1852. In 1851 Flachéron exhibited seven large views of Rome at the International Exhibition, London. Flachéron left Rome in 1867, perhaps for Paris, where he died in 1883.

Reference: Helsted, "Rome in Early Photography," p. 346.

PLATE 35. Frédéric Flachéron. *The "Colonnacce," Forum of Nerva, Rome.* Salt print from paper negative, 1852, 34.3×27.5 cm (13½×10¹³⁄₁₆ in). Signed and dated in negative, lower left: "F. Flacheron/1852."

Nearly every photographer in nineteenth-century Rome recorded this view of the remains of the first-century A.D. Forum of Nerva. Only the occupant of the store at the right changed: the bakery shown here appeared in about 1850 and disappeared within a few years. Flachéron often returned to the same sites again and again. At the same time of day in 1849, for example, he made a horizontal version of this same view, now in the Bibliothèque Nationale, Paris.

EUGÈNE CONSTANT

§ Little is known about the life of Eugène Constant. A letter to the London *Art Journal* places him within the group of amateur photographers who gathered around Flachéron in Rome: "*There is the Prince Giron des Anglonnes, Signor Caneva, M. Constant and M. Flacheron (this formed in 1850 the photographic clique), and on the whole, their method of manipulation is attended with more success than is generally met with in* [England]." (*Humphrey's Journal of Photography*, vol. 5, July 15, 1852, p. 100.) Other salt prints by Constant, all of Roman subjects, are dated 1848.

PLATE 36. Eugène Constant. *Temple of Saturn, Roman Forum, Rome.* Salt print from albumen-on-glass negative, early 1850s, 21.1×28.3 cm (8⁵⁄₁₆×11⅛ in). Numbered in negative, lower right: "11". Signed on verso, upper left: "Constant".

The Roman Forum remained a picturesque disorder of landscape and architecture throughout the nineteenth century, despite continuing excavation and restoration. In this photograph, however, Constant created a rigorous rectilinear structure using the eight columns of the west face of the Temple of Saturn, to which the assortment of built elements around and behind offer contrast. The crisp definition of the dark areas and the sharpness of the edges suggest that this print was made from an albumen-on-glass negative, a process that Constant used with dexterity (*Bulletin de la Société française de Photographie*, vol. 2, 1856, p. 54).

PLATE 37. Auguste-Rosalie Bisson. *Roman Forum and Church of Ss. Luca e Martina, Rome.* Albumen print from wet-collodion glass-plate negative, before 1864, 28.6×39.5 cm (11¼×15⁹⁄₁₆ in). Photographer's stamp on mount: "BISSON JEUNE PHOTOG. DE S. M. L'EMPEREUR." Titled in pencil on mount: "Arc de Septime Sévère".

Like Constant's view of the Roman Forum, Bisson's photograph presents a strong formal order made up of the jumble of ruins and remains that constituted the northwest corner of the Forum in the nineteenth century. Bisson framed the Arch of Septimius Severus and the baroque Church of Ss. Luca e Martina, just outside of the Forum, with the Temple of Concord at the left and the end of the ruined Temple of Saturn at the right. The extraordinary richness of the print suggests that Bisson intended the picture for exhibition.

ADOLPHE BRAUN
1812–1877

§ Adolphe Braun was born in Besançon, but he settled in Alsace in 1831 after artistic training in Paris. He began his career as a draftsman for a textile firm,

Dollfus-Meigs, in Mulhouse. By 1848 Braun had become sufficiently successful to establish his own studio in the Mulhouse suburb of Dornach and to publish an album of original floral designs. An ambitious and enterprising businessman, Braun began to use photography rather than lithography to reproduce flowers. His handsome, large albumen prints of formally arranged and casually disposed flowers created a sensation when Braun exhibited a group at the Exposition Universelle, Paris, in 1855, and the jury awarded Braun a gold medal for the variety and usefulness of his images to the textile industry. During these years, Braun exhibited and sold his floral photographs in Britain as well as France. Perhaps as a result of his success at the Exposition Universelle, Braun gave up textile design to devote himself entirely to photography. He soon ran one of the largest studios in the world: in 1869 Braun estimated that his stock consisted of about 4,000 picturesque views taken either by himself or one of his operators. Braun also exhibited panoramas, landscapes, and portraits at the major European photographic exhibitions despite growing professional responsibilities. These included being the official photographer to the Court of Napoléon III, a service for which he was made Chevalier of the Legion of Honor in 1860. The need to assure the permanence of his prints led Braun, like many of his contemporaries, to experiment with various methods of duplicating the light-sensitive, fragile photographic print. In 1866 Braun purchased a franchise for use of a carbon process from Joseph Wilson Swan, who had perfected Alphonse-Louis Poitevin's original invention of 1855. The carbon process and, after 1876, the woodburytype guaranteed Braun's ability to produce permanent prints. Braun specialized in the reproduction of fine arts, even publishing facsimiles of graphic works on fine carbon tissues. In 1876 the firm changed its name to Braun et Cie. Braun died in Dornach the following year. In 1889 the name became Braun, Clément et Cie, and the company continued well into the twentieth century.

Reference: Rosenblum, "Adolphe Braun."

PLATE 38. Adolphe Braun. *Arch of Constantine, Rome.* Carbon print from glass-plate negative, before 1876, 36.2×48.1 cm (14¼×18⅖ in). Printed on mount: "A. BRAUN à DORNACH, (Haut-Rhin)". Written in ink on mount, partially cut off: "431 Rome. Ar".

The triumphal arch of Constantine, erected in 315 A.D. by the Emperor to commemorate his victory over Maxentius in 312 A.D., stands between the Colosseum and the Roman Forum. A highly visible remnant of antiquity, the arch was one of the most photographed monuments in nineteenth-century Rome. Braun's view of the south side of the arch includes the edge of the Colosseum at the extreme right and, within the central bay, the ruins of the Meta Sudans, an ancient fountain that probably was erected by Domitian at the end of the first century A.D. and removed by Mussolini in 1936.

232

GIOACCHINO ALTOBELLI
POMPEO MOLINS
Born 1827

§ Gioacchino Altobelli and Pompeo Molins began their careers as painters. From about 1860 to 1865, they shared a photography studio in Rome and worked for the French Academy as photographers. After their partnership ended in 1865, Altobelli managed the photography studio of Enrico Verzaschi until 1875, but he also continued to work independently. Molins worked on commission for the British publisher and archeologist John Henry Parker (1806–1884), recording ruins and monuments in and around Rome. Unfortunately, Molins' studio burned down in 1893, badly injuring him and destroying the more than three thousand negatives that Parker had assembled and Molins had received after Parker's death. The most complete set of Parker's collection known today exists in the Kelsey Museum of Archaeology, the University of Michigan, Ann Arbor.

Reference: Keller and Breisch, *A Victorian View of Ancient Rome.*

PLATE 39. Gioacchino Altobelli and Pompeo Molins. *Arch of the Silversmiths, Rome.* Albumen print from wet-collodion glass-plate negative, early 1860s, 26.4×36.8 cm (10⅜×14½ in). Signed in pencil on mount: "Altobelli e Molins".

This arch was dedicated to the Emperor Septimius Severus and his family by the guild of silversmiths in 204 A.D. Its relief sculpture, which represented the Imperial family offering sacrifices to the gods, was altered by Caracalla, son and successor of Septimius. After he murdered his own wife Plautilla and his only brother Geta, Caracalla had their portraits chiseled from the arch. The inscription, just visible here on the lintel, also was modified. Characteristically, Altobelli and Molins have added the anecdotal detail of men gambling before the arch.

PIETRO DOVIZIELLI

§ Nothing is known about the life of Pietro Dovizielli, one of Italy's most celebrated and impressive early photographers. The evident popularity of his widely exhibited photographs makes this absence of information very surprising. He showed at the Exposition Universelle, Paris, in 1855, where he won a second-class medal for his *"charming views of Rome made on albumen glass negatives"* (quoted from the jury report, *La Lumière*, May 2, 1855, p. 71). The *Sun* reviewed the Architectural Photography Association's exhibition in 1861: *"What shall we say of such astounding photographs as those two brought to us from Rome by P. Dovizielli; No. 30, the Coliseum, the grand old ruined Coliseum, and No. 52, St. Peter's sublime and world-famous cathedral? What—but that they are the very paragons of architectural photography! Yonder it is the vera effigies of that grim and wondrous*

pile, before the mere idea of which poor Edgar Poe thus mused in poetic contemplation..." (quoted in *The Journal of the Photographic Society*, vol. 7, January 24, 1860/1, p. 120). Dovizielli also exhibited at the Esposizione Italiana in Florence in 1861 and the Universal Exhibition, London, in 1862. His photographs of paintings won a bronze medal at the Exposition Universelle in Paris in 1867. In 1864 John Murray's *Handbook of Rome and Its Environs* (London: 7th ed., p. xxii) described Dovizielli as one of Rome's finest photographers, thus assuring the patronage of countless British travelers.

PLATE 40. Pietro Dovizielli. *Spanish Steps and the Church of Trinità dei Monti, Rome*. Albumen print from albumen-on-glass negative, *ca.* 1854, 40.2×31.1 cm (15 13/16×12 1/4 in). Photographer's oval blindstamp on mount: "ETABLISSEMENT PHOTOGRAFIQUE/RUE BABUINO 135/P. DOVIZIELLI/ROME". Printed on mount: "PIAZZA DI SPAGNA". Numbered in pencil on mount: "63".

Piazza di Spagna, the Spanish Steps, and Trinità dei Monti mark one of the centers of nineteenth-century Rome. Built in the early eighteenth century, the steps form a wonderfully inviting public space. They are located between the piazza, with its fountain designed by Bernini's father, Pietro (1562–1629), in the early seventeenth century, and the Franciscan church, consecrated by Pope Sixtus V in 1585. The church was devastated during the French Revolution, but restored by order of Louis XVIII in the nineteenth century. Unlike many other nineteenth-century views of the steps, Dovizielli's picture does not show the crowds that normally congregated there. Only the corner of a vendor's tent at the left suggests the usual commercial activity of the site.

PLATE 41. Pietro Dovizielli. *Church of S. Giovanni in Laterano and Porta S. Giovanni, Rome*. Albumen print from albumen-on-glass negative, *ca.* 1854, 29.5× 40 cm (11 5/8×15 3/4 in). Photographer's oval blindstamp on mount: "ETABLISSEMENT PHOTOGRAFIQUE/RUE BABUINO 135/P. DOVIZIELLI/ROME". Printed on mount: "PORTA S. GIOVANNI". Numbered in pencil on mount: "46".

Dovizielli's photograph shows the roofline of the eastern facade of S. Giovanni in Laterano, the major church of Rome since the time of Constantine, rising above the third-century Aurelian walls of Imperial Rome. To the right is the Porta S. Giovanni, a grand rusticated gateway built by Pope Gregory XIII in 1574 to mark the entry of the Via Appia Nuovo into Rome. Beyond stand the remains of two towers of the Roman fortifications. This juxtaposition of diverse historical constructions, so typical of Rome, probably determined the vantage point of the photographer, who thus could appeal to the taste of both tourist and historian.

JAMES ANDERSON
1813–1877

§ James Anderson, born Isaac Atkinson in Blencairn, Cumberland, began his career as a painter, studying art in Paris under the assumed name of William Nugent Dunbar. In 1838 he moved to Rome, where he developed a successful business making small bronze models of sculptures under the name of James Anderson. He became interested in photography in 1849, possibly as a means of reproducing the sculpture that he copied. In 1853 he established a photographic studio in Rome, and in 1859 he published his first catalog. Anderson rapidly became one of the best-known photographers in Italy, specializing in reproductions of works of art. In 1864 John Murray's *Handbook of Rome and Its Environs* (London: 7th ed., p. xxii) listed his photographs as "*the best we have seen, ... extremely faithful and good, and of different sizes to suit all purses and purchasers. ... Mr. Anderson is the most extensive producer of photographs in Rome.*" By 1881, the guidebook (London: 13th ed., p. 23) specified the further convenience that Anderson's dealer Spithöver "*will forward photographs at a moderate charge to England ... and the United States. ... by which all trouble at the frontier custom-houses will be avoided.*" He also exhibited his work abroad, showing at the Universal Exhibition, London, in 1862, for example. Anderson married Maria de Mutis, and they had four sons. The eldest, Domenico (1854–1939), carried on the studio after his father's death in Rome in 1877, and the business continued to be run by the family until after World War II. When the studio finally closed in 1960, Fratelli Alinari acquired 40,000 of Anderson's glass-plate negatives. Even today Anderson's photographs continue to be a major source for art historians.

PLATE 42. James Anderson. *Braccio Nuovo, Vatican Galleries, Rome*. Albumen print from wet-collodion glass-plate negative, *ca.* 1854, 28.1×36.4 cm (11 1/16× 14 5/16 in). Photographer's oval blindstamp on mount: "JAMES ANDERSON/ ROME". Blindstamp on mount: "LIBRERIA TEDESCA/DI/GIUSE SPITHÖVER, /IN ROMA". Written in pencil on mount: "43".

The Braccio Nuovo was built by Raffael Stern for Pope Pius VII between 1817 and 1822, a time of developing interest in the design of public museums. The gallery houses some of the major works of the Vatican's collection of antique sculpture, including the marble copy of Lysippus' Apoxyomenos, here visible against the doorway. Anderson's photograph clearly describes the manner of installation. Classical busts on half-columns alternating with free-standing statues in niches encircle the generously sky-lit gallery, and ancient mosaics cover the floor. A colossal basalt crater marks the center of the hall.

ROBERT MACPHERSON
1811–1872

§ Robert Macpherson, a Scottish Highlander of the same family as James Macpherson, the author of the forged epic poem *Ossian*, studied medicine in Edinburgh from 1831 to 1835 but did not complete his degree. In about 1840 he moved to Rome, where he became a landscape painter of some competence and a lively member of the British artistic community. Resplendent in appearance, with flaming red hair and often dressed in the kilt of his clan, Mac–as his friends called him–was described as argumentative, generous, and energetic. Macpherson was a Catholic, which increased his distinctiveness among the British in Rome. In 1849 he married Geraldine Bate, the niece of the British writer Anna Jameson. Macpherson took up photography in 1851, perhaps because he needed a reliable profession to support his growing family. Within a few years he had become one of the most accomplished of the photographers in Italy. By 1859 he had 187 views available for one scudo each, a list that had increased to 305 by 1863. Macpherson maintained active professional connections abroad, taking an interest in the formation of the Scottish Photographic Society and exhibiting photographs in London and in Edinburgh. A large public show of over 400 of his photographs at the Architectural Photography Association, London, in 1862, furthered his reputation. *The Athenaeum*, like most other periodicals, enthusiastically praised the exhibition: "*A magnificent series of the monuments of Rome is on view at No. 9, Conduit Street. They are photographed by Mr. Robert Macpherson, of that city; the subjects chosen with fine taste, and the pictures executed with skill and delicacy. From this exhibition the collector may obtain everything he wants of Rome, from the Coliseum to a cameo.*" (August 9, 1862, p. 181.) Macpherson also bought and sold works of art to supplement his income, not an unusual practice for British artists in Rome at that time. Most spectacular was his acquisition of Michelangelo's *Entombment of Christ* for a small sum from a Roman picture dealer in 1846. After cherishing it for many years as "Geraldine's fortune," he finally sold the painting to the National Gallery, London, for £2,000 in 1868. Macpherson died in Rome in 1872, survived by his wife and four children

Reference: Coffey and Munsterberg, "Robert Macpherson."

PLATE 43. Robert Macpherson. *View of Rome from the French Academy, Monte Pincio*. Albumen print from wet-collodion glass-plate negative, probably before 1863, 29.8×39.7 cm (11¾×15⅝ in). Titled in ink on mount: "St Peter's from Pincio".

Macpherson's view from the French Academy frames the dome of St. Peter's between trees in the gardens of Monte Pincio. Countless artists, including Jean-Baptiste-Camille Corot, represented the subject, and many chose to play off the circular architectural elements of the fountain basin and the dome. Macpherson broke that symmetry by showing only half the fountain. The resulting photograph describes the tranquility of the Villa Medici's gardens and the celebrated vista rather than the extent of the view. Instead of a contrast of near and far, Macpherson's image juxtaposes the view and its copy in the still water of the basin.

PLATE 44. Robert Macpherson. *Palazzo dei Consoli, Gubbio*. Albumen print from wet-collodion glass-plate negative, *ca.* 1864, 26.7×40.6 cm (10½×16 in). Photographer's oval blindstamp on mount: "MACPHERSON/ROME", numbered "331a" in pencil in center of oval.

Although most of his subjects were in and around Rome, Macpherson also took photographs elsewhere in Italy. This view of the fourteenth-century Palazzo dei Consoli in Gubbio describes the dramatic juxtaposition of monument and formal space with the open landscape so characteristic of the hill towns of central Italy. Macpherson's use of a lens of wide angle enabled him to capture the whole of the impressive facade from one side of the Piazza della Signoria. The resulting spatial distortion intensifies the sense of emptiness.

PLATE 45. Robert Macpherson. *Bas relief, west facade, Orvieto Cathedral*. Albumen print from wet-collodion glass-plate negative, probably before 1859, 27.6× 37.1 cm (10⅞×14⅝ in). Photographer's oval blindstamp on mount: "MACPHERSON/ROME", numbered "133" in pencil in center of oval. Titled on Macpherson's list from 1859: "133. Bas-reliefs illustrative of the history of Christ".

Macpherson listed five photographs of Orvieto Cathedral in his catalog of 1859: a general view of the cathedral, two views of two of the portals, and two details of the bas relief sculpture that ornaments the west facade. This picture, one of the latter, describes the sheen of the carved marble surface as well as the virtuosity of the modeling. The section shown here contains scenes from the life of Christ and Mary.

LÉON GÉRARD

§ Nothing is known of Gérard's life except the travels indicated by his photographs: Nuremberg and Bamberg in 1857, the Rhine Valley, Switzerland, northern Italy, and Loire-et-Cher in France. He exhibited a few of these photographs at the Société française de Photographie in 1861, where they attracted praise from the art critic Ernst Lacan (*La Lumière*, 1861, p. 42). Like other contemporary photographers such as Louis de Clercq and Robert Henry Cheney, Gérard exploited the grainy softness of waxed-paper negatives and the smooth finish of albumen prints. Using these means, he created haunting images that seem to express a personal and highly cultivated sensibility.

PLATE 46. Léon Gérard. *Terra cotta decoration, southern apse, Church of S. Maria delle Grazie, Milan*. Albumen print from waxed-paper negative, *ca.* 1857, 26.4 × 36 cm (10⅜ × 14³/₁₆ in). Signed, titled, and numbered in negative: "Léon Gérard/ Milan/103". Titled in ink on mount: "Détails de l'Abside de Sta Maria delle Grazie./Milan/(Terre Cuite)".

The abbey church of S. Maria delle Grazie, built during the fifteenth and sixteenth centuries, is best known for its sixteen-sided dome, possibly designed by Donato Bramante (1444–1514) between 1492 and 1497. Its refectory contains Leonardo da Vinci's *Last Supper*. Gérard's photograph depicts the terra cotta decoration on the southern apse. Although informative architecturally, the picture transforms the view into a study of light and dark, modeling a sensuously carved surface.

POMPEO POZZI

§ Pompeo Pozzi photographed architecture in Milan and northern Italy from about 1850. Many of his photographs are marked on the mount with the blind-stamp, "Pozzi-Milano." Nothing is known of his life or career.

PLATE 47. Attributed to Pompeo Pozzi. *Sepulchral monuments of the Andreani, Corenno Plinio*. Albumen print from waxed-paper negative, *ca.* 1860, 26.7 × 37.8 cm (10½ × 14⅞ in).

The fourteenth-century tombs of the Andreani, located in Corenno Plinio on Lake Como, are impressive examples of Northern Gothic sepulchral monuments. Pozzi's photograph emphasizes the scale and depth of the aristocratic family's memorials, which squeeze and dwarf the narrow church door that appears between them. A third tomb stands to the left of the two shown here.

PLATE 48. Léon Gérard. *View of the Mole from Giudecca, Venice*. Albumen print from waxed-paper negative, *ca.* 1857, 22.5 × 35.2 cm (8⅞ × 13⅞ in). Signed and numbered in negative, left center: "Léon Gérard/Venise" and right center: "162". Titled in ink on mount: "Venise./Vue du Môle, prise à la pointe de la Giudecca".

This photograph by Gérard creates an almost emblematic view of Venice: the Campanile of San Marco, extended by its reflection in the Grand Canal, bisects the long strip of the Mole. The stillness of the picture, the importance of the reflection, and the apparent immateriality of the architecture create an image closer in spirit to the watercolor depictions of Venice by earlier artists, such as Joseph Mallord William Turner, than to contemporary photographic views. This is typical of the generally poetic and allusive nature of Gérard's photographs.

CARLO PONTI

§ Carlo Ponti was an optician who became one of Italy's most prominent photographers. His studio sold views from all over the country but specialized in depictions of architectural subjects in Venice. Beginning in the 1860s, Ponti sold Venetian views in albums entitled *Ricordo di Venezia*. Judging from the variety of prints found in extant examples, the purchaser must have selected twenty photographs to be bound within an inexpensive embossed cover. All of the photographs were mounted on board, often stamped with decorative surrounds, and many of the pictures had printed notices in Italian, French, or English on the verso describing the location of the view and a little of its history. In 1866 Ponti was awarded the title of Optician and Photographer to H.M. the King of Italy at Venice.

Plates 49, 51, 53.

PLATE 49. Carlo Ponti. *Doge's Palace and Church of S. Maria della Salute, Venice*. Albumen print from wet-collodion glass-plate negative, 1860s(?), 24.9 × 34.6 cm (9¹³/₁₆ × 13⅝ in). Photographer's blindstamp on mount: "CARLO PONTI/VE-NEZIA". Titled in pencil on verso of photograph: "Ducal Palace, Venice, Church of La Salute."

Ponti's photograph depicts the commercial activity of the Riva degli Schiavoni, the landing stage of the city and lagoon steamers, which is set against one of Venice's most famous vistas. To the left rise the distinctive domes of S. Maria della Salute, while along the Mole stand the fourteenth-century Doge's Palace and the sixteenth-century Libreria Vecchia and, between them, the two granite-topped columns that mark the approach to the piazzetta between the water and the Piazza San Marco. Immediately to the right, over the Ponte della Paglia, are the Prigioni Criminali.

PLATE 50. Anonymous. *Piazza San Marco, Venice*. Albumen print from wet-collodion glass-plate negative, 1860s(?), 22.1 × 27.1 cm (8¹¹/₁₆ × 10¹¹/₁₆ in).

The Piazza San Marco is bounded by two Renaissance buildings, the Procuratie Vecchie on the north and the Procuratie Nuove on the south, the Napoleonic Nuova Fabbrica on the west, and the Byzantine Basilica of San Marco on the east. The scale and unity of the long-arcaded buildings create one of the most impressive public spaces in the world. In this picture, the photographer has squared off the trapezoidal piazza by simultaneously cropping it and framing it with two of the three bronze flagstaffs in front of the basilica. The shadow of the Campanile falls across the strikingly empty piazza.

PLATE 51. Carlo Ponti. *Baptismal font, Baptistery, Basilica of San Marco, Venice.* Albumen print from wet-collodion glass-plate negative, 1860s(?), 32.1 × 25.9 cm (12⅝ × 10³⁄₁₆ in).

The Baptistery of San Marco lies to the south of the basilica, next to the Chapel of San Zeno. At the east end are an altar and tombs, while in its center is the large bronze baptismal font shown here, designed by Jacopo Sansovino (1486–1570) in 1545. Reliefs adorn the lid, and on the top stands a statue of St. John the Baptist by Francesco Segala (d. 1593?). The view was a popular one, almost duplicated by the contemporary photographer Carlo Naya, Ponti's major rival.

JAKOB AUGUST LORENT
1813–1884

§ Jakob August Lorent was one of the first German photographers to gain an international reputation. Born in Charleston, South Carolina, Lorent grew up in Mannheim, where his family had moved when he was four. He studied natural sciences, especially botany and zoology, at the University of Heidelberg, and after completing his studies in 1836 Lorent began traveling extensively throughout Europe and the Near East. In the course of these journeys, he identified eight new species of plants, which were named after him. In 1850 Lorent's foster-father died, leaving Lorent with a private income for the rest of his life. He was married in London in the same year. Lorent appears to have taken up photography in 1853, when he signed and dated a number of large waxed-paper negatives of Venetian architectural subjects. These photographs won him a gold medal at the first German industrial exhibition in Munich in 1854 and a first-class medal at the Exposition Universelle, Paris, in 1855. In 1856 Ernst Lacan reviewed Lorent's Venetian photographs at the Photographic Exposition, Brussels, with the highest praise: "*Ses vues de Venise, obtenues, nous le croyons, sur papier ciré, ont une ampleur, une harmonie, une vigueur, qui en font des oeuvres tout à fait magistrales. . . . Indépendamment de leurs dimensions exceptionnelles, ces vues ont un grand aspect, et l'on y retrouve toute la chaleur du beau soleil de l'Adriatique. M. Laurent* [sic] *est le Baldus vénitien.*" [His views of Venice, taken, we believe, with waxed-paper negatives, have an amplitude, a harmony, a vigor, that make the works magisterial. . . . Independent of their exceptional dimensions, the views have a grandeur, and one finds in them all the heat of the beautiful Adriatic sun. M. Lorent is the Venetian Baldus.] (*La Lumière*, October 11, 1856, p. 1.) In 1858 Lorent became a member of the Société française de Photographie. At the end of the year, he returned to Mannheim. In 1859–1860, Lorent traveled to Egypt, where he produced pictures that he regarded as his finest achievement, and trips to Greece (1860), Rome (1863), Jerusalem (1864), and southern Italy (1865) followed. Lorent exhibited these new photographs, as well as his earlier views of Venice and northern Italy, throughout the early 1860s; they won many prizes. In Mannheim, in 1861, 1862, and 1865, he issued a selection of pictures of Egypt, Greece, and Jerusalem to accompany accounts of the three trips. In 1865 Lorent began a new project, which occupied the next six years: the documentation of South German medieval architecture, using wet-collodion negatives and albumen prints. Three hundred and fifteen of these pictures were published in four volumes between 1865 and 1870. In 1870 three German princes gave him the honorific "von" in recognition of his photographic accomplishment. In 1873 he moved to Merano, on the southernmost edge of the Alps, where he continued to photograph and write about photography until his death in 1884.

Reference: Franz Waller, "Jakob August Lorent."

PLATE 52. Jakob August Lorent. *Ca' da Mosto, Venice.* Salt print from waxed-paper negative, 1853(?), 48.4 × 38.1 cm (19¹⁄₁₆ × 15 in). Signed in negative, lower center: "A. Lorent". Written in pencil on mount: "Dr A. Lorent/Venise Si vende da Guise Milani S. Marco 77. Palazzo a St. Apostoli (Venezia)/114".

The Ca' da Mosto, located on the Grand Canal in Venice, is a thirteenth-century house named after a celebrated family of seafarers. The Gothic windows of the first floor as well as the surrounding panels and marble facings of the original building remain, despite many later additions and alterations. In the fifteenth century, the house became one of the best-known inns in Venice under the name Albergo del Leon Bianco. Its guests included Emperor Joseph II in the 1760s.

PLATE 53. Carlo Ponti. *Casa del Tintoretto, Venice.* Albumen print from wet-collodion glass-plate negative, 1860s(?), 35.6 × 27 cm (14 × 10⅝ in). Photographer's blindstamp on mount: "PONTI/RIVA DEI SCHIAVONI/VENEZIA". Printed text on verso of mount: "Maison du Tintoretto. On ignore le premier propriétaire ainsi que l'architecte de cette maison, reconnue au style du/siècle 14e. Les fenêtres et la porte de l'étage inférieur sont une restauration d'un âge plus récent./Ici mourut l'an 1594 Jacques Robusti, surnommé le Tintoretto. La maison appartient à la famille Casser, qui l'acheta du fils du peintre même."

The painter Jacopo Robusti, known as Tintoretto, died in 1594 in the house that now bears his name. An early fifteenth-century building with Gothic detailing, the Casa del Tintoretto adjoins the Casa Mastelli in the Fondamenta dei Mori. The street acquired its name from three sculptures of men in Oriental dress that fill niches in the facades of the houses. One of them is clearly visible here at the left.

LEOPOLDO ALINARI
1832–1865
ROMUALDO ALINARI
1830–1891
GIUSEPPE ALINARI
1836–1891

§ Leopoldo Alinari was apprenticed to a well-known engraver, Giuseppe Bardi, in about 1845. Alinari not only learned the art of engraving, but he also came into contact with photography. By 1852 he had become sufficiently proficient with the camera to open a small photographic studio in Florence with Bardi's help. These early photographs by Leopoldo Alinari are identified by a blindstamp with Bardi's name. In 1854 Leopoldo's two brothers, Romualdo and Giuseppe, joined him, and together they founded Fratelli Alinari, Fotografi Editori. Their records and correspondence suggest that Leopoldo was the photographer, Giuseppe the business organizer, and Romualdo the administrator. The brothers rapidly gained a reputation for their reproduction of works of art as well as for picturesque views of Italian sights. They won a second-class medal at the Exposition Universelle, Paris, in 1855, for their pictures of Florence and Pisa, and in 1856 Ernst Lacan described their photographs displayed in Brussels: "*Ce qui distingue surtout les oeuvres de MM. Alinari, c'est le choix intelligent des effets de lumière, la pureté des lignes et une transparence dans les ombres.*" [That which distinguishes the works of MM. Alinari above all is the intelligent choice of effects of light, purity of line, and transparency in the shadows.] (*La Lumière*, October 4, 1856, p. 1.) During these years, they also received permission to photograph the paintings in the Uffizi Gallery, a much sought-after privilege. They photographed works of art in many other churches and museums. Leopoldo died in 1865, leaving his share of the business to his young son, Vittorio. By the end of the decade, the highly successful firm occupied a large studio on the Via Nazionale in Florence that had an exterior terrace for posing portrait sitters. When the capital of Italy moved to Florence in 1864, the brothers became the official government photographers, making portraits of Victor Emmanuel, members of the cabinet, and leading cultural figures. By the 1880s the company employed over one hundred people, and their published catalogs listed tens of thousands of photographs. When the last two brothers died in 1891, Vittorio took over management of the firm. In 1920 Fratelli Alinari was acquired by a Florentine group, and today the holdings of Anderson and Brogi have been united with those of Alinari under the name Fratelli Alinari. Their photographs became a standard source for art historians, and they can be found in every art library.

Reference: Zevi, *Alinari: Photographers of Florence.*

PLATE 54. Fratelli Alinari. *Palazzo delle Cascine, Florence.* Albumen print from wet-collodion glass-plate negative, *ca.* 1855, 24.1 × 32.4 cm (9½ × 12¾ in). Photographers' oval blindstamp on mount: "FRATELLI ALINARI/FOTOGRAFI/FIRENZE/PRESSO LUIGI BARDI". Titled in ink on mount: "Firenze/R. Palazzo delle Cascine".

The Cascine, 300 acres between the Arno and the Mugnone rivers west of Florence, was laid out as a park by the Medici during the Renaissance. In the nineteenth century, when the area was opened to the public, it became a popular place for fashionable rendezvous as well as solitary meditation. Shelley wrote "Ode to the West Wind" there in 1819. This photograph shows the southern facade of the Palazzo, an elegant eighteenth-century villa, and beyond it the characteristic profile of the Duomo and Campanile of Florence.

PLATE 55. Fratelli Alinari. *Palazzo Strozzi and Palazzo Corsi, Florence.* Albumen print from wet-collodion glass-plate negative, *ca.* 1855, 34.3 × 26.4 cm (13½ × 10⅜ in). Photographers' blindstamp on mount: "FRATELLI ALINARI/FOTOGRAFI/FIRENZE/PRESSO LUIGI BARDI". Titled in ink on mount: "Firenze./Palazzo Strozzi e Loggetta Corsi".

The Palazzo Strozzi, begun in 1489 for Filippo Strozzi but not finished until 1526, is one of the great monuments of the Florentine Renaissance. Its complicated architectural history probably includes contributions by Benedetto da Maiano (d. 1497) and by Il Cronaca (1474–1508), who designed the renowned cornice. This picture emphasizes the facade, which dwarfs the more delicate Palazzo Corsi by Michelozzo de Bartolommeo (1396–1472) to the north. The fashionable Via Tornabuoni is alive with people and carriages, almost all of them moving too rapidly to appear as more than ghostly blurs.

LOUIS-ALPHONSE DAVANNE
1824–1912

§ Louis-Alphonse Davanne, born in Paris in 1824, was a chemist and photographer. He was a founding member of the Société française de Photographie in 1854. Davanne first studied photography with Aimé Girard (1830–1898), with whom he tested the permanence of photographic positives between 1854 and 1863. The early results of this work earned them one of the gold medals from duc de Luynes, awarded by the Société française de Photographie in 1859. They published their studies in *Recherches théoriques et pratiques sur la formation des épreuves photographiques positives* (Paris: Gauthier-Villars, 1864). In 1852 the dentist Barreswill, the publisher Lerebours, the lithographer Joseph Lemercier, and Davanne cooperated to perfect a photolithographic process that used an asphalt base. To demonstrate the formula, they presented a set of photolithographs made from

some of Henri Le Secq's negatives to the Institut de France in 1854. Davanne is credited with conceiving the idea for a portable darkroom in 1855 and for developing the principle of a portable camera. Such a camera was actually assembled in 1859. Davanne later taught photographic technique at the Ecole des Ponts et Chaussées in 1872, at the Sorbonne in 1879, and he lectured at the Conservatoire des Arts et Métiers in 1891. Davanne's work was exhibited throughout the major cities of Europe between 1855 and 1898, with two exhibitions in London in 1858 and 1862. He traveled to France, Germany, Italy, Spain, and Algeria making photographs of landscapes, buildings and monuments, urban life, and reproductions of artworks. His early salt prints from paper negatives are sensitive, careful studies quite unlike the less interesting later works that bear his monogram blindstamp. Davanne died in Saint-Cloud in 1912.

Reference: *After Daguerre*, n.p.

PLATE 56. Alphonse Davanne. *Courtyard, Convent of San Francisco, Palma, Majorca.* Salt print from waxed-paper negative, early 1850s, 16.8×21.9 cm (6⅝× 8⅝ in).

The convent or friary of San Francisco was built under the protection of the kings of Majorca in the thirteenth century, but the main facade of the church was redesigned by Francisco Herrera (1576–1656) in the early seventeenth century. Next to the church is the cloister of the Franciscan monks, the courtyard of which appears here. Davanne's photograph records the architectural character of the cloister while simultaneously acknowledging its informal use. The image presents a rhythmic pictorial order of light and dark.

CHARLES CLIFFORD
Died 1863

§ Charles Clifford, a British resident of Madrid by 1852, was the court photographer to Queen Isabella of Spain, who often gave presentation albums of his photographs. In 1856 Clifford produced *Vistas del Capricho*, an album comprising fifty views of the fifteenth-century palace at Guadalajara and the eighteenth-century summer palace at Capricho. Clifford also took portraits. In 1861 he made a formal portrait of Queen Victoria on behalf of Queen Isabella. It was so well received that Queen Victoria commissioned a painted copy. She also bought some of his Spanish views. An album, *Voyage en Espagne*, was displayed in London at the first exhibition of the Photographic Society in 1854, and in 1856 four hundred images were exhibited under the same title at the Société française de Photographie. Based on these exhibitions, a series was planned for publication in both cities in 1863. It was never realized, probably because Clifford died in that year.

PLATE 57. Charles Clifford. *Ruins of the monastery of San Jerónimo, Yuste.* Albumen print from wet-collodion glass-plate negative, late 1850s, 41.3×31.6 cm (16¼×12 7/16 in). Titled in ink on mount: "SPAIN/RUINS OF MONASTERY-YUSTE".

The monastery at Yuste (Guadalajara), founded in 1404 by the Hieronymite order, is known primarily as the retirement place of the Emperor Charles V, who lived there as a monk from 1557 to 1558. Although the Emperor died at Yuste, he was buried at the Escorial, northwest of Madrid. The original monastic buildings at Yuste were destroyed during the Peninsular War (1808–1814), but the choir of the church, built in 1508, and the Emperor's death chamber, built in 1554, still stand. Clifford's photograph describes these ruins, peopled by an abbé and a layman, who is perhaps the photographer himself.

PLATE 58. Charles Clifford. *The Alhambra, Granada.* Albumen print from wet-collodion glass-plate negative, late 1850s, 29.2×41 cm (11½×16⅛ in). Photographer's oval blindstamp on photograph, lower right: "C. CLIFFORD/PHOTOGRAPHER". Written in ink on mount: "Granada. The Alhambra."

The Alhambra is situated on a natural acropolis and overlooks the city of Granada. Walls about thirty feet high enclose the entire complex, within which are two churches as well as numerous houses and palaces. The principal sections were built by Yusuf I (1334–1354), although the Alhambra was changed by many additions and damaged both during the Peninsular War (1808–1814) and in the earthquake of 1821. Some years earlier, in the 1770s, a survey funded by the government was undertaken to report on the condition of the Alhambra, but it was not until 1830 that the architect José Contreras Osorio was given funds to repair it properly. His work was continued by his son Rafael Contreras y Muñyoz (b. 1824), who was put in charge of the restoration of the Alhambra in 1852. The Alhambra was such a popular site that the Court of the Lions, with ornate Moorish arches, was replicated in the Great Exhibition at the Crystal Palace, London, 1851. In 1879 the site was declared a national monument. Clifford's picture is taken from a vantage point that underlines the Alhambra's role as a fortress. It is isolated at the top of the steep cliff and surrounded by lush stands of pine.

A. RICHEBOURG

§ Richebourg, who made a daguerreotype as early as 1840 (collection F. Braive), was trained by Daguerre's student, the Paris optician Vincent Chevalier. He is known to have taught photography himself, and he maintained a studio in Paris. He became a member of the Société française de Photographie in 1855, when his work began to be exhibited. Exhibitions in Paris as well as Brussels and London

followed regularly until 1867. As early as 1852 Richebourg experimented with enlargements, and the following year he put forth the idea of using photographs for passport identification. In 1859 Théophile Gautier wrote the text to accompany sixty albumen prints by Richebourg in the publication (which had been intended to include over two hundred images), *Trésors d'art de la Russie ancienne et moderne* (Paris: Gide, 1859). He photographed the installations of the Paris Salons of 1857, 1861, and 1865 and made a series of views of Prince Napoléon's Maison pompéienne in Paris. The range of his activities was so diverse that in the 1860s he even recorded murderers and their victims for the police department. He is last mentioned in the magazine *Le Moniteur de la Photographie* in 1872.

Reference: *After Daguerre,* n.p.

PLATE 59. A. Richebourg. *Portico of the Church of St. Isaac and the Admiralty, Leningrad.* Albumen print from wet-collodion glass-plate negative, 32.5×31 cm (12¹³⁄₁₆×12³⁄₁₆ in). Plate 4 in *Trésors d'art de la Russie ancienne et moderne* (Paris: Gide, 1859), with text by Théophile Gautier. Printed on mount: "SAINT-ISAAC/ PORTIQUE ET VUE DE L'AMIRAUTÉ/Richebourg, Photogr. Pl. 4 Gide, éditeur, Paris."

In 1703 Peter the Great established the capital of Russia in St. Petersburg, now Leningrad. He commanded the building of the Admiralty, which was designed by Adrian Dmietrievich Zakharov (1761–1811) and altered considerably in 1823. The cathedral, to the southwest of the Admiralty, was built during the reigns of Alexander I and Alexander II, between 1817 and 1858, by the French architect Auguste Ricard Montferrand (1786–1856). It had been newly finished when Richebourg took this picture. Perhaps the unusual angle of the photograph can best be explained by the photographer's desire to include in a single view these principal sites of nineteenth-century St. Petersburg.

P. MORAITES

§ Moraites appears to have been one of the most successful of the native photographers in Greece during the nineteenth century. Moraites exhibited his works abroad, where he also may have sold them, since the number of pictures by Moraites that has appeared in recent years suggests a wider audience than tourists to Greece. By the 1870s, Moraites had gained a modest critical reputation in both Europe and America. Hermann Vogel reviewed Moraites' photographs at the International Exposition in Vienna in 1873: "[Moraites] *contributes some good pictures of the Athenian ruins; these are, for the study of antiquity, invaluable.*" (*Photographic Journal of America,* vol. 10, 1873, p. 557.)

PLATE 60. P. Moraites. *View of the Acropolis with the Temple of Zeus and Arch of Hadrian, Athens.* Albumen print from wet-collodion glass-plate negative, 1860s, 25.4×32.9 cm (10×12¹⁵⁄₁₆ in). Signed and numbered in negative, lower center: "P. Moraites/42". Written in ink on mount: "View from Ilissus including Olympieium, Arch of Hadrian, Theatre of Bacchus/Odeium of Herodes Atticus or of Regilla & Acropolis."

Among the notable ancient ruins of Athens are the Temple of Zeus, finished by the Emperor Hadrian in 131–132 A.D. after centuries of building, and the Arch of Hadrian, erected in honor of that Roman emperor. Moraites' photograph shows the Acropolis rising above these two Roman monuments on the still-open plain of the city.

GEORGE M. BRIDGES

§ The Reverend George Bridges learned Talbot's process from Nicolaas Henneman, Talbot's printer, in 1845. Shortly thereafter, he left for a seven-year trip around the Mediterranean. His journey included stops at Malta, Italy, Greece, and the Near East. Some of the resulting salt prints were prepared for publication as parts of a portfolio entitled *Selections from Seventeen-Hundred Genuine Photographs: (Views-Portraits-Statuary-Antiquities.) Taken Around the Shores of the Mediterranean Between the Years 1846–52. With, or Without, Notes, Historical, and Descriptive. By a Wayworn Wanderer.* Like Nègre's *Midi de la France,* however, the full project never seems to have materialized. The quotations Bridges placed at the bottom of the title page suggest the gentlemanly spirit of his Grand Tour: "*L'Univers est une espèce de livre, d'ont on n'a lu que le première page quand on n'a vu que son pays.* § *The grand object of all Travelling is to see the Shores of the Mediterranean. On these Shores were the four great Empires of the World–the Assyrian–the Persian–the Grecian–and the Roman. All our Religion–almost all our Law–almost all our Arts–almost all that sets us above savages, has come to us from the Shores of the Mediterranean. Dr. Johnson.*" Bridges also published a book of twenty-one salt prints, each with a letterpress description, entitled *Palestine As It Is: In a Series of Photographic Views Illustrating the Bible* (London: J. W. Hogarth, 1858–1859). Like other amateur photographers in Talbot's circle, including Talbot himself, Bridges seems to have stopped photographing by 1860.

PLATE 61. George M. Bridges. *East facade, Temple of Athena Nike, Acropolis, Athens.* Salt print from paper negative, *ca.* 1850, 21×16.8 cm (8¼×6⅝ in). Plate v in *Selections from Seventeen-Hundred Genuine Photographs: (Views–Portraits–Statuary–Antiquities.) Taken Around the Shores of the Mediterranean Between the Years 1846–52. The Illustrations of the Acropolis of Athens.* Titled in contents: "The Temple of 'The Wingless Victory'-eastern front". Numbered in pencil on

mount: "15 " and "v". Photographer's stamp in black ink on verso of mount.

The Temple of Athena Nike, also known from Pausanias' description as the Temple of the Wingless Victory, was built between 427 and 424 B.C. to commemorate the Greek victory over the Persians in 478 B.C. This Ionic temple at the southwestern edge of the Acropolis remained in excellent condition until 1687, when the whole structure was pulled down to provide stone for the Turkish fortification of the Acropolis against the Venetians. Between 1835 and 1838, a team of German archeologists reconstructed the temple but neglected to secure its foundations firmly. As a result, a new phase of reconstruction was undertaken between 1936 and 1940. Bridges' view seems an appropriate one for the gentleman-amateur that he was, concerned with a leisurely perusal of the temple and its setting rather than a rigorous examination of specific architectural aspects.

JEAN WALTHER
1806–1866

§ Jean Walther was the son of Jean-Philippe Walther (1775–1852), a Lieutenant Colonel in the Swiss army and a cloth merchant. Jean and his brother David entered the cloth business in Vevey. Jean married Jeanne-Louise-Elizabeth Berengies in 1835 and had become sufficiently prosperous to buy a chateau called "Val Ombré" by 1842. Walther later photographed its buildings, vineyards, and gardens. In the late 1840s, about the same time as trips to Italy, England, and France, Walther took up photography. In the course of the next decade, Walther made at least two hundred paper negatives, most of subjects around Vevey and Geneva. Blanquart-Evrard published views by him of Greece, Malta, and Venice. Walther continued as an active photographer into the late 1850s; four photographs at the Société française de Photographie are inscribed "1856" on their verso. In the mid-1850s, however, Walther's fortunes seem to have declined, and in 1857 he sold his property. He died, without children, in Vevey in 1866. The largest collection of his work is now in the Musée du Vieux-Vevey.

Reference: typescript biography, Musée du Vieux-Vevey (copy in the Bibliothèque Nationale, Paris).

PLATE 62. Jean Walther. *View of the Erechtheion from the southwest, Acropolis, Athens.* Salt print by Blanquart-Evrard(?) from waxed-paper negative by Walther, 16.2×21 cm (6⅜×8¼ in). Plate 60, titled "Temple de Minerve Polliade, à Athènes," in *Mélanges photographiques* (Lille: Imprimerie photographique de Blanquart-Evrard, 1851–1853).

The Erechtheion, built between 421 and 406 B.C. on the northern edge of the Acropolis, expresses a very different sensibility from the classical grandeur of

the Parthenon. Walther's view beautifully illustrates the arrangement of the porches of the Erechtheion. The Porch of the Maidens, located on the temple's south side facing the Parthenon, is visible only to those on the Acropolis itself (see plates 63, 64). The corresponding structure on the north side of the temple, a deep Ionic porch with impressive columns, can be seen from afar (see plate 65). The east and west ends also are defined by Ionic columns, although those seen here on the west were blown down in a violent storm on October 26, 1852 and not replaced until 1904. Two wooden forms, windlasses or supports for columns in the process of reconstruction, lie in the foreground.

JAMES ROBERTSON
ca. 1831–after 1881

§ Robertson, a Scotsman, probably started as a gem engraver and exhibited four works at the Royal Acacemy, London, between 1833 and 1840. He moved to Constantinople sometime during the 1840s and there became Superintendent and Chief Engraver of the Mint. On one of his return trips to Britain, Robertson married Marie Matilda Beato, porbably a relation of Felice Beato, for in the early 1850s Robertson began to photograph with Beato. Their relationship is not clear. Some of the photographs are signed "Robertson & Beato," others "Robertson, Beato et Cie" (or "& Co."), and yet others with either "Robertson" or "Beato." They worked together in Malta (1850?), Constantinople (1853), Athens (1854), the Crimea (1855), Egypt (1857), Palestine (1857), and India (1857). In the mid-1850s they changed their technique from paper negatives and salt prints to glass negatives and albumen prints. Robertson exhibited widely and published pictures in England and France, especially during the 1850s. The *Illustrated London News*, for example, printed views from Constantinople regularly over his name during the mid-1850s. Little is known of Robertson after he left India, except that he continued to live in Constantinople until 1881.

Plates 63, 75.

Reference: Vaczek and Buckland, *Travelers in Ancient Lands*, pp. 195–196.

PLATE 63. James Robertson. *View of the Erechtheion from the southwest, Acropolis, Athens.* Salt print from albumen-on-glass negative, 1854, 23.7×29.7 cm (9⁵⁄₁₆× 11¹¹⁄₁₆ in). Signed in ink on print, lower right: "Robertson". Printed on mount: "ATHÊNES".

Robertson's picture of the Erechtheion describes the brilliance with which the Ionic temple incorporates the irregularities of its site and the surrounding ancient shrines into a single, elegant structure. The photograph also records evidence of much damage suffered by the temple: two fires during the classical period,

conversion to a church in the seventh century, a Turkish harem in the fifteenth century, and a powder magazine in the seventeenth century, as well as bombardment during the War of Independence in 1827 and serious storm damage in 1852. The whiteness of the porch lintel testifies to the partial restoration that had been accomplished between 1842 and 1844. The major work was not undertaken until the first two decades of the twentieth century.

WALTER HEGE
1893–1955

§ Walter Hege was born in Naumburg in 1893. Before World War I, he was apprenticed to a painter and he taught himself photography. He served as a soldier during the war, but was discharged after being wounded twice. He then attended the Hochschule für Architektur und Bauwesen in Weimar, and from 1918 to 1920, he studied photography with Hugo Erfurth (1874–1948) in Dresden. Within a few years, he had established himself as a photographer in his native Naumburg, and in 1924 he published *Der Naumburger Dom und seine Bildwerke* (Berlin: Deutscher Kunstverlag), which had appeared in eight editions by 1952. The book marked the start of a thirty-year collaboration between Hege and Deutscher Kunstverlag, during which Hege contributed illustrations to more than thirty-nine of their publications. In 1928 Hege went to Athens to photograph the Acropolis, possibly at the suggestion of Gisela Richter, Curator of Greek and Roman Art at the Metropolitan Museum of Art, and the pictures appeared in 1930 in *Die Akropolis* (Berlin: Deutscher Kunstverlag). In 1929 Hege became professor of photography at the Hochschule für Architektur und Bauwesen, Weimar, a position he held through the 1930s. Perhaps because of the technical facilities available at the school, Hege made two films: one about the Bamberger Cathedral in 1930 and the other in 1932, "At the Nest of the Wild Eagle," set in the Bavarian Alps. Hege had begun experimenting with color photography in the 1920s, and during World War II he used the best processes available to photograph German churches and castles that he felt might be damaged or destroyed. Some of these pictures were published. In 1953 to celebrate both their long collaboration and Hege's sixtieth birthday, Deutscher Kunstverlag issued *Der Meister der Lichtbildkunst*. Hege also received the D.O. Hill medal from the Gesellschaft Deutscher Lichtbildner, an organization of commercial photographers to which he belonged. During the early 1950s Hege worked in Karlsruhe and Naumburg. He died in Weimar in 1955 while giving a guest lecture at the Hochschule für Architektur und Bauwesen.

Plates 64, 67.

PLATE 64. Walter Hege. *Caryatids, Porch of the Maidens, Erechtheion, Acropolis, Athens.* Silver print, 1928, 28.6×20.2 cm (11¼×7¹⁵⁄₁₆ in). Reproduced as plate 92, titled "Erechtheion, Koren" in *Die Akropolis* (Berlin: Deutscher Kunstverlag, 1930). Stamped on verso: "AUFNAHME: WALTER HEGE, NAUMBERG-SALLE/ REPRODUKTION NUR MIT NAMENSANGABE UND BESONDERER GENEHMIGUNG DES URHEBERS GESTATTET." Written in pencil on verso: "Hege, Walter,/photographe Weimar (b. 1893)."

In this photograph, Hege has chosen to describe the subtle rhythms that visually unite the maidens with their ornamental setting rather than to place the sculpture within the total architectural scheme of the porch. In *Die Akropolis*, this view was only one of a series that fully depicts the porch. Skillful retouching of the negative has concealed modern iron roof supports. All of the statues were damaged during the War of Independence and, by the beginning of the twentieth century, only four of the six remained in place. Recently they have been replaced with facsimiles and the remaining originals moved to the Acropolis Museum to protect them from environmental pollution.

WILLIAM JAMES STILLMAN
1828–1901

§ After graduation in 1848 from Union College in Schenectady, where he was born, Stillman traveled to London to study art. In 1849 he met John Ruskin, whose theories had a deep influence on the aspiring young painter. After a brief mission to Hungary and a stay in France, Stillman returned to New York. In 1855 he founded the first serious art journal in the United States, *The Crayon*, and served as its editor from January 1855 until June 1856. By 1860 Stillman was back in Europe, and in that year he took an Alpine trip with Ruskin. Stillman later claimed that his career as a painter had been destroyed by Ruskin's devastating criticism of his art. In any case, he did not paint again. On the outbreak of the Civil War, Stillman returned to America, but, declared unfit for service, he accepted the post of American consul in Rome, where he moved in 1862. In 1865 he became the consul of the United States on Crete, but his support of the Cretan insurrection angered the ruling Turks, and Stillman left for Athens in 1868. There he began to photograph the ruins of the Acropolis, partly from a need to earn money and partly from his belief that better photographs could be made than any that existed. *The Acropolis of Athens Illustrated Picturesquely and Architecturally in Photography* (London: F. S. Ellis, 1870) was the result. It contained twenty-five carbon prints without text. Stillman may have undertaken the project to assuage the difficulties of his personal situation: his wife, Laura Mack, committed suicide in 1869, and his son needed hospitalization in London. The Greek consul-general, Mr. Spartali, and the family of Dante Gabriel Rossetti, the

Pre-Raphaelite painter, offered Stillman and his family great support during this period. In 1871 Stillman married Spartali's daughter Marie. She brought him into Rossetti's circle, she herself serving as a model for Rossetti as well as for the photographer Julia Margaret Cameron (1815–1879). She persuaded Stillman to pose as Merlin in Rossetti's *Beguiling of Merlin* in 1873. Later the Stillmans and the Rossettis shared a cottage in Robertsbridge, Sussex. During the 1870s Stillman often returned to the United States, and on one such trip published *Poetic Localities of Cambridge* (Boston: James R. Osgood & Co., 1876), illustrated with heliotypes. Stillman continued to write and publish books on a variety of subjects, and he was a special correspondent for the London *Times*. He retired to Surrey in 1898, where he died in 1901. Shortly before his death he published a two-volume memoir, *The Autobiography of a Journalist* (Boston: Houghton Mifflin and Company), an interesting description of a varied career.

Plates 65, 66, 68.

Reference: Lindquist-Cock, "Stillman, Ruskin & Rossetti."

PLATE 65. William James Stillman. *North porch, Erechtheion, Acropolis, Athens.* Albumen print from wet-collodion glass-plate negative, 1868–1869, 23.7×18.7 cm (9⁵⁄₁₆×7⅜ in). Unnumbered plate in *The Acropolis of Athens Illustrated Picturesquely and Architecturally in Photography* (London: F. S. Ellis, 1870). Numbered in negative, lower left: "20". Printed on mount: "ATHENS–THE ACROPOLIS./Photographed by W. J. Stillman. Published by Marion & Co. 22 & 23 Soho Square, London."

The north porch of the Erechtheion serves three purposes. Most obviously, it houses the major entrance to the west cella of the temple, marked by an elaborately decorated doorway behind the Ionic colonnade of the facade. Beyond the main block of the temple in a projection of the facade is a second, smaller door that leads to a courtyard containing the olive tree of Athena, the sanctuary of Pandrosos, and the tomb of Kekrops. Finally, a shaft in the porch floor, which has a corresponding hole in the roof, exposes the site of the sacred trident marks of Poseidon in the rock of the Acropolis itself. Stillman's photograph, made before the restoration of the porch, documents the extensive damage done to the mostly Augustan reconstruction of the original Greek superstructure and door.

PLATE 66. William James Stillman. *East porch, Parthenon, Acropolis, Athens.* Albumen print from glass-plate negative, 1869, 23.5×18.9 cm (9½×7⁷⁄₁₆ in), arched top. Unnumbered plate in *The Acropolis of Athens Illustrated Picturesquely and Architecturally in Photography* (London: F. S. Ellis, 1870). Titled, signed, and numbered in negative: lower left, "East Colonnade"; and lower right, "WS 69" and "15". Printed on mount: "ATHENS–THE ACROPOLIS./Photographed by W. J. Stillman. Published by Marion & Co. 22 & 23 Soho Square, London."

Stillman's photograph of the east porch of the Parthenon shows the view between the stately procession of the columns of the temple front and the broken stumps of the interior row. Framed at the end of the vista of the Parthenon's north side is a nearly perfectly preserved column, which displays with clarity the stacking of the fluted drums as well as entasis, a refinement characteristic of the Doric order. The elegant top-hatted gentleman–perhaps Stillman himself–provides scale, a visual focus, and a witty counterpart to the impressive columnar order of the picture.

PLATE 67. Walter Hege. *The Parthenon and the Odeion of Herodes Atticus, Athens.* Silver print, 1928, 35.6×26.8 cm (14×10⁹⁄₁₆ in). Numbered in pencil on verso: "Nr. 736". Stamped on verso: "PROFESSOR W. HEGE" and "AUFNAHME: WALTER HEGE, G.D.L. WEIMAR/REPRODUKTION NUR MIT NAMENSANGABE UND BESONDERER GENEHMIGUNG DES URHEBERS GESTATTET."

Hege's photograph dramatically juxtaposes the quintessentially Greek architecture of the Parthenon with the massive Roman facade of the Odeion of Herodes Atticus. The Odeion, built by Herodes on the death of his wife in 160 A.D., seated five to six thousand spectators comfortably in a grand interior space that, according to Pausanias' account of the second century A.D., had an especially splendid cedar roof.

PLATE 68. William James Stillman. *View from the southwest corner of the Parthenon, Acropolis, Athens.* Carbon print from glass negative, 1868–1869, 16.5× 21.9 cm (6½×8⅝ in). Unnumbered plate in *The Acropolis of Athens Illustrated Picturesquely and Architecturally in Photography* (London: F. S. Ellis, 1870).

Stillman's photograph depicts an uncommon view of the Parthenon: the ruined cella seen from the top of the southwest corner of the temple. The interior, shown here with only the rubble of the original cella walls and columns, contained a mosque until archeologists removed it in 1844. Beyond the eastern facade of the Parthenon lie the scattered remains of other monuments, including the Temple of Roma. A strikingly romantic image, this photograph dramatically isolates the temple from the dark cloudy sky, the mountains, and the sprawl of distant Athens.

AUGUSTE SALZMANN
1824–1872

§ Auguste Salzmann, a painter who exhibited religious and allegorical paintings at the Paris Salon, was very interested in archeology. Inspired by the research of the archeologist Louis-Félicien-Joseph Caignart de Saulcy (1807–1880), he left

for Jerusalem in December 1853 to photograph works of Jewish, Christian, and Islamic architecture. Controversial dating schemes had been developed by de Saulcy during research undertaken between 1850 and 1851, which he had just published in *Voyages autour de la Mer Morte et dans les terres bibliques* (Paris: Gide et J. Baudry, 1853). Attracted by the arguments that de Saulcy's theories aroused, Salzmann modified previous plans to photograph the Crusader monuments of the Near East and went instead to Jerusalem. With the help of an assistant named Durheim, he made about two hundred waxed-paper negatives of the monuments in question. Salzmann described the resulting photographs as having "*a conclusive brutality*," an indication of the contemporary faith in the veracity of the medium. (Preface, *Jérusalem*, p. 3.) In 1854 Blanquart-Evrard published the first edition of the book that resulted, *Jérusalem, époques judaïque, romaine, chrétienne, arabe. Explorations photographiques par A. Salzmann.* Two years later a revised edition appeared, entitled *Jérusalem, étude et reproduction photographique des monuments de la ville sainte depuis l'époque judaïque jusqu'à nos jours, par Auguste Salzmann, chargé par le Ministère de l'Instruction publique d'une mission scientifique en Orient* (Paris: Gide et J. Baudry). This second portfolio existed in two sizes, a deluxe edition of 174 photographs and a small edition with 40 reduced photographs. A volume of text, *Etudes sur Jérusalem*, accompanied the plates. The publication was splendid, but the cost–1,422 francs–was prohibitive, with the result that the publication did not enjoy commercial success and few complete sets are known today. Salzmann continued to pursue his archeological researches. From 1858 to 1867 he excavated at Rhodes, where he discovered the Necropolis of Camiros. Photographs that he made were published as photolithographs in *Nécropole de Camiros, journal des fouilles exécutées dans cette nécropole pendant les années 1858 à 1865* (Paris: Detaille, 1875). Salzmann returned to Jerusalem in 1863, this time with de Saulcy, and he made photographs for a new work about the city. De Saulcy's *Carnets de voyage en Orient, 1845–1869* (Paris: Presses Universitaires de France, 1955) contains many references to these pictures by Salzmann, which are extremely rare today.

Reference: Isabelle Jammes, *Blanquart-Evrard*, pp. 93–103.

PLATE 69. Auguste Salzmann. *Absalom's tomb, Valley of Kidron, Jerusalem.* Salt print by Blanquart-Evrard from waxed-paper negative by Salzmann, 1854, 32.7 ×22.9 cm (12⅞×9 in). Unnumbered plate in *Jérusalem, étude et reproduction photographique des monuments de la ville sainte depuis l'époque judaïque jusqu'à nos jours par Auguste Salzmann, chargé par le Ministère de l'Instruction publique d'une mission scientifique en Orient* (Paris: Gide et J. Baudry, 1856). Numbered in negative, lower left: "40" (later obscured in negative). Printed on mount: "Aug. Salzmann/JÉRUSALEM/VALLÉE DE JOSAPHAT/Détails du tombeau d'Absalom/Gide et J. Baudry, éditeurs. Imp. Photogr. de Blanquart-Evrard, à Lille."

Absalom's tomb probably was built during the Maccabean period (167–63 B.C.) although tradition attributes it to the son of David, based on *II Samuel* xviii, 18: "*Absalom had taken and raised up for himself in his lifetime a pillar which is in the king's dale, for he said, I have no son to keep my name in remembrance, and called the pillar by his name and it is called Absalom's monument until this day.*" The tomb undoubtedly owes its location below the eastern wall of Jerusalem to the Jewish belief that the resurrection will begin on the Mount of Olives (*Zachariah* xiv, 4). Perhaps because of the religious significance given to the land itself, Salzmann has emphasized the physical connection of the free-standing sepulchral monument with the rock from which it was hewn. Other photographs of the tomb published in *Jérusalem* describe its placement on the hillside, as well as details of surface and carving.

PLATE 70. Auguste Salzmann. *Doorway, Church of the Holy Sepulchre, Jerusalem.* Salt print by Blanquart-Evrard from waxed-paper negative by Salzmann, 1854, 33×23.5 cm (13×9¼ in). Unnumbered plate in *Jérusalem, étude et reproduction photographique des monuments de la ville sainte depuis l'époque judaïque jusqu'à nos jours par Auguste Salzmann, chargé par le Ministère de l'Instruction publique d'une mission scientifique en Orient* (Paris: Gide et J. Baudry, 1856). Numbered in negative, lower left: "78" (later obscured in negative). Printed on mount beneath photograph: "Aug. Salzmann/JÉRUSALEM/SAINT-SÉPULCRE/Porte Ouest/Gide et J. Baudry, éditeurs. Imp. Photogr. de Blanquart-Evrard, à Lille."

The Church of the Holy Sepulchre traditionally marks the accepted location of Christ's sepulchre and the repository of the relics of the True Cross. Originally built by the Crusaders in the twelfth century, the rambling structure has been reconstructed and restored repeatedly over the centuries. Salzmann's photograph shows the portal of the west side, one of the objects of discussion in the proposed dating scheme of the archeologist de Saulcy. Before the walled-up doorway is a straw basket, often discoverable in the corners of nineteenth-century views.

PLATE 71. Auguste Salzmann. *Detail of lintel, Tombs of the Kings, Jerusalem.* Salt print by Blanquart-Evrard from waxed-paper negative by Salzmann, 1854, 23.3×31.8 cm (9⁹⁄₁₆×12½ in). Unnumbered plate in *Jérusalem, étude et reproduction photographique des monuments de la ville sainte depuis l'époque judaïque jusqu'à nos jours par Auguste Salzmann, chargé par le Ministère de l'Instruction publique d'une mission scientifique en Orient* (Paris: Gide et J. Baudry, 1856). Numbered in negative, lower left: "46" (later obscured in negative). Printed on mount: "Aug. Salzmann./JÉRUSALEM/TOMBEAU DES ROIS DE JUDA/Encadrement de feuillages et de fruits/Gide et J. Baudry, éditeurs. Imp. Photogr. de Blanquart-Evrard, à Lille."

The ancient burial place known as the Tombs of the Kings possibly contained the remains of Queen Helena of Adiabene, Mesopotamia, who came to Jerusalem with her children in about 45 A.D. and converted to Judaism. Salzmann's photograph shows a detail of the richly carved frieze that marks the entrance to the large, rock-hewn burial complex. Such details, so characteristic of Salzmann's work in Jerusalem, surely resulted from his intention to provide precise archeological evidence in his photographs.

LOUIS-CONSTANTIN-HENRI-FRANÇOIS-XAVIER DE CLERCQ
1836–1901

§ Louis de Clercq, who was born into a wealthy family in Oignies, Pas-de-Calais, acted as a courier for Napoléon III during the war with Austria in 1859, carrying messages between Paris and the Imperial Court. At the conclusion of the war, de Clercq abandoned a planned trip to Switzerland and northern Italy for a more interesting opportunity: a trip with the historian of Crusader castles, Emmanuel-Guillaume Rey, who was leading a scientific expedition to Syria. Comte Melchior de Vogüé, a distinguished archeologist and friend of de Clercq's brother-in-law, comte Alexandre de Boisgelin, had suggested de Clercq as an assistant for the expedition. During the autumn and winter of 1859–1860, the party traveled through Syria and Asia Minor. In Beirut, de Clercq met two men who decisively influenced his subsequent career—comte de Perthuis and the French ambassador, Péretié. Péretié encouraged de Clercq to pursue what became a lifelong passion for Near Eastern archeology. De Clercq also traveled in Palestine, Egypt, and Spain during this trip. Upon his return to France, he compiled 220 of his photographs into six handsomely bound volumes, a few copies of which are known today. He exhibited some of the photographs in Paris and Brussels in 1861 and at the Universal Exhibition, London, in 1862, where they attracted favorable critical attention. In 1862 de Clercq returned to the Near East and began to collect Near Eastern antiquities under the guidance of Péretié. He pursued this interest for the rest of his life. In about 1885, with the help of the archeologist Joachim Menant, de Clercq started a catalog of his extensive collection which he published prior to his donation of the collection to the Louvre. The final product, seven large and scholarly volumes, was completed in 1911. Louis de Clercq also held various political offices in his native Oignies, Pas-de-Calais, and Paris between 1870 and 1889, when he turned all of his attention to his collection. Although twice married, de Clercq died in 1901 leaving no children.

Reference: Babelon, "Louis de Clercq," pp. v–xiv.

PLATE 72. Louis de Clercq. *Tripoli, Lebanon.* Two albumen prints from three waxed-paper negatives, 1859, 20×81.6 cm (7$\frac{7}{8}$×32$\frac{1}{8}$ in). Unnumbered plate in *Villes, monuments et vues pittoresques de Syrie*, volume 1, *Voyage en Orient* (Paris: privately issued, 1859–1860). Numbered in negative, lower right: "20". Printed on mount: "TRIPOLI".

Louis de Clercq included many panoramas in his six volumes of photographs of the Near East and Spain. They represent an impressive technical achievement, since the difficulties inherent in mid-nineteenth-century photography only multiplied when the negatives had to form a continuous image. The panoramas also reveal the period's interest in conveying as much information about the experience of place as possible. Tripoli, founded in the seventh century B.C., became the capital of a federation of three Phoenician cities—as indicated by its name. Every subsequent conqueror of the Mediterranean, including the Crusaders, occupied the port city.

PLATE 73. Louis de Clercq. *Krak of the Knights (Kalaat-el-Hosn), Syria.* Albumen print from waxed-paper negative, 1859, 21.7×27.5 cm (8$\frac{9}{16}$×10$\frac{13}{16}$ in). Unnumbered plate in *Châteaux au Temps des Croisades en Syrie*, volume 2, *Voyage en Orient* (Paris: privately issued, 1859–1860). Photographer's stamp on mount: "L de C". Printed on mount: "KALAAT-EL-HOSN. / (DEUXIÈME ENCEINTE) / Extérieur, (midi.)".

The Krak of the Knights, one of the most impressive examples of military architecture in the Near East, was critical to the defense of the Holy Land during the medieval period. By the nineteenth century, however, the castle had become desolate and the area was an arduous journey from the inhabited parts of the region. Louis de Clercq's view of a tower on the south side of the Krak of the Knights, a stunningly abrupt juxtaposition of geometric shapes, describes the massiveness of the great stone exterior walls. Such pictures by de Clercq provided valuable information for contemporary archeologists as well as pleasure to the curious by conveying a vivid sense of place to those who could not visit the site.

PLATE 74. Louis de Clercq. *Southern side, Krak of the Knights (Kalaat-et-Hosn), Syria.* Albumen print from waxed-paper negative, 1859, 18.4×26.8 cm (7$\frac{1}{4}$×10$\frac{9}{16}$ in). Unnumbered plate in *Châteaux au Temps des Croisades en Syrie*, volume 2, *Voyage en Orient* (Paris: privately issued, 1859–1860). Photographer's stamp on mount: "L de C". Printed on mount: "KALAAT-EL-HOSN. / Vue générale."

This more general view by de Clercq shows the south side of the Krak, where the redoubt, a formidable strongwork of linked towers, slopes to an eighty-foot thick wall called the Mountain. Another fortified wall and a steep drop complete the defenses on the south side. This photograph is the first of a series of

more detailed images of the fort–including the preceding plate–that appeared in the second volume of de Clercq's *Voyage en Orient*.

FELICE BEATO
ca. 1830–1906(?)

§ Felice or Felix Beato (see Worswick and Spence, p. 148, n. 9, for his use of "Felix") appears to have been a Venetian who became a naturalized British citizen. At least some of the contemporary press in Britain continued to regard him as an Italian as late as the early 1860s, when various magazines referred to him as "Signor Beato" (see, for example, *Photographic News*, vol. 15, November 1, 1861, p. 526). In the early 1850s, Beato met James Robertson in Malta, and they began a partnership that lasted until 1857. From 1853 to 1857 they worked together in Constantinople, Athens, the Crimea, Egypt, Palestine, and India. Some of their photographs are signed "Robertson & Beato" (plate 75) and others "Robertson, Beato and Co." Gail Buckland has suggested that the word "Company" may have been added to include the photographer Antonio Beato, with whom F. Beato often has been confused (Vaczek and Buckland, p. 190). Beato went on to China in 1860, where he documented the destruction caused by the Anglo-Chinese War. In 1861 he seems to have returned to London with a large group of photographs taken during his travels in the East. *The Athenaeum* published an enthusiastic review of them in 1862: "*At Mr. Hering's, Regent Street, may be seen a large collection of photographic views and panoramas taken by Signor Beato during the Indian Mutiny and the Chinese War.... As photographs, these leave nothing to be desired; while some of the panoramas... which are in no less than six pieces each, must have demanded extraordinary care in preparation.*" (*The Athenaeum*, June 14, 1862, pp. 793–4.) Later in 1862, Beato went to Japan, where he lived for many years. A number of albums, including *Photographic Views of Japan* (Yokohama 1868), collected his Japanese photographs. Beato probably left Japan in 1877, when he sold his negatives and studio to baron von Stillfried. In 1886 the *British Journal of Photography* credited him with an improvement of the albumen process that dramatically cut the necessary time of the exposure (vol. 33, March 19, 1886, p. 181). In the late 1880s Beato moved to Burma, where he opened stores in Rangoon and Mandalay that sold native furniture and crafts. Illustrated stock catalogs now in the Victoria and Albert Museum indicate that he also sold these objects by mail. Since Beato contributed to the Indian Exhibition in Delhi in 1904, he seems to have stayed in the East. Advertisements in the *Rangoon Times* of January 1907 announcing the liquidation of F. Beato Ltd. suggest that Beato probably had died shortly before, in 1906. No references to him are known after that date.

Plates 75, 88, 90, 96, 97.

Reference: Lowry, "Victorian Burma by Post."

PLATE 75. James Robertson and Felice Beato. *Istanbul and the Bosporus from the Seraskier Tower.* Salt prints from five wet-collodion glass-plate negatives, 1853, 24.3×147.6 cm (9⁹⁄₁₆×58⅛ in). Signed in three negatives, bottom: "Robertson and Beato". Written in pencil on verso: "Vue de Constantinople".

The most popular views of Istanbul traditionally were taken either from the Galata Tower, visible here across the Golden Horn, or from the Seraskier Tower in Stamboul, from which this view was taken. While the view from the Galata Tower showed the landform and city of Stamboul clearly, the view from the Seraskier Tower revealed more of the picturesque quality of the city. From this vantage point, the mosques, Great Bazaar, and a warren of streets lie immediately below, and the Ministry of War and its barracks to the left. The choice of a panoramic format–which by implication surrounds the viewer with the subject–emphasizes the wealth of immediate and absorbing detail.

MAXIME DU CAMP
1822–1894

§ Maxime Du Camp, a native Parisian, learned photography from Gustave Le Gray in 1849. His only known photographs were made during his trip through Greece, Egypt, Palestine, Syria, and Asia Minor with his friend Gustave Flaubert between 1849 and 1851. They had requested and received commissions: Du Camp from the French Ministry of Education to photograph places of interest in the Near East; and Flaubert to report data suitable for use by Chambers of Commerce. Upon Du Camp's return, 125 photographs selected from approximately 200 waxed-paper negatives were printed by Blanquart-Evrard in *Egypte, Nubie, Palestine et Syrie* (Paris: Gide et J. Baudry, 1852). This was the first major book published in France to be illustrated with photographs. Du Camp had traveled in this region prior to his trip with Flaubert and written of his experiences in *Souvenirs et paysages d'Orient* (Paris: A. Bertrand, 1848). During the Revolution of 1848, Du Camp fought with the French National Guard and in 1853 received the Cross of the Legion of Honor for his services. In 1851 he helped found *Revue de Paris*, the journal that was to publish Flaubert's *Madame Bovary*. Du Camp published his memoirs, *Souvenirs littéraires* (Paris: Librairie Hachette) in 1882–1883, and he died in Paris in 1894.

PLATE 76. Maxime Du Camp and Aimé Rochas. *The Citadel and the Mosque of Mohammed Ali from the Nile Hotel, Cairo.* Salt print by Blanquart-Evrard from waxed-paper negative by Du Camp after a daguerreotype by Rochas, 1840s, 15.6×20.2 cm (6⅛×7¹⁵⁄₁₆ in). Plate 1 in *Egypte, Nubie, Palestine et Syrie, dessins photographiques recueillis pendant les années 1849, 1850 et 1851, accompagnés d'un texte*

explicatif et précédés d'une introduction par Maxime Du Camp, chargé d'une mission archéologique en Orient par le Ministère de l'Instruction publique. (Paris: Gide et J. Baudry, 1852). Printed on mount: "LE KAIRE./Maxime Du Camp. Gide et J. Baudry, Editeurs./VUE GÉNÉRALE./Imprimerie Photographique de Blanquard[sic]-Evraid, à Lille./Pl. 1."

According to Du Camp's introduction (p. 55), *Egypte, Nubie, Palestine et Syrie* contained three copy prints that Du Camp made after daguerreotypes by Aimé Rochas. The three views depict Cairo (shown here), the Pyramids, and the interior of the temple at Medinet-Habu. Du Camp must have felt that his representation of Egypt would not be complete without the inclusion of these subjects, and his own photographs of the sites must have become unusable. Such borrowing from other photographers–often uncredited–as well as the translation of images from one medium to another was common among nineteenth-century photographers.

PLATE 77. Maxime Du Camp. *Heraldic Pillar of Tuthmosis III, Temple of Amun, Karnak.* Salt print by Blanquart-Evrard from waxed-paper negative by Du Camp, 1850, 19.7 × 15.6 cm (7¾ × 6⅛ in). Plate 39 in *Egypte, Nubie, Palestine et Syrie, dessins photographiques recueillis pendant les années 1849, 1850 et 1851, accompagnés d'un texte explicatif et précédés d'une introduction par Maxime Du Camp, chargé d'une mission archéologique en Orient par le Ministère de l'Instruction publique.* (Paris: Gide et J. Baudry, 1852). Printed on mount: "THÈBES./Maxime Du Camp. Gide et Baudry, Editeurs./PALAIS DE KARNAK./PILIERS DEVANT LE SANCTUAIRE DE GRANIT./Imprimerie Photographique de Blanquard[sic]-Evrard, à Lille./Pl. 39".

Tuthmosis III contributed extensively to the building of the vast temple complex at Karnak as a religious offering of thanks for his impressive military victories. The monolithic granite pillar shown here is one of a pair representing Tuthmosis' unification of Upper and Lower Egypt. The bas relief on this particular face shows the Pharaoh receiving divine approval. Du Camp's photograph presents the pillar without reference to scale or context, a view that transforms the object into an emblematic image of Pharaonic Egypt.

CLAUDIUS GALEN WHEELHOUSE
1826–1909

§ Wheelhouse was born in Snaith, Yorkshire, in 1826, the second son of a surgeon, James Wheelhouse. He attended the grammar school there until age seven, when he was transferred to Christ's Hospital Preparatory School at Hertford. In 1836 he entered Christ's Hospital, London, as a student. Following an apprenticeship with R. C. Ward, in Ollerton, Newark, he began studies at the Leeds School of Medicine in 1846. He received his diploma from the Royal College of Surgeons three years later. Wheelhouse took his first post in 1849: medical officer to a yachting party of Lord Lincoln, later Duke of Newcastle, during a nine-month trip around the Mediterranean. While on this journey, he photographed many of the sites visited by later photographers such as Francis Bedford and Louis de Clercq: Spain, Athens, Constantinople, Egypt, and the Holy Land. Unfortunately, all of Wheelhouse's paper negatives, which he had given to Lord Lincoln, were destroyed by fire in 1879. An album of his views entitled *Photographic Sketches from the Shores of the Mediterranean* exists in the collection of the Royal Photographic Society, Bath. Wheelhouse may have continued to photograph, since he is known to have exhibited albumen prints at the Leeds Photographic Society in 1857, but this certainly was not his primary occupation. Upon his return to England in 1851, he entered a partnership with Joseph Prince Garlick in Leeds and the same year was elected Surgeon to the Public Dispensary and Demonstrator of Anatomy in the Medical School. In subsequent years he became Lecturer on Anatomy, Physiology and Surgery, and served twice as President of the school. In 1884 he became Surgeon to the Leeds Infirmary. During the last thirty years of his life, Wheelhouse received many honors, including an Honorary LL.D. from McGill University in 1897 and a Doctor of Science degree from the University of Leeds in 1904. Wheelhouse had married Agnes Caroline Cowell in 1860 and they had three daughters. He retired from medical practice in 1891 and settled in Filey, where he was made a Justice of the Peace for the East Riding of Yorkshire. He died and was buried in Filey in 1909.

Reference: Plarr, *Lives of the Fellows,* vol. 2, pp. 509–510.

PLATE 78. Claudius Galen Wheelhouse. *The Great Hypostyle Hall, Temple of Amun, Karnak.* Salt print from paper negative, ca. 1850, 17.8 × 20.3 cm (7 × 8 in). Titled in ink on verso of photograph: "Hall of Columns Karnac–Egypt".

The Great Hypostyle Hall of the Temple of Amun at Karnak, built during the Eighteenth Dynasty by Sety I and his son Rameses II, consisted of 134 columns arranged in sixteen rows. Those in the central nave are seventy-nine feet high, while those in the aisles–shown here–measure forty-six feet. Most photographers in Egypt took at least one picture similar to this one, attempting to convey the massiveness of the stone and the extraordinary scale of the vast temple. The eastern pylon, visible in the distance, marks the extent of the complex.

JOHN BULKLEY GREENE
ca. 1832–1856

§ John B. Greene was the son of an American, also named John B. Greene, who managed a branch of the banking firm Welles and Williams at 28 Place Saint-

Georges, Paris. His first photographic expedition, a trip to Upper Egypt and Nubia, took place between the fall of 1853 and 1854. Ninety-four prints from the approximately two hundred waxed-paper negatives he brought back to France were published in 1854 by Blanquart-Evrard as *Le Nil–Monuments–Paysages–Explorations photographiques par J. B. Greene* (Lille: Imprimerie photographique de Blanquart-Evrard). Unlike Blanquart-Evrard's earlier publication about Egypt, Maxime Du Camp's *Egypte, Nubie, Palestine et Syrie* (plates 76, 77), Greene's work includes few conventionally descriptive views of favorite tourist sites. Instead, his pictures fall into two types: poetic landscapes of the Nile and the empty desert and views of archeologically important monuments. Upon his return to Paris, Greene became one of the founding members of the Société française de Photographie and, about this time, he also joined the Société asiatique, which suggests that his trip had inspired a professional interest in the material. In 1854 Greene went back to Egypt, prepared for archeological as well as photographic work. He had obtained permission to excavate at Deir-el-Bahari and at Thebes, where he cleared the Temple of Rameses III. He also exposed extensive inscriptions on the second pylon at Thebes, which he later published in a pamphlet illustrated with lithographs made after his photographs. Three albums in the collection of the Institut de France, presented by Greene to the Académie des Inscriptions et Belles-Lettres, contain the most complete group of Greene's Egyptian work. About Christmas 1855, Greene set off to study Egyptian remains in Algeria. He worked mostly in the coastal town of Cherchell, where he photographed the progress of the excavation of a large Christian tomb. During breaks in the work, Greene also photographed the surrounding countryside. The photographs Greene took in Algeria do not look at all like those he made in Egypt. Perhaps in response to the different character of the place, he filled the picture frames with often startling details and rich patterns of light and shadow. Greene returned to France briefly before setting off for a third trip to Egypt toward the end of 1856. A letter from Théodule Deveria to the Egyptologist François-Joseph Chabas indicates that Greene was seriously ill at the time of his departure but hoped that the Egyptian climate would cure him as it evidently had once before. Unfortunately, this did not prove the case, and Greene died in Egypt in November at the age of twenty-four.

Reference: Bruno Jammes, "John B. Greene, an American Calotypist."

PLATE 79. John Bulkley Greene. *Temple of Maharakka, Nubia.* Salt print from waxed-paper negative, 1854, 22.1×28.9 cm (8 11/16×11 3/8 in). Plate P. 38 in *Le Nil–Monuments–Paysages–Explorations photographiques par J. B. Greene* (Lille: Imprimerie photographique de Blanquart-Evrard, 1854). Signed in negative, lower right: "J. B. Greene." Written in pencil beneath photograph on mount: "38/ Vue du Temple de Maharraka / of. G/–".

The Temple of Maharakka, an unfinished Roman work on the west bank of the Nile, marked the southern boundary of Egypt under the Ptolemies and Romans. Greek and Roman inscriptions on the temple walls document its dedication to the gods Serapis and Isis. Interestingly, Greene classified this photograph that describes the temple in the desert as a landscape rather than a monument (the letter "P" before the plate number in Blanquart-Evrard's publication stands for "paysage"). Unlike the work shown here, a view marked as a monument ("M") fills the frame with the ruins.

PLATE 80. John Bulkley Greene. *Dromos, Temple of Sebua, Nubia.* Salt print from waxed-paper negative, 1854, 23.2×30 cm (9 1/8×11 3/16 in). Plate P. 51 in *Le Nil–Monuments–Paysages–Explorations photographiques par J. B. Greene* (Lille: Imprimerie photographique de Blanquart-Evrard, 1854). Numbered and signed in negative, lower left: "P. 51"; and lower right: "J. B. Greene". Titled in pencil on mount: "51./Vue du Temple de Ouadi Esseboua".

The Temple of Sebua, situated south of Maharakka along the Nile, is named for the sixteen lions that originally lined the approach from the river. Built by Rameses II for Amun and the sun god Ra-Harakhte, the structure was converted to a Coptic church, and traces of Christian paintings still remain on the walls. As with the previous picture, Greene classified this photograph as a landscape.

FRANCIS BEDFORD
1816–1894

§ Francis Bedford, a painter and lithographer, began to photograph in the early 1850s and rapidly achieved a considerable critical reputation. *The Photographic News* (vol. 1, pp. 230–1), and the *Times* (January 18, 1861) found his photographs the finest of any in the exhibition of the Photographic Society in 1861. On the strength of this reputation, Queen Victoria commanded Bedford to accompany the Prince of Wales on a tour of the Near East in 1862. The four-month expedition resulted in 210 large albumen prints from wet-collodion negatives of views of the Mediterranean countries. On his return to England, Bedford exhibited 172 of them in London, where they were greeted with great enthusiasm. *The Art Journal* called them "*the most interesting series of photographs that has ever been brought before the public. . . . Nothing can be more beautiful than the precision of these views.*" (Vol. 24, 1862, p. 211.) The images continued to be popular: forty-eight of the pictures appeared in reduced format as illustrations to *The Holy Land, Egypt, Constantinople, Athens, etc.* (London: Day, 1867). Bedford continued to exhibit, publish, and sell photographs until his death in 1894, becoming particularly well known for his views of picturesque landscapes and monuments in Britain.

PLATE 81. Francis Bedford. *Kiosk of Trajan and Temple of Hathor, Philae.* Albumen print from wet-collodion negative, 1862, 23.7×28.4 cm (9⁵⁄₁₆×11³⁄₁₆ in). No. 20 in *Photographic Pictures made by Mr. Francis Bedford during the Tour in the East in which by command he accompanied His Royal Highness the Prince of Wales* (London: Day & Son, n.d.). Titled, dated, and signed in negative: bottom center, "PHILAE Mar 13/62"; and lower right, "20. F. Bedford". Printed on mount: "Bedford's Photographs of the Tour in the East of H. R. H. the Prince of Wales./ PHILAE.—THE HYPAETHRAL TEMPLE, AND SMALL CHAPEL.—No. 20./Day & Son, Lithographers to the Queen, Gate Street, London, W. C."

The isle of Philae, located at the head of the Nile's First Cataract, offered a welcome respite for travelers to the south. The Kiosk of Trajan, an uncompleted temple that also was known as Pharaoh's Bed, was one of the favorite sites on the island. Nineteenth-century guidebooks especially recommended the view by moonlight. Most photographers showed the kiosk as travelers first encountered it–rising above the landing stage for the boats. Bedford, on the other hand, chose to depict the less commonly seen view from the interior of the island.

FRANCIS FRITH
1822–1898

§ Francis Frith was born to a Quaker family in Chesterfield, Devonshire. He attended Quaker schools in Birmingham before being apprenticed to a cutlery firm in Sheffield in 1838. Within the next ten years, Frith also tried his hand at wholesale grocery and printing. In 1850, however, he began to take photographs and by 1856 was sufficiently well established to embark on an extensive tour of Egypt. Frith traveled up the Nile from Cairo to Abu Simbel, photographing many views three times, often using different formats of wet-collodion negatives: stereoscopic, 8 by 10, and 16 by 20 inch plates. One of the major photographic publishers in Britain, Negretti and Zambra, published the stereoscopic views, while Thomas Agnew and Sons offered a selection of loose prints from the larger sizes. Frith's photographs of Egypt met with such success that he was able to finance another trip to the Near East, this time concentrating on Palestine and Syria. This trip, in which Frith went from Egypt to the Holy Land, lasted from November 1857 to May 1858. James Virtue and Co. published the best of the 8 by 10 inch negatives from both journeys in a single edition, and the others appeared in *Egypt and Palestine Photographed and Described by Francis Frith* (London: James Virtue and Co., 1858–1860). Despite the great physical difficulties of such expeditions, Frith returned to Egypt once more in the summer of 1859 and traveled farther up the Nile to the Fifth Cataract–farther than any photographer had ever been. The same year he opened his own establishment at Reigate, Surrey, producing albumen prints in large enough quantities to satisfy

the great public demand for his photographs of the Near East as well as Western Europe and Britain. The firm also made prints from negatives by other photographers whose work Frith published. The familiar tourist view from the later nineteenth century, printed on glossy albumen paper and stamped "Frith's Series" or "F. Frith & Co.," most often came from negatives made by one of Frith's stable of photographers rather than Frith himself. Even more ubiquitous, however, are the picture postcards made by F. Frith and Company, examples of which could be bought until the 1960s. After his death in 1898, Frith's children and their descendants managed the firm. It remained in the family until 1968, when it was sold, only to go bankrupt shortly thereafter. Frith and Company ceased to exist in 1971.

PLATE 82. Francis Frith. *The Pyramids of Mycerinus, Chephren and Cheops, Giza.* Albumen print from wet-collodion glass-plate negative, 1858, 37.5×47.9 cm (14³⁄₄×18⁷⁄₈ in). Unnumbered plate in *Egypt, Sinai, and Jerusalem: A Series of Twenty Photographic Views by Francis Frith* (London: William Mackenzie, n.d.). Signed and dated in negative, lower left: "Frith 1858". Printed on mount: "Frith. Photo./THE PYRAMIDS OF EL-GEEZEH./From the South West."

The Great Pyramids at Giza were among the most renowned tourist sites in the Near East, being both the quintessential Egyptian monument and one of the great monuments of antiquity. Frith photographed them many times, almost always with people placed in the foreground and in the middle distance to provide a sense of the extraordinary scale of these royal tombs and to mark the expanse of monotonous desert around them. This picture represents a great technical achievement as well. Frith described the trials of evenly coating these mammoth glass plates with the wet collodion, which sometimes actually was boiling in the heat of the sun (*Egypt and Palestine Photographed and Described by Francis Frith*, London: J. S. Virtue, 1858–1860, vol. 2, descriptive notes to "Early Morning at Wady Kardassy, Nubia").

CLAUDE-JOSEPH-DÉSIRÉ CHARNAY
1828–1915

§ Désiré Charnay was born in Fleurieux, Rhône. After studying at the Lycée Charlemagne in Paris, Charnay traveled in Germany and Britain before 1850, when he settled in New Orleans as a schoolteacher. In the early 1850s, Charnay read John Lloyd Stephens' best-selling accounts of travel in Central America, *Incidents of Travel in Central America, Chiapas and Yucatan* (New York: Harper and Brothers, 1841) and *Incidents of Travel in Yucatan* (New York: Harper and Brothers, 1843). The books inspired Charnay to become an explorer, and he returned to France to plan his new career. After acquiring the support of the

French Ministry of Public Instruction for an expedition to the Yucatan, he left for Boston in 1857. He spent eight months touring the United States before arriving in Mexico, where he spent ten months in Mexico City organizing his expedition to the ruins. In addition to all the technical difficulties incumbent upon any nineteenth-century photographer, Charnay faced great problems caused by Mexico's civil war. Nonetheless, he managed to visit and photograph Mitla, Palenque, Chichén-Itzá, and Uxmal between 1858 and 1860. His success was extraordinary. Travel was slow, conditions dangerous, his photographic materials unreliable, and the sites remote as well as overgrown with dense rain forest. Charnay returned to France in early 1861, disappointed by his inability to do more than photograph the sites. In 1862–1863 he published forty-nine views as a large portfolio entitled *Cités et ruines américaines, Mitla, Palenque, Izamal, Chichen-Itza, Uxmal* (Paris: Gide), accompanied by a volume of text. Following Stephens' example, Charnay wrote a lively account of his travels and included an essay by Viollet-le-Duc about the monuments themselves. Another edition of the book, with a shortened text and fewer plates, appeared as *Le Mexique et ses monuments anciens* (Paris: Emile Bondonneau) in 1864. The success of his enterprise caused him to be selected as the official photographer and writer for a French expedition to Madagascar in 1863. In 1864 Charnay went back to Mexico with the troops sent to protect the French regime of the Emperor Maximilian, and when the Maximilian government collapsed in 1867, Charnay traveled to the United States. In 1875 he visited Brazil, Chile, and Argentina for the popular magazine *Le Tour du Monde*, which had published some of his earlier travel accounts. In 1878–1879 the French government sent Charnay to Java and Australia to collect items of natural history and ethnology. The major expedition of Charnay's career, however, was an extended Mexican expedition in 1880–1882. Supported both by the French government and an American businessman, Charnay was able to excavate, photograph, and take casts from the Yucatan ruins as well as collect artifacts there. This expedition received great scholarly and popular attention. It was published in French journals and in the book *Les anciennes villes du Nouveau monde* (Paris: Hachette et Cie, 1885), which was illustrated with wood-engravings after Charnay's photographs. A revised edition appeared in English in 1887. In 1886 Charnay visited Mexico for the last time. He saw the World Columbian Exposition, Chicago, in 1893, and he traveled to Yemen in 1897. His last years were spent in Paris, where he wrote about his adventures in popular travelogs as well as in fictional form. Charnay was made an officer of the Legion of Honor in 1888. He died in Paris in 1915.

Reference: Davis, *Désiré Charnay*.

PLATE 83. Désiré Charnay. *The Red House, Chichén-Itzá, Mexico*. Albumen print from wet-collodion glass-plate negative, 1860, 34.1 × 42.1 cm (13 7/16 × 16 9/16 in). Plate 31 in *Cités et ruines américaines: Mitla, Palenque, Izamal, Chichen-Itza,*

Uxmal, recueillies et photographiées par Désiré Charnay, avec un texte par M. Viollet-le-Duc (Paris: Gide, 1862). Signed in negative, lower left: "Charnay". Printed title pasted on mount: "Charnay, photogr. Pl. 31. Gide, éditeur, Paris./LA PRISON, A CHICHEN-ITZA".

The Red House, formerly known as the prison, is a Late Classic Mayan structure in the older section of Chichén-Itzá. One of the best preserved of the ruins, the building sits on a high platform. Charnay's photograph depicts the condition of the Red House while suggesting some of the difficulties experienced by nineteenth-century explorers of the remote and desolate site.

JOHN MURRAY
1809–1898

§ John Murray was the son of a farmer in Blackhouse, County Aberdeen. After receiving his medical degree in 1832, he entered the medical service of the Army of the East India Company. In 1867 he became Inspector General of Hospitals in the northwest provinces, a post he held until 1871. As a specialist in cholera, he served in many campaigns and greatly improved conditions for the British troops. His photographic career began sometime after 1849, when he became Medical Officer in charge of the Medical School at Agra. In December 1857, thirty views from waxed-paper negatives were exhibited in London by the publisher J. Hogarth, and the exhibition was followed the next year, 1858, by a pamphlet entitled *Photographic Views in Agra and Its Vicinity*, with letterpress descriptions of the plates. The following year, Hogarth published twenty-two photographs in a portfolio called *Picturesque Views in the Northwestern Provinces of India*. After Murray's retirement in 1871, he became president of the Epidemiological Society of London. He died in Sheringham in 1898.

PLATE 84. John Murray. *The Taj Mahal from the southeast, Agra*. Salt print from paper negative, 1857, 35.7 × 45.7 cm (14 1/16 × 18 in). Unnumbered plate in *Photographic Views in Agra and its Vicinity* (London: J. Hogarth, 1857). Titled in pencil on mount: "The Taj from the Paper Works". Printed on mount: "Photographed by J. Murray, M.D. Agra./LONDON, PUBLISHED DEC. 1, 1857, BY J. HOGARTH, 5, HAYMARKET."

Shah Jehan built the Taj Mahal between 1632 and 1654 as a tomb for his favorite wife, Mumtaz Mahal. Constructed entirely of white marble, the Taj is flanked on the west by a mosque of red sandstone and by an exact replica on the east, added for symmetry. This is one of five photographs of the Taj issued as a part of the publication on Agra. Taken from the southeast, the view includes a pile of bleached rags that a local industry would use for paper making. The trees and undergrowth offer a pointed contrast to the formal gardens beyond the wall.

LINNAEUS TRIPE
1822–1902

§ As early as 1839, Linnaeus Tripe was listed under the Twelfth Regiment Native Infantry, stationed in Bangalore, rising to the rank of Captain in 1856. In 1855 he was appointed photographer to the British Mission at the court of Ava, Burma, where he photographed 120 buildings, temples, and general views in thirty-six days despite bad weather and sickness. These Burmese views were published in Bangalore in 1857 for the Madras Photographic Society. In 1856 the Madras Presidency appointed Tripe official photographer, a post he held for four years. A selection of over one hundred of his Indian photographs was published in a series of six volumes classified according to the seven urban areas of the Presidency: Madura, Tanjore and Trivady (together), Poodoocottah, Ryakotta, Seringham, and Trichinopoly. Various contemporaries provided site descriptions, which were set in letterpress for the volumes. About 1860 a new administration of the Madras Presidency under Sir Charles Trevelyan eliminated the position of the official photographer, at which point Tripe seems to have abandoned photography. He continued his military career and was promoted to Major in 1861 and to Colonel in 1870. After retiring in 1875 as an Honorary Major General from the same regiment in which he had enlisted as an ensign thirty-six years earlier, he returned to his birthplace, Davenport, where he died in 1902 at the age of eighty.

References: Desai, *Linnaeus Tripe*; and Markham, *Memoir*, p. 255.

PLATE 85. Linnaeus Tripe. *Amarapoora, Burma.* Salt print from waxed-paper negative, 1855, 24.9×33 cm (9¹³⁄₁₆×13 in). Another print from same negative (India Office, London) is titled: "No. 66. Amerapoora Shwe-Doung-Dyk Pagoda".

Amarapoora, located six miles south of Mandalay in Burma, was founded in 1793 and served as the country's capital until 1849. The view shown here was taken from the embankment of a water tank northeast of the city. The grainy quality of the print and the clouds, painted by hand in the negative, are typical of Tripe's Burmese work and heighten the sense of the remoteness of the place. Tripe numbered this 66 in a group of 120 photographs taken in 1855 and published in Bangalore in 1857; numbers 38–95 were also taken in Amarapoora. Tripe wrote about the images, in a self-effacing and unpublished short preface, that they "*should not be looked upon as a challenge to Photographic criticism but as a series of views of subjects interesting on account of their novelty, many having been retrieved solely on that account.*" Signed and dated "L. Tripe, Bangalore, 20th Feb. 57," this preface was printed and glued to the portfolio.

PLATE 86. Linnaeus Tripe. *South facade, Rajrajesvara Temple, Tanjore.* Albumen print from waxed-paper negative, 1856–1857. 28.9×36.4 cm (11³⁄₈×14⁵⁄₁₆ in). Plate 18, titled "The South facade of the Subrahmanya, Swami's temple," in *Photographic Views in Tanjore and Trivady* (1858). Photographer's blindstamp on mount: "PHOTOGRAPHER TO GOVERNMENT/LT". Printed number glued to mount: "18".

The Rajrajesvara temple, built by Rajaraja the Great, who reigned from 985 to 1018, forms the core of this temple complex dedicated to Siva in the southeastern Indian city of Tanjore. The base of the temple measures 180 feet in length, with a pyramidal structure rising 190 feet, topped by a stone weighing eighty tons. Tripe's photograph shows one unit of a repeated section of the base and the first register of the pyramid. This picture was included in a book as one of several documenting the complex. The accompanying letterpress description stresses the importance of this temple as a masterpiece of the Golden Age of Hindu architecture.

W. H. PIGOU

§ W. H. Pigou of the Bombay Army Medical Service became a corresponding member of the Photographic Society of Bombay in 1854, the year it was founded. He is mentioned in connection with other British photographers in India, which suggests that he might also have been British. In 1855 the Bombay Government appointed a photographer, Colonel T. Biggs, to record Muslim architecture in Bijapur and Ahmedabad. Pigou took over this post after the Indian Mutiny of 1857, the revolt instigated by the native Bengal army against British rule. He died while photographing the sites and was succeeded by A. C. Neill, working in Mysore. The London publisher John Murray issued two volumes on Indian architecture. The first, *Architecture in Dharwar and Mysore* (London 1866) includes descriptive text and ninety-eight plates, sixty by Pigou and the balance by Neill and T. Biggs. The second volume, *Architecture at Beejapoor* (London 1866), contains seventy-six plates but does not list the photographers.

Reference: Worswick and Embree, *The Last Empire*, pp. 4–6.

PLATE 87. W. H. Pigou. *Temple, Chitradurga, India.* Albumen print from waxed-paper negative, 27.9×39.4 cm (11×15½ in). Plate 77 in *Architecture in Dharwar and Mysore. Photographed by the Late Dr. Pigou, Bombay Medical Service, A. C. B. Neill, Esq. and Colonel Biggs, Late of the Royal Artillery. With an Historical and Descriptive Memoir by Colonel Meadows Taylor, M. R. I. A., F. R. G. S. I. and Architectural Notes by James Fergusson, F. R. S., M. R. A. S.* (London: John Murray, 1866). Titled and signed in negative, lower right: "Chittuldroog/Dr. Pigou" (?). Printed label pasted on mount: "PLATE LXXVII. CHITTULDROOG. Temple of Chamoondee."

The temple shown here is located on the fortified hill near Chitradurga, between Bangalore to the south and Dharwar to the north. Unlike most Indian temples, which form a single unit, this complex consists of detached pavilions. In Pigou's photograph, the various architectural elements are juxtaposed with the overwhelming landscape from which they emerge. The small projections as well as the crown of the granite pillar all supported lamps that were lit on festival days. The curious stone "gallows" in the center of the image served in the performance of religious rites. According to the accompanying letterpress commentary, these acts and the practice of human sacrifice gave the site an evil reputation.

PLATE 88. Felice Beato. *Tomb of Iltutmish, Delhi.* Albumen print from wet-collodion negative, 1858, 30.3×25.9 cm (11$\frac{15}{16}$×10$\frac{3}{16}$ in). Numbered in negative, lower left: "53" (reversed). Titled in pen on mount: "Goree Shah's tomb in the Kootub/–Delhi–". Titled in pencil on mount: "Goree Shah's/tomb in Kootub".

Iltutmish, whose tomb stands northwest of the Qutb Minar, reigned in Delhi from 1211 to 1236, succeeding his father-in-law and the first slave king of Delhi, Qutb-un-din-Aibak. Erected by Iltutmish's two children about 1236, the square tomb has seven-foot-thick exterior walls and measures forty-three feet on each side. The arched doors, which face all directions except toward Mecca, are of red sandstone and are inscribed with verses from the Koran. Inside, the cenotaph rests on a high base, which covers the chamber containing the true grave. The two men, possibly keepers of the mosque, provide a gauge of scale for this monumental tomb.

P. A. JOHNSTON

§ In order to document the sites in India more thoroughly and efficiently, photographers replaced draftsmen in the 1850s. In addition to military men in the pay of the government, large commercial firms were established. Johnston & Hoffman was one of these firms. Very little is known about Johnston beyond his partnership in the firm. In the 1870s and 1880s, Johnston & Hoffman, among others, issued catalogs that listed a considerable number of prints to supply a large European and colonial public. Johnston & Hoffman were known for their studies of local industries (teak, jute, and tea), and the firm also provided photographs of archeological sites that continue to be published in the *Encyclopedia Britannica*.

Reference: Worswick and Embree, *The Last Empire*, pp. 4, 9.

PLATE 89. P. A. Johnston. *Tirumala Nayak's Palace, Madura.* Silver chloride print from glass negative, 1880s, 27.9×20.3 cm (11×8 in). Titled in pencil on verso: "Tirumal Naicks Palace/Madura".

Tirumala Nayak, who reigned from 1623 to 1660, built an enormous temple and palace in Madura, the capital of the Nayak dynasty. The size of this complex reflects a continuation of the temple expansion that occurred during the Hindu architectural renaissance in the eleventh century in order to accommodate increased ritualistic activity. The quadrangle, partly visible at the right, measures 76.8 by 45.7 meters (252 by 150 feet), with columned aisles on three sides and the great Durbar Hall and Throne Room on the fourth. Johnston's photograph emphasizes the tremendous scale of the palace by including a person, dwarfed amidst the granite columns.

PLATE 90. Felice Beato. *Qutb Minar, Delhi.* Albumen prints from two wet-collodion glass-plate negatives, 1858, 58.7×23.7 cm (23$\frac{1}{8}$×9$\frac{5}{16}$ in). Written in ink on mount: "–Kootub–".

The Quwat-Islam (might of Islam), India's earliest mosque complex, is located southwest of Delhi and marked Delhi as the political stronghold of India. Between 1210 and 1232, the ruling monarch, Iltutmish, completed the victory tower shown here, which had been begun by his father-in-law Qutb-un-din-Aibak in the southeast corner of the mosque area. The first three stories of the Qutb Minar are of red sandstone, the two upper stories of white marble, and the whole is intermittently inscribed with elaborate decorative carving and verses from the Koran. The unusual photographic format of two negatives placed vertically accommodates the great height of the tower without losing clarity of detail. (Another example is Berenice Abbott's *Exchange Place*, plate 132.)

SAMUEL BOURNE
1834–1912

§ Born in Nottingham in 1834, Samuel Bourne left his banking career and went to Calcutta in 1863 to photograph the landscape and architecture of India. He traveled to the Himalayas and, despite the difficult terrain, he returned twice, in 1865 and 1866, before leaving for England in 1870. While in India, he wrote a number of articles published in the *British Journal of Photography* describing his treks. Soon recognized as an important landscape photographer, Bourne entered a partnership with Charles Shepherd about 1864. The firm of Bourne & Shepherd became a leading supplier of Indian views, and it is still in business today. The Calcutta branch issued a large catalog called *A Permanent Record of India*, in which images were catalogued according to location by city and by negative number. Although it consisted mainly of topographical and city views, mostly taken by Bourne, it also included views of local industry, such as jute, tea, coal, iron, steel, metals, opium, railways, and silk, which were probably taken in the 1860s and 1870s. The title of the catalog reveals a common contemporary atti-

tude toward the medium: the veracity of photographs as evidence. Bourne returned to Nottingham and became a partner in a textile company. He was elected to the committee of the Nottinghamshire Photographic Association, founded in 1884. In 1887 he became a member of the Photographic Society of Great Britain. He continued to photograph until shortly before his death in Nottingham.

Reference: Heathcote, "Samuel Bourne."

PLATE 91. Samuel Bourne. *View over the Ganges River, Varanasi.* Albumen print from wet-collodion glass-plate negative, 1867–1868, 18.7×31.8 cm (7⅜ × 12½ in). Signed and numbered in negative, lower center: "1166/Bourne". Titled in pencil on mount: "Benares".

Benares is the religious capital of Hindu India and the northern center for the worship of Siva. Situated on the Ganges River, the city is now called Varanasi after the Varuna and Asi, two rivers that feed into the Ganges at this point. This photograph, taken from the great seventeenth-century mosque on the north bank of the Ganges, gives an elevated view over the city's long riverfront. Most distinctive are the pukka mahals, dense masses of narrow streets with overhanging houses, and the ghats, flights of stone steps leading to the holy river. These ghats serve as public bathing places for the numerous pilgrims, and their landings frequently become platforms for burning the dead. The catalog of Bourne & Shepherd lists some thirty negatives of this city alone, an exceptionally large number, indicating the great interest that Varanasi held for the nineteenth-century viewer.

JOHN THOMSON
1837–1921

§ Born in Scotland, John Thomson is known for his thirty-six woodburytypes in the publication *Street Life in London* (London: Sampson Low, Marston, Searle & Rivington, 1877–1878), which was issued in twelve monthly editions beginning in February 1877. Now regarded as a classic treatment of social problems, it was the first such publication to use both text and photographic illustration. In 1865 Thomson had left England to spend a decade in Asia. The photographs he made resulted in a four-volume publication, *Illustrations of China and Its People* (London: Sampson Low, Marston, Low & Searle, 1873–1874), with 218 autotypes of the inhabitants, culture, geography, antiquities, and architecture of China. Soon after the publication of *Street Life*, Thomson turned to portraiture in London, where he died in 1921.

PLATE 92. John Thomson. *The Seventeen-Arch Bridge, Yuan Ming Yuan, Peking.* Albumen print from glass-plate negative, 1870–1872, 16.2×22.4 cm (6⅜×9 5/16

in). Reproduced as number 47 on plate 18, titled "The Great Marble Bridge, Yuen-Ming-Yuen," in *Illustrations of China and Its People*, volume 4 (London: Sampson Low, Marston, Low & Searle, 1874). Titled in pencil on mount: "The 17 Arch Bridge 'Yuen Ming Yuen' ".

All three of John Thomson's photographs included in this book were taken at Yuan Ming Yuan, the Old Summer Palace complex chiefly designed for the eighteenth-century emperor Ch'ien Lung. Inspired by pictures of Versailles, Ch'ien Lung decided to embellish an older palace and pleasure grounds. About 1737 he employed Jesuit priests to design copies of the great European villas he so admired. The Seventeen-Arch Bridge, constructed entirely of white marble, leads to an island on which there is a temple dedicated to the dragon deity. In *Illustrations of China and Its People*, Thomson recalls the past beauty of the stagnant lake as "*once ablaze with the pink flowers of the lotus, and the air laden with their fragrance*" (p. 47). The ruined condition of the Summer Palace resulted from the allied Anglo-British invasion and the burning of the grounds in 1860.

PLATE 93. John Thomson. *Hunting Ground, Yuan Ming Yuan, Peking.* Albumen print from glass-plate negative, 1870–1872, 18.6×23.2 cm (7 5/16×9⅛ in). Titled in pencil on mount: "The Hunting ground Pagoda Yuen Ming Yuen".

The Hunting Ground, also known as Hsiang Shan or "the perfumed mountain," was laid out during the Chin dynasty (*ca.* 1200). The pagoda shown here may be one of many built by Emperor Ch'ien Lung in the eighteenth century during the redesigning and expansion of the Summer Palace grounds. This seven-tiered monument is intended to be the embodiment of a mountain. Situated on a hill, it provides the focal point for an image that is primarily concerned with the landscape. A decade before, in 1860, Felice Beato had taken a similar photograph of the Summer Palace grounds shortly after the site had been devastated by James Bruce, Eighth Earl of Elgin (1811–1863) and son of Thomas Bruce, Seventh Earl of Elgin, who was responsible for bringing the Elgin marbles from the Parthenon to England.

PLATE 94. John Thomson. *The Bronze Temple, Wan Show Shan, Yuan Ming Yuan, Peking.* Albumen print from glass-plate negative, 1870–1872, 23.3×18.4 cm (9 3/16×7¼ in). Reproduced as number 48 on plate 19, titled "The Bronze Temple, Yuen-Ming-Yuen," in *Illustrations of China and Its People*, volume 4 (London: Sampson Low, Marston, Low & Searle, 1874). Titled in pencil on mount: "The Bronze Temple 'Wan Shu Shan' Yuen Ming Yuen".

The Bronze Temple was one of the few structures that survived the ravages of Lord Elgin's siege in October 1860, when a consuming fire burned for five days. Wan Show Shan, the name of the New Summer Palace, is located at Yuan Ming Yuan, then about six miles from the city, now part of Peking. Thomson's

picture is taken from an elevated viewpoint that allows comparison of the fine workmanship of the crown of the temple with the ruined condition of its base and of the surrounding landscape.

CHARLES LEANDER WEED
1824–1903

§ Charles Leander Weed was born in New York State. Long eclipsed by photographers such as Carleton Watkins and Eadweard Muybridge (1830–1904), who achieved international recognition, Weed's pioneering photographic efforts in Yosemite in 1859 preceded those of his more celebrated contemporaries. His photographs, reproduced in 1859 in *Hutchings' California Magazine*, may have been the catalyst for Watkins' first trip in 1861. By 1854 Weed was the camera operator in the daguerreotype portrait studio of G. W. Watson, with whom Weed soon expanded the business. In 1858 he became the junior partner in the Sacramento studio of Robert Vance, the leading daguerreotypist of the 1850s in California, and the company became known as Vance & Weed. Weed made photographs of rural California, using the relatively new wet-collodion process, which had been introduced to California at the State Fair in 1855. His series of mining views on the American River in 1858 failed to draw much public attention, and a fire in the studio further delayed any display of the work. In 1860, when interest in improving steamship traffic to China and Japan was steadily increasing on the West Coast, Weed went to the Far East and established a gallery in Hong Kong. After returning to California, he once again traveled to the East and produced magnificent mammoth-plate prints in 1867. That same year the publisher Thomas Houseworth exhibited Weed's work at the Exposition Universelle, Paris, where it won the international award for landscape photography. Weed traveled to the Hawaiian Islands in 1865, producing the earliest mammoth-plate photographs taken in that area. He also made portraits of royalty during this trip. Weed produced stereographs during the 1860s and 1870s and was probably a member of the Lawrence & Houseworth (a stereographic firm since 1855) expedition to the Sierra Nevadas in 1864. In the 1870s he allied himself with photographic publishers, among them Bradley & Rulofson, Silas Selleck, and Charles Lake Cramer, and he may have accompanied Muybridge to Yosemite in 1872. By 1880 he had become a photoengraver. He died in Oakland, California.

Reference: Palmquist, "Charles Leander Weed."

PLATE 95. Charles Leander Weed. *River view, Nagasaki.* Albumen print from wet-collodion glass-plate negative, 1867, 39.4×51.4 cm (15½×20¼ in). Plate 5

in *Oriental Scenery* (San Francisco: Thomas Houseworth & Co., 1869?). Titled in pen on mount: "River View in Nagasaki/Japan/5". Printed on mount: "Thomas Houseworth & Co., Publishers, 317–319 Montgomery St., San Francisco." Printed on verso of mount: "ORIENTAL SCENERY/Published by/Thomas Houseworth & Co./317 & 319/MONTGOMERY STREET,/SAN FRANCISCO./AWARDED THE/PRIZE MEDAL/AT THE/PARIS INTERNATIONAL EXHIBITION, 1867,/FOR THE/Finest Photographs of Scenery on the Pacific Coast./CATALOGUES FREE." with design from the prize medal.

Weed's albumen print, made from a mammoth glass plate, shows one of the many tributaries that empty into Nagasaki Bay. The villas with walled gardens that can be seen in this view probably belonged to prosperous people. Weed's composition, with the river winding gently into the mountainous background, is a characteristic example of nineteenth-century landscape aesthetic. Even here, in an unfamiliar geographic area, Weed has transformed the otherwise remote setting into a lyrical evocation of the serenity of river dwelling.

PLATE 96. Felice Beato. *Buddhist temple and cemetery, Nagasaki.* Albumen print from wet-collodion glass-plate negative, 1864–1865, 20.6×28.1 cm (8⅛× 11 1/16 in).

Beato took this view on a side street of Nagasaki, a seaport town located on the west coast of Kyushu province. The shop-lined street leads to a Buddhist temple and ends against an extensive terraced graveyard just beyond the town. Curious people can be seen peering from the shadows at the unusual sight of a Westerner with a camera. Japan had been closed to foreigners by the government of the Shogun in 1636. Nagasaki, however, became the only center of international trade; Dutch and some Chinese merchants enjoyed limited commercial privileges there, although under strict government control.

PLATE 97. Felice Beato. *Daimyo compound, Tokyo.* Albumen prints from five wet-collodion glass-plate negatives, 1865–1866, 22.5×137.5 cm (8⅞×54⅛ in). Written in pencil on verso: "Panorama of Yedo / from Atangayama / Japan".

The feudal lords, or Daimyos, who held responsibility for the behavior of their clans, were subject to the complete authority of the Shogun government in Tokyo. The Shogunate required that Daimyos spend six months in residence there, where they were virtually held hostage within a walled compound, such as the one shown. Since Tokyo was essentially closed to foreigners, Beato's five-part panorama, taken from Atagoyama between 1865 and 1866, offers an unusual and extremely rare view of a Japanese city. Beato gained access to Tokyo through his association with Aimé Humbert, the Swiss minister to the court of Shogun Keiki.

CARLETON E. WATKINS
1829–1916

§ Carleton Watkins left his home and family in Oneonta, New York, in 1851 or 1852 to travel to the West Coast in the great wave of western expansion. Perhaps he was further enticed by the West after the 1851 exhibition in New York City in which Robert Vance displayed three hundred whole-plate views of California. He learned photography in Vance's daguerreotype studio in San Francisco in 1854, working first as a stand-in photographer and then as a full-time employee. By 1861 he had his own studio and concentrated on topographical views and landscapes rather than on the more popular portrait photographs of the day. With the rapid expansion and settlement in the West during the 1850s and 1860s, Watkins was often commissioned to make photographs for use as evidence in land-fraud cases, specifically in the New Almaden Quicksilver Mine and Peralta disputes. As this novel use of the medium met with success, Watkins continued to make landscape photographs. He made his first trip to Yosemite in 1861, and he became a contributing member of the California State Geological Survey. He returned to Yosemite many times in the 1860s, making photographs for various surveys, including the geological survey under the supervision of Clarence King. In 1867 he photographed the Oregon and Columbia River region. The same year he opened the Yosemite Art Gallery, which he moved to a more fashionable address in 1872. Watkins' magnificent landscapes were exhibited at the Paris Exposition of 1867, where they won an international award. Between 1872 and 1874 Watkins was commissioned to photograph the estate of Thurlow Lodge in Menlo Park for its owner Milton S. Latham, the California senator and entrepreneur. Several sets of photographs from this massive undertaking were bound, including a pair of atlas folio albums that contains sixty albumen prints. This systematic, comprehensive documentation of a single building is the only known example by Watkins of an architectural commission in the mammoth-plate format. He declared bankruptcy in 1874 and lost the Yosemite Art Gallery to I. W. Taber. By 1876 the gallery is recorded as owned by Taber, who gained control of Watkins' negatives, which he printed in the 1870s and 1880s. After this setback, Watkins embarked on a second series of views. In 1881 Watkins became the manager of the Yosemite Art Gallery, then owned by W. H. Lawrence, who was no longer listed as the proprietor after 1887. By 1892, the gallery was no longer listed in the directory. Although Watkins received commissions in the 1890s, only some were completed and encroaching blindness prevented the completion of others. In 1906 the San Francisco earthquake destroyed the contents of his studio. Watkins died in a hospital in 1916, financial success and good health having eluded him throughout his career.

References: *California History*, 1978; and Palmquist, "Carleton E. Watkins."

PLATE 98. Carleton E. Watkins. *Buckeye tree, California*. Albumen print from wet-collodion glass-plate negative, *ca.* 1870, 39.1×51.8 cm (15⅜×20⅜ in). Titled and numbered in pencil on verso: "Cala Buckeye/No 365." Stamped twice on verso: "ACCESSION NO. 7282/Gift of Y.P. & C. Co./Items no. 1–1243" and "43".

Watkins began to photograph trees in Yosemite in the late 1860s. Interested in botanical descriptions, he was drawn to splendid examples even when his primary concern was defined by a particular commission. Thus he included images of fine arboreal specimens in his documentation of Thurlow Lodge. This photograph expresses the natural fertility and vastness of the American West juxtaposed with the provisional character of early settlement.

PLATE 99. Carleton E. Watkins. *Washerwoman's Bay, San Francisco, California*. Albumen print from wet-collodion glass-plate negative, 1858(?), 26.7×42.5 cm (10½×16¾ in). Photographer's blindstamp on mount: "Watkins". Titled on mount in pen: "Washerwoman's Bay in 1858".

During the decade between 1846 and 1856, settlement in San Francisco was concentrated in the downtown area. About 1853, population density caused the outskirts of the city to develop. Washerwoman's Bay, also known as Washerwoman's Lagoon, became the northern outpost for urban dwelling. Land use changed as a result of this decentralization and, with limited low land available for resettlement, the middle classes often attempted to level the hills with steam shovels, meeting with varying degrees of success. New major roads were built to increase commerce and facilitate settlement. Watkins' view of Washerwoman's Bay, with its lot lines and newly constructed houses, is a vivid description of this active expansion in the San Francisco area.

Reference: Lotchin, *San Francisco*, pp. 15–16, 42.

PLATE 100. Anonymous. *Market Street, between 15th and 16th Streets, Denver, Colorado*. Albumen print from wet-collodion glass-plate negative, 1865, 13.4×19.7 cm (5¼×7¾ in).

One of the earliest photographs of Denver, this view shows a wagon train on what is now Market Street between 15th and 16th Streets, but was formerly Holladay, between F and G Streets. Although no threat is apparent, the fifteen covered wagons are in the defensive circular formation designed to give maximum protection from attack. There were six mules and one driver per wagon. The view also includes part of the newly constructed building called the First National Block, which can be seen in the distance on the right-hand corner of 15th Street. Its roof was added in the 1870s.

Reference: Bancroft, *Denver's Lively Past*, p. 8.

TIMOTHY O'SULLIVAN
1840–1882

§ Timothy O'Sullivan, an Irish immigrant, worked in Mathew Brady's Washington, D.C. studio from 1858 until 1862, when he was hired by Alexander Gardner (1821–1882) following Gardner's departure from the Brady studio. As the official photographer to the Army of the Potomac, O'Sullivan recorded camp life and military technology for the series *Photographic Incidents of the War* (Washington, D.C.: Gardner/Philp and Solomons, 1863). He later produced forty-four negatives for *Gardner's Photographic Sketchbook of the War* (Washington, D.C.: Philp and Solomons, 1866), in which a total of one hundred plates were published in two volumes. In 1867 his association with various government-sponsored expeditions commenced, the first being the geological survey under Clarence King. In late 1870 he was hired by Lieutenant George Montague Wheeler to be the photographer on the military survey of the land west of the one-hundredth meridian. The following spring he worked in Nevada, California, and Arizona with Wheeler. O'Sullivan returned to work with King's expedition of 1872, but in 1873 he went back out west with Wheeler. The result was published as part of *Photographs Showing Landscapes, Geological and other Features* (plates 101 and 102). O'Sullivan returned to Washington to print negatives for the Army Corps of Engineers in 1874 and in the following year continued to print negatives he had made on the Wheeler expedition, some of which were sold separately to the general public. In 1880 he became the chief photographer for the Department of the Treasury, a post left vacant by the death of his close friend Lewis Emory Walker. He held it for only a short time before tuberculosis forced him to retire. He died on Staten Island in 1882.

References: Newhall, *T. H. O'Sullivan*; and Snyder, *American Frontiers*.

PLATE 101. Timothy H. O'Sullivan. *Zuni Pueblo, McKinley County, New Mexico*. Albumen print from wet-collodion glass-plate negative, 1873, 20.3×27.5 cm (8×10¹³⁄₁₆ in). Number 19 in *Photographs Showing Landscapes, Geological and other Features, of Portions of the Western Territory of the United States, Obtained in Connection with Geographical and Geological Explorations and Surveys West of the 100th Meridian, 1st Lieut. Geo. M. Wheeler, Corps of Engineers, U.S. Army, In Charge* (Washington, D.C.: U.S. Government Printing Office, 1874–1875). Numbered in negative: "23" four times, each one scratched out. Printed on mount: "WAR DEPARTMENT/CORPS OF ENGINEERS. U.S. ARMY./Geographical & Geological Explorations & Surveys West of the 100th Meridian. Expedition of 1873.–Lieut. Geo. M. Wheeler, Corps of Engineers, Commanding./T.H. O'Sullivan, Phot. No 19./SECTION OF SOUTH SIDE OF ZUNI PUEBLO, N.M."

The Zuni Pueblo, located on the Zuni Indian Reservation in northwestern New Mexico, was built in the sixteenth century and rebuilt in 1695. O'Sullivan made this photograph in 1873 as part of the Wheeler expedition, and it was printed and published later in Washington, D.C.

PLATE 102. Timothy H. O'Sullivan. *Church of San Miguel, Sante Fe, New Mexico*. Albumen print from wet-collodion glass-plate negative, 1873, 27.3×20 cm (10³⁄₄×7⅞ in). Number 11 in *Photographs Showing Landscapes, Geological and other Features, of Portions of the Western Territory of the United States, Obtained in Connection with Geographical and Geological Explorations and Surveys West of the 100th Meridian, 1st Lieut. Geo. M. Wheeler, Corps of Engineers, U.S. Army, In Charge* (Washington, D.C.: U.S. Government Printing Office, 1874–1875). Printed on mount: "WAR DEPARTMENT/CORPS OF ENGINEERS, U.S. ARMY./Geographical & Geological Explorations & Surveys West of the 100th Meridian. Expedition of 1873–Lieut. Geo. M. Wheeler, Corps of Engineers Commanding./T. H. O'Sullivan, Photo. No 11./THE CHURCH OF SAN MIGUEL,/The oldest in Santa Fé, N.M."

The Church of San Miguel, the oldest Christian church in Santa Fe, was built in 1628. Closed in 1640, it was rebuilt, only to be burned during the Pueblo Rebellion of 1680. Extensively restored in 1710, the roof was replaced again in 1830. The upper, stepped sections of the tower, here seen intact, fell during a storm and remained in a state of partial disrepair until 1888, when a simple rectangular tower was erected. Published in the same survey as the preceding image, this photograph reflects contemporary interest in the historical importance of the site.

GEORGE N. BARNARD
1819–1902

§ Born in Connecticut, George Barnard opened his first daguerreotype studio in 1843 in Oswego, New York. Ten years later he made a daguerreotype of burning mills in Oswego that is considered the earliest news photograph (collection of the International Museum of Photography at George Eastman House, Rochester). In 1854 Barnard moved to Syracuse and began to use the collodion process. He was hired by Mathew Brady in Washington, D.C. in 1862, where he worked with Timothy O'Sullivan and Alexander Gardner. Gardner left Brady's employ in 1863 as a result of not having received due credit for his work. This circumstance doubtless prompted the care with which he assigned credit to the photographers included in his publications: the 1863 series *Photographic Incidents of the War*, which he published with Philp and Solomons, and *Gardner's Photographic Sketchbook of the War*, also published by Philp and Solomons in 1866, which included eight negatives by Barnard and Gibson, printed by Gardner. Barnard's association with Brady was brief; by 1863 he had been named official photog-

rapher of the Military Division of the Mississippi. When General Sherman began his campaign from Nashville through to Atlanta and on to the sea, Barnard accompanied the troops as official photographer. Due to strong public interest in the North in the military campaign, he wrote to ask Sherman's permission to publish a portfolio independently. The result was *Photographic Views of Sherman's Campaign* (New York: George N. Barnard, 1866), which comprised sixty-one plates. Barnard returned to Syracuse briefly before moving to Chicago in 1869. There his gallery was destroyed by the great fire of 1871, however, and in 1875 he was hired by George Eastman in Rochester. Soon after he moved again, this time to Plainsville, Ohio, where he maintained a studio between 1884 and 1886. Little is known of his photographic activities after this date. He died in Cedarville, New York, in 1902.

Reference: Barnard, reprint (Newhall preface).

PLATE 103. George N. Barnard. *Atlanta, Georgia, after Sherman's March.* Albumen print from wet-collodion glass-plate negative, 1864, 25.4×35.7 cm (10× 14⅛ in). Plate 46 in *Photographic Views of Sherman's Campaign* (New York: George N. Barnard, 1866). Printed on mount: "Photo. from nature By G. N. Barnard./CITY OF ATLANTA, GA NO 2."

Barnard's photograph of the city that was devastated by Sherman on September 1, 1864, was published as the forty-sixth plate of *Photographic Views of Sherman's Campaign.* Atlanta had been evacuated, its railroad destroyed, and its buildings blown up. Dramatic cloud formations, added by Barnard's use of a second negative, contrast with the stillness of the city streets and heighten the trauma of the aftermath. The image records for posterity one of the targets of Sherman's campaign: the bank, the economic basis of the community, is neatly reduced to rubble, while the saloon remains remarkably intact.

PLATE 104. George N. Barnard. *View from the Capitol, Nashville, Tennessee.* Albumen print from wet-collodion glass-plate negative, 1863, 25.4×35.6 cm (10×14 in). Plate 3 in *Photographic Views of Sherman's Campaign* (New York: George N. Barnard, 1866). Printed on mount: "Photo. from nature By G. N. Barnard./NASHVILLE FROM THE CAPITOL."

Nashville became the capital of Tennessee in 1843, and the Capitol Building was begun in 1845, designed by William Strickland (1788–1854). It was completed in 1859 by his son Francis Strickland (1818–1895). Shortly thereafter, the Union Army occupied the city and its Capitol, converting the building into a fortified citadel. In Barnard's photograph the stockades have been removed but the breastworks remain. The image contrasts the formality of the monumental classical building and its cannons to the modest town and open landscape beyond. Here, too, the sky was added with a second negative.

LEWIS EMORY WALKER
1825–1880

§ Lewis Emory Walker lived in Greenwich, Massachusetts, when he first began photographing for the U.S. Department of the Treasury. Although the exact year of the commission is not known, the earliest of these negatives in the collection of the Still-Picture Section at the National Archives, Washington, D.C., is dated July 1, 1858. In 1868, and again in 1870, he helped his friend and fellow photographer Timothy O'Sullivan print negatives taken by O'Sullivan during Clarence King's survey expedition. In between, on July 1, 1869, George S. Boutwell hired Walker as the official photographer, specifically responsible to the Office of the Supervising Architect of the Treasury at a yearly compensation of $2,500. Prior to this appointment, Walker had been engaged in the execution of military maps and in copying military papers and drawings. He held his position as photographer of the Treasury Building, documenting various phases of its construction, until his death in 1880, when O'Sullivan assumed the post.

PLATE 105. Lewis Emory Walker. *Construction of the south wing, Department of the Treasury, Washington, D.C.* Albumen print from wet-collodion glass-plate negative, 1861, 23.5×31.9 cm (9¼×12⁹⁄₁₆ in). Dated in negative, on building stone: "Sept 16/1861".

The core of the present Treasury Building was designed by Robert Mills (1781–1855) and built between 1836 and 1842. Thomas Ustick Walter (1804–1887) succeeded Mills and was responsible for alterations and additions between 1855 and 1869, when it was finally completed. Walker's photograph of the south wing offers a precise record of its method of construction, including the date, September 16, 1861, that was scratched in the negative. As the last column was hoisted into place (at the left), the others stood in various stages of completion. Four columns have Ionic capitals, while only three of these carry a stone lintel. The posed group of men, workers as well as more elegantly dressed gentlemen (perhaps the architect and various engineers), provides scale and suggests pride in the building.

J. R. MOELLER

§ The following plate is all that is known of J. R. Moeller. He was probably a citizen of Grand Island, Nebraska, the subject of the carefully rendered panoramic series made in 1885.

PLATE 106. J. R. Moeller. *Grand Island, Nebraska.* Panorama of eight albumen prints from eight glass-plate negatives and, on verso, sixteen albumen

prints from sixteen glass-plate negatives, 1885, each print of the panorama approximately 11.1×17.8 cm (4⅜×7 in); each print on verso approximately 9.2 ×7.6 cm (3⅝×3 in). Mounted on accordion-fold pages between cloth covers. Titled, signed, and dated in gold-stamped letters: "GRAND ISLAND NEB./ 1885/J. R. MOELLER. PHOTO". Titled in ink on mount of panorama: "From Courthouse looking west From Courthouse looking north From Courthouse looking east From Courthouse looking south". Titled in ink on verso of mount, one title per image from left to right: "Public School (south side) Masonic Hall Schaupps Mill Wolbach Bros. B & M. Depot Citizen National Bank Courthouse 3rd Str. looking east W.P.R.R. Hotel W.P. Shops 1st National Bank Opera House Thummel & Platt G. I. Banking Co. Withers & Kolls Public School (north side)".

Moeller's eight-part panorama of Grand Island, the seat of Hall County, Nebraska, was taken from the cupola of the centrally located court house. The vista gives two parts of the panorama to each of the cardinal points, beginning with the west and moving clockwise. It depicts the view in all four directions over the city and across the plains to the horizon. While the eight images do not line up precisely, the overall effect is one of a complete view. Sixteen individual photographs of the most prominent city buildings are mounted on the back of the panorama. Among these are the public school, various shops, the train station, the bank, the court house itself, and the opera house, all of which are carefully identified.

WILLIAM HERMAN RAU
1855–1920

§ Rau, a native of Philadelphia, received his first photographic assignment in 1874 when he was hired to accompany the U. S. expedition to observe the transit of Venus, the passing of the planet in front of the sun. He next traveled to the Rocky Mountains and later to Egypt and the Middle East before opening a studio in 1885 in Philadelphia with his brother George. Rau produced many lantern slides from the trip to the Middle East, and these were issued throughout the 1890s. A careful businessman, in 1895 he moved his studio to a fashionable section of Philadelphia, where he prospered as a portraitist. His work was exhibited at the Salon of the Pennsylvania Academy of Fine Arts in 1889 and again in 1898. In 1890 he was hired by the Pennsylvania Railroad and in 1895 by the Lehigh Valley Railroad, for which he produced mammoth-plate and panoramic albumen prints, the latter with a panoramic camera he fashioned himself. According to Rau, he took more than two hundred pictures of the railway line that ran between New York and Niagara Falls, developing them in a railcar specially outfitted with a darkroom. They were exhibited in major cities along the line and its connections (*American Journal of Photography*, April 1897, p. 175). In 1904 he

was named official photographer of the St. Louis Exposition, and the following year he photographed the Lewis & Clark Exposition in Portland, Oregon. Back in Philadelphia, he was commissioned to document the dedication ceremonies of the new Pennsylvania State House in 1906. He later developed Robert Peary's photographs of the discovery of the North Pole (1909). Rau died in Philadelphia in 1920, survived by his wife Louise Bell and two daughters. Louise Bell was herself a photographer and the daughter of William Bell, the expeditionary photographer. A son-in-law, William Haden, became head of the studio after Rau's death.

References: Finkel, unpublished biography; and Panzer, *Philadelphia Naturalistic Photography*, p. 40.

PLATE 107. William H. Rau. *Towanda, Pennsylvania, from Table Rock*. Albumen print from glass-plate negative, late 1890s, 42.9×51.8 cm (16⅞×20⅜ in). Printed in negative, lower left: "617 TOWANDA FROM TABLE ROCK. L.V.R.R."; and lower right: "WILLIAM H. RAU, PHILA." Numbered on verso: "101".

Towanda is the seat of Bradford County in northern Pennsylvania. This mammoth-plate photograph provides a broad topographical description of the progressive cutting away of rural landscape by the developing town. This view, part of the series that Rau produced for the Lehigh Valley Railroad, also includes the new covered railroad bridge crossing the river.

PLATE 108. William H. Rau. *Coal breaker, Wilkes-Barre, Pennsylvania*. Albumen print from glass-plate negative, late 1890s, 42.5×51.8 cm (16¾×20⅜ in). Printed in negative, lower left: "577 COAL BREAKER AT SOUTH WILKES-BARRE. L.V.R.R."; and lower right: "WILLIAM H. RAU, PHILA." Written on verso: "63".

Wilkes-Barre, the seat of Luzerne County, is located in the northeastern section of Pennsylvania, just south of Scranton. Rau's mammoth plate of the coal breaker is essentially a diagram of the way in which coal is processed for hauling. Chunks of coal are transported by the conveyor seen at the right to the top of the building, from where they proceed down through the breaker to be broken up by a series of processes, both mechanical and manual. The coal then is loaded onto the flat-top rail cars and hauled along a spur to the main track, along which it will travel to its final destination.

PLATE 109. Anonymous. *Pier under construction, Inchgarvie, Forth Bridge*. Silver print from glass-plate negative, 1887, 41.6×56.4 cm (16⅜×22 3/16 in). Unidentified monogram signature in negative, lower left. Titled and dated in negative,

lower right: "No 23/INCHGARVIE/9 APRIL 1887." Written in pencil on verso: "20/9 April 87."

The triple-cantilever Forth Bridge spanning the Firth of Forth on the eastern coast of Scotland was the first long-span railway bridge to be built of steel. It was the culmination of over a century of ironwork development, which commenced with the single-arched, one-hundred-foot Iron Bridge over the Severn River in Shropshire, the cast iron for which had been produced in three months at Coalbrookdale in 1779. The Forth Bridge was remarkable for its two 1,700-foot spans, made possible by means of an innovation in structural design based on the cantilever principle. Four railway companies, the Great Northern, the North-Eastern, the Midland, and the North-British, all interested in the east coast traffic, financed the operation. Completed in 1890, the bridge facilitated trade and communication from northeast Scotland to the south of England. This photograph, dated April 9, 1887, shows the central pier of the Forth Bridge under construction. The pier was built on the islet of Inchgarvie, which is located in the deep central channel in the estuary. One hundred and fifty feet above the foundation, the temporary lifting platform at the top of the picture is placed at the level of the rail bed. This is only half of the pier's ultimate height. Public interest was intense: *From the visit of their Royal Highnesses the Prince and Princess of Wales, August 23, 1884, down to the present day, hardly a week has passed without bringing some person of rank or distinction. Dom Pedro of Brazil, the Kings of Saxony and of Belgium, and the Shah of Shahs, head this list, which includes, without exaggeration at any rate one-tenth of all people distinguished by rank or by scientific or social attainments.* (*Engineering*, February 28, 1890, p. 64.) It has often been photographed and has a minor role in Alfred Hitchcock's film "The 39 Steps."

EDOUARD(?) DURANDELLE

§ Nothing is known of Durandelle's life except that he worked with the photographer Delmaet between 1866 and 1888. Durandelle specialized in photographs of construction and industry. His best-known project is probably the documentation of the sculpture and ornament of the opera house designed by Charles Garnier (1825–1898). The photographs were published in four of the eight volumes of *Le nouvel Opéra de Paris* (Paris: Ducher et Cie, 1875–1881). He also recorded the building in Paris of the new Hôtel de Ville and the Sacré-Coeur.

PLATE 110. Edouard Durandelle. *Hydraulic apparatus, foundry, Biache Saint-Vaast, Pas-de-Calais*. Albumen print from glass-plate negative, 1870s (?), 44.9 × 53.8 cm (17¹¹⁄₁₆ × 21³⁄₁₆ in). Unnumbered plate in *Fonderies et Laminoirs de Biache St. Vaast*. Printed on mount: "ESCHGER GHESQUIÈRE & Cie /DURANDELLE PHOT./FONDERIES & LAMINOIRS DE BIACHE ST VAAST (PAS-DE-CALAIS)/ APPAREILS HYDRAULIQUES".

Durandelle's photograph of the interior of a foundry belongs to a portfolio that documents Eschger Ghesquière & Cie in Biache Saint-Vaast, Pas-de-Calais. The images in this group, probably commissioned to publicize the company, include various views of the machinery and the foundry operations. Much of Durandelle's career consisted of such records of industry and construction.

THOMAS ANNAN
1829–1887

§ Thomas Annan was a commercial photographer in Glasgow with a studio on Hope Street, which he opened with his brother Robert in 1855. In 1866 the Glasgow City Improvements Act designated the wynds and closes of the city for demolition in an effort to relieve the over-crowded living conditions. Annan was hired by the Trustees of the Improvements Act to photograph these areas, and in 1868 he made thirty-one albumen prints, of which two identical sets are known to have been bound. In 1878, in response to numerous requests by members of the Trust, several sets of these photographs were bound and presented to the Town Council. In 1878 or 1879, an edition of one hundred volumes, each comprising forty carbon prints, was published by the Glasgow City Improvements Trust under the title *Photographs of Old Closes, Streets, &c. taken 1868–1877*. Annan's purpose was not only to provide an historical document, as demanded by citizens and local government, but also to record an urban slum on the verge of demolition. Several other publications that included Annan's work were published during his lifetime. Among these were: *The Old Country Houses of the Old Glasgow Gentry*, comprising one hundred plates (Glasgow: James Maclehose, 1870), and *Memorials of the Old College Glasgow* (Glasgow: James Maclehose, 1871), with photographs of the college as it was in 1870 before undergoing renovations as well as many portraits of "the principal and professors." Annan established the photographic firm T. R. Annan & Sons in 1873. Long after his death, the firm published two editions of one hundred copies each, comprising fifty photogravures under the title *Old Closes and Streets, A Series of Photogravures, 1868–1890* (Glasgow 1900). Although based on the 1878 edition by the Glasgow City Improvements Trust, these editions were filled with substitutions and additions. Some of the pictures were altered by whitening the drying clothes, adding clouds, or sharpening the blurred figures. The accompanying text only briefly mentioned Annan and his association with the Improvements Act.

Reference: Annan, reprint (Mozley preface).

PLATE 111. Thomas Annan. *High Street, Glasgow*. Albumen print from glass-plate negative, published 1878 or 1879, 28.9 × 38.7 cm (11³⁄₈ × 15¼ in). Plate 4

in *Glasgow Improvements Act. 1866. Photographs of Streets, Closes &c. Taken 1868–71.* Photographer's blindstamp on mount: "T. Annan Photo./Glasgow." Printed label pasted to mount: "4. High Street, from College Open."

Before the nineteenth century, Glasgow prospered as a trading, commercial, and academic center. The university was established there in 1450, and members of the academic community lived along High Street, an ancient road. By the 1830s, High Street had deteriorated and its buildings were inhabited by poor, mainly Irish, immigrants who worked in the textile mills, foundries, and factories. Heavily over-populated, this area and the Saltmarket became prime targets for demolition under the Glasgow City Improvements Act of 1866.

PLATE 112. Thomas Annan. *Close, 101 High Street, Glasgow.* Albumen print from glass-plate negative, published 1878 or 1879, 27.9×22.2 cm (11×8¾ in). Plate 10 in *Glasgow Improvements Act. 1866. Photographs of Streets, Closes &c. Taken 1868–71.* Printed label pasted to mount: "10. Close, No. 101 High Street."

Closes or wynds were narrow passages that led from the streets to side entrances of workers' houses, the tenants of which often shared a common stair quite remote from the building's street facade. This image shows the length of such a close off Glasgow's High Street. The wash on the lines, visible in almost all of Annan's views of these alleys, gives a vivid sense of the impoverished and crowded conditions of what was considered the worst slum in Great Britain.

PLATE 113. Charles Marville. *Rue de la Grande-Truanderie from rue Montorgueil, Paris.* Albumen print from wet-collodion glass-plate negative, 1862–1865, 32.7×27.3 cm (12⅞×10¾ in). Photographer's blindstamp on mount: "CH MARVILLE/PHOTOGRAPHE/DU MUSEE IMPERIAL/DU LOUVRE". Titled in pencil on mount: "Rue de la Grande Truanderie, de la rue Montorgueil".

The section of the rue de la Grande-Truanderie shown in the foreground of this picture disappeared in the early 1860s to make way for rue de Turbigo. Marville made this picture for the city of Paris (which now holds the negatives in the Bibliothèque historique de la Ville de Paris) as a record of the streets that baron Haussmann's new plans were to destroy. Inevitably the picture also reveals incidental information about contemporary life. The baskets at the right almost certainly contained an early morning delivery of fresh foodstuffs, while the sacks piled on the cart at the left probably held coal or wood.

HENRY AND T. J. DIXON

§ The Society for Photographing Relics of Old London was established in 1875 by private citizens for the purpose of recording buildings endangered by urban growth. Until 1881 the Society published the photographs in fascicles without text; thereafter, they were accompanied by letterpress commentaries on the buildings' restoration or anticipated destruction as well as by historical information about the sites. The last issue was produced in 1886, by which time a total of 120 consecutively numbered and four unnumbered photographs had been published. Two teams of photographers were responsible for most of the plates: A. & J. Bool and Henry Dixon and Son. The Bools made both negatives and prints for numbers one through eighteen and only negatives for numbers nineteen through twenty-four, which were printed by Dixon and his son T. J. The balance were both photographed and printed by the two Dixons, whose firm became known as Henry Dixon and Son in 1887. Unlike Annan, the Dixons, on behalf of the Society, were more concerned with the historical importance of a building and its location in the city than with social commentary.

Reference: Prescott, "Architectural Views."

PLATE 114. Henry and T. J. Dixon. *King's Head Inn Yard, Southwark, London.* Carbon print from glass-plate negative, late 1870s, 17.9×22.5 cm (7 1/16×8⅞ in). Plate 50 in *The Society for Photographing Relics of Old London* (London: SPROL, 1881). Numbered in negative, lower right: "50". Printed on mount: "KING'S HEAD INN YARD, SOUTHWARK/THE SOCIETY FOR PHOTOGRAPHING RELICS OF OLD LONDON 1881/PHOTOGRAPHED & PRINTED IN PERMANENT CARBON/BY HENRY DIXON. 112, ALBANY ST. LONDON N.W." Written in pencil on mount: "50"; and in ink: "Am 55".

Southwark, located on the south side of the Thames, near London Bridge, was the site of a Roman settlement. It became part of the city in 1531. Situated on the main road from France, it was also well traveled by pilgrims to Becket's shrine in Canterbury. King's Head Inn, called Pope's Head Inn before 1540, was one of many that stood on the east side of Borough High Street, opposite Southwark Street. (Its altered name probably occurred as a result of the 1534 Act of Supremacy, which established Henry VIII as the self-proclaimed head of the Church of England.) In 1676, a fire destroyed five hundred homes and most of the inns, including the King's Head. They were rebuilt, many with elaborate wooden balconies like those shown here, which sometimes accommodated the audience at outdoor theater performances. The inn was torn down in 1885. By the early decades of the nineteenth century, Southwark had become a notorious slum. It was the site of the Marshalsea prison, where Charles Dickens' father was imprisoned for debt, and of the blacking warehouse in which the young Dickens worked. Consequently the teeming neighborhood gave rise to many of Dickens' characters and settings.

PLATE 115. Henry and T. J. Dixon. *College Street with Church of St. Michael Paternoster Royal, London.* Carbon print from glass-plate negative, 1879, 22.9×

17.8 cm (9×7 in). Plate 94 in *The Society for Photographing Relics of Old London* (London: SPROL, 1884). Dated and numbered in negative, lower right: "1879/ 94". Printed on mount: "COLLEGE STREET./NO 94/THE SOCIETY FOR PHO-TOGRAPHING RELICS OF OLD LONDON 1884/PHOTOGRAPHED & PRIN-TED IN PERMANENT CARBON/BY HENRY DIXON. 112, ALBANY ST. LON-DON N.W." Written on mount: "Am 75".

At the north end of the Southwark Bridge, near the Thames, is College Hill, former home of Richard Whittington (d. 1423), three times Lord Mayor of London. Although Whittington caused St. Michael Paternoster Royal to be re-built and was buried there, Sir Christopher Wren (1632–1723) redesigned the church in 1684. It was completed in 1713, with the steeple also added that year. The elaborate door of the Innholders Hall on College Street was reconstructed after the Great Fire of London in 1666. In the Society's publication of 1884, a de-tail of the door follows this image, while a photograph of the church itself be-gins the section devoted to the historic College Hill area. Since 1968, the church has served as the headquarters of the Missions to Seamen.

JEAN-EUGÈNE-AUGUSTE ATGET
1857–1927

§ The commonly accepted view of Eugène Atget's life has existed in the realm of legend until very recently. The description of Atget as a solitary figure who died a neglected old man is contradicted by the facts of his rich and varied life. Born in Libourne, near Bordeaux, he was a sailor, an actor, and a painter before turn-ing to photography around 1890. Throughout his photographic career, Atget chose to work with a simple wooden bellows camera and cumbersome 18 by 24 cm glass plates. All of his photographs, amounting to perhaps 10,000 pictures, are numbered according to a complex system that has been unraveled by Maria Morris Hambourg and the curators at The Museum of Modern Art. These num-bers indicate that Atget worked in series, compiling groups of photographs con-cerning certain locations or concepts, such as picturesque old Paris or the envi-rons of Paris. He photographed in a highly selective fashion, avoiding almost all works of the nineteenth century, for example. The Eiffel Tower appears only once, and the great projects of baron Haussmann hardly at all. On the other hand, seventeenth- and eighteenth-century architecture interested him greatly, and he recorded the parks of Versailles and Saint-Cloud in scores of images. Over the years Atget sold many pictures to museums and libraries as well as to the Commission des Monuments historiques, which had bought photographs since the Mission héliographique in 1851. Atget also worked on commission for the city of Paris, documenting neighborhoods and buildings in danger of de-molition. He sold prints to private collectors and, occasionally, even to foreign

institutions, notably the Victoria and Albert Museum, London. He also counted among his clients many craftsmen, artisans, and architects. The painter Maurice Utrillo is one who may have patronized the studio on the rue Compagne-Première, announced by the modest sign "Documents pour Artistes." About 1925 his work was discovered by the surrealist painter and photographer Man Ray (1890–1979). Fascinated by the seemingly strange and accidental quality of Atget's vision, Man Ray published four of his works in the periodical *La révolution surréaliste* by 1926. It was also in this period that Berenice Abbott met Atget, visiting his studio several times to buy prints; eventually she took his portrait. When Abbott revisited him in the fall of 1927, she found the studio closed and Atget dead. After inquiry among his friends, she managed to find the executor of the estate, André Calmettes, from whom she purchased the approximately 1,300 negatives and 5,000 prints that remained in the studio. Abbott published and exhibited the work, and in 1956 she produced a portfolio of modern prints from his negatives. In 1968 she sold the collection to The Museum of Modern Art, New York, which has catalogued the work and is publishing four volumes from the collection.

References: Abbott, *The World of Atget*; and Szarkowski and Hambourg, *The Work of Atget*.

PLATE 116. Eugène Atget. *Oval Court, Fontainebleau*. Gold-toned printing-out paper from glass-plate negative, 1903, 21.7×17.6 cm (8 9/16×6 15/16 in). Titled in pencil on verso: "Fontainebleau–coin/Cour ovale 6408".

Although built in many different stages, the royal chateau at Fontainebleau is largely the creation of François 1er. This photograph by Atget shows the oval courtyard of the chateau originally on the site, seen through the colonnade built by Gilles Le Breton, a master mason François 1er brought from Paris. The pilaster-framed doorway leads to the Grande Vis, or Royal Stairway, of François 1er, who is portrayed here in a bust over the entrance between the statues of Minerva and Juno. Atget made about two dozen pictures of Fontainebleau in 1903, at least eight of which depict various aspects of the Oval Court. Here he combined its two most architecturally interesting features: the doorway and the colonnade.

PLATE 117. Eugène Atget. *Maison de Balzac, rue Berton, Paris*. Gold-toned printing-out paper from glass-plate negative, 1922, 17.6×21.7 cm (6 15/16×8 9/16 in). Numbered in negative, upper left and lower right: "6318" (reversed). Titled and numbered in pencil on verso: "Rue Berton 6318".

Rue Berton lies in the Parisian district of Passy, which at the time of this pho-tograph was still a rural village. Atget often photographed there (1901, 1913, 1914, 1922, and 1927), finding in it many appropriate subjects for his series of photographs depicting picturesque old Paris. This view of one of the quiet

streets typical of the area is made especially noteworthy by the presence of Balzac's house at the left.

PLATE 118. Eugène Atget. *Arbor of the Triumphal Arch, Versailles.* Gold-toned printing-out paper from glass-plate negative, 1906, 21.4×17.6 cm (8⅞₆×6¹⁵⁄₁₆ in). Titled and numbered in pencil on verso: "Versailles–Bosquet de/l'arc de Triomphe" and "6489".

The Arbor of the Triumphal Arch, one of two formal gardens on the north side of Versailles, was built by the landscape architect André Le Nôtre (1613–1683). By the time of Atget's photograph, changing fashion and neglect had destroyed all the elements of the original design except for the sculptural group, *Triumphant France*, by J. B. Tubi, which is visible in the distance at the left. Atget regularly made exterior views of Versailles between 1901 and 1906, often depicting formal gardens with sculpture.

FREDERICK HENRY EVANS
1853–1943

§ Frederick H. Evans was born in London. He was a bookseller there until 1898, with George Bernard Shaw and Aubrey Beardsley among his clients. Evans became extremely interested in taking photographs of architecture shortly before the turn of the century and began to photograph cathedrals, drawn to them by their spiritual and physical beauty. He concentrated on examples of medieval and Renaissance architecture in Britain and France throughout his career. Although 120 of his photographs were exhibited at the Architectural Club of Boston in 1897, it was his exhibition at the Royal Photographic Society in London in 1900 that established his reputation. One of his first large projects was a comprehensive record of the Chapter House at York Minster. In about 1902 he produced ninety-seven platinotypes of interior views and details of the sculptural decoration of York, each carefully mounted on grey paper bearing his monogram blindstamp and all gathered into a hand-made portfolio. Many other works were published in *Country Life*, which commissioned him in 1905 to record French chateaux as well as sites of general interest. In 1900 Evans was elected a member of the Linked Ring, the international society dedicated to the promotion of photography as an art form. Other members included Evans' friends Alfred Stieglitz, F. Holland Day (1864–1933), Edward Steichen, and Alvin Langdon Coburn (1882–1966). Evans described his method of presentation –the use of multiple mounts, perfected throughout his own work–to the Americans, and he later became the first British photographer to have photographs published in *Camera Work* (no. 4, 1903), edited by Stieglitz in New York. In 1911 Evans made another architectural series, this one of Westminster

Abbey for *Country Life*. There is a marked contrast between the quality of reproduction in the weekly and the impeccable standards of Evans' original photographs, a disparity that Stieglitz, for example, never would have allowed. Evans continued to exhibit his work in London, and in 1928 he was elected an Honorary Fellow of the Royal Photographic Society. He made photographs until late in life, with an exhibition in London in 1933. He died in London.

Reference: Newhall, *Frederick H. Evans.*

PLATE 119. Frederick H. Evans. *Interior view, Bourges Cathedral.* Platinum print, 1900, 11.9×7 cm (4¹¹⁄₁₆×2¾ in). Photographer's rectangular blindstamp on mount: "FHE". Written in pencil on mount: "Bourges Cathedral–Height and Light". Bookplate pasted to verso of mount: "EX LIBRIS/FREDERICK H. EVANS/LET THOSE WHO/HOLD THE TORCH/HAND IT ON TO/OTHERS." Photogravure from same negative published as plate 3, titled "Height and Light in Bourges Cathedral" in *Camera Work*, no. 4, October 1903.

Evans is particularly well-known for photographs of Gothic cathedrals, especially views that hold the promise of light and space just beyond the position of the viewer. He described the process of taking this photograph: *"I was perforce limited on that hurried holiday to a tiny hand-camera for plates three and a quarter inches square; but while lamenting that fact I felt a trifle consoled in the thought that it might possibly help to prove that mere acreage has nothing to do with art, and that, remembering Turner's little drawings and their wonderful accomplishment in the conveying of awe, mystery, atmosphere, space, etc., I might be tempted by the Fates with an opportunity of showing that even so small a camera could, if its user saw the right thing and knew it to be in the right condition, accomplish something sufficiently far along Turner's road to merit some share of the sort of applause meted out to his drawings."* (*Camera Work*, no. 4, October 1903, pp. 17–18.)

PLATE 120. Frederick H. Evans. *View from the Tapestry Room, Kelmscott Manor, Oxfordshire.* Platinum print, 1896, 18.6×9.8 cm (7⁵⁄₁₆×3⅞ in). Photographer's rectangular blindstamp on mount: "FHE". Titled in pencil on mount: "In Kelmscott Manor".

Kelmscott Manor, thirty miles from Oxford, on the Thames, was built in 1570. In 1871 William Morris rented the house, which he shared with Dante Gabriel Rossetti and Frederick Startridge Ellis. Some years after his death in 1896, the year Evans took this photograph, Morris' widow bought the house. It was inherited by their youngest daughter Mary, and upon her death in 1938 it became part of a trust administered by Oxford University and, since 1962, by the Society of Antiquaries. The Tapestry Room on the second floor, Rossetti's former studio, overlooks a yard to the south. The buildings are most likely a part

of the original Stuart structure, to which additions were made in the eighteenth and nineteenth centuries. Another print from the same negative in the collection of the Royal Photographic Society, wider by about 2.86 cm (1⅛ in), includes the window frame, which results in a much heavier, less romantic image.

Reference: Dufty, *Kelmscott*.

ALFRED STIEGLITZ
1864–1946

§ The eldest of six children, Alfred Stieglitz was born and grew up in Hoboken, New Jersey. After the retirement of his father in 1881, the family moved to Europe, where they lived for five years. Stieglitz had attended City College in New York between 1879 and 1881 and, once in Europe, he entered the Berlin Polytechnic Institute to study mechanical engineering. By 1883, however, he had transferred to Hermann Vogel's photography classes, having discovered photography with great excitement. In 1887 Stieglitz won the first prize of the *Amateur Photographer* contest awarded by Peter Henry Emerson (1856–1936), the eminent British photographer and theoretician. After a string of successes, he returned to America in 1890. He became a partner in the Photochrome Engraving Company but resigned in 1895, after which he lived on a small private income. In 1893 Stieglitz married Emmeline Obermeyer, with whom he had a daughter, Katharine, in 1898. Stieglitz continued his success in the photographic community of New York. He joined the Society of Amateur Photographers in 1891 and became the editor of their magazine, *American Amateur Photography*, in 1893. The periodical changed dramatically under his direction, increasingly expressing Stieglitz' advanced visual ideas. Stieglitz enlarged its circulation, but he antagonized many of the society's members, and in 1896 he resigned. He then became the editor of another New York photography magazine, *Camera Notes*, in which he published some of the most promising younger photographers, among them, Edward Steichen, Clarence H. White (1871–1925), and Alvin Langdon Coburn (1882–1966). In 1902, however, Stieglitz resigned from this journal, too, and started the Photo-Secession movement and its periodical *Camera Work*. The fifty issues of *Camera Work*, which was published quarterly between 1903 and 1917, charted the progress of the avant-garde in literature as well as the visual arts. Stieglitz was the first to publish works by European artists such as Matisse and Picasso, by young photographers such as Paul Strand (1890–1976), and by authors such as Gertrude Stein. In 1905, with the help of Edward Steichen, Stieglitz opened a gallery known as "291" at 291 Fifth Avenue, where he exhibited works similar in spirit to those published in *Camera Work*. One of the unknown artists he showed there was Georgia O'Keeffe (born 1887), whom Stieglitz married in 1924. In 1917 Stieglitz closed "291" and stopped publishing

Camera Work, turning all his attention to his own photographs. Among other subjects, he photographed the landscape of Lake George–where he spent his summers beginning in 1918–and made an extraordinary series of portraits of Georgia O'Keeffe. In 1921 and 1924 Anderson Galleries, New York, staged exhibitions of Stieglitz' work. In 1924 Stieglitz became the first photographer to be represented in an American museum when the Boston Museum of Fine Arts accepted his gift of twenty-seven of his prints. Partly in response to demands from artists, Stieglitz opened a new gallery called "An Intimate Place" in 1925, and in 1929 he moved to another space, which he called "An American Place." He continued to show works of modern art, although increasingly Stieglitz, rather than the art, became the center of his gallery. People visited from all over the world to seek his advice and encouragement. In 1946 he suffered a heart attack in "An American Place" and died a few days later in New York City.

Plates 121, 123, 125.

Reference: Norman, *Alfred Stieglitz: An American Seer*.

PLATE 121. Alfred Stieglitz. *30th Street and Fifth Avenue* (?), *New York City*. Negative, 1899; contact silver print, before 1932, 11.9×8.9 cm (4¹¹⁄₁₆×3½ in). Written in pencil on verso: "EE/EX 1932". Gravure from same negative published as plate 3, titled "The Street–Design for a Poster," in *Camera Work*, no. 3, July 1903.

Stieglitz' title, "The Street–Design for a Poster," suggests the graphic simplicity of this image, which evokes a sense of the city on a cold, snowy day at dusk. His technical studies in Germany enabled him to extend the range of photographic materials beyond their generally accepted limits. During the 1890s Stieglitz sought to portray the qualities of light present in storms and other elemental conditions that had been considered impossible to photograph. This print belongs to that period and shares with these pictures a concern for subtle and transitory illumination.

DRAHOMIR JOSEPH RUZICKA
1870–1960

§ Ruzicka was born in Bohemia, but in 1876 the family of seven emigrated to America, which his father had decided offered more financial opportunities than Central Europe. They lived in Wahoo, Nebraska, for five years before moving to New York. After graduating from the New York University School of Medicine in 1891, Ruzicka moved to Europe, where he continued his studies with Wilhelm Röntgen, the discoverer of the X-ray. He maintained a general medical practice until 1922, when a heart ailment forced him to retire. By this time, Ruzicka had become an active amateur photographer. Although he tried mak-

ing photographs in 1904, he had been dissatisfied with the results and abandoned it until 1909, when some German photographs in the magazine *Photo-era* inspired a renewed interest. Beginning in 1912, Ruzicka exhibited widely in America and Europe and, by the end of World War I, he had established a critical reputation as one of the leading pictorial photographers. He was particularly influential in Prague, where he belonged to a photographic circle that included the young Josef Sudek (1896–1976). Among many offices and honors, Ruzicka served as president of the New York Camera Club and was an honorary fellow of the Royal Photographic Society in Great Britain, a member of the Pictorial Photographers of America, and a fellow of the Photographic Society of America. He died in New York in 1960.

Reference: Jeníček, *D. J. Ruzicka*.

PLATE 122. Drahomir Joseph Ruzicka. *Singer and Woolworth Buildings, Broadway, New York City*. Silver print, after 1913, 34.1×13.3 cm (13 7/16×5 1/4 in). Written on verso of mount in pen: "Lower Broadway./D. J. Ruzicka/N.Y./ 25.00". Written on verso of mount in pencil: "R. B. 454.50/chloride/one of the best of this kind-/Pgh/217/A 12×20". Stamp on verso of mount: "PITTSBURGH SALON/MARCH 1917/No. 217".

Two of the earliest and most memorable skyscrapers in the New York skyline were the Singer Building, designed by Ernest Flagg (1859–1947) and completed in 1908, and the Woolworth Building, designed by Cass Gilbert (1859–1934) and completed in 1913. Ruzicka's photograph places the buildings in distinctive profile against the sky, their height emphasized by the extreme narrowness of the picture's format. The pedestrian in the foreground provides a human equivalent to the dramatic verticality of the buildings as well as a reference for their extraordinary scale.

PLATE 123. Alfred Stieglitz. *New York City*. Photogravure, 1910, 33.2×25.6 cm (13 1/16×10 1/16 in). A smaller version published as plate 6, titled "Old and New New York," in *Camera Work*, no. 36, October 1911.

Stieglitz included a smaller version of this image, which he titled "Old and New New York," in a group of sixteen pictures that he published in *Camera Work* in 1911. Another gravure from the same series, "The City of Ambition," gives name to Stieglitz' fascination with New York's relentless expansion. He told the painter Marsden Hartley in 1914 that "[the city] *is like some great machine, soulless, and without a trace of heart . . . Still I wonder whether there is anything more truly wonderful than New York in the world just at present*" (Norman, p. 80). Many of his contemporaries shared this interest. Alvin Langdon Coburn (1882–1966), for example, published *New York* (New York: Brentano's) in 1910, a book of twenty photogravures that develops a similar interpretation of the same subject matter. The man standing at the right in "Old and New New York" may be Marius de Zayas, the Mexican caricaturist and painter whose work Stieglitz exhibited at "291" and published in *Camera Work*.

CHARLES SHEELER
1883–1965

§ Sheeler began his artistic career at the School of Industrial Art, in his native Philadelphia, between 1900 and 1903. He then attended William Merritt Chase's painting classes at the Pennsylvania Academy of Fine Arts between 1903 and 1906. Visiting Europe in 1909, he first saw the modern paintings that later proved influential. Sheeler began to photograph professionally in 1912, specializing in recording new buildings for architectural firms. He also continued to paint and in 1913 exhibited six paintings at the Armory Show, New York. By the end of the decade, Sheeler's work in all media began to display the sensitivity to texture, shape, and tonal contrast that typifies his mature art. He and Morton Schamberg (1881–1918), friends and fellow artists, photographed together in Philadelphia and Doylestown, Bucks County, during these years. Sheeler's photographs of Doylestown were exhibited at the Modern Gallery, New York, in 1917, and two of them won first and fourth prizes at the annual Wanamaker Exhibition in 1918. Other prizes went to Schamberg and Paul Strand (1890–1976). After Schamberg's death, Sheeler moved to New York, where he became friendly with Strand. They collaborated on a movie about New York in 1920, called *Manhatta*, or *New York the Magnificent*. From 1923 to 1929, he was a staff photographer for Condé Nast, working with Steichen as a photographer at *Vogue* during the 1920s. He documented the Ford Motor plant at River Rouge, Detroit, in 1927, producing a series of powerful images of industry. The fact that he made only thirty-two photographs during his six weeks there testifies to the deliberation that lay behind the confident, assured compositions of his finished works. In 1929 Sheeler traveled to Europe for the last time. While there he made a series of photographs of Chartres Cathedral and visited *Film und Foto*, the exhibition held in Stuttgart. Ten years later, The Museum of Modern Art held a major retrospective exhibition of Sheeler's art, including a small group of photographs. During the 1940s he worked as the staff photographer at the Metropolitan Museum of Art, illustrating several of their books, including *The Great King, King of Assyria* (New York 1946). Although Sheeler primarily worked as a painter during the late 1940s and 1950s, he did execute a few photographic projects, including commissioned works of the Pabst Brewing Company and the Pittsburgh blast furnaces. In 1959 Sheeler suffered a stroke that left him unable to paint or photograph, and in 1965 he died from a second stroke.

References: Rourke, *Charles Sheeler*; and *Charles Sheeler*.

PLATE 124. Charles Sheeler. *Fortieth Street looking west toward Broadway, New York City.* Silver print, *ca.* 1920, 24.1×16.2 cm (9½×6⅜ in). Titled in pencil on mount: "40e RUE OUEST PHOTO SHEELER/40th St. west toward Broadway".

Like many photographers of the 1920s and 1930s, Sheeler found great visual pleasure in the unrelenting geometry of New York's skyscrapers. This view down West Fortieth Street uses light and vantage point to explore the strong vertical patterns of the buildings. The physical and psychological distance from any human dimension is also characteristic of Sheeler's work, which often describes the city as an exclusively architectural rather than a human experience.

PLATE 125. Alfred Stieglitz. *Rockefeller Center from the Shelton Hotel, New York City.* Silver print, 1935, 24.1×18.7 cm (9½×7⅜ in). Written in pencil on verso: "A-1/E large".

Stieglitz often photographed New York City from the Shelton Towers Hotel, Lexington Avenue between 48th and 49th Streets, after he moved there in 1925. Rockefeller Center, seen here during its construction, was built between 1932 and 1940 by a committee of architects: Reinhard and Hofmeister; Hood and Fouilhoux; Corbett, Harrison and MacMurray; and Benjamin Wister Morris. This photograph shows the thin face of the newly completed RCA Building, the flat slab of 444 Madison Avenue, and the smaller tower of Rockefeller Center's 630 Fifth Avenue rising out of the darkness of midtown. The spires of St. Patrick's Cathedral at the right are dwarfed by the new skyscrapers. Stieglitz made several other photographs of this same view, all of which suggest the power and mystery of the constantly changing city.

LANGDON HADLEY LONGWELL
Born 1900

§ Longwell began to photograph when he was about fourteen years old. During his early twenties, he studied photography in Chicago, and he earned his living making lantern slides. About 1924 he became one of the first members of the newly established Fort Dearborn Camera Club as well as a founding member of the Photographic Society of America. He also began to exhibit his photographs in salons all over the world. From 1927 to 1929, he worked at a studio in Madison, Wisconsin, where he took pictures of local events and celebrations. In 1930 he returned to Chicago and began to work for the studio of Hedrich-Blessing, which specialized in architectural photography. During the Century of Progress Exposition, Chicago, in 1933, he was especially active for the firm. In 1934, however, he began working for studios as well as mail-order houses, work that continued until his retirement in 1970. Longwell has written books about stamp collecting, a hobby in which he has passionate interest.

PLATE 126. Langdon H. Longwell. *Wabash Avenue and Wacker Drive, Chicago.* Silver print, 1920s (?), 37.1×32.2 cm (14⅝×12¹¹⁄₁₆ in). Signed in pencil on verso: "LH Longwell".

Longwell's view of downtown Chicago transforms the particular place into a general statement about the American city. Only the massive architectural units and the cars fill the deep luminous space enclosed by the flat building facades. The strongly defined shape of the trestle, which supports the electrical lines for trolley-cars, emphasizes the recession into hazy distance. It is an image that seems appropriate to the Chicago of the period, suggesting the toughness and vitality characteristic of America's heartland.

SAMUEL HERMAN GOTTSCHO
1875-1971

§ Samuel Gottscho took his first photograph at Coney Island, in his native Brooklyn, in the summer of 1896. He continued to photograph while working as a traveling salesman of laces and fabrics, but in 1925 he decided to become a professional photographer. Gottscho began with commissions from architects and landscape designers, with whom he rapidly gained a considerable reputation. During the 1930s, the depression diminished such opportunities, and Gottscho worked instead for builders in Manhattan and Queens. In 1940 he began an extensive project of documentation for the New York Botanical Garden, in the Bronx, and through that experience became one of the most proficient photographers of gardens and flowers in America. Many of the publications of the Botanical Garden contain his photographs. During the 1940s Gottscho also started to depict the wildflowers that grew in the vicinity of his summer house on Schroon Lake in the Adirondacks. These botanical pictures appeared in magazines, including *Colliers, House and Garden,* and *Woman's Day,* as well as in his book *Wildflowers: How to Know and Enjoy Them* (New York: Dodd, Mead, 1951). In 1967 he received the Distinguished Service Medal of the Botanical Garden. Before his death in New York in 1971, Gottscho deposited collections of his work in the Museum of the City of New York and Avery Library, Columbia University. His negatives are housed in the Library of Congress, Washington, D.C.

PLATE 127. Samuel H. Gottscho. *Manhattan and the East River.* Bromo-chloride print, 1931, 23.5×17.8 cm (9¼×7 in). Titled and signed in pencil on mount: "Power Houses–East River Samuel H. Gottscho". Titled in pencil on verso of mount: "'Power House–East River' #1/Bromo-chloride". Photographer's stamp on verso of mount: "Photograph No. 17484/SAMUEL H. GOTTSCHO/150-35 86th AVENUE/JAMAICA, NEW YORK". Exhibition label from First Detroit International Salon of Industrial Photography, 1933, pasted on verso of mount.

Representations of Manhattan as a center of commercial activity, dense with buildings and filled with smoke, became popular shortly after 1900. Gottscho's view of the commercial piers and power station along the East River owes much to the image of New York that those pictures articulated. As in his view from the Rainbow Room (plate 129), Gottscho has transformed pictorial traditions represented by such photographers as Stieglitz (plate 123) and Ruzicka (plate 122) into native American material. The photograph also reflects the contemporary pleasure found in industrial landscapes (plates 136, 141–143).

MARGARET BOURKE-WHITE
1904–1971

§ Margaret Bourke-White began studying photography with Clarence H. White (1871–1925) at Teacher's College, Columbia University, during the 1920s, and she continued to photograph during her college years at Cornell University. After graduation in 1927, she became a freelance photographer in Cleveland, where she developed a strong interest in industrial subjects. At this time, Bourke-White's pictures already displayed the compositional boldness and sense of graphic design that allowed her work to transfer so successfully to the printed page. In 1929 she returned to New York and became the first staff photographer of Henry Luce's new magazine *Fortune*. She developed a profitable combination of work: six months of the year she devoted to *Fortune* and the other six months she worked on various advertising assignments for companies such as Goodyear Tire. In 1931, following a visit to the U.S.S.R., Bourke-White published an account of her travels titled *Eyes On Russia* (New York: Simon and Schuster), the first of many books. In 1934 *Fortune* assigned her the task of reporting on the drought in the midwestern United States. According to Bourke-White, the experience changed her life, and her subsequent work became more socially responsive than it previously had been. Her experiences on the farms of America resulted in *You Have Seen Their Faces*, published in 1937 (New York: Viking Press). Co-authored with Erskine Caldwell, who later became her husband, the book offers a forceful indictment of the sharecropper system in both words and pictures. The single most important phase of Bourke-White's professional life began with the first issue of *Life* magazine on November 23, 1936, which carried her photograph of the Fort Peck Dam, Montana, on its cover. From that first cover until 1957, when Parkinson's disease prevented her from working, *Life* provided her most challenging and responsive forum. Assignments led her to the Italian and German fronts of World War II and placed her with General Patton when his troops liberated Buchenwald. She photographed the events following the partition of India and Pakistan, the war in Korea, the aftermath of the death of Gandhi as well as American and foreign political life. *Portrait of Myself* (New York: Simon and Schuster), published in 1963, was her last book.

PLATE 128. Margaret Bourke-White. *View from the Terminal Tower, Cleveland, Ohio*. Silver print, 1928, 10.2×7.6 cm (4×3 in). Signed in pencil on mount: "Bourke-White".

In a sophisticated variation of the standard view from a monument, Bourke-White included the place from which the view was taken within the view itself. The dominating presence of the Terminal Tower marks the solid buildings of downtown Cleveland with its strong shadow. The decorative mounting and signing of this print, as well as the strong sense of design and evocative use of shadows, suggest the influence of Clarence H. White, with whom Bourke-White studied photography.

PLATE 129. Samuel H. Gottscho. *View from the Rainbow Room, RCA Building, New York City*. Silver print, 1934, 26.8×19.1 cm (10⁹⁄₁₆×7½ in). Written in ink on verso: "Rainbow Club–table, flower box and night view". Written in pencil on verso: "Lights in Empire State/arranged in cross at Xmas". Photographer's stamp on verso: "Photograph No. 2239/SAMUEL H. GOTTSCHO/150-35 86th AVENUE/JAMAICA, NEW YORK" and Gottscho-Schleisner, Inc. stamp.

Gottscho's photograph simultaneously shows two of the newest and most dramatic additions to the New York skyline in the early 1930s: the distinctive shape, outlined in glittering lights, of the Empire State Building and the RCA Building, from which the picture was taken. The luxury of the Rainbow Room combined with the glamorous vista of the city at night make this image an amusing tribute to the glory of modern New York.

FAY STURTEVANT LINCOLN
1894–1975

§ F. S. Lincoln first used a camera at age eighteen while growing up in Keene, New Hampshire. He supported himself with his photography during study of chemical engineering at the Massachusetts Institute of Technology, which he entered in 1913. At the end of that academic year, Lincoln left M.I.T. During World War I, he served in France, and after the armistice he attended courses at the university of Besançon. In 1919 Lincoln reentered M.I.T. as a student in biology, graduating in 1922. In 1929 he formed a partnership with Peter Nyholm, and by 1933 they had established a studio at 114 East 32nd Street in New York. During the 1930s Lincoln worked extensively throughout the eastern United States, completing a commission at Colonial Williamsburg, among many other projects. Pictures of Charleston appeared in *Charleston, Photographic Studies by F. S. Lincoln* (New York 1946), published by Lincoln's own company, Corinthian Publications. Many other photographs, especially of antebellum architecture, appeared in *Architectural Forum*, *Architectural Record*, *Time*, *Life*, and *House and Garden*. In 1934 and 1937 he traveled to France, and some of these photo-

graphs appeared in *Mont St. Michel* (New York: Corinthian Publications, 1947). About 1965 Lincoln closed his New York studio and moved to Pennsylvania to be near his sister. His one marriage, to Julia Chiholsky, a photographer, ended in divorce. A keen ice skater, Lincoln also tried to walk seven miles a day until the end of his life. He died in Centre Hall, Pennsylvania, in 1975. His collection of almost 10,000 prints, negatives, logs, and files was donated to the Pennsylvania Historical Collections and Labor Archives, Fred Lewis Pattee Library, Pennsylvania State University.

PLATE 130. Fay Sturtevant Lincoln. *Main banking room, Irving Trust Company, New York City.* Silver print, 1932 (?), 23.7×18.4 cm (9$\frac{5}{16}$×7$\frac{1}{4}$ in). Signed in pencil on mount: "F. S. Lincoln". Written in pencil on verso of mount: "Irving Trust Co. #1 Wall St./ Dupls". Photographer's stamp on verso of mount: "F. S. LINCOLN/Photographer/114 EAST 32nd STREET/NEW YORK CITY/685P9".

Lincoln probably took this view of the main banking room of the Irving Trust Building at 1 Wall Street, designed by Voorhees, Gmelin, and Walker, soon after its completion in 1932. The splendid interior, decorated with red and gold mosaics by Hildreth Meière, is brilliantly illuminated by light from the enlarged lancet windows. The photograph describes the Art Deco room as a cathedral of commerce, an interpretation that is surely in accord with the architectural design itself.

EDWARD JEAN STEICHEN
1879–1973

§ Steichen was born in Luxemburg in 1879, but in 1881 his family moved to Hancock, Michigan, where his father worked in the mines and his mother made hats. In 1889 they moved to Milwaukee, where Steichen studied painting and helped organize the Milwaukee Art Students' League. He left school at fifteen and began working for a lithography company, where he used photography as the basis for poster designs. He also photographed independently, and in 1898 the Philadelphia Photographic Salon accepted his photographs for exhibition. In 1899 Clarence H. White (1871–1925) and Alfred Stieglitz accepted most of his submissions to a show at the Art Institute of Chicago, and in 1900 F. Holland Day (1864–1933) included his work in the London exhibition "The New School of American Photography." Steichen traveled to New York in that same year—where Stieglitz bought some of his photographs for five dollars each—and then went on to Paris and London. Success followed him. In 1901 the Paris Salon accepted some of his paintings, and in 1902 he had an exhibition of paintings and photographs in Paris. Steichen then returned to New York, where Stieglitz praised his work highly and devoted the second issue of *Camera Work* to his pictures. Together they founded "291," the gallery at 291 Fifth Avenue, and de-

signed the interior. In 1906 Steichen went back to France and sent Stieglitz examples of modern art: drawings by Rodin; watercolors by Paul Cézanne and John Marin; paintings and sculpture by Picasso and Matisse; stage designs by Edward Gordon Craig. These became the basis for many of Stieglitz' exhibitions at "291." In 1911 Steichen took his first fashion photographs on assignment for *Art et Décoration*. With the outbreak of World War I, he returned to New York and continued to work with Stieglitz at "291" until his commission as a First Lieutenant in the American Army in 1917. A technical advisor on aerial photography, Steichen became a Colonel in 1918 and a Chevalier of the Legion of Honor in 1919. At the end of the war, he returned to France and energetically pursued photography, after making a great bonfire of almost all his paintings. Back in New York in 1923, Steichen became the chief photographer for Condé Nast's fashion magazines, *Vogue* and *Vanity Fair*. He also produced portraits and advertisements that contain the same elegance and wit as his distinctive fashion photography. In 1939, feeling stifled by the managerial aspects of the job and its demands, Steichen retired to Connecticut, where he pursued color photography and plant breeding, especially of delphiniums. With the entrance of America into World War II, Steichen enlisted again, becoming a Lieutenant Commander in the U.S. Navy in 1942. From 1945 to 1946 he was in command of navy combat photography. In 1947 Steichen began an entirely new career as Director of Photography at The Museum of Modern Art, New York. During his fifteen-year tenure, he organized a number of highly successful and influential exhibitions. The most celebrated of these was the *Family of Man*, which opened in 1955 and circulated throughout the world. In 1962 Steichen again retired to his farm in Connecticut. He died in 1973.

PLATE 131. Edward Steichen. *Empire State Building, New York City.* Silver print, 1932, 24.1×19.4 cm (9$\frac{1}{2}$×7$\frac{5}{8}$ in). Numbered in negative, upper center: "1345-21". Titled and signed on verso: "Empire State Bldg/Photograph by Steichen/(Steichen's own signature)/PRINT TO BE 36″ high/36/1932/Exh. #284/BOOK PL. 218/5-263-P/OOP/W. Orig. Handwrtg." Various other stamps on verso concerning publication of the photograph.

The Empire State Building, designed by Shreve, Lamb and Harmon, immediately became a symbol of New York upon its completion in 1931. It appears most often in unmistakable silhouette seen from afar, as in Gottscho's picture of the view from the Rainbow Room (plate 129). Although less common, Steichen's dramatic view from below is no less characteristic of the period's fascination with the dynamic force of this new architectural expression. This double exposure, which Steichen titled "The Maypole," fuses the visual movement and vitality of the photograph with the sense of energy and excitement generated by the new building.

BERENICE ABBOTT
Born 1898

§ Berenice Abbott spent only a few semesters at Ohio State University before moving to New York, where she lived for three years. In 1921 she left for Europe, studying drawing and sculpture in Paris with Emile Bourdelle and continuing her studies at the Kunstschule in Berlin. In 1923 financial difficulties forced her to take an assistantship with Man Ray (1890–1979), the surrealist painter and photographer. It was during this time that she discovered the work of Eugène Atget, and she purchased the contents of his studio after his death in 1927. In 1926 Abbott opened her own studio in Paris, where she produced memorable portraits of figures of the avant-garde: James Joyce, André Gide, Jean Cocteau, Marcel Duchamp. Abbott returned to New York in 1929. Fascinated with the emergence of the modern city, she decided to record New York in all its aspects. She began the project on her own time, supporting herself with freelance magazine assignments and a teaching job at the New School for Social Research. In 1935, however, she began to work for the Federal Art Project, which provided materials, assistants, and a car. A selection of these photographs was published in 1939 as *Changing New York*, with a text by Elizabeth McCausland. Prints and the negatives from the Federal Art Project were deposited in the Museum of the City of New York. During the 1940s, Abbott published a book about photographic technique, *A Guide to Better Photography* (New York: Crown Press, 1941) and another volume of her photographs, *Greenwich Village Today and Yesterday* (New York: Harper and Bros., 1949). She also had become very interested in the photographic demonstration of scientific principles and during the 1940s and 1950s made many pictures of physical and chemical reactions. In 1968 Abbott moved to Maine, where she lives.

PLATE 132. Berenice Abbott. *Exchange Place, New York City*. Two silver prints, 1936, 11.4×18.7 cm (4$\frac{1}{2}$×7$\frac{3}{8}$ in), bottom print; 18.4×18.7 cm (7$\frac{1}{4}$× 7$\frac{3}{8}$ in), top print. Photographer's stamp on verso of top print: "photograph/ berenice abbott/56 w. 53rd st./new york city".

Abbott's photograph of Exchange Place emphasizes the dramatic height of downtown Manhattan by extending the picture's vertical format through the use of two negatives. Vividly illustrating the urban concentration of the financial district, this image portrays the massive buildings of Exchange Place pressing in on all sides, leaving only a fragment of sky at the top of the picture. Many photographers depicted the canyons of Manhattan, although most—including Abbott herself—looked down into the streets or straight ahead along street level, as Ruzicka did in his photograph of Broadway (plate 122).

PLATE 133. Berenice Abbott. *Interior, Pennsylvania Station, New York City*. Two silver prints, *ca.* 1937, 23.3×16 cm (9$\frac{3}{16}$×6$\frac{5}{16}$ in), left print; 23.3×18.7 cm

(9$\frac{3}{16}$×7$\frac{3}{8}$ in), right print. Photographer's stamp on versos: "photograph/berenice abbott/50 commerce st./new york city".

Abbott intended that her photographic series, *Changing New York*, should describe the diversity and richness of the city's architecture. She photographed the new, but more often her interest was in the old and the typical. Abbott was not only concerned with making an inventory of individual buildings, but also with characterizing the city's neighborhoods. Pennsylvania Station, one of the finest works by McKim, Mead and White (completed 1910), concealed its great iron and glass interior behind massive Doric colonnades. This view by Abbott evokes a sense of the space that filled this descendent of Paxton's Crystal Palace (plate 6). The structure was destroyed in 1963 to make way for the present entertainment and office complex, thus losing one of America's greatest public spaces.

FRANK NAVARA
Born 1898

§ Frank Navara, born in Bohemia, became interested in photography at about eleven or twelve years of age when his father gave him a small camera. During World War I, however, the scarcity of the necessary materials prevented him from pursuing his hobby, and he did not photograph again until he emigrated to New York in 1923. In the United States he was employed by the Fairchild Camera and Instrument Corporation, and in 1930 he again started to photograph seriously in his free time. He joined the Pictorial Photographers of America in 1932 and worked actively for them. During the late 1930s, he served on their Executive Committee. Through the P.P.A., Navara met Ruzicka, also from Bohemia. About 1938 Navara attended a series of lectures given in New York by Ansel Adams (b. 1902), which encouraged him to develop a clearer, more precise photographic style. Navara has exhibited and published widely, his pictures appearing in European and American shows as well as in *Life* magazine, *U.S. Camera*, and *Leica Annual*. Now retired from business, Navara continues to photograph and is active in his local camera club.

PLATE 134. Frank Navara. *Rental cabins near Woodstock, New Hampshire*. Silver print, 1935, 34.3×26.5 cm (13$\frac{1}{2}$×10$\frac{7}{16}$ in). Titled and signed in pencil by photographer on mount and verso: "Like Doll's Houses–Frank Navara". Stamp pasted on verso: "MEMBER/PICTORIAL/PHOTOGRAPHERS/OF AMERICA". Exhibition stamp pasted on verso: "1938/EXHIBITED AT THE/FOURTH INTERNATIONAL LEICA/EXHIBIT". Reproduced on p. 5, titled "Like Dollhouses," in *Life*, vol. 4, no. 4, January 24, 1938. (This reproduction including the information "LEICA, F12.5 AT 1/60 SEC." is pasted on the verso.)

Frank Navara's picture of rental cabins near Woodstock, New Hampshire, was selected by *Life* as one of the most striking works included in two shows of

photographs made with small cameras. Taken from an observation tower with a Leica, the picture emphasizes the repetitive sameness of the summer cottages while creating a striking formal composition. This is the only photograph made with a 35-millimeter camera in this book.

WALKER EVANS
1903–1975

§ Born in St. Louis, Walker Evans was raised in an elegant Chicago suburb and educated at Phillips Academy, Andover, Massachusetts. After a year at Williams College and a few courses at the Sorbonne, Evans decided to become a photographer. His first photographs, taken in 1928, already reveal the sense of form and order that characterizes his mature pictures. Evans began his first major photographic project in 1930, in collaboration with Lincoln Kirstein: a series of photographs of early Victorian houses in New England and New York. A selection of these photographs was exhibited at The Museum of Modern Art in 1933 and published in *American Photographs* (New York: The Museum of Modern Art, 1938). In 1932 Evans traveled to Cuba, and in 1933 twenty-eight of his photographs were published in *The Crime of Cuba*, with text by Carleton Beals (Philadelphia and London: J. B. Lippincott & Co.). In 1935 Evans made five hundred negatives of African art for distribution to colleges and libraries through the General Education Board. Between 1935 and 1938, Evans worked for the Farm Security Administration, photographing the effects of the depression on southern farms as well as on industrial towns in West Virginia and Pennsylvania. Although Evans only remained with the F.S.A. for three years, he produced an extraordinary body of pictures. Some of these accompanied James Agee's *Let Us Now Praise Famous Men* (Boston: Houghton Mifflin Company, 1941), which describes the families and the environment of several sharecroppers with whom Evans and Agee lived in 1936. From 1943 to 1945 Evans worked for *Time* magazine as a writer, and from 1945 to 1965 he was a staff photographer at *Fortune* magazine, for which he produced forty portfolios and photographic essays. Evans also photographed on the New York subway in 1938 and 1941, as well as in the streets of Chicago during the mid-1940s, creating vivid portraits of Americans, for the most part caught unaware, often harassed and exhausted. Evans became a professor of photography at the School of Art and Architecture, Yale University, in 1965. He died in New Haven in 1975.

Reference: Szarkowski, *Walker Evans*.

PLATE 135. Walker Evans. *Drawing room, Belle Grove Plantation, Iberville Parish, Louisiana.* Silver print, 1935, 19.7×24.1 cm (7¾×9½ in). Stamped on verso: "Walker Evans"; and numbered in pencil: "11" and "76".

Belle Grove was one of the largest and most splendidly crafted of the Louisiana plantation homes. Built for the Virginia planter John Andrews in 1857, the house was designed by James Gallier, Jr. (1827–1868) in a distinctively Palladian style that was unusual for the region. Belle Grove deteriorated seriously during the 1920s, and despite various attempts at conservation, the house was razed after World War II. Evans' photograph of the drawing room (which he called the breakfast room) reveals evidence of structural decay in the walls and ceiling, although the magnificent moldings and Corinthian columns are still mostly intact.

PLATE 136. Walker Evans. *Bethlehem, Pennsylvania.* Silver print, 1935, 19.4× 24.1 cm (7⅝×9½ in). Numbered in negative, upper center: "RA 1167 A" (reversed). Numbered in pencil on verso: "FSA 61/#663". Stamped on verso: "Walker Evans"; and numbered in pencil: "11" and "142".

Evans' earliest photographs for the Farm Security Administration date from June, July, and November 1935, when he worked in the coal-mining towns of West Virginia and industrial towns of Pennsylvania. This picture of Bethlehem, Pennsylvania, combines the cemetery, simple brick houses, and steel mills into a single forceful industrial landscape. It also suggests the parameters of an ordinary existence there: a lifetime of work in the steel mills that ends only with death.

ALBERT RENGER-PATZSCH
1897–1966

§ Albert Renger-Patzsch was born in Würzburg, Germany, and educated in Dresden, where he studied classics, acquiring great respect for clarity and order. After serving in the German army, he returned to Dresden, where he studied chemistry. By 1925, after a three-year appointment as the director of the Folkwang Archives in Hagen, he had established himself as a commercial photographer. His first book of photographs was published that year, *Das Chorgestühl von Cappenberg* (Berlin: Auriga-Verlag, 1925), and two years later, *Die Halligen* (Berlin: Albertus-Verlag, 1927) was published. This was followed in 1928 by the influential *Die Welt ist Schön* (Munich: Kurt Wolff Verlag), with text by Carl Georg Heise and one hundred pictures by Renger-Patzsch. *Die Welt ist Schön* put forward a new pictorial approach: found objects and incidental detail were rediscovered for their material substance and appreciated for their inherent beauty. Renger-Patzsch epitomizes the cool, objective observer whose camera is the perfect mechanism with which to experience the pure object. This attitude influenced his photographs of architectural subjects, and his style has been compared to that of an architect's technical drawing. Also in 1928, Renger-Patzsch moved his business to Essen. He produced photographs for many more books on German architecture and related subjects throughout the 1930s. He later moved to Wamel, where he remained until his death in 1966.

References: *Avant-garde Photography*, pp. 18–19; and Mellor, *Germany*, pp. 9–14.

PLATE 137. Albert Renger-Patzsch. *South aisle, Church of St. Katharine, Brandenburg*. Silver print, 22.7×16.8 cm ($8\frac{15}{16}×6\frac{5}{8}$ in). Reproduced as plate 120, titled "Gliederung der Innenwand 120. Brandenburg, Katharinenkirche. Blick durch die Durchbrechungen der eingezogenen Strebepfeiler der Südwand," in *Norddeutsche Backsteindome, aufgenommen von Albert Renger-Patzsch, beschrieben von Werner Burmeister* (Berlin: Deutscher Kunstverlag, 1930). Photographer's stamp on verso: "RENGER-FOTO D.W.B./JEDE REPRODUKTION/VERBOTEN".

Designed by Hinrich Brunsberg von Stettin in the first half of the fifteenth century, the late Gothic brick Church of St. Katharine stands in the center of Brandenburg. Renger-Patzsch's view up the staircase into the balcony along the south wall emphasizes the upward thrust of the double-arched interior buttresses. He has depicted an integral element of the structure while expressing his fundamental attitude toward architecture, developed in *Die Welt ist Schön*: that beauty resides in organic, decorative, and structural elements alike.

PLATE 138. Albert Renger-Patzsch. *South aisle, Church of St. Maria auf dem Sande, Wroclaw, Poland*. Silver print, 22.7×16.8 cm ($8\frac{15}{16}×6\frac{5}{8}$ in). Reproduced as plate 114, titled "Gewölbeformen, 114. Breslau, dreikappige Wechselgewölbe im südlichen Seitenschiff der Sandkirche," in *Norddeutsche Backsteindome aufgenommen von Albert Renger-Patzsch, beschrieben von Werner Burmeister* (Berlin: Deutscher Kunstverlag, 1930). Photographer's stamp on verso: "RENGER-FOTO D.W.B./JEDE REPRODUKTION/VERBOTEN".

Wroclaw, part of Poland since 1945, was formerly the city of Breslau in Prussia. The fourteenth-century Sandkirche, or St. Maria auf dem Sande, stands on an island in the Oder River. By photographing the tri-capped spring vaulting, Renger-Patzsch not only described distinctive features of the interior but also expressed his tenet that decorative patterns beyond those inherent in the subject are revealed through composition and format.

PLATE 139. Albert Renger-Patzsch. *Towers and east front, abbey, Murbach, Alsace*. Silver print, late 1930s, 38.3×28.4 cm ($15\frac{1}{16}×11\frac{3}{16}$ in).

The abbey church of Murbach was begun in 728 and completed at the end of the twelfth century. Of the original structure, only the choir and the transept surmounted by two towers remain. This partial view of the building, with the towers emerging from the landscape, depicts structure meshing with environment, a subject that fascinated Renger-Patzsch and results here in a statement of a romantic, particularly German, sensibility. The French region of Alsace, which changed hands frequently, was occupied by the Germans in 1940 and recovered for France by French and American troops in 1945 at the end of World War II.

AUGUST SANDER
1876–1964

§ August Sander was born in Herdorf, Germany, and began photography as an adolescent. At the age of twenty he was drafted for compulsory military service, serving from 1896 until 1899. He then pursued photography by apprenticing in various studios and became proficient in portrait as well as architectural and industrial photography. He simultaneously enrolled at the Dresden Academy of Art, where he studied portrait and landscape painting. In 1902 he married and, by 1904, was the sole proprietor of a photographic and painting studio. With the outbreak of World War I, he was drafted again and served in the medical corps before returning to his business in Cologne in 1918. In 1927 he joined the author Ludwig Mathar on a trip to Sardinia, intending to produce a collaborative book, although this was never realized because of contractual disagreements with the publisher. Soon after, his first publication *Antlitz der Zeit* (Munich: Transmare Verlag / Kurt Wolff Verlag, 1929) appeared. It comprised sixty plates and was a small part of a photographic document of German people arranged by individual types within the various social strata. By 1934 the Nazis had seized all copies and banned the publication of further copies, in part because all races were included and it did not promote the Aryan ideal. Because of the unpopular content of this project, Sander began to make landscape photographs and continued to accept commissions from architects, Wilhelm Riphahn (1889–1964) and Hans Heinz Lüttgen (1895–1976), among others. In 1933 and 1934, he produced the photographs and sometimes the text for a series titled *Deutsches Land, Deutsches Volk* (Bad Rothenfelde: L. Holzwarth Verlag, first published in 1934). The series was intended to include ten books, but only six were actually printed. Before the outbreak of World War II, Sander systematically documented sites in Cologne as he anticipated the destruction of the city. Immediately after the war, he photographed the ruins. In 1944 he moved to Kuchhausen, west of Cologne, and continued to produce industrial and landscape photographs. Although the large group of negatives that remained in Cologne survived the war, a fire destroyed them in 1946. After the war, Sander produced books and portfolios and was awarded many honors, including the much esteemed Cultural Prize of the German Photographic Society in 1961. He died in Kuchhausen.

Reference: Kramer, *August Sander*.

PLATE 140. August Sander. *Rooftops with Cologne Cathedral*. Silver print, 1930s, 17×23.3 cm ($6\frac{11}{16}×9\frac{3}{16}$ in). Typed and pasted above photograph: "Fotovermerk: Ein Blick über die Dächer von Köln / Foto: August Sander Köln-Lindenthal". Titled in pencil on verso: "Ein Blick über den Dom St. Alban". Photographer's stamp on verso: "august sander/lichtbildner/köln-lindenthal/durenerstr. 201/fernruf 42492".

In 1815 King Frederick William III of Prussia commissioned Karl Friedrich Schinkel (1781–1841), the state architect, to preserve what remained of the unfinished thirteenth-century Cologne Cathedral. Schinkel's pupil, Ernest F. Zwirner (1802–1861), continued the project and in 1833 submitted a proposal to complete the reconstruction. In 1842 Frederick William IV laid the foundation of the new section, and the structure was completed in 1880. Sander's view over a residential section of Cologne contrasts the elegant proportions of the distant cathedral with the heavy helmeted towers of the twelfth-century Church of St. Alban in the foreground, a church that was destroyed during World War II.

PLATE 141. August Sander. *Andernach and the Rhine River from the Kranenberg.* Silver print, 1930s, 22.9×29.2 cm (9×11½ in). Photographer's blindstamp on photograph, lower left: "AUG. SANDER/KÖLN/LINDENTAL". Written in pencil on mount: "Andernach". Photographer's stamp on verso of photograph: "august sander/lichtbilder kuchhausen bei leuscheid/sieg". Typed label pasted on verso of mount: "August Sander: 'Das Rheintal von Mainz bis Köln.' "

Andernach, formerly an ancient Roman town and German Imperial city, lost its commercial importance in the fifteenth century when it became part of the Cologne Electorate. This view along the left bank of the Rhine is of a twentieth-century industrial city punctuated by cherished reminders of the past: the fifteenth-century octagonal watch tower near the center and the twelfth-century parish church to the right. The picture belongs to a series documenting the Rhine Valley that Sander intended as a portfolio but never completed.

FRITZ HENLE
Born 1909

§ The son of a Dortmund surgeon, Fritz Henle is a self-taught photographer. He graduated from the State School for Photography in Munich in 1930, the same year he made his first photographic trip to the Near East. An apprenticeship in Florence with Clarence Kennedy (1892–1972) followed in 1931–1932. Kennedy, who became one of the very few art historians to have pursued photography with the same seriousness and success that characterizes his scholarly work, was an important influence for the young photographer. Henle produced many small topographical and architectural views of Florence and other Italian cities at that time. In 1934 he was hired by the Italian Lloyd shipping line and sent to India to make publicity photographs. When the line was extended to the Far East, Henle traveled to China in 1935 and Japan in 1936. His first documentary project was made possible through a commission from Time-Life. About fifteen photographs were reproduced in an issue of *Fortune* under the title "Japanese Empire" (vol. 14, no. 3, Sept. 1936). Henle arrived in New York in 1936 to pho-

tograph the United States, an assignment financed by Rollei, the camera manufacturer. This massive undertaking was interrupted by World War II. Between 1936 and 1942 he worked for *Life* magazine, which published many of his photographs, several as cover pictures. In 1942, after becoming a U.S. citizen, Henle was hired by the Office of War Information, for whom he worked until the end of the war. He traveled extensively in the U.S. and Mexico. As a freelance photographer, he worked for several fashion magazines, as a result of which he traveled to the Caribbean islands. In 1958 he became a resident of St. Croix, which has since been his home. His first exhibition (of the Japanese photographs) was mounted in the RCA Building lobby in 1936, and his work has continued to be exhibited regularly ever since. He has produced several books of travel photographs as well as many on technique and on working with a Rollei camera. He is still photographing actively.

PLATE 142. Fritz Henle. *Cooling towers, Dortmund.* Silver print, 1929, 7.8×10.8 cm (3 1/16×4¼ in). Signed, dated, and titled in pencil on mount: "Fritz Henle 1931/Metal work through the fog."

Henle's view from a bridge in Dortmund, in the Ruhr River Valley, shows the cooling towers for the blast furnace of a steelworks: three venturi-shaped stacks belching smoke. This industrial landscape, disappearing into the heavily polluted sky, becomes an ethereal backdrop for the clearly delineated silhouettes of the vertical beams and railing in the foreground. This image by the young Henle reflects the photography of the European avant-garde. Although the image today is uncontroversial, it did not seem so in 1929. A short-sighted critic could dismiss virtually all the innovative photography of the period as M. F. Agha did in a parody in *Pictorial Photography in America* in 1929: "*Modernistic photography is easily recognized by its subject matter: Eggs (any style.) Twenty shoes, standing in a row. A skyscraper, taken from a modernistic angle. Ten tea cups standing in a row. A factory chimney seen through the iron work of a railroad bridge (modernistic angle). The eye of a fly enlarged 2000 times.*" (Quoted in Pultz and Scallen, p. 60.)

WERNER MANTZ
Born 1901

§ As an adolescent Werner Mantz began making photographs with a Kodak Brownie, and for five years he recorded his native Cologne and its surrounding landscape. Although he initially considered photography as a hobby, Mantz now recalls that he always regarded photographs as historical statements (Schürmann, p. 4). He pursued his education in Munich, where he refined his technical knowledge of photography, becoming a superb printer. By 1922 he had returned to Cologne and established himself as a freelance photographer, working

closely with artists and sculptors. He was introduced to architectural photography as a specialized area by the architect Wilhelm Riphahn, one of whose buildings Mantz had photographed independently. In 1927, thanks to Riphahn, Mantz began his career as an architectural photographer with many large contracts, documenting the city, its apartment houses, single-family residences, and even architects' offices. The quality of his photographs became so well known that he soon began to receive commissions from some twenty-five other architects, including Erich Mendelsohn (1887–1953) and Hans Heinz Lüttgen (1895–1976). August Sander also worked for Lüttgen, but Mantz had little contact with him. Many of these images were reproduced in the main architectural periodicals of the day. Mantz was a member of the professional society of Cologne photographers. Drawn by the rapid land and building development in the Netherlands and discouraged by the decreasing opportunities for architectural photography in Germany, Mantz moved to Maastricht, close to the German border, in 1932. There he opened a second studio with an old school friend, Karl Mergenbaum, but he kept the Cologne studio open until 1938, when his photography became entirely concentrated on subjects in the Netherlands. He supplemented his architectural work with portraits of children, which were very popular, but he continued to receive both private and public commissions. In 1937 and 1938 he worked for the Staatsmijnen (national mines) in Heerlen in the province of Limburg. He was also commissioned by Provinciale Waterstraat to photograph the newly improved streets of Limburg over the four seasons in order to test the efficacy of their design. He retired in 1971 and continues to reside in Maastricht, the Netherlands.

Reference: Honnef, *Werner Mantz*.

PLATE 143. Werner Mantz. *S.B.B. Geleen industrial site, the Netherlands*. Silver print, 1937–1938, 22.9×17 cm (9×6¹¹⁄₁₆ in). Dated and signed in pencil on verso: "1937 W. Mantz".

While Mantz was working on the government commission to record the mining area in Heerlen, he made several photographs of an industrial site of the company S.B.B. Geleen. It is likely that these views were commissioned by the firm. Mantz constructed an image of delicate complexity, playing the details of the shutters at the left against the fenestration in the background. This space is dislocated by the open-work steel trestles, which appear to lie uncertainly between the two.

PLATE 144. August Sander. *Apartment of Dr. Lehmann, Dresden*. Silver print, 1929 or 1930, 22.9×16.8 cm (9×6⅝ in). Written in pencil on verso: "AUGUST SANDER: INTERIEUR/*ca.* 1931".

The architect Hans Heinz Lüttgen (1895–1976) was responsible for the interior design, including the furniture, of Dr. Hans (?) Lehmann's apartment. This image of an interior clearly illustrates contemporary German design standards. Both Sander and Werner Mantz were hired by Lüttgen to photograph his projects. In 1928, just prior to taking this photograph, Sander made a portrait in Cologne of the architect and his wife, intended as part of the portfolio *Man of the Twentieth Century*, which was only completed in the late 1950s. In the uncertainty of Germany's future and because of the increasingly hostile climate, Lüttgen, like many other architects, left Germany in 1939 and moved to Switzerland and Brazil before settling in New York.

PLATE 145. Werner Mantz. *Villa, Marienburg, Cologne*. Silver print, 1928, 17× 22.2 cm (6¹¹⁄₁₆×8¾ in). Signed and dated in pencil on verso: "W. Mantz/1928". Photographer's stamp: "Photographie:/WERNER MANTZ/Köln, Hohenstaufenring 46/Telefon Anno 5474". Photographer's stamp: "Reproduktion ds. Bildes nur mit/Genehmigung und Namen des Urhebers/(phot. Werner MANTZ-Köln) sowie unter/Einsendung eines. Belegexemplares gestattet./(Gesetz betr. d. Urheberrecht v.9.1. 1907)."

This image, the result of one of the first contracts between the architect Wilhelm Riphahn and Mantz, shows the interior of a villa near Cologne. Contemporary with the preceding view by August Sander, this photograph presents a strikingly bare room with an ornate Venetian glass chandelier and a plant, potted in a Chinese vase. These surprisingly decorative details, which recall the past, offer a compelling contrast to the otherwise thoroughly modern interior. The many cacti reflect a popular design element of the period; a single cactus appears in Sander's image.

THEODOR LUKAS FEININGER
Born 1910

§ T. Lux Feininger, the brother of Andreas and Lawrence and son of the painter Lyonel Feininger, was born in Berlin. Between 1926 and 1929 he studied stage design with Oskar Schlemmer at the Bauhaus, where he remained as a postgraduate until 1932. He was already well versed in photography, a medium that was only introduced to the Bauhaus in 1929 by Walter Peterhans and practiced by few other students. During his Bauhaus years, Feininger's photographs were exhibited by the Berlin photographic agency Dephot. In 1937 he left Germany and moved to New York, leaving most of his negatives and some paintings behind; they were never recovered. His work was exhibited intermittently in New York throughout the 1940s and early 1950s at the Julien Levy Gallery and museums: The Museum of Modern Art in 1943, the Brooklyn Museum and the Whitney Museum of American Art in 1951. In 1953 he was appointed lecturer

in drawing and painting at Harvard, a position he held until 1962, when he joined the Museum School of the Boston Museum of Fine Arts as instructor of painting and drawing. He retired in 1975 and continues to live in Massachusetts.

Reference: *T. Lux Feininger.*

PLATE 146. T. Lux Feininger. *Curtain wall, Workshop Building, Bauhaus, Dessau.* Silver print, late 1920s, 11.3 × 8.3 cm (4 7/16 × 3 1/4 in). Signed and titled on verso: "C photo T. Lux Feininger / The Bauhaus / [reflections in / workshop bldg.]". Label pasted on verso: "Germanic Museum / Loan / 94.49".

The Bauhaus was the embodiment of the most advanced attitudes toward architecture and design during the first half of the twentieth century. The school was founded in Weimar in 1919 by Walter Gropius (1883–1969) and transferred to Dessau in 1925, where Gropius' seminal building was constructed (1925–1926). In 1928 Gropius returned to his private architectural practice in Berlin, and Hannes Meyer (1889–1954) replaced him as director. The position was held by Ludwig Mies van der Rohe (1886–1969) from 1930, through the move to Berlin in 1932, until 1933, when the school was closed down by the Nazis. After World War II, the Bauhaus building, now in East Germany, was considerably altered, and the curtain wall was filled in with brickwork. It has been restored in recent years. Feininger combined the camera angle with the reflections in the Workshop Building to produce an image typical of the photographic works coming from the Bauhaus and expressive of the design principles taught there.

PLATE 147. Werner Mantz. *Apartment house, Kalkerfeld, Cologne.* Silver print, 1928, 38.7 × 22.4 cm (15 1/4 × 8 13/16 in). Titled, dated, and signed in pencil on verso: "Köln-Kalkerfeld 1928 W. Mantz".

This apartment building was designed by the Cologne architect Wilhelm Riphahn, who commissioned Mantz to make this photograph. Today the building is known as "Buschforst" (forest copse). Mantz's picture, like that in plate 143, highlights the strong compositional elements of dark and light and integrates the strongly geometric shadows with the equally geometric architectural elements. Mantz made other images of this building, both details and full views.

SELECTED BIBLIOGRAPHY

Abbott, Berenice (text by Elizabeth McCausland). *Changing New York*. New York: E. P. Dutton and Co., Inc., 1939.

Abbott, Berenice. *Photographs*. New York: Horizon Press, 1970.

Abbott, Berenice. *The World of Atget*. New York: Horizon, 1964.

After Daguerre: Masterworks of French Photography (1848–1900) from the Bibliothèque Nationale. Introduction by Weston Naef, catalog by Bernard Marbot. New York: Metropolitan Museum of Art, in association with Berger-Levrault, Paris (exhibition catalog), 1981.

The American Image, Photographs from the National Archives, 1860–1960. Introduction by Alan Trachtenberg. (Exhibition at the National Archives, Washington, D.C.) New York: Pantheon Books, 1979.

Annan, Thomas. *Photographs of the Old Closes and Streets of Glasgow 1868/1877*. Glasgow, 1878–1879; reprint, preface by Anita Ventura Mozley, New York: Dover Publications, Inc., 1977.

Archer, Mildred. *Early Views of India, The Picturesque Journeys of Thomas and William Daniell 1786–1794*. London: Thames and Hudson Ltd., 1980.

Arnold, H. P. J. *William Henry Fox Talbot, Pioneer of Photography and Man of Science*. London: Hutchinson Benham, 1977.

Avant-Garde Photography in Germany 1919–1939. San Francisco: Museum of Modern Art (exhibition catalog), 1980.

Babelon, E. "Louis de Clercq," in *Les Bronzes*, vol. 3 of *Collection de Clercq. Catalogue*, ed. A. De Ridder. 8 vols. Paris: Leroux, 1905.

Baier, Lesley. *Walker Evans at Fortune 1945–1965*. Wellesley, Massachusetts: The Wellesley College Museum (exhibition catalog), 1977.

Bancroft, Caroline. *Denver's Lively Past*. Boulder, Colorado: Johnson Publishing Co., 1959.

Barnard, George N. *Photographic Views of Sherman's Campaign*. New York: George N. Barnard, 1866; reprint, preface by Beaumont Newhall, New York: Dover Publications, Inc., 1977.

Becchetti, Piero. *Fotografi e fotografia in Italia, 1839–1880*. Rome: Edizioni Quasar, 1978.

Borcoman, James. *Charles Nègre 1820–1880*. Ottawa: The National Gallery of Canada / Galerie Nationale du Canada for the Corporation of the National Museums of Canada (exhibition catalog), 1976.

Bossert, Dr. Helmuth Th. and Heinrich Guttmann. *Aus der Frühzeit der Photographie 1840–1870*. Frankfurt: Societats-Verlag, 1930.

Braive, Michel F. (trans. David Britt). *The Photograph: A Social History*. London: Thames and Hudson, 1966.

Bramson, Henrik, Marianne Brøns and Bjorn Ochsner. *Early Photographs of Architecture and Views in Two Copenhagen Libraries*. Copenhagen: Thaning and Appel, 1957.

Brettell, Richard. *Historic Denver, The Architects and the Architecture 1858–1893*. Denver: Historic Denver, Inc., 1973.

Briggs, Asa. *Iron Bridge to Crystal Palace: Impact and Images of the Industrial Revolution*. London: Thames and Hudson in collaboration with The Ironbridge Gorge Museum Trust (exhibition catalog), 1979.

Buckland, Gail. *Fox Talbot and the Invention of Photography*. Boston: David R. Godine, 1980.

Buckland, Gail. *Reality Recorded: Early Documentary Photography*. Greenwich, Connecticut: New York Graphic Society, 1974.

Bull, Deborah and Donald Lorimer. *Up the Nile: A Photographic Excursion: Egypt 1839–1898*. New York: Clarkson N. Potter, Inc., 1979.

California History, The Magazine of the California Historical Society, vol. LVII, Fall 1978, "Special Issue: Carleton E. Watkins."

Cartier-Bresson, Henri. *The Decisive Moment*. New York: Simon and Schuster, 1952.

Charles Sheeler. Essays by Martin Friedman, Bartlett Hayes, Charles Millard; catalog by Abigail Booth. (Exhibition at the National Collection of Fine Arts, Washington, D.C.) Washington, D.C.: Smithsonian Institution Press, 1968.

Cheronnet, Louis. *Paris tel qu'il fut: 104 photographies anciennes*. Paris: Editions Tel, 1951.

Chevedden, Paul E. *The Photographic Heritage of the Middle East, An Exhibition of Early Photographs of Egypt, Palestine, Syria, Turkey, Greece & Iran, 1849–1893*.

(Exhibition at the University of California, Los Angeles, Research Library.) Malibu, California: Undena Publications, 1981.

Christ, Yvan. *L'Age d'or de la Photographie* (*Arts et Artisans de France*). Paris: Vincent Fréal et Cie, 1965.

Christ, Yvan with Marcel Bovis. *150 ans de Photographie française, avec l'histoire des anciens procédés*. Paris: Photo-Ciné-Revue, 1979.

Churchill, Kenneth. *Italy and English Literature 1764–1930*. London: Macmillan Press Ltd., 1980.

Clegg, Jeanne. *Ruskin and Venice*. London: Junction Books, 1981.

Coe, Brian. *The Birth of Photography: The Story of the Formative Years 1800–1900*. New York: Taplinger Publishing Company, 1977.

Coffey, Barbara and Marjorie Munsterberg. "Robert Macpherson, 1811–1872." Unpublished article.

Coplans, John. "C. E. Watkins at Yosemite." *Art in America*, vol. 66, no. 6, November–December 1978, pp. 100–108.

Davis, Keith F. *Désiré Charnay: Expeditionary Photographer*. Albuquerque, New Mexico: The University of New Mexico Press, 1981.

Desai, Usha. *Captain Linnaeus Tripe–1822 to 1902*, unpublished exhibition checklist, Dudley Johnston Gallery, Royal Photographic Society, London, February–March 1977.

Dictionary of American Biography. 24 vols. New York: Charles Scribner's & Sons (under the auspices of the American Council of Learned Societies), 1928–1958.

Dictionary of National Biography, eds. Leslie Stephen and Sidney Lee. 63 vols. and supplements. London: Smith, Elder & Co., 1885–1940.

Dictionnaire de biographie française, eds. J. Balteau, M. Barroux, M. Prévost, Roman d'Amat. 80 fascicles. Paris: Letouzey et Ané, 1929–1976.

Dufty, A. R. *Kelmscott: An Illustrated Guide*. London: The Society of Antiquaries, 1969.

Eder, Josef Maria (trans. Edward Epstean). *History of Photography*. New York: Columbia University Press, 1945.

Evans, Walker. *Walker Evans: Photographs for the Farm Security Administration 1935–1938*. New York: Da Capo Press, Inc., 1973.

Evenson, Norma. *Paris: A Century of Change, 1878–1978*. New Haven, Connecticut: Yale University Press, 1979.

Finkel, Kenneth. *Nineteenth Century Photography in Philadelphia*. New York: Dover Publication, Inc., in cooperation with the Library Company of Philadelphia, 1980.

Finkel, Kenneth. "William Herman Rau." Unpublished biography.

Ford, Colin, ed., essay by Roy Strong. *An Early Victorian Album: The Photographic Masterpieces (1843–1847) of David Octavius Hill and Robert Adamson*. New York: Alfred A. Knopf, 1976.

'From today painting is dead.' The Beginnings of Photography. (Exhibition at The Victoria and Albert Museum.) London: The Arts Council of Great Britain, 1972.

Galassi, Peter. *Before Photography: Painting and the Invention of Photography*. New York: The Museum of Modern Art (exhibition catalog), 1981.

Gardner, Alexander. *Gardner's Photographic Sketch Book of the Civil War*. Washington, D.C.: Philp & Solomons, 1866; reprint, introduction by E. F. Bleiler, New York: Dover Publications, Inc., 1959.

Gernsheim, Helmut and Alison. *The History of Photography 1685–1914*. New York: McGraw-Hill Book Company, 1969.

Gernsheim, Helmut and Alison. *L. J. M. Daguerre 1787–1851: The World's First Photographer and Inventor of the Daguerreotype*. Cleveland and New York: The World Publishing Company, 1956.

Gernsheim, Helmut and Alison. *The Recording Eye. A Hundred Years of Great Events as seen by the camera 1839–1939*. New York: G. P. Putnam's Sons, 1960.

Gernsheim, Helmut and Alison. *Roger Fenton. Photographer of the Crimean War: His Photographs and his Letters from the Crimea*. London: Secker & Warburg, 1954.

Goldschmidt, Lucien and Weston J. Naef. *The Truthful Lens*. New York: The Grolier Club, 1980.

Goodrich, L. Carrington and Nigel Cameron. *The Face of China: As Seen by Photographers and Travelers 1860–1912*. New York: Aperture, 1978.

Haaften, Julia van. " 'Original Sun Pictures': A Check List of the New York Public Library's Holdings of Early Works Illustrated with Photographs, 1844–1900." *Bulletin of the New York Public Library*, vol. 80, Spring 1977, pp. 355–415.

Haaften, Julia van. *Egypt and the Holy Land in Historic Photographs. 77 Views by Francis Frith*. New York: Dover Publications, Inc., 1980.

Hambourg, Maria Morris and Marie de Thézy. *Charles Marville, Photographs of Paris from the Time of the Second Empire on Loan from the Musée Carnavalet, Paris*. New York: French Institute/Alliance Française (exhibition catalog), 1981.

Hannavy, John. *Roger Fenton of Crimble Hall*. Boston: David R. Godine, 1976.

Harker, Margaret F. *The Linked Ring: The Secession Movement in Photography in Britain, 1892–1910*. London: Heinemann, 1979.

Haskell, Francis. *Rediscoveries in Art. Some Aspects of Taste, Fashion and Collecting in England and France*. Ithaca, New York: Cornell University Press, 1976.

Haskell, Francis and Nicholas Penny. *Taste and the Antique, The Lure of Classical Sculpture 1500–1900*. New Haven, Connecticut: Yale University Press, 1981.

Heathcote, Bernard V. and Pauline F. "Richard Beard: an Ingenious and Enterprising Patentee," *History of Photography*, vol. 3, October 1979, pp. 313–329.

Heathcote, Pauline F. "Samuel Bourne of Nottingham," *History of Photography*, vol. 6, April 1982, pp. 99–112.

Hege, Walter (introduction by Gerhart Rodenwaldt). *Die Akropolis*. Berlin: Deutscher Kunstverlag, 1930.

Heilbrun, Françoise and Philippe Néagu. *Charles Nègre, photographe, 1820–1880*. (Exhibition at the Musée Reattu, Arles.) Paris: Editions de la Réunion des Musées nationaux, 1980.

Helsted, Dyveke. "Rome in Early Photography," *History of Photography*, vol. 2, October 1978, pp. 335–346.

Henle, Fritz. *Fritz Henle*. St. Croix, Virgin Islands: Fritz Henle Publishing, 1973.

Hershkowitz, Robert. *The British Photographer Abroad: The First Thirty Years*. London: Robert Hershkowitz Ltd., 1980.

Hewison, Robert. *Ruskin and Venice*. London: Thames and Hudson, 1978.

Honnef, Klaus, intro. *Werner Mantz, Fotografien 1926–1938*. (Exhibition at the Rheinisches Landesmuseum, Bonn.) Cologne: Rheinland-Verlag, 1978.

Hopkinson, Tom. *Treasures of the Royal Photographic Society 1839–1919*. New York: Focal Press, Inc., 1980.

Hough, Richard. *Images on Paper: Mid-19th Century French Photography*. (Exhibition at Stills, The Scottish Photography Group Gallery.) Edinburgh: Stills, 1979.

Houghton, Lord. "Edward Cheney. In Memoriam." *Miscellanies of the Philoblon Society*, vol. 15, 1877–1884, pp. 1–18.

Hunnisett, Basil. *Steel-engraved Book Illustration in England*. Boston: David R. Godine, 1980.

Jammes, André. *Photography: Men and Movements. William H. Fox Talbot, Inventor of the Negative-Positive Process*. New York: Macmillan Publishing Co., Inc., 1973.

Jammes, André with Robert Sobieszek and Minor White. *French Primitive Photography*. (Exhibition at the Philadelphia Museum of Art.) New York: Aperture, 1969.

Jammes, Bruno. "John B. Greene, an American Calotypist," *History of Photography*, vol. 5, October 1981, pp. 305–324.

Jammes, Isabelle. *Blanquart-Evrard et les origines de l'édition photographique française*. Geneva: Librairie Droz, 1981.

Janis, Eugenia Parry. "The Man on the Tower of Notre Dame: New Light on Henri Le Secq," *Image*, vol. 19, December 1976, pp. 13–25.

Janis, Eugenia Parry. "Photography" in *The Second Empire 1852–1870, Art in France under Napoléon III*, pp. 401–433. Philadelphia, Pennsylvania: Philadelphia Museum of Art (exhibition catalog), 1978.

Jeníček, Jiří. *D. J. Ruzicka*. Prague: Státní nakladatelství krásné literatury, hudby a umění, 1959.

Jenkyns, Richard. *The Victorians and Ancient Greece*. Cambridge, Massachusetts: Harvard University Press, 1980.

Johnson, Edgar. *Charles Dickens, His Tragedy and Triumph*. Rev. and abridged. Harmondsworth, Middlesex: Penguin Books, Ltd., 1979.

Johnson, J. W. *The Early Pacific Coast Photographs of Carleton E. Watkins*. Albuquerque, New Mexico: Museum of New Mexico (exhibition catalog), 1976.

Jussim, Estelle. *Visual Communication and the Graphic Arts. Photographic Technologies in the Nineteenth Century*. New York: R. R. Bowker Co., 1974.

Keller, Judith and Kenneth A. Breisch. *A Victorian View of Ancient Rome. The Parker Collection of Historical Photographs in the Kelsey Museum of Archaeology*. Ann Arbor, Michigan: Kelsey Museum of Archaeology, The University of Michigan (exhibition catalog), 1980.

Kramer, Robert. *August Sander. Photographs of an Epoch: 1904–1959*. (Exhibition at the Philadelphia Museum of Art.) New York: Aperture, 1980.

Krautheimer, Richard. *Rome, Profile of a City, 312–1308*. Princeton, New Jersey: Princeton University Press, 1980.

Lefebvre, Henri. *La vieille photographie depuis Daguerre jusqu'à 1870*. Paris: Vigier et Brunissen, 1931.

Lerebours, Nicolas-Marie Paymal. *Excursions daguerriennes. Vues des monuments les plus remarquables du globe*. 2 vols. Paris: Rittner et Goupil, 1840–1842.

Lindquist-Cock, Elizabeth. "Stillman, Ruskin & Rossetti: the Struggle between Nature and Art," *History of Photography*, vol. 3, January 1979, pp. 1–14.

Lloyd, Valerie. *Photography: the First Eighty Years*. London: P. & D. Colnaghi & Co. Ltd. (exhibition catalog), 1976.

Longford, Elizabeth. *Queen Victoria, Born to Succeed*. New York: Harper & Row, 1964.

Looney, Robert F. *Old Philadelphia in Early Photographs 1839–1914*. New York: Dover Publications, Inc., 1976.

Lotchin, Roger W. *San Francisco, 1846–1856, from Hamlet to City*. New York: Oxford University Press, 1974.

Lowry, John. "Victorian Burma by Post, Felice Beato's Mail-Order Business," *Country Life*, March 13, 1975, pp. 659–660.

Marbot, Bernard. *Une Invention du XIXe Siècle: la photographie: expression et technique*. Paris: Bibliothèque Nationale (exhibition catalog), 1976.

Markham, Clements R. *Memoir of the Indian Surveys*. 2nd ed. London: sold by W. H. Allen & Co., 1878.

Mathews, Oliver. *Early Photographs and Early Photographers, A Survey in Dictionary Form*. New York: Pitman Publishing Corporation, 1973.

McAndrew, John. *Venetian Architecture of the Early Renaissance*. Cambridge, Massachusetts: M.I.T. Press, 1980.

Mellor, David, ed. *Germany–The New Photography 1927–1933*. London: The Arts Council of Great Britain, 1978.

Michaelson, Katherine. *A Centenary Exhibition of the Work of David Octavius Hill 1802–1870 and Robert Adamson 1821–1848.* Edinburgh: The Scottish Arts Council (exhibition catalog), 1970.

Müller-Wulckow, Walter (introduction by Reyner Banham). *Architektur der zwanziger Jahre in Deutschland.* Konistein im Taurus: Karl Robert and Hans Koster, 1975.

Nash, Ernest. *Pictorial Dictionary of Ancient Rome.* 2 vols. 1961; reprint, New York: Hacker Art Books, 1981.

Néagu, Philippe. *La Mission héliographique, photographies de 1851.* Paris: Archives photographiques de la Direction du Patrimoine (exhibition catalog), 1980.

Newhall, Beaumont. *A Catalogue of the Epstean Collection on the History and Science of Photography.* New York: Columbia University Press, 1937.

Newhall, Beaumont. *The Daguerreotype in America.* 3rd rev. ed. New York: Dover Publications, 1976.

Newhall, Beaumont. *The History of Photography.* Rev. ed. New York: The Museum of Modern Art, 1964.

Newhall, Beaumont. *Frederick H. Evans.* Rochester, New York: George Eastman House, 1964.

Newhall, Beaumont and Nancy. *T. H. O'Sullivan: Photographer.* Rochester, New York: George Eastman House, 1966.

Newhall, Beaumont and Nancy. *Masters of Photography.* New York: George Braziller, Inc., 1958.

Norman, Dorothy. *Alfred Stieglitz: An American Seer.* New York: Random House, 1966.

Onne, Eyal. *Photographic Heritage of the Holy Land 1839–1914.* Manchester: Institute of Advanced Studies, Manchester Polytechnic, 1980.

Palmquist, Peter E. "California's Peripatetic Photographer, Charles Leander Weed," *California History,* vol. LVIII, Fall 1979, pp. 194–219.

Palmquist, Peter E. "The Life and Photography of Carleton E. Watkins," *The American West, The Magazine of Western History,* vol. XVII, July/August 1980, pp. 14–29.

Panzer, Mary. *Philadelphia Naturalistic Photography 1865–1906.* New Haven, Connecticut: Yale University Art Gallery (exhibition catalog), 1982.

Pinkney, David H. *Napoleon III and the Rebuilding of Paris.* Princeton, New Jersey: Princeton University Press, 1958.

Plarr, Victor Gustave. *Plarr's Lives of the Fellows of the Royal College of Surgeons of England.* Revised by Sir D'Arcy Power, W. G. Spencer and G. E. Gask. 2 vols. London: Simpkin, Marshall Ltd., for the Royal College of Surgeons, 1930.

Potonniée, George (trans. Edward Epstean). *The History of the Discovery of Photography.* New York: Tennant and Ward, 1936; reprint, New York: Arno Press, Inc., 1973.

Prescott, Gertrude Mae. "Architectural Views of Old London," *The Library Chronicle,* new series, no. 15. Austin, Texas: Humanities Research Center and the General Libraries, the University of Texas, 1981.

Preston, Harley. *London and the Thames, Paintings of Three Centuries.* (Exhibition at the Department of the Environment at Somerset House.) London: London Celebration Committee for the Queen's Silver Jubilee, 1977.

Pultz, John and Catherine B. Scallen. *Cubism and American Photography, 1910–1930.* Williamstown, Massachusetts: Sterling and Francine Clark Art Institute (exhibition catalog), 1981.

The Real Thing: An Anthology of British Photographs 1840–1950. (Exhibition at the Hayward Gallery.) London: Arts Council of Great Britain, 1975.

Reiff, Daniel. "Viollet le Duc and Historic Restoration: the West Portals of Notre-Dame," *Journal of the Society of Architectural Historians,* vol. 30, March 1971, pp. 17–30.

Renger-Patzsch, Albert. *Die Welt ist Schön.* Munich: Kurt Wolff Verlag, 1928.

Renger-Patzsch, Albert and Werner Burmeister. *Norddeutsche Backsteindome.* Berlin: Deutscher Kunstverlag, 1930.

Reynaud, Léonce, ed. *Les Travaux publics de la France. Routes et ponts, chemins de fer, rivières et canaux, ports de mer, phares et balises.* 5 vols. Paris: J. Rothschild, 1883.

Robinson, Cervin and Rosemarie Haag Bletter. *Skyscraper Style, Art Deco New York.* New York: Oxford University Press, 1975.

Rosenblum, Naomi. "Adolphe Braun: a 19th-Century Career in Photography," *History of Photography,* vol. 3, October 1979, pp. 357–372.

Rourke, Constance. *Charles Sheeler: Artist in the American Tradition.* New York: Harcourt Brace and Co., 1938.

Rowland, Benjamin. *The Art and Architecture of India, Buddhist/Hindu/Jain* (The Pelican History of Art). Baltimore, Maryland/Harmondsworth, Middlesex: Penguin Books, 1953.

Rudisill, Richard. *Mirror Image: The Influence of the Daguerreotype on American Society.* Albuquerque, New Mexico: University of New Mexico Press, 1971.

Ruskin, John. *The Works of John Ruskin* (Library Edition), eds. E.T. Cook and A. Wedderburn. 39 vols. London: George Allen, 1903–1912.

Schaeffer, Emil. *Attische Kultstätten.* Zurich: Orell Füsseli Verlag, 1931.

Schimelli, Wladimiro and Filippo Zevi. *Gli Alinari. Fotografi a Firenze. 1852–1920.* Florence: Edizioni Alinari, 1977.

Schürmann, Wilhelm. "Interview with Werner Mantz," *Camera,* no. 1, January 1977, pp. 4–12.

Schuyler, Montgomery. *American Architecture and Other Writings,* eds. William H. Jordy and Ralph Coe. 2 vols. Cambridge, Massachusetts: Harvard University Press, 1961.

Schwarz, Heinrich. *David Octavius Hill: Der Meister der Photographie.* Leipzig: Insel-Verlag, 1931.

Un siècle de photographie de Niepce à Man Ray. (Exhibition at the Musée des Arts décoratifs.) Paris: Union centrale des Arts décoratifs, 1965.

Smith, Graham, "Hill & Adamson: St. Andrews, Burnside & the Rock and Spindle," *The Print Collector's Newsletter,* vol. x, no. 2, 1979, pp. 45–48.

Snyder, Joel. *American Frontiers: The Photographs of Timothy H. O'Sullivan, 1867–1874.* New York: Aperture, 1981.

Sobieszek, Robert A. *British Masters of the Albumen Print.* Chicago: The University of Chicago Press, 1976.

Steinert, Otto. *Die Kalotypie in Frankreich: Beispiele der Landschafts-Architektur und Reisedokumentationsfotografie.* Essen: Museum Folkwang (exhibition catalog), 1965–1966.

Stevenson, Sara. *David Octavius Hill and Robert Adamson.* Edinburgh: National Gallery of Scotland, 1981.

Stillman, William James. *The Autobiography of a Journalist.* 2 vols. Boston: Houghton Mifflin and Company, 1901.

Szarkowski, John. *The Photographer's Eye.* New York: The Museum of Modern Art, 1966.

Szarkowski, John. *Looking at Photographs. 100 Pictures from the Collection of The Museum of Modern Art.* New York: The Museum of Modern Art, 1973.

Szarkowski, John. *Walker Evans.* New York: The Museum of Modern Art, 1971.

Szarkowski, John and Maria Morris Hambourg. *The Work of Atget: Volume I. Old France.* New York: The Museum of Modern Art, 1981.

Taft, Robert. *Photography and the American Scene: A Social History, 1839–1889.* New York: The Macmillan Company, 1938.

Talbot, William Henry Fox. *The Pencil of Nature.* London: 1844–1846; reprint, introduction by Beaumont Newhall, New York: Da Capo Press, 1969.

Thomas, Alan. *Time in a Frame, Photography and the Nineteenth-Century Mind.* New York: Schocken Books, 1977.

Thomson, John. *The Straits of Malacca, Indo-China, and China or, Ten Year's Travels, Adventures, and Residence Abroad.* New York: Harper & Brothers, 1875.

Thornton, Ann. *Rome in Early Photographs, 1846–1878.* Copenhagen: The Thorvaldsen Museum, 1977.

T. Lux Feininger. Photographs of the Twenties and Thirties. Introduction by T. Lux Feininger. New York: Prakapas Gallery (exhibition catalog), 1980.

Travis, David. *Photography Rediscovered. American Photographs, 1900–1930.* New York: The Whitney Museum of American Art (exhibition catalog), 1979.

Tsigakou, Fani-Maria. *The Rediscovery of Greece.* New York: Caratzas, 1981.

Turner, Frank M. *The Greek Heritage in Victorian Britain.* New Haven, Connecticut: Yale University Press, 1981.

Vaczek, Louis and Gail Buckland. *Travelers in Ancient Lands, A Portrait of the Middle East. 1839–1919.* Boston: New York Graphic Society, 1981.

Viollet-le-Duc. (Exhibition at the Galeries nationales du Grand Palais, Paris.) Paris: Editions de la Réunion des Musées nationaux, 1980.

Viollet-le-Duc, Eugène-Emmanuel. *Dictionnaire raisonné de l'architecture française du XIe au XVIe siècle.* 10 vols. Paris: B. Bance et al., 1854–1868.

Waller, Franz. "Jakob August Lorent, a Forgotten German Travelling Photographer," *The Photographic Collector,* vol. 3, no. 1, Spring 1982, pp. 21–40.

Walther, Jean. Typescript biography, Musée du Vieux-Vevey (copy in Bibliothèque Nationale, Paris).

Watson, Wendy M. *Images of Italy: Photography in the Nineteenth Century.* South Hadley, Massachusetts: Mount Holyoke College Art Museum (exhibition catalog), 1980.

Wingler, Hans M. *The Bauhaus: Weimar Dessau Berlin Chicago.* Cambridge, Massachusetts, and London: The M.I.T. Press, 1969.

Williams, Susan I. *Samuel Bourne: In Search of the Picturesque.* (Exhibition at the Sterling and Francine Clark Art Institute.) Williamstown, Massachusetts: McClelland Press, 1981.

Worswick, Clark and Jonathan Spence. *Imperial China: Photographs 1850–1912.* New York: Pennwick/Crown, 1978.

Worswick, Clark. *Japan: Photographs 1854–1905.* New York: Pennwick/Alfred A. Knopf, 1979.

Worswick, Clark and Ainslie Embree. *The Last Empire: Photography in British India, 1855–1911.* New York: Aperture, 1976.

Zevi, Filippo, ed. (introduction by John Berger). *Alinari: Photographers of Florence 1852–1920.* Florence: Alinari Edizioni & Idea Editions in association with the Scottish Arts Council, 1978.

INDEX

Plate numbers are in italics and precede the page references. Sites are indexed by geographical location under country.

282

DESIGNED BY ELEANOR MORRIS CAPONIGRO

THE LETTERPRESS PRINTING AND COMPOSITION IN MONOTYPE BEMBO

AND CASTELLAR BY THE STINEHOUR PRESS, LUNENBURG, VERMONT

THE PLATES PRINTED BY THE MERIDEN GRAVURE COMPANY,

MERIDEN, CONNECTICUT

BINDING BY PUBLISHERS BOOK BINDERY

LONG ISLAND CITY, NEW YORK

DISTRIBUTED BY CALLAWAY EDITIONS,

NEW YORK